Ultimate Lighting Design

teNeues

Editor in chief:	Vanessa Thaureau
Project coordination and research:	Miina Matsuoka
Texts:	Sean Weiss, Miina Matsuoka
Copy editor:	Sean Weiss
Art direction:	Hervé Descottes, Désirée von la Valette
Production :	Susanne Olbrich, Nicole Rankers fusion publishing Stuttgart . Los Angeles, www.fusion-publishing.com
Translations French:	Vanessa Thaureau (Mise-en-éclairage: …), ASCO International (project texts, firm biography)
Translations German:	AllGerman Translations
Translations Italian:	Claudio Del Luongo
Translations Spanish:	Silvia Gómez de Antonio
Translations English:	Vanessa Aubry (Hervé Descottes Biography)

Published by teNeues Publishing Group

teNeues Publishing Company
16 West 22nd Street, New York, NY 10010, USA
Tel.: 001-212-627-9090, Fax: 001-212-627-9511

teNeues Book Division
Kaistraße 18, 40221 Düsseldorf, Germany
Tel.: 0049-(0)211-994597-0, Fax: 0049-(0)211-994597-40

teNeues Publishing UK Ltd.
P.O. Box 402, West Byfleet, KT14 7ZF, Great Britain
Tel.: 0044-1932-403509, Fax: 0044-1932-403514

teNeues France S.A.R.L.
4, rue de Valence, 75005 Paris, France
Tel.: 0033-1-55766205, Fax: 0033-1-55766419

teNeues Ibercia S.L.
Pso. Juan de la Encina 2-48, Urb. Club de Campo
28700 S.S.R.R. Madrid, Spain
Tel./Fax: 0034-91-6595876

www.teneues.com

© 2005 teNeues Verlag GmbH + Co. KG, Kempen

Printed in Italy

ISBN-10:	3-8327-9016-0
ISBN-13:	978-3-8327-9016-5

Bibliographic information published by
Die Deutsche Bibliothek. Die Deutsche Bibliothek lists
this publication in the Deutsche Nationalbibliografie;
detailed bibliographic data is available in the Internet
at http://dnb.ddb.de.

Projects by:

**Hervé Descottes /
L'Observatoire International**

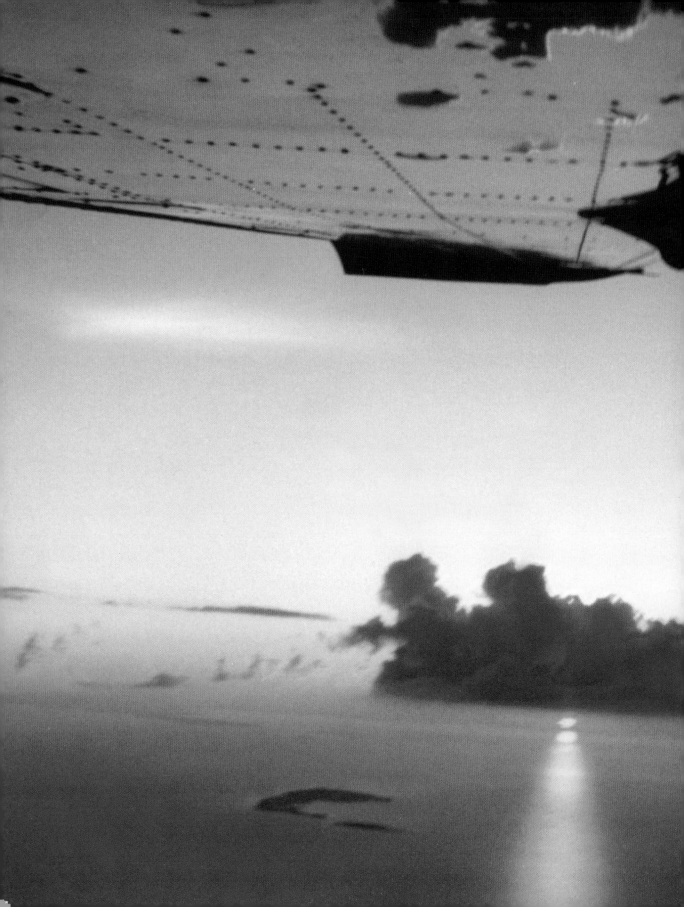

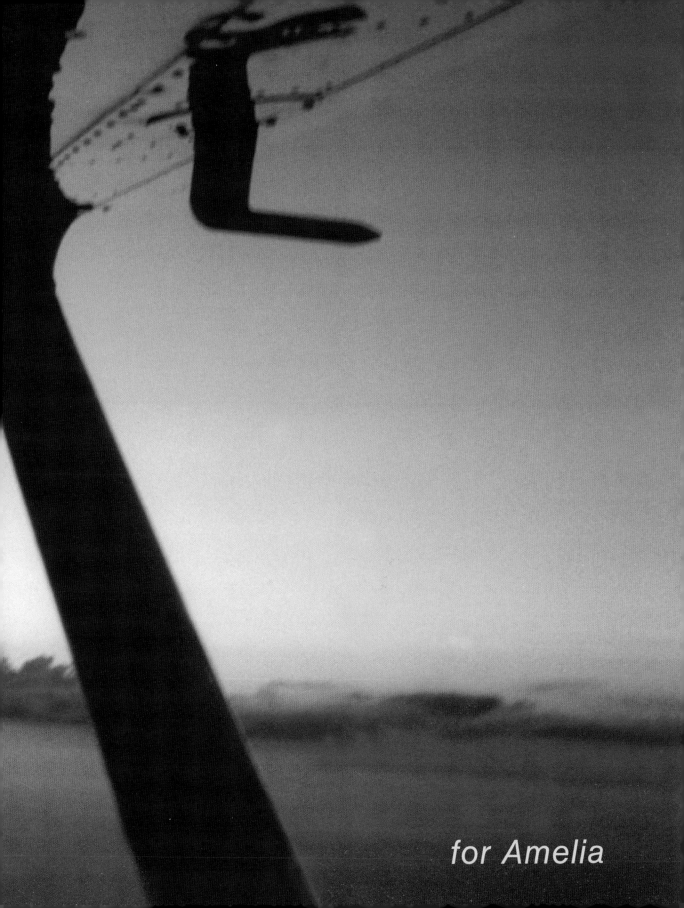

for Amelia

Americas

Europe

Asia

Fixtures

Appendix

Mise-en-éclairage: The Lighting Projects of Hervé Descottes and L'Observatoire International

Hervé Descottes met with Henry Urbach, a gallerist and critic in New York, to discuss the ideas that animate his body of work.

HU: How do your projects begin?

HD: Observation is really at the origin of our work; it's how we develop our response to a given situation, to a site, to a moment. We move towards an emotional understanding of the project that means going deeper into the design problem at hand—towards a different wavelength, something you can't always perceive visually, but somehow sense.

HU: Your work evolves in collaboration with clients, architects and other designers. How would you characterize this process?

HD: An essential aspect of our work is to understand the context we are operating within and the destination we all seek. Beyond that it can vary quite a lot. With Frank Gehry, for example, our work often involves reinforcing spatial sequence and hierarchy; with Steven Holl, it's more a matter of intensifying the poetic and emotional impact of a project.

HU: Part of the lighting designer's task is to establish a rapport between natural and other, artificial forms of light. How do you think about this?

HD: With sunlight there is a definite daily cycle. The sun starts very low, then slowly rises and falls over the course of its 180° arc, and this gives a very specific sense of time passing. With artificial light, as well as by mediating sunlight, you have the opportunity to manipulate the cycle and introduce other kinds of time, other forms of duration.

HU: What's an example of another form of duration?

HD: Lighting can create a kind of imprint related to memory. Very often you don't recall architectural details of a space but what remains with you is a sense of its atmosphere. Lighting can provoke and reawaken these memories, and that has a strong impact on our sense of identity, belonging, and personal balance. You can feel very violated by certain types of light; others make you feel very secure, like being in a cocoon.

HU: Your work spans the globe. Are there local visual traditions you engage?

HD: I think it's important to seriously consider the site you are working on and identify major elements. But if clients from Mexico or Hong Kong ask a Frenchman working in New York for help with a project, it's not to bring them their own cultural heritage. What we do is offer a modern, international vision and integrate that with the specific qualities of the project.

HU: Architecture can be enhanced with lighting, and its mistakes can also be covered up. Does your work offer a corrective or counterpoint?

HD: I think we stick to what's essential. The best result is when you don't understand the lighting of a space, but you feel very good about it—almost as if you see it with your eyes closed, like tuning a vibration.

HU: How does this vibration find its pitch?

HD: We try to bring soul to a project. Memory, organization, a clear sense of order: that is the soul of a project. When everything is well orchestrated and harmonized, you feel the vibration is right.

HU: And how do you move towards this sense of order and well-being?

HD: We organize space—a landscape, an interior, a district, at whatever scale—with light. By placing light, you give order to space. It's a huge responsibility really, as lighting also has a social and political dimension. Light is associated with power and carries a sense of authority, with its many privileges and inequalities. It's definitely an issue when we work in developing countries. Often we want to provide dim lighting levels but security concerns lead us elsewhere.

HU: You advocate lower lighting levels than convention demands?

HD: The night affords us the chance to reconnect with the cosmos, to understand our relationship to the universe and our place in it. By overlighting, by blinding people, you create a veil that diminishes this connection. Our spiritual well-being depends on sustaining this sense of belonging.

HU: A number of your projects make use of blue or magenta light. What do these colors signify for you?

HD: Magenta is something we use because we want to use a color; it gives a sense of euphoria and it's interesting to grab it when we can. Our relationship with blue is very different. I would say it's the only color of light that is a non-color. The sky, for instance, is not painted blue but it looks blue because of its great depth.

HU: For years you've photographed the sky from airplanes. What do these images mean for you?

HD: Flying places us in a different temporal condition: we rush through time zones; day meets night through the same window; we see forms of light that don't normally appear to us on earth. In the air, sunrise begins with sharp white light instead of amber or yellow. We see what we always see, but in a completely different way.

Mise-en-éclairage: Die Beleuchtungsprojekte von Hervé Descottes und L'Observatoire International

Hervé Descottes traf sich mit Henry Urbach, einem New Yorker Galleristen und Kritiker, um über die Ideen, die sich als Leitfaden durch sein Werk ziehen, zu sprechen.

HU: Wie gehen Sie an Ihre Projekte heran?

HD: Die Grundlage unserer Arbeit ist Beobachtung. So entwickeln wir unsere Lösung für eine bestimmte Situation, für einen Ort, für einen Moment. Wir versuchen, das Projekt auf Gefühlsebene zu begreifen, was es uns erlaubt, uns intensiver mit dem vorliegenden Designproblem auseinanderzusetzen. Wir bewegen uns so auf eine andere Wellenlänge zu, auf etwas, das nicht immer mit den Augen zu erfassen ist, man aber trotzdem spüren kann.

HU: Ihre Arbeit entwickelt sich in Zusammenarbeit mit Kunden, Architekten und anderen Designern. Wie würden Sie diesen Prozess beschreiben?

HD: Ein wesentlicher Bestandteil unserer Arbeit besteht darin, die Struktur, in der wir uns bewegen, und das Ziel, das wir alle verfolgen, zu verstehen. Darüber hinaus kann sich ein Projekt von anderen sehr unterscheiden. Bei Frank Gehry zum Beispiel ist die Verstärkung der räumlichen Sequenz und Hierachie oft Teil unserer Arbeit; bei Steven Holl geht es mehr darum, die poetische und emotionale Wirkung eines Projektes zu intensivieren.

HU: Teil der Aufgabe eines Lichtdesigners ist es, eine Verbindung zwischen natürlichen und anderen, künstlichen Lichtarten herzustellen. Wie stehen Sie dazu?

HD: Beim Tageslicht gibt es einen unveränderlichen Kreislauf, der sich täglich wiederholt. Die Sonne geht sehr weit unten auf, steigt langsam weiter empor und folgt einem Bogen von 180° wieder nach unten. Das erzeugt einen sehr genauen Eindruck von vergehender Zeit. Bei künstlichem Licht, wie auch bei indirektem Sonnenlicht, hat man die Möglichkeit, den Ablauf zu manipulieren und andere Formen von Zeit, andere Arten von Dauer, einzubringen.

HU: Was wäre ein Beispiel für eine andere Art von Dauer?

HD: Beleuchtung kann eine Art Eindruck erzeugen, der mit Erinnerung verbunden ist. Sehr oft erinnert man sich nicht an architektonische Einzelheiten eines Gebäudes, sondern was bleibt, ist der Eindruck seiner Atmosphäre. Beleuchtung kann diese Erinnerungen reizen und wieder hervorholen. Und das kann einen starken Einfluss auf unser Gefühl für Identität, Zugehörigkeit und persönliches Gleichgewicht haben. Man kann manche Arten von Licht durchaus als sehr störend empfinden, andere wiederum umgeben uns wie ein Kokon, geben uns ein Gefühl von Sicherheit.

HU: Sie arbeiten auf der ganzen Welt. Beziehen Sie regionale Sehgewohnheiten mit ein?

HD: Meiner Meinung nach ist es sehr wichtig, sich mit dem Ort, an dem man arbeitet, sehr genau auseinanderzusetzen und die Hauptbestandteile zu erkennen. Aber wenn ein Kunde aus Mexiko oder Hongkong einen in New York arbeitenden Franzosen um Hilfe bei einem Projekt bittet, dann erwartet er nicht, sein eigenes kulturelles Erbe in dieser Arbeit wiederzufinden. Wir bieten eine moderne, internationale Vision und verbinden sie mit den besonderen Eigenschaften des Projekts.

HU: Beleuchtung kann Architektur bereichern, und Fehler können durchaus auch kaschiert werden. Schafft Ihre Arbeit einen Ausgleich oder einen Gegenpol?

HD: Ich glaube, dass wir uns an das Wesentliche halten. Am besten ist, wenn man die Beleuchtung eines Raumes nicht versteht, man sich aber sehr wohl fühlt – fast so, als ob man mit geschlossenen Augen sehen könnte, so wie man fein eingestellte Schwingungen wahrnehmen kann.

HU: Wie findet die Schwingung die richtige Frequenz?

HD: Wir versuchen, einem Projekt Substanz zu verleihen. Erinnerung, Organisation, ein eindeutiges Gefühl von Ordnung: das ist der Kern eines Projekts. Wenn alles genau aufeinander abgestimmt ist, fühlt man, dass die Schwingung stimmt.

HU: Und versuchen Sie, diesen Eindruck von Ordnung und Wohlgefühl zu erreichen?

HD: Wir teilen einen Raum – eine Landschaft, einen Innenraum, ein Stadtviertel, von welcher Größe auch immer – mit Licht ein. Indem man Licht an bestimmten Stellen platziert, erhält ein Raum Ordnung. Es ist zweifellos eine große Verantwortung, da Be-

leuchtung ja auch eine soziale und politische Dimension hat. Licht wird mit Macht in Verbindung gebracht und transportiert ein Gefühl von Autorität, mit ihren vielen Privilegien und Ungerechtigkeiten. Das beschäftigt uns immer, wenn wir in Entwicklungsländern arbeiten. Wir würden oft die Beleuchtung gerne dunkler halten lassen, aber Sicherheitsbedenken lassen das nicht zu.

HU: Befürworten Sie eine dunklere Beleuchtung als üblich ist?

HD: Die Nacht erlaubt uns, wieder mit dem Kosmos in Verbindung zu treten, unsere Beziehung zum Universum und unseren Platz darin zu verstehen. Durch zu starke Beleuchtung, die blendet, schafft man einen Schleier, der diese Verbindung überdeckt. Unser geistiges Wohlbefinden hängt davon ab, dieses Zugehörigkeitsgefühl aufrecht zu erhalten.

HU: In einigen Ihrer Projekte verwenden Sie blaues oder magentarotes Licht. Was bedeuten diese Farben für Sie?

HD: Wir verwenden ein Magentarot, weil wir eine Farbe einsetzen wollen. Es vermittelt ein Hochgefühl, und das möchten wir so oft wie möglich festhalten. Unsere Beziehung zu Blau ist völlig anders. Ich würde sagen, dass es die einzige Farbe von Licht ist, die eigentlich keine Farbe ist. Der Himmel zum Beispiel ist nicht blau angemalt, sieht aber aufgrund seiner Tiefe blau aus.

HU: Seit Jahren fotografieren Sie den Himmel vom Flugzeug aus. Was bedeuten diese Bilder für Sie?

HD: Fliegen versetzt uns in eine andere zeitliche Lage: wir rasen durch verschiedene Zeitzonen; Tag geht im gleichen Fenster in Nacht über; wir sehen Arten von Licht, die wir normalerweise auf der Erde nicht sehen. Hoch oben in der Luft fängt der Sonnenaufgang mit gleißendem weißem statt bernsteinfarbenem oder hellgelbem Licht an. Wir sehen, was wir immer sehen, nur auf eine völlig andere Art.

Mise-en-éclairage: Les Projects d'Herve Descottes et de L'Observatoire International

Galeriste et critique d'art à New York, Henry Urbach a rencontré Herve Descottes pour discuter des idées qui animent so travail.

HU : Comment démarrent vos projets ?

HD : Observer est vraiment à l'origine de notre travail, c'est ainsi que nous élaborons une réponse une à situation donnée, à u lieu, à un moment. Notre compréhension des projets est avant tout émotionnelle, en essayant d'aller profondément dans le problèmes de design, à travers différentes dimensions, quelque chose que vous ne pouvez pas toujours percevoir visuellemen mais que l'on ressent d'une manière intuitive.

HU : Votre travail s'effectue en collaboration avec des clients, des architectes et d'autres designers. Comment caractériserie: vous ce processus ?

HD : Un aspect essentiel de notre travail est de bien comprendre le contexte dans lequel nous intervenons, la direction reche chée par tous. Au-delà de cela, les choses varient sans cesse. Avec Frank Gehry par exemple, notre travail consiste souven à renforcer des séquences spatiales et une hiérarchie dans l'architecture. Avec Steven Holl, il est plus question d'intensifier l poésie et l'impact émotionnel d'un projet.

HU : Le rôle des lighting designers est en partie d'établir un rapport entre lumière naturelle et artificielle. Comment conceve vous cela ?

HD : Avec la lumière du soleil, vous avez un cycle journalier bien défini. Le soleil commence sa course très bas, s'élève lente ment puis retombe, après avoir dessiné un arc de 180. Cela donne une sensation très précise du temps qui passe. La lumièr artificielle mêlée à celle du soleil, permet de jouer avec les cycles et d'intervenir sur le temps, d'introduire d'autres formes d durée.

HU : Quelles sont les autres formes de durée ?

HD : La lumière peut créer une sorte d'empreinte liée à la mémoire. On ne se rappelle pas souvent précisément les détai architecturaux d'un espace, mais ce qui nous reste est une sensation, celle de son atmosphère. La lumière provoque et réveill ces sensations, elle a un impact très fort sur notre sentiment d'identité, d'appartenance et d'équilibre personnel. On peut s sentir très agressés par certains types d'éclairages, là où d'autres vous donnerez l'impression d'être en sécurité comme dar un cocon.

HU : Vous travaillez dans le monde entier. Existe-t-il des traditions visuelles locales ?

HD : Il est important d'étudier sérieusement le contexte culturel du site sur lequel vous intervenez et d'en identifier les élément majeurs. Mais si des clients venus du Mexique ou de Hong Kong demandent à un Français vivant à New York de les aider su un projet, ce n'est pas pour leur proposer leur propre héritage culturel. Ce que nous faisons est d'offrir une vision moderne e internationale et de l'intégrer dans les qualités spécifiques d'un projet.

HU : La lumière peut magnifier une architecture et dissimuler ses défauts. Votre travail offre-t-il de corriger une architecture o de lui donner un contrepoint ?

HD : Je pense qu'il faut rester au plus proche de l'essentiel, de ce qui existe. Le meilleur résultat c'est quand on ne compren pas comment est fait l'éclairage d'un espace, mais il vous fait vous sentir bien, presque comme si vous pouviez le voir avec le yeux fermés, comme ressentir des vibrations musicales.

HU : Comment cette vibration trouve-t-elle sa tonalité ?

HD : On essaye d'apporter une âme à un projet. La mémoire, l'organisation, un sens clair de l'ordre, tout cela contribue à l'âm d'un projet. Quand tout est bien orchestré et harmonisé, vous sentez que c'est la bonne vibration.

HU : Comment travaillez vous ce sens de l'ordre et du bien être ?

HD : Nous organisons l'espace – un paysage, un intérieur, un quartier, à n'importe quelle échelle, avec la lumière. En éclairan vous donnez de fait de l'ordre à un espace. C'est vraiment une grande responsabilité, d'autant plus que l'utilisation de la lumièr peut révéler une dimension politique et sociale. L'utilisation de la lumière est liée au pouvoir et incarne une autorité, avec se

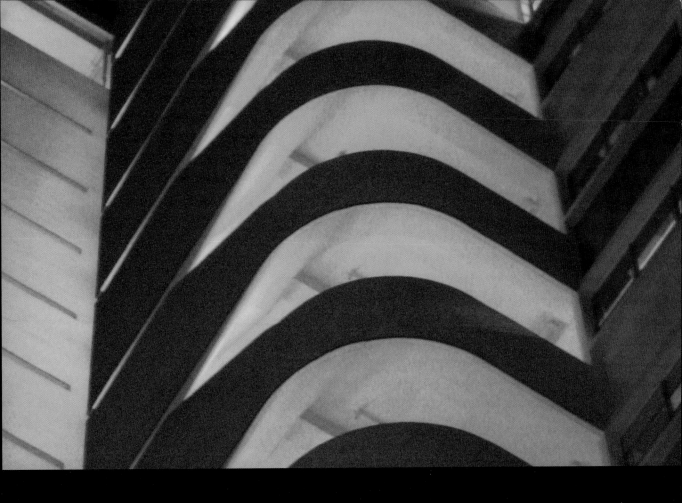

nombreux privilèges et inégalités. C'est définitivement un enjeux en travaillant dans les pays en développement. Souvent nous voudrions travailler dans une gamme de lumières atténuées, mais les exigences liées à la sécurité nous conduisent à faire autre chose.

HU : Vous préférez l'utilisation de lumières tamisées plutôt que de répondre à des exigences conventionnelles ?

HD : La nuit nous offre la chance de se reconnecter avec le cosmos, de ressentir notre relation à l'univers, et la place que l'on y occupe. En sur éclairant, en aveuglant les gens, vous créez un voile qui diminue cette connexion. Notre bien-être spirituel dépend et se régénère dans cette sensation d'appartenance universelle.

HU : Dans un certain nombre de vos projets, vous utilisez des lumières bleues ou magenta. Qu'est-ce que ces couleurs signifient pour vous ?

HD : Nous utilisons le magenta parce que nous voulons utiliser de la couleur, cela apporte une sorte d'euphorie et c'est intéressant de l'utiliser quand nous le pouvons. Notre relation au bleu est très différente, je dirais que, dans notre contexte, c'est la seule couleur qui n'en est pas une. Le ciel par exemple, n'est pas peint en bleu mais nous apparaît bleu à cause de son immense profondeur.

HU : Depuis des années, vous photographiez le ciel depuis vos voyages en avion. Qu'est ce que vous y voyez ?

HD : Le fait d'être en vol nous place dans condition temporelle différente. On traverse de manière éclair des zones de temps, on voit le jour rencontrer la nuit à travers la même fenêtre, on voit des formes de lumières qui normalement n'apparaissent pas sur terre. Dans les airs, le soleil se lève dans une lumière blanche tranchante, plutôt qu'ambrée ou jaune. Nous voyons ce que nous voyons tout le temps, mais d'une tout autre façon.

Hervé Descottes mantuvo una entrevista con Henry Urbach, galerista y crítico en Nueva York, para debatir sobre las ideas que estimulan el grueso de su trabajo.

HU: ¿Cómo arrancan sus proyectos?

HD: Realmente la observación es el origen de nuestro trabajo, así es como desarrollamos nuestra respuesta a una situación determinada, a un lugar concreto, a un instante específico. Nos trasladamos hacia un entendimiento emocional del proyecto que implica profundizar más en la complicación del diseño a mano, hacia una longitud de onda distinta, algo que no siempre puedes percibir visualmente, pero que sí puedes sentir de alguna manera.

HU: Su trabajo evoluciona en colaboración con clientes, arquitectos y otros diseñadores. ¿Cómo describiría este proceso?

HD: Un aspecto esencial de nuestro trabajo es entender el contexto en el que estamos trabajando y el resultado que todos perseguimos. Aparte de eso, el proceso puede variar bastante. Por ejemplo, con Frank Gehry nuestro trabajo a menudo implica el reforzamiento de la secuencia espacial y la jerarquía; con Steven Holl, se trata más de una cuestión de intensificación del impacto poético y emocional de un proyecto.

HU: Parte del trabajo de un diseñador de iluminación es establecer una relación entre la luz natural y otras formas de luz artificial. ¿Cómo piensan en eso?

HD: Con la luz del sol existe un ciclo diario definido. El sol sale muy bajo, después va ascendiendo lentamente y se pone por encima del curso de su arco de 180 grados, y esto da una sensación muy específica del paso del tiempo. Con la luz artificial además de contar con la luz solar, se tiene la oportunidad de manipular el ciclo y de presentar otros tipos de tiempo, otras formas de duración.

HU: ¿Cuál sería un ejemplo de otra forma de duración?

HD: La iluminación puede crear un tipo de impronta en la memoria. Con mucha frecuencia no recordamos detalles arquitectónicos de un espacio, sino que lo que permanece con nosotros es un sentido de su ambiente. La iluminación puede provocar y volver a despertar esos recuerdos, y esto produce un gran impacto en nuestro sentido de identidad, pertenencia y equilibrio personal. Podemos sentirnos muy importunados por ciertos tipos de luz, otros nos hacen sentir muy seguros, como si estuviésemos entre algodones.

HU: Su trabajo se extiende por todo el mundo. ¿Existen tradiciones visuales locales con las que usted conecte?

HD: Creo que es importante considerar seriamente el lugar en el que se está trabajando e identificar los principales elementos. Pero si clientes de México o Hong Kong solicitan ayuda para un proyecto a un francés que está trabajando en Nueva York, eso no es para que les aporte su propia herencia cultural. Lo que hacemos es ofrecer una visión moderna e internacional e integrarla en las cualidades específicas de cada proyecto.

HU: La arquitectura se puede realzar con la iluminación y sus imperfecciones también se pueden ocultar. ¿Su trabajo ofrece una rectificación o un contrapunto?

HD: Creo que nos ceñimos a lo que es esencial. El mejor resultado se obtiene cuando no se entiende la iluminación de un espacio, pero te sientes bien con ella, casi como si la vieras con los ojos cerrados, como afinando un acorde.

HU: ¿Cómo encuentra su tono ese acorde?

HD: Tratamos de dar alma a un proyecto. Memoria, organización, un claro sentido del orden, eso es el alma de un proyecto. Cuando todo está bien orquestado y armonizado, sientes que el acorde suena bien.

HU: Y, ¿cómo se trasladan hacia ese sentido de orden y bienestar?

HD: Organizamos el espacio, ya sea un paisaje, un interior, una zona, a la escala que sea, con luz. Por medio de la situación de la luz se distribuye el espacio. Ciertamente es una gran responsabilidad, ya que la iluminación también tiene una dimensión política y social. La luz se asocia con el poder y aporta un sentido de autoridad, con sus numerosos privilegios y desigualdades. Esto es un hecho indiscutible cuando trabajamos en países en vías de desarrollo. A menudo queremos proporcionar niveles de

HU: ¿Usted aboga por niveles de iluminación de menor intensidad que los que se demandan normalmente?

HD: La noche nos proporciona la oportunidad de volver a ponernos en contacto con el cosmos, para entender nuestra relación con el universo y nuestro lugar en él. Si utilizas una iluminación excesiva, si deslumbras a la gente, creas un velo que disminuye ese contacto. Nuestro bienestar espiritual depende de la preservación de ese sentido de pertenencia.

HU: Una parte de sus proyectos utilizan la luz azul o la luz magenta. ¿Qué significado tienen esos colores para usted?

HD: El color magenta lo utilizamos porque queremos usar un color, da una sensación de euforia y es interesante echar mano de él cuando podemos. Nuestra relación con el color azul es muy distinta. Yo diría que es el único color de luz que no tiene color. El cielo, por ejemplo, no está pintado de azul pero parece azul por su gran profundidad.

HU: Durante años usted ha fotografiado el cielo desde aviones. ¿Qué significado tienen esas imágenes para usted?

HD: Volar nos sitúa en una condición temporal distinta: nos precipitamos a través de zonas del tiempo; el día se encuentra con la noche a través de la misma ventana; vemos formas de luz que normalmente no se nos presentan en la tierra. En el aire, la salida del sol empieza con una luz blanca intensa en lugar de ámbar o amarilla. Vemos lo que siempre vemos, pero de una forma completamente distinta.

Hervé Descottes ha incontrato Henry Urbach, un gallerista e critico di New York, per discutere le idee che animano la sua struttura di lavoro.

HU: Come iniziano i vostri progetti?

HD: Il nostro lavoro scaturisce dall'osservazione; è il modo in cui sviluppiamo la nostra risposta ad una determinata situazione ad un luogo, ad un momento. Ci muoviamo verso una comprensione emozionale del progetto, il che significa approfondire nel problema illuminotecnico in questione – verso una lunghezza d'onda diversa, un qualcosa che non si è sempre in grado di percepire visualmente, ma in qualche modo di sentire.

HU: Il vostro lavoro si sviluppa in cooperazione con clienti, architetti ed altri designer. Come caratterizzerebbe questo processo?

HD: Un aspetto essenziale del nostro lavoro è quello di comprendere il contesto in cui operiamo e la destinazione a cui miriamo. Per il resto, può variare molto. Con Frank Gehry, ad esempio, il nostro lavoro implica spesso un rafforzo della sequenza e gerarchia degli spazi; con Steven Holl, si tratta piuttosto di intensificare l'impatto poetico ed emotivo di un progetto.

HU: Fa parte del compito del designer dell'illuminazione stabilire un rapporto tra la forma naturale ed altre forme artificiali della luce. Di che avviso è al riguardo?

HD: Con la luce del sole esiste un ciclo giornaliero ben definito. Il sole parte molto in basso, poi si alza lentamente e si abbassa nel corso del suo arco di 180°, il che produce una sensazione molto specifica di come il tempo trascorre. Con la luce artificiale e con la mediazione della luce del sole, si ha modo di manipolare il ciclo e di introdurre altri tipi di tempo, altre forme di durata.

HU: Mi può dare un esempio di un'altra forma di durata?

HD: L'illuminazione può, per così dire, imprimersi nella memoria. Molto spesso non si ricordano dettagli architettonici di un luogo, ma ciò che rimane impressa è una sensazione dell'atmosfera del posto. L'illuminazione può provocare e risvegliare queste memorie, e ciò ha un forte impatto sul nostro senso d'identità, d'appartenenza e di equilibrio personale. Ci si può sentire oltremodo disturbati da determinati tipi di luce; altri fanno invece sentire molto a proprio agio, come se ci si trovasse in un involucro protettivo.

HU: Il vostro lavoro si estende a tutto il globo. Esistono tradizioni locali in termini visuali nel cui senso vi impegnate?

HD: Penso che sia importante considerare seriamente il luogo in cui si sta operando, identificando gli elementi salienti. Ma se clienti provenienti dal Messico o da Hong Kong chiedono ad un francese che vive a New York di assisterli in un progetto, non lo fanno per ottenere ciò che corrisponde alla loro eredità culturale. Ciò che noi facciamo è offrire una visione moderna ed internazionale integrandovi le particolarità specifiche del progetto in questione.

HU: L'architettura può essere rivalutata dall'illuminazione ed è possibile anche nascondere i suoi difetti. Il vostro lavoro ha anche carattere correttivo o di contrappunto?

HD: Penso che ci atteniamo all'essenziale. Il miglior risultato si ottiene quando non si comprende l'illuminazione di uno spazio ma si nutrono ottime sensazioni al riguardo – quasi come se si vedesse ad occhi chiusi, come se si sintonizzasse una vibrazione.

HU: Come fa questa vibrazione a trovare la giusta intonazione?

HD: Tentiamo di conferire anima ad un progetto. Memoria, organizzazione, un chiaro senso dell'ordine: è questa l'anima di un progetto. Quando tutto è bene orchestrato ed armonizzato, si sente che la vibrazione è giusta.

HU: E come vi muovete verso questo senso dell'ordine e dell'agevolezza?

HD: Organizziamo lo spazio – un paesaggio, un interno, un distretto, in qualsiasi misura – con la luce. Posizionando la luce, si conferisce ordine ad uno spazio. Si tratta effettivamente di una grande responsabilità, dato che l'illuminazione ha anche una dimensione sociale e politica. La luce viene associata al potere e trasporta un senso di autorità, con i suoi tanti privilegi e le

sue molte ineguaglianze. Si tratta di una tematica di assoluto riguardo quando lavoriamo in Paesi in via di sviluppo. Spesso desideriamo fornire livelli di illuminazione sommessi, ma considerazioni di sicurezza ci portano ad altre soluzioni.

HU: Invocate livelli di illuminazione inferiori a quanto tradizionalmente richiesto?

HD: La notte ci da l'opportunità di riconnetterci con il cosmo, di comprendere la nostra relazione con l'universo e il nostro posto nel medesimo. Illuminando eccessivamente, abbagliando la gente, si crea un velo che riduce questa connessione. Per preservare il nostro benessere spirituale è necessario sostenere questo senso d'appartenenza.

HU: In tutta una serie dei vostri progetti viene adottata luce color blu o magenta. Cosa significano questi colori per voi?

HD: Utilizziamo il magenta perché vogliamo usare un colore; conferisce un senso di euforia ed è interessante adottarlo quando possiamo. Il nostro rapporto con il blu è molto diverso. Direi che si tratta dell'unico colore della luce che non è un colore. Il cielo, ad esempio, non è pitturato in blu, ma ha un aspetto blu a causa della sua grande profondità.

HU: Per anni avete fotografato il cielo da aerei. Cosa significano queste immagini per voi?

HD: Volando ci si porta in condizioni temporali diverse: frecciamo attraverso le fasce orarie, il giorno incontra la notte attraverso il medesimo finestrino; vediamo forme di luce che normalmente non ci appaiono sulla terra. In aria, il levarsi del sole inizia con una nitida luce bianca invece del color ambra o giallo. Vediamo ciò che vediamo sempre, ma in una maniera completamente diversa.

Americas

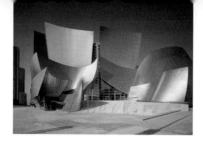

Walt Disney Concert Hall

Location: Los Angeles, California, USA
Architects: Frank O. Gehry and Associates, USA
Completed: 2003

This 2265 seat concert hall features an undulating, steel exterior punctured by interior light, bringing interior activity outside. The entire project encompasses an outdoor amphitheater, an urban park, and public gardens. The lighting concept channels the energy and emotion of the interior auditorium into additional public spaces and exterior. Lighting effects in the auditorium are synchronized in public spaces, and timed to change with key moments of the performance.

Das Äußere dieses 2265 Besucher fassenden Konzertsaals besteht aus geschwungenen Stahlpanelen, die Licht aus dem Inneren nach außen dringen lassen und so das Geschehen innerhalb des Konzertsaals nach draußen projizieren. Das gesamte Projekt umfasst ein Freiluftamphitheater, einen Stadtpark, sowie öffentliche Gartenanlagen. Durch die Konzeption der Lichtanlagen werden Energie und Emotionen aus dem Zuhörersaal zusätzlich an der Öffentlichkeit zugängige Plätze und nach draußen weitergelenkt. Lichteffekte im Auditorium und in den Anlagen sind synchronisiert und verändern sich zeitgleich mit Schlüsselszenen der Vorstellung.

Cette salle de concert de 2265 places arbore un extérieur onduleux en acier inoxidable percé d'une lumière interne, apportant l'activité intérieure vers l'extérieur. L'ensemble du projet englobe un amphithéâtre extérieur, un parc urbain et des jardins publics. Le concept d'éclairage canalise l'énergie et l'émotion de l'auditorium intérieur dans des espaces publics supplémentaires et vers l'extérieur. Les effets de lumière dans l'auditorium sont synchronisés dans les espaces publics, et ils sont temporisés afin de changer lors des moments forts du spectacle.

Esta sala de conciertos con capacidad para 2265 personas presenta un exterior ondulado de acero atravesado por una luz interior que lleva la actividad interior hacia el exterior. La totalidad del proyecto abarca un anfiteatro exterior, un parque urbano y jardines públicos. El concepto de iluminación canaliza la energía y la emoción del interior del auditorio hacia los espacios públicos adicionales y el exterior. Los efectos luminosos del auditorio están sincronizados en los espacios públicos, y programados para cambiar con los momentos clave de la puesta en escena.

Questa sala dei concerti da 2265 posti a sedere, con un esterno in acciaio punteggiato da luce interna che trasporta l'attività interna all'esterno. L'intero progetto comprende un anfiteatro esterno, un parco cittadino e giardini pubblici. Il concetto di illuminazione incanala l'energia e le emozioni dell'auditorio interno in spazi pubblici addizionali ed all'esterno. Gli effetti di illuminazione nell'auditorio sono sincronizzati in spazi pubblici e temporizzati in modo tale da cambiare in momenti chiave dello spettacolo.

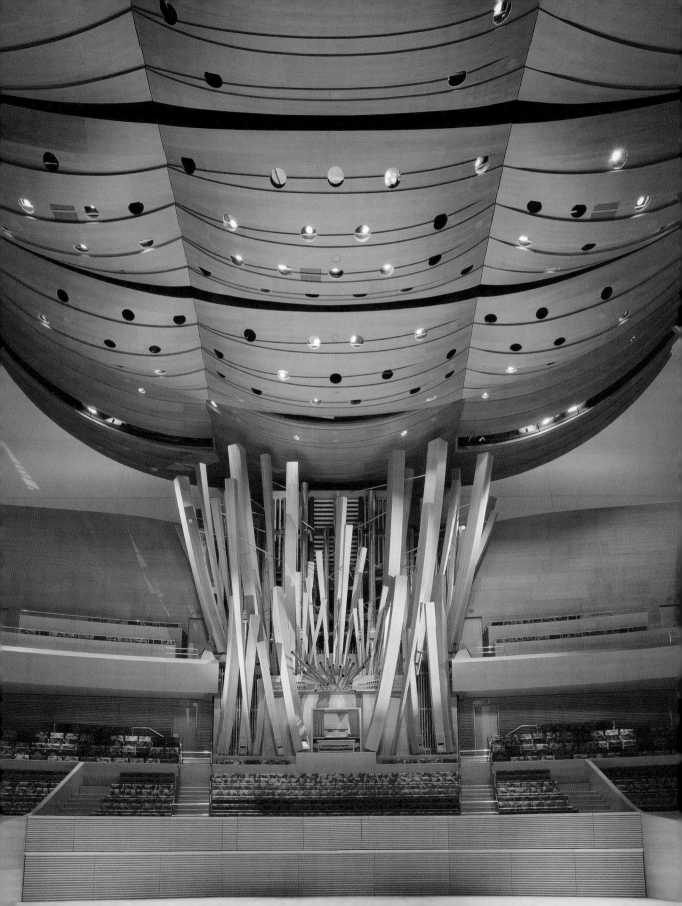

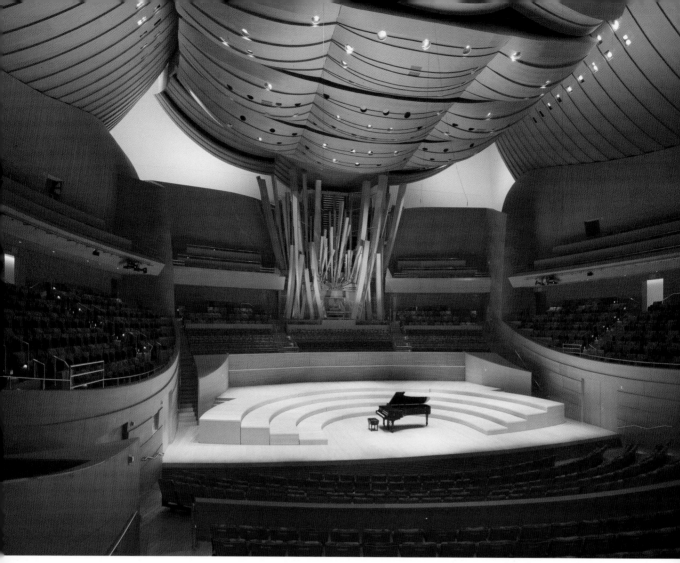

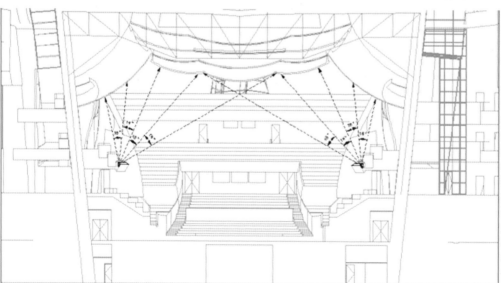

Walt Disney Concert Hall 28

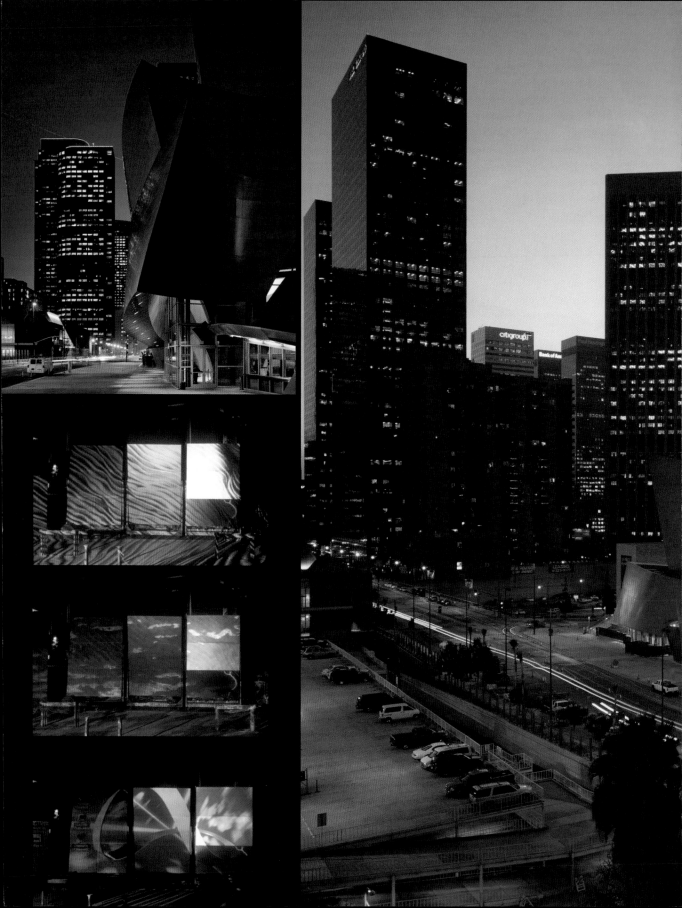

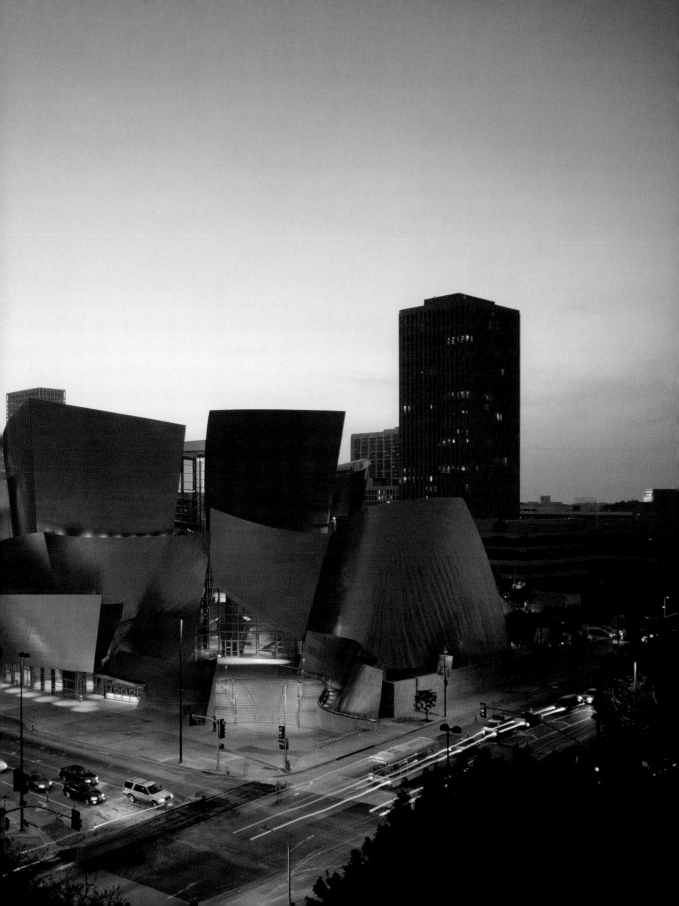

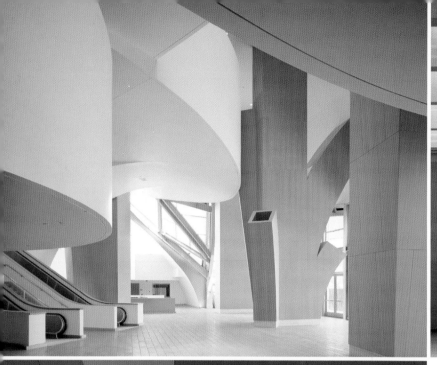

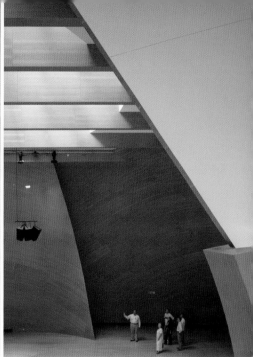

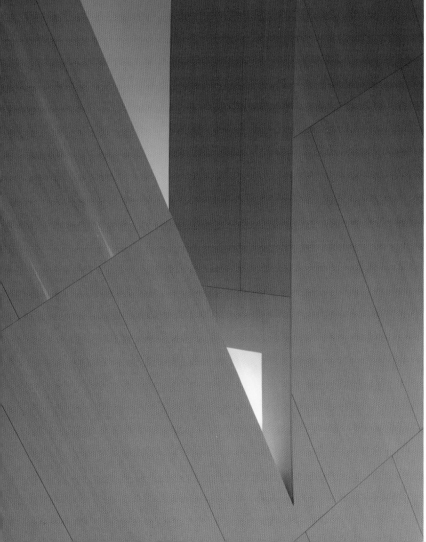

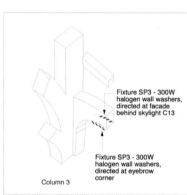

Fixture SP3 - 300W halogen wall washers, directed at facade behind skylight C13

Fixture SP3 - 300W halogen wall washers, directed at eyebrow corner

Column 3

AXONOMETRIC OF COLUMN 3
SCALE: NTS

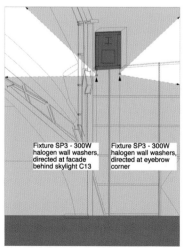

Fixture SP3 - 300W halogen wall washers, directed at facade behind skylight C13

Fixture SP3 - 300W halogen wall washers, directed at eyebrow corner

EXTRACT SECTION A4_2.32
SCALE: 1/8"=1'-0"

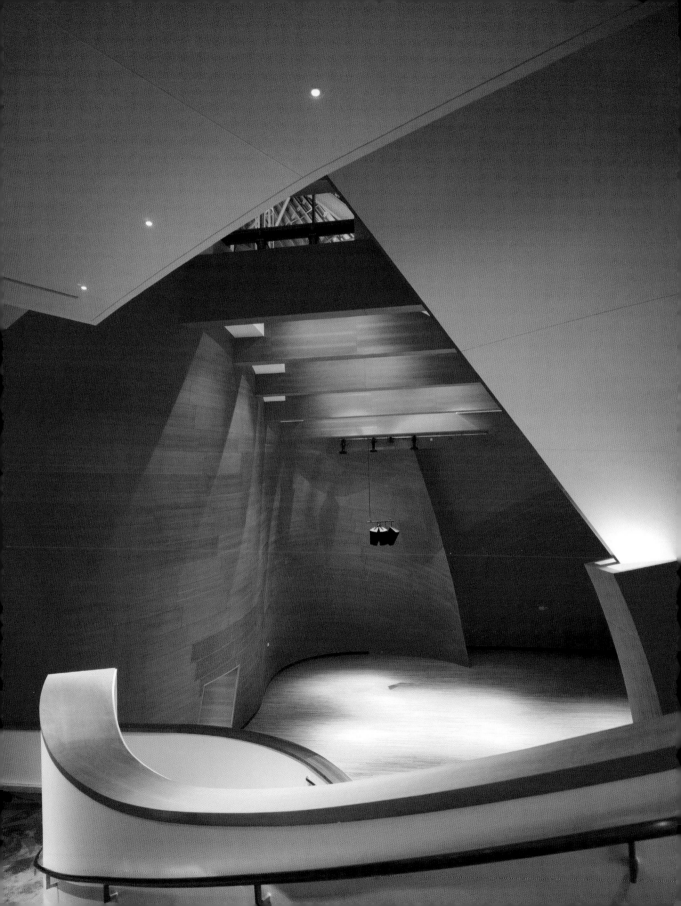

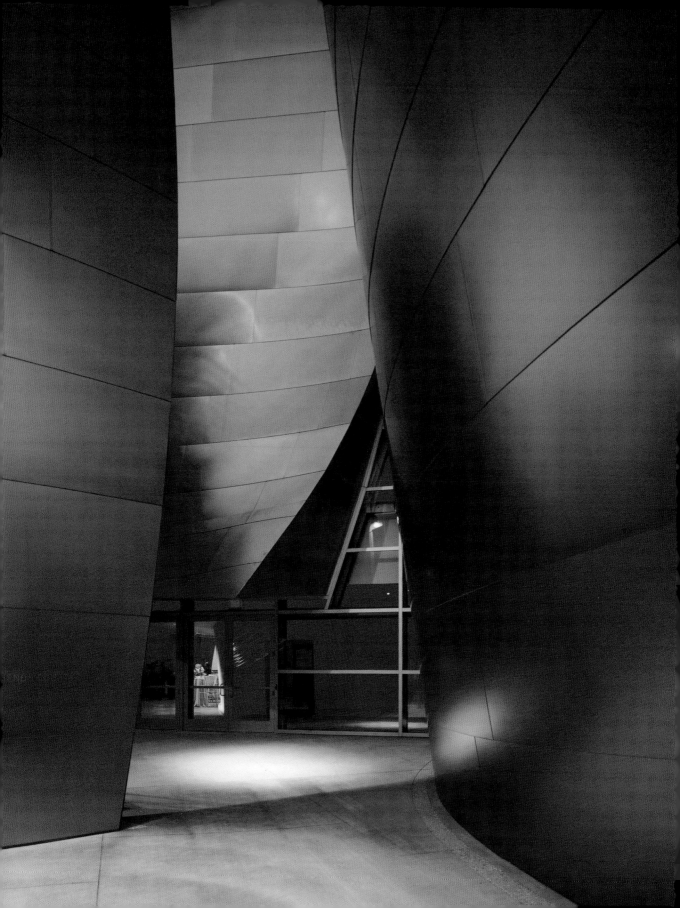

Chapel of Saint Ignatius

Location: Seattle University, Seattle, Washington, USA
Architects: Steven Holl Architects, USA
Completed: 1995

As a space designed for reflection and meditation, the lighting concept engages an intentionally serene mood. Here, the lighting concept responds to architect Steven Holl's notion of "Seven Bottles of Light in a Stone Box," in which each light corresponds to an aspect of Jesuit Catholic worship. This effect is realized through lighting embedded behind baffles, reflecting colored surfaces to create a colored glow. In addition, suspended fixtures and wall sconces designed by Holl dim to emanate the warmth of candlelight.

In diesem zur Reflektion und Meditation entworfenen Raum wurde das Beleuchtungskonzept bewusst eingesetzt, um eine ruhige und friedliche Atmosphäre zu gestalten. Das Konzept liegt in Einklang mit der Idee von „Sieben Flaschen Licht in einem Kasten aus Stein", die Architekt Steven Holl dem Projekt zugrunde gelegt hat. Jedes dieser Lichter steht für einen Aspekt des christlich jesuitischen Glaubens. Der gewünschte Effekt wird erreicht, indem Lampen hinter Blenden verborgen werden, ihr Licht an deren farbigen Oberflächen reflektiert und so ein warmer Schimmer in dem jeweiligen Farbton erzeugt wird. Zusätzlich können von der Decke herabhängende Lampen und Wandleuchten, die ebenfalls von Steven Holl entworfen wurden, gedimmt werden, wodurch die Wärme von Kerzenlicht nachempfunden wird.

Cet espace étant dédié à la réflexion et à la méditation, le concept d'éclairage recrée intentionnellement une atmosphère sereine. Ici le concept d'éclairage répond à la notion de l'architecte Steven Holl de « Seven Bottles of Light in a Stone Box » (sept bouteilles de lumière dans un écrin en pierre), où chaque lumière correspond à un des aspects du culte jésuite catholique. Cet effet est réalisé par des luminaires disposés derrière des déflecteurs, réfléchissant sur des surfaces colorées afin de créer une luminosité colorée. En supplément des suspentes et des appliques murales, imaginées par Holl, sont affaiblies pour émaner une chaude atmosphère de lumière de cierges.

Como espacio diseñado para la reflexión y la meditación, el concepto de la iluminación implica un ambiente intencionadamente sereno. Aquí, el concepto de iluminación responde a la noción del arquitecto Steven Holl de "Siete Botellas de Luz en una Caja de Piedra", en la que cada luz corresponde a un aspecto del culto católico jesuita. Este efecto se consigue por medio de una iluminación empotrada detrás de deflectores, que reflejan superficies coloreadas para crear un brillo de color. Además, los accesorios luminosos suspendidos y los apliques de pared diseñados por Holl bajan su intensidad para producir la calidez de una vela.

Come spazio destinato alla riflessione ed alla meditazione, il concetto di illuminazione produce un'atmosfera intenzionatamente serena. Qui il concetto di illuminazione corrisponde alla nozione dell'architetto Steven Holl "Sette bottiglie di luce in una cassa di pietra", in cui ogni luce corrisponde ad un aspetto del culto cattolico gesuita. Questo effetto viene realizzato incorporando l'illuminazione dietro a schermi, riflettendo superfici colorate per creare una luminosità colorata. Addizionalmente a ciò, corpi d'illuminazione sospesi e lampade murali progettati da Holl emanano una luce calda come la luce di candela.

*"We can find no scars
But internal difference
Where the meanings are"*

Emily Dickinson

This text was written at the beginning of our collaboration on the Chapel of Saint Ignatius
with Steven Holl, providing our initial lighting concept in verse.

No gesture, everything here
 is common,
 stable as stone or water, or
 light: the same
 elements you remember from earlier, from when you were
 a child. Then, newly housed in your own
 body, housed in buildings, you were always waiting
 for the sky
 to recover you: attending to
 the hilled burr
 of sunlight you wanted the sky without
 shutters, only the breaks
 of clouds and cloud-shadows crossing, coming
 like good fishermen to reel you home; and at night
 in the dark you imagined the stars
 galaxied themselves
 as people in damp countries do, gathering
 at fires, emanating
 from inside. So, in the stretched winters
 you held a piece

 of the past fall's rain in the pocket of your thickest
 coat; a gray rock, fit
 to the cusp of your palms.
 Summers, a sweat-polished round of cedar rode in the worn
 side hold of your jeans, recalling wetter springs.
 The stone and the wood acted
 as anchors, as walls
 do: like the anchors of fisher-boats,
 they slowed you, letting
 the arrowed light
 work, letting
 light
 hinge your body to your mind. Over windows, the sky kept
 opening and opening,
 bleeding color, sowing the imminent
 seeds: a curved
 shade like that of dawn
 or of dusk on billed waves, rising:
 a fledgling and endless body before glass.

 Claire Peacock

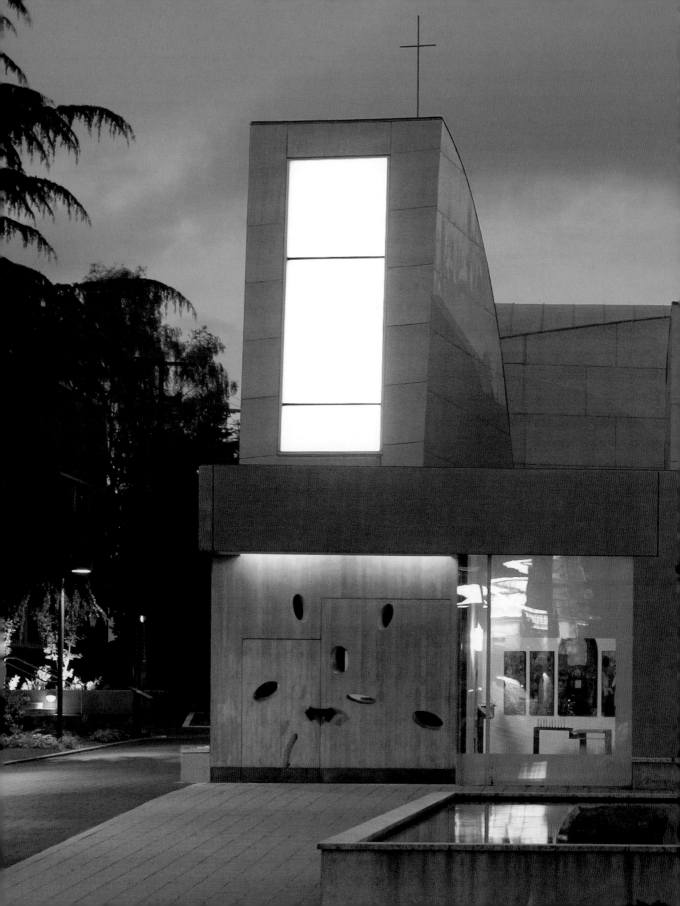

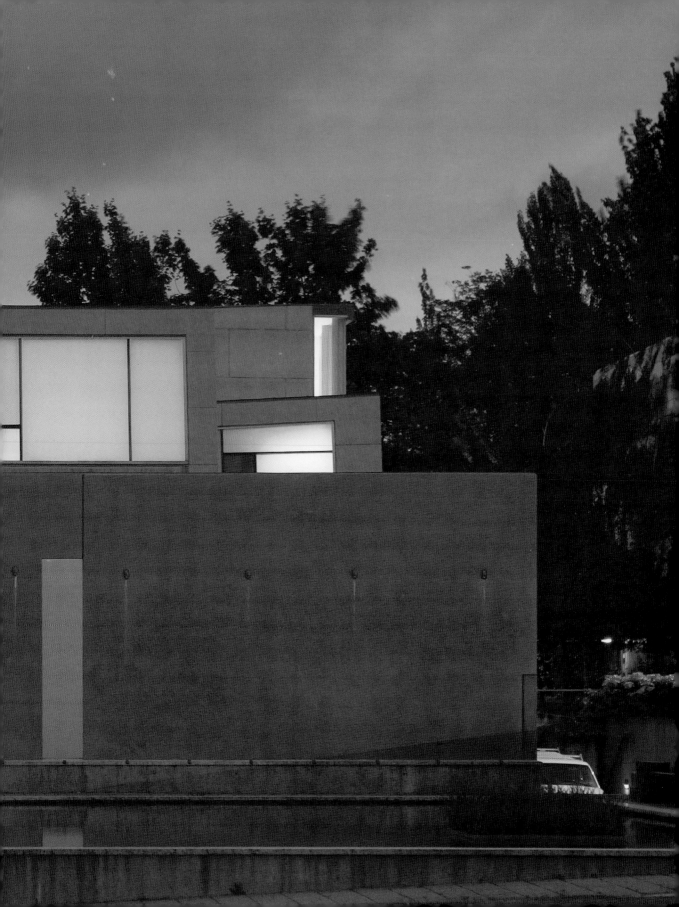

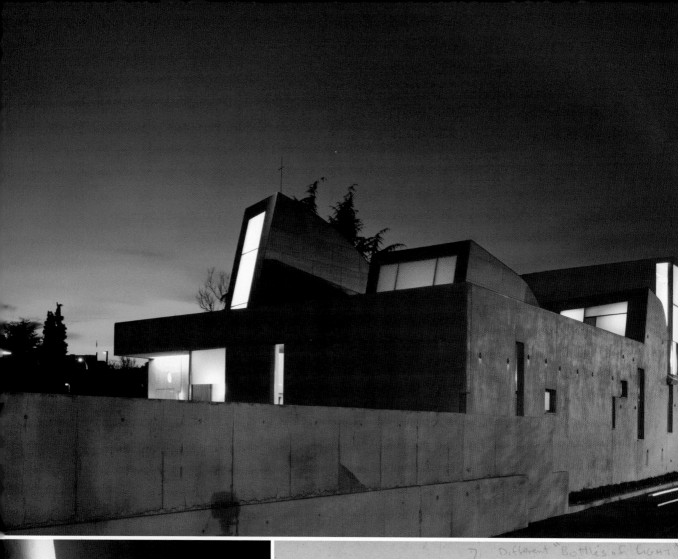

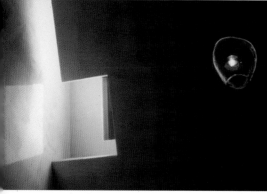

Chapel of Saint Ignatius

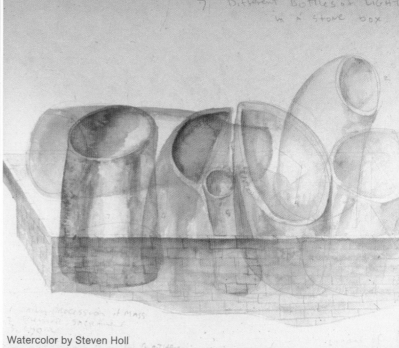

Watercolor by Steven Holl

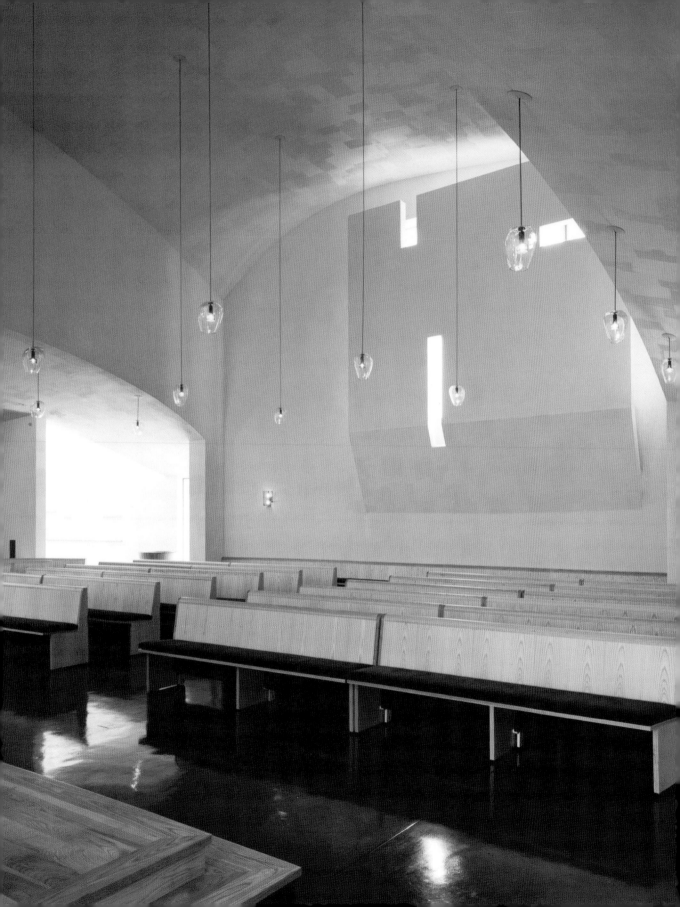

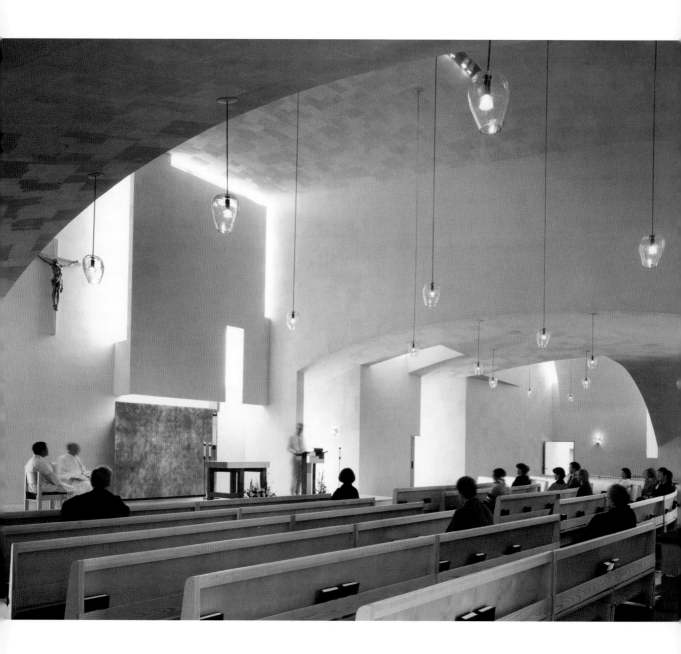

Chapel of Saint Ignatius

Bellevue Art Museum

Location: Bellevue, Washington, USA
Architects: Steven Holl Architects, USA
Completed: 2001

Located within the building are museum, artists' studio spaces, and classrooms. The gallery space boasts two distinct types of lighting. First, general lighting is embedded light pockets used as reflectors. The second type consists of removable accent lights in the ceiling, and can be adjusted for rotating displays. The museum's mission was founded on the motto "See, Explore, Make Art," from which architect Steven Holl developed the design concept of "tripleness." This notion entails an openness of experience, thought, and contact that characterize the space on three levels and in three galleries. Three different light conditions and three circulation options respond to this idea.

In dem Gebäude befinden sich die Räumlichkeiten des Museums, Ateliers und Unterrichtsräume. Die Gallerie ist mit zwei unterschiedlichen Beleuchtungstypen ausgestattet. Die Allgemeinbeleuchtung besteht aus versteckten Lichtquellen, die als Reflektoren fungieren. Bei dem zweiten Typ handelt es sich um bewegliche Akzentleuchten, die an der Decke montiert sind und bei wechselnden Auslagen je nach Bedarf eingestellt werden können. Die Grundkonzeption des Museums beruht auf dem Motto „Sehen, Erforschen, Kunst Schaffen", aus dem der Architekt Steven Holl das Konzept der „Dreiheit" entwickelt hat. Aus diesem Gedanken entspringt eine Offenheit von Erleben, Nachdenken und Kontakt, die das Gebäude auf drei Etagen und in drei Gallerien charakterisiert. Drei verschiedene Lichtverhältnisse und drei Möglichkeiten des Rundgangs entsprechen dieser Vorstellung.

Dans l'immeuble se trouve un musée, des espaces d'ateliers d'artistes, et des salles de cours. L'espace de galerie s'enorgueilli de deux différents types d'éclairages. En premier lieu, l'éclairage général est composé de poches de lumière encastrées utilisées comme réflecteurs. Le second type est constitué d'éclairages ponctuels amovibles situés dans le plafond, qui peuvent être ajustés pour les expositions temporaires. L'objectif du musée était fondé sur la devise « voir, explorer, faire de l'art » à partir de laquelle l'architecte Steven Holl a développé son concept de « tripleness » (trinité). Cette notion réclame une ouverture d'esprit pour l'expérience, la pensée et le contact, cette notion se caractérise par un espace sur trois niveaux et dans trois galeries. Ces différentes conditions de lumière, et ces trois options de circulation répondent à cette idée.

Los espacios ocupados por los estudios de los artistas, las aulas y el museo están situados dentro del edificio. El espacio de la galería ostenta dos tipos distintos de iluminación. El primero es una iluminación general que está empotrada en linternas que se usan como reflectores. El segundo tipo consiste en luces de acento desmontables situadas en el techo, y que pueden adaptarse para las vitrinas giratorias. El objetivo que persigue el museo se basa en el lema: "Mira, Explora, Produce Arte", a partir del cual el arquitecto Steven Holl desarrolló el concepto de diseño de "trialidad". Esta noción encierra una apertura de la experiencia, del pensamiento, y un contacto que caracteriza el espacio en tres niveles y en tres galerías. Tres tipos distintos de condiciones de luz y tres opciones de circulación responden a esta idea.

Nell'edificio si trovano il museo, gli spazi degli atelier degli artisti e le aule. La zona galleria vanta due tipi di illuminazione diversi. Il primo, l'illuminazione generale, viene assicurata da tasche luminose incassate utilizzate come riflettori. Il secondo tipo consiste in luci d'accento rimovibili sistemate nel soffitto e può essere regolato per display rotanti. La missione del museo fu basata sul motto "Vedi, esplora, realizza arte", da cui l'architetto Steven Holl sviluppò il concetto di design della "triplicità". Questa nozione comporta un'apertura dell'esperienza, del pensiero e del contatto che caratterizza lo spazio su tre livelli ed in tre gallerie. Tre diverse condizioni di illuminazione e tre opzioni di circolazione rispondono a tale idea.

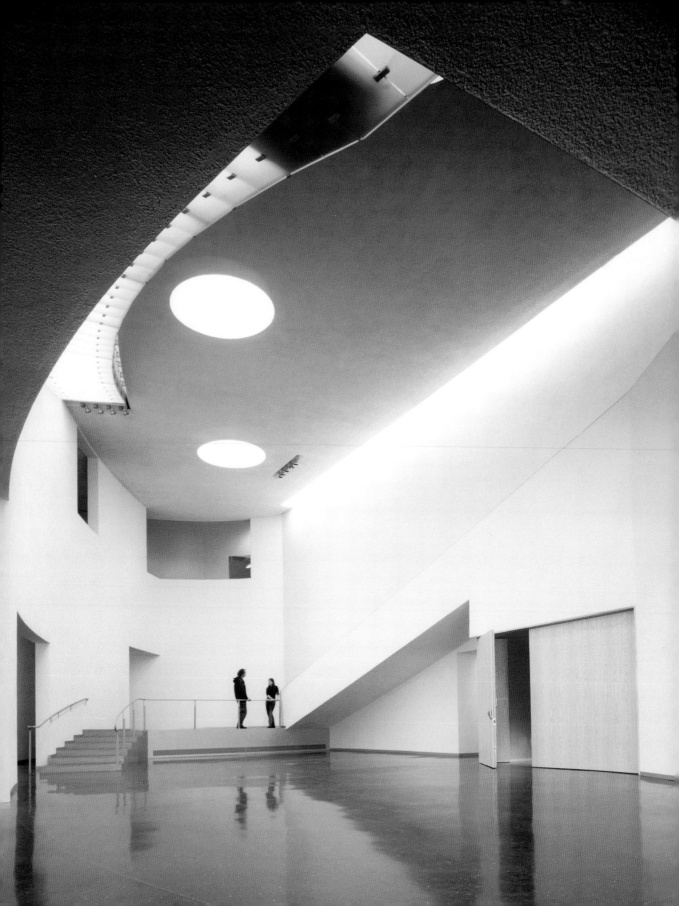

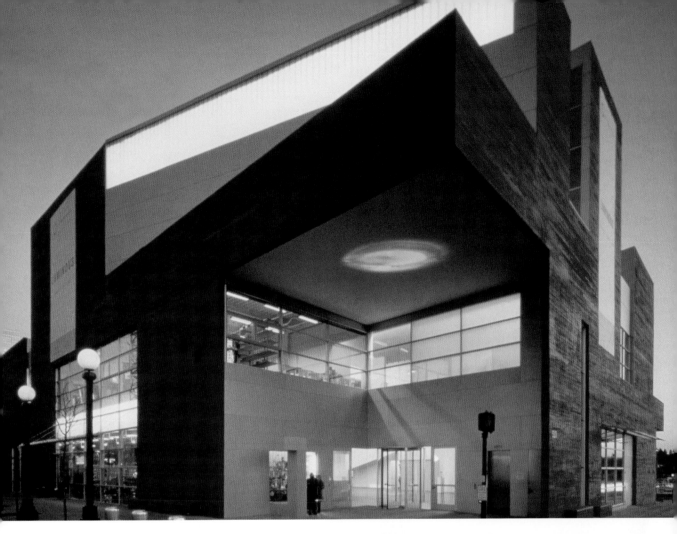

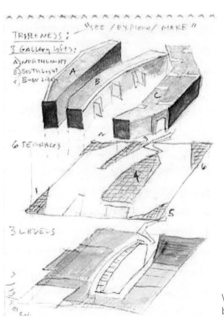

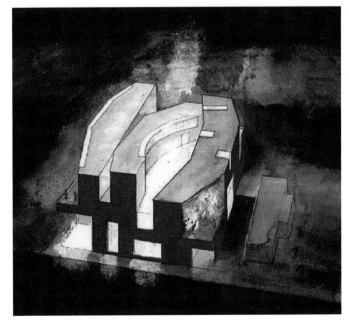

Watercolors
by Steven Holl

Bellevue Art Museum

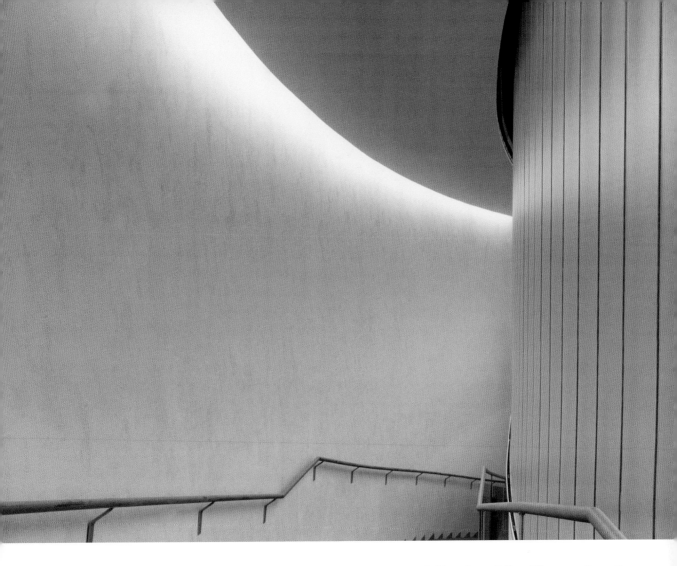

ght exists everywhere, and we reveal it through material. The way you capture light makes all the difference. Sometimes we phasize a texture, keeping the light source close by and grazing the surface. Sometimes we push the light far away, avoiding adows and emphasizing the quality of the light itself." H.D.

cht gibt es überall, und wir bringen es durch Material zum Vorschein. Die Art, wie Licht eingefangen wird, ist der entscheidende terschied. Manchmal heben wir eine Struktur hervor, indem wir die Lichtquelle in der Nähe behalten und die Oberfläche streifen. nchmal drängen wir das Licht weit weg an den Rand, vermeiden damit Schatten und heben die Beschaffenheit des Lichts selbst vor." H.D.

a lumière existe partout, et nous la révélons dans sa matérialité. La façon dont on la capture fait toute la différence. Parfois nous centuons une texture, en plaçant la source lumineuse au plus près de la surface, en la frôlant. Parfois on place la lumière au plus n, en évitant les ombres et en accentuant la qualité de la lumière pour elle-même. » H.D.

a luz existe en todas partes, y la revelamos a través del material. La forma en que se captura la luz marca la diferencia. A veces fatizamos una textura, manteniendo la fuente de luz cerca y rozando la superficie. Otras veces situamos la luz lejos, impidiendo sombras y enfatizando la calidad de la propia luz." H.D.

a luce esiste dappertutto, e noi la riveliamo attraverso il materiale. È il modo in cui si cattura la luce a fare tutta la differenza. volta enfatizziamo una struttura tenendovi vicina la fonte luminosa e radendo la superficie. Talvolta invece allontaniamo molto uce, evitando le ombre ed enfatizzando la qualità della luce stessa." H.D.

Bellevue Art Museum

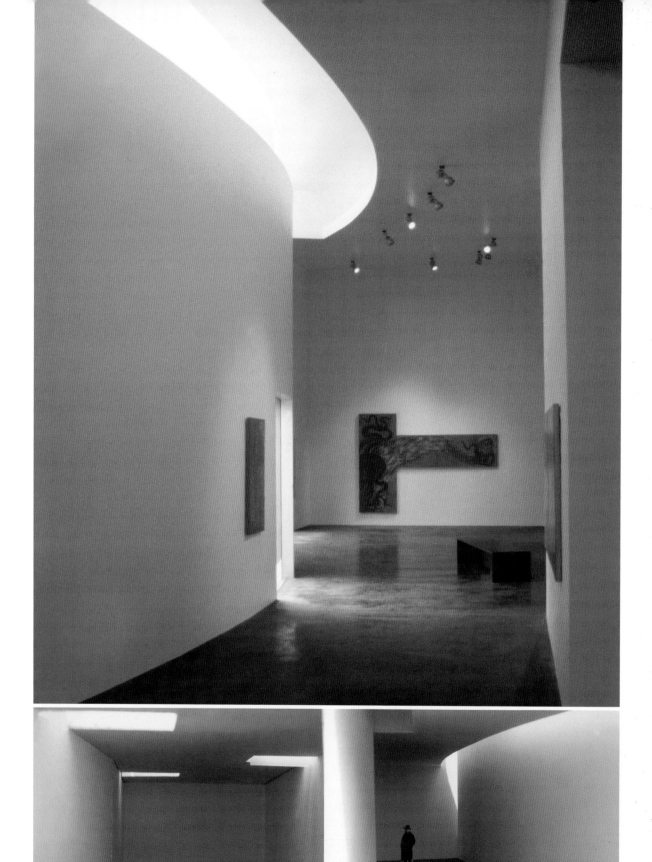

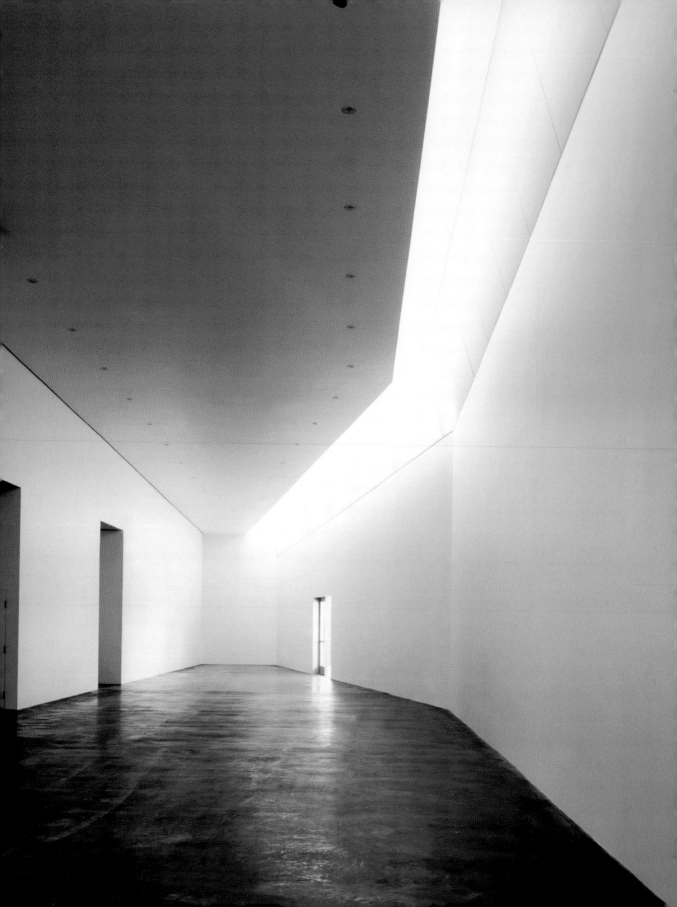

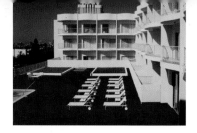

The Standard Hollywood

Location: Hollywood, California, USA
Interior Designer: Shawn Hausman, USA
Completed: 2002

In order to confer on the hotel an unmistakable nighttime presence on Sunset Boulevard, each balcony is highlighted with blue light, which as a group also accents the length of the building. On the courtyard side, the same fixtures are installed in an orange tone, to create a warm and sexy atmosphere for the pool and bar.

Um dem Hotel bei Nacht ein auf dem Sunset Boulevard unverwechselbares Aussehen zu verleihen, wurde jeder Balkon durch ein blaues Licht hervorgehoben. Zusammengesehen akzentuiert diese Beleuchtung die Länge des Gebäudes. Auf der Innenhofseite wurden die gleichen Lampen angebracht, die hier jedoch in einem Orangeton leuchten. Sie geben dem Pool und der Bar eine warme, sexy Atmosphäre.

Afin de conférer à cet hôtel une présence nocturne sans équivoque sur le Sunset Boulevard, chaque balcon est souligné d'une lumière bleue, la vision de groupe opère une accentuation de la longueur de l'immeuble. Côté jardin les mêmes équipements sont installés dans une tonalité orange, afin de créer une atmosphère chaude et sexy pour la piscine et le bar.

Con el fin de dotar al hotel de una presencia inconfundiblemente nocturna en el Sunset Boulevard, cada balcón está realzado con luz azul que, en conjunto, también acentúa la extensión del edificio. En la zona del patio, los mismos accesorios de iluminación están montados en un tono naranja para crear un ambiente sexy y cálido en la piscina y el bar.

Per conferire all'albergo una presenza notturna inconfondibile al Sunset Boulevard, ogni balcone viene esaltato da una luce blu accentuante nel suo complesso anche la lunghezza dell'edificio. Nel cortile, i medesimi elementi sono installati in tonalità arancione per creare un'atmosfera calda e seducente per la piscina ed il bar.

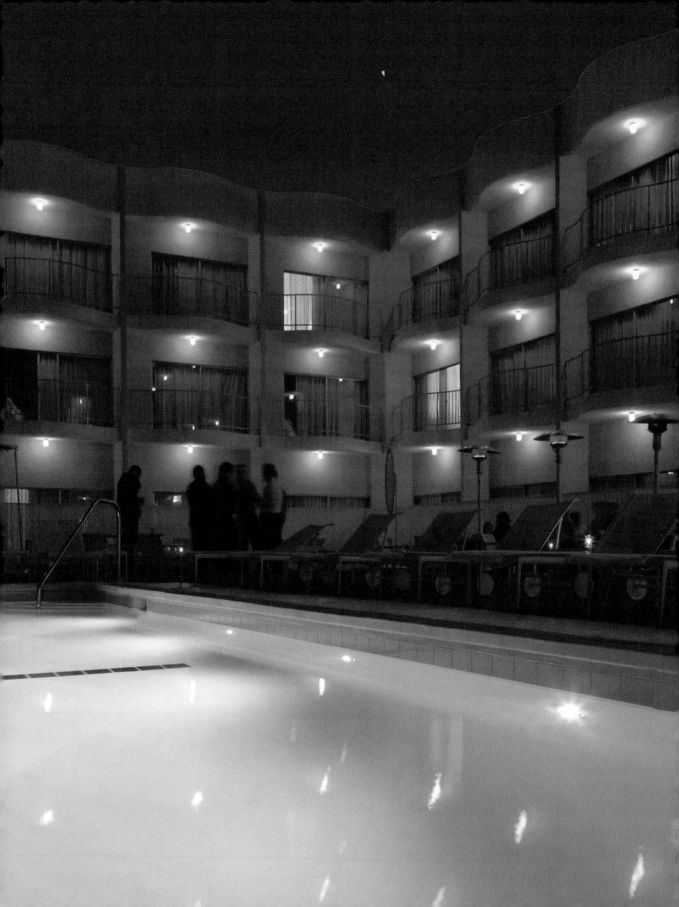

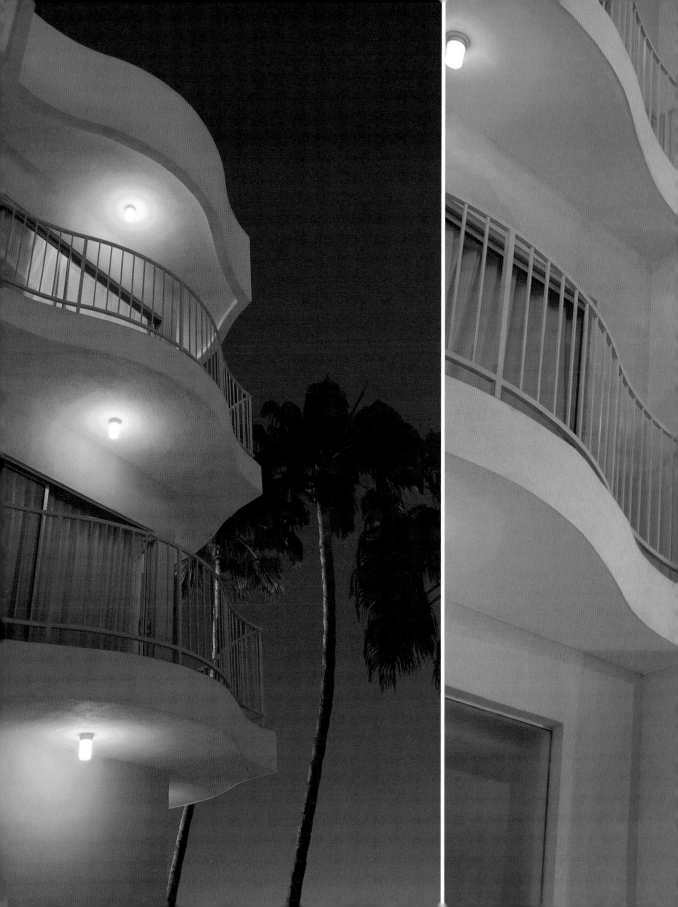

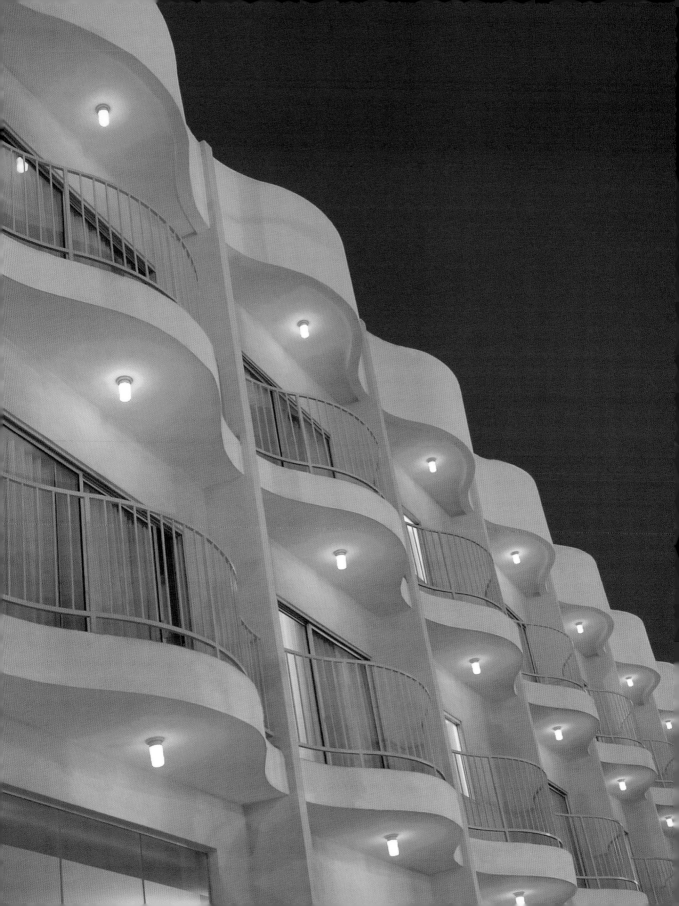

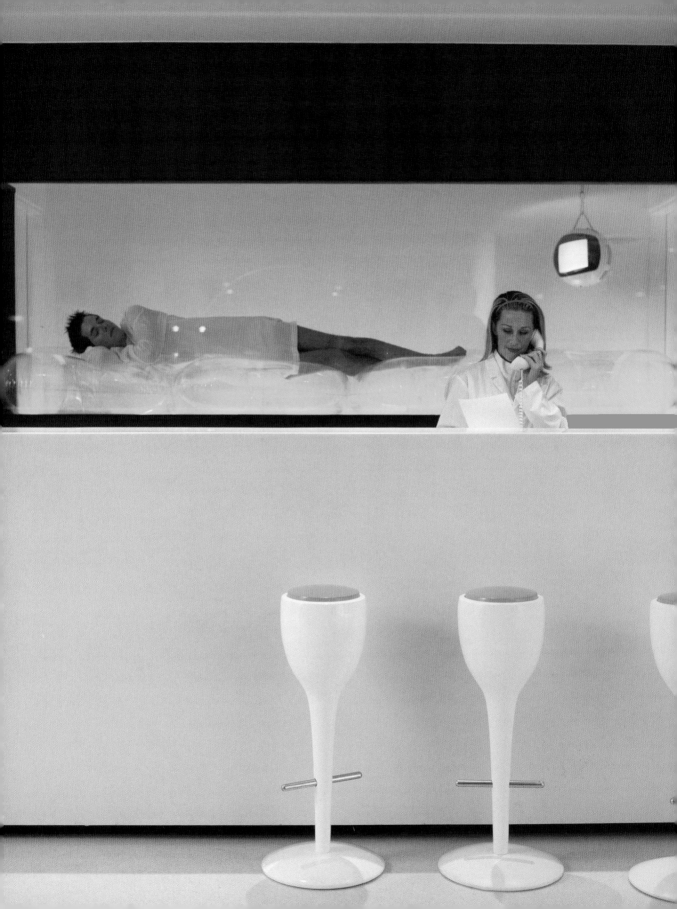

The Standard Hollywood

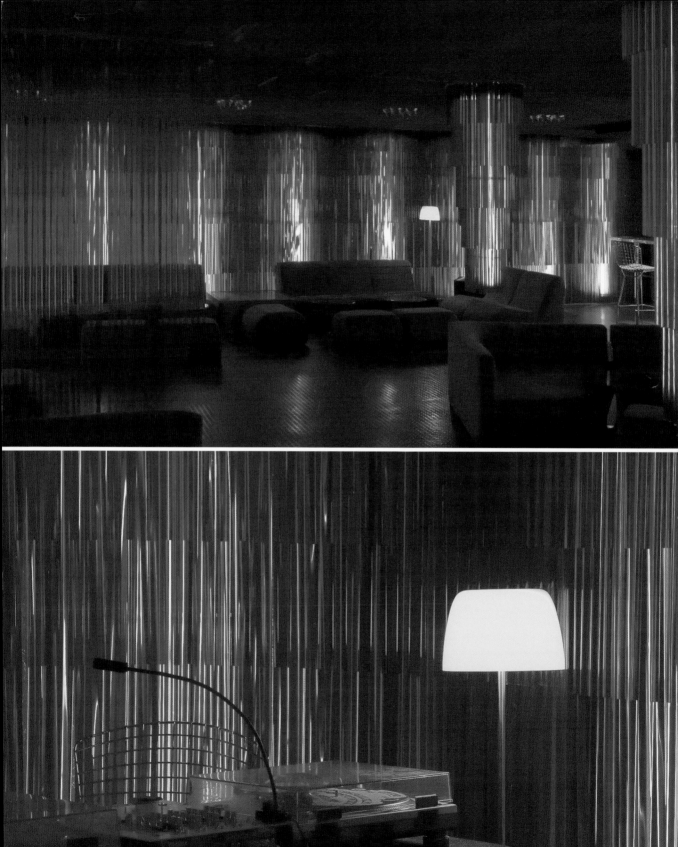

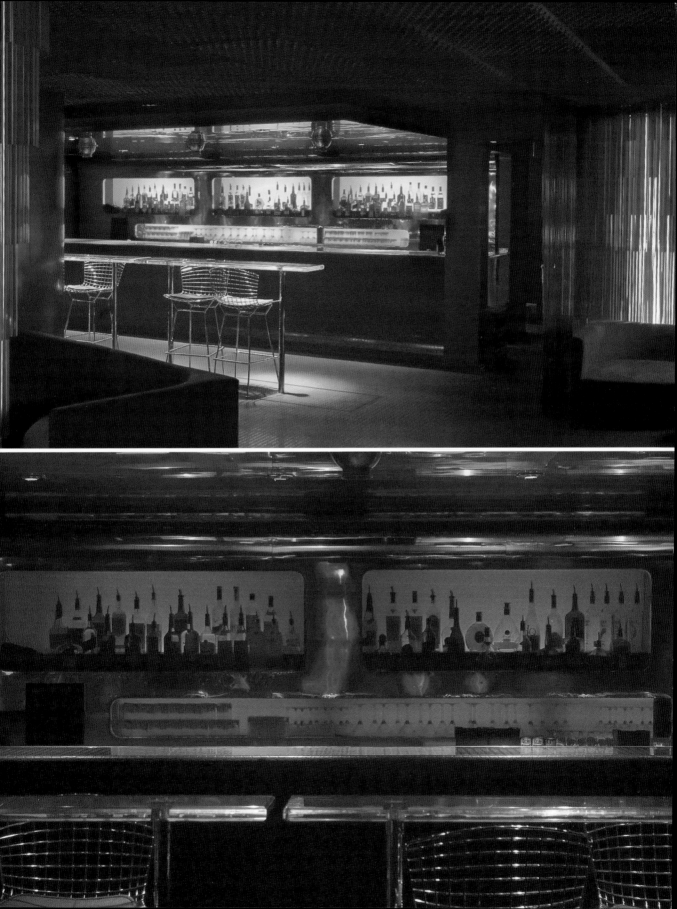

The Standard L.A.

Location: Los Angeles, California, USA
Interior Designer: Shawn Hausman, USA
Completed: 2003

Lighting amplifies specific identities in the hotel's public spaces. On the roof, light is interjected into a fantastical garden. Here, the dramatic night lights of downtown Los Angeles provide a backdrop in an otherwise intimate space. In the lobby, colored pink and magenta lights reflect the uniquely modern spirit of Los Angeles.

Zweck und Nutzung verschiedener, allen Hotelgästen zur Verfügung stehender Räume werden durch die Beleuchtung hervorgehoben. Ein Phantasiegarten wird vom Dach aus mit Licht durchflutet. Die funkelnden Lichter der nächtlichen Innenstadt von Los Angeles bilden den Hintergrund zu einem sonst eher intimen Ort. Der moderne Geist der Stadt Los Angeles zeigt sich in rosa und tiefroter Beleuchtung in der Hotellobby.

L'éclairage amplifie les identités spécifiques dans les espaces publics de l'hôtel. Sur le toit la lumière est intégrée dans un jardin fantastique. Ici, les lumières nocturnes dramatiques du centre ville de Los Angeles fournissent une toile de fond à un espace ordinairement intime. Dans le salon des lumières rose et magenta reflètent l'esprit particulièrement moderne de Los Angeles.

La iluminación amplía identidades específicas en las zonas públicas del hotel. En el tejado, la luz se interpone en un jardín fantástico. Aquí, las dramáticas luces nocturnas del centro de la ciudad de Los Ángeles proporcionan un telón de fondo en lo que de otra forma sería un espacio íntimo. En el recibidor, luces de colores rosa y magenta reflejan el exclusivo espíritu moderno de Los Ángeles.

L'illuminazione amplifica le identità specifiche delle aree pubbliche dell'albergo. Sul tetto, la luce è intercalata per formare un giardino fantastico. Qui le drammatiche luci notturne del centro di Los Angeles producono uno sfondo in uno spazio altrimenti raccolto. Nell'atrio, luci colorate in rosa e magenta riflettono lo spirito moderno unico di Los Angeles.

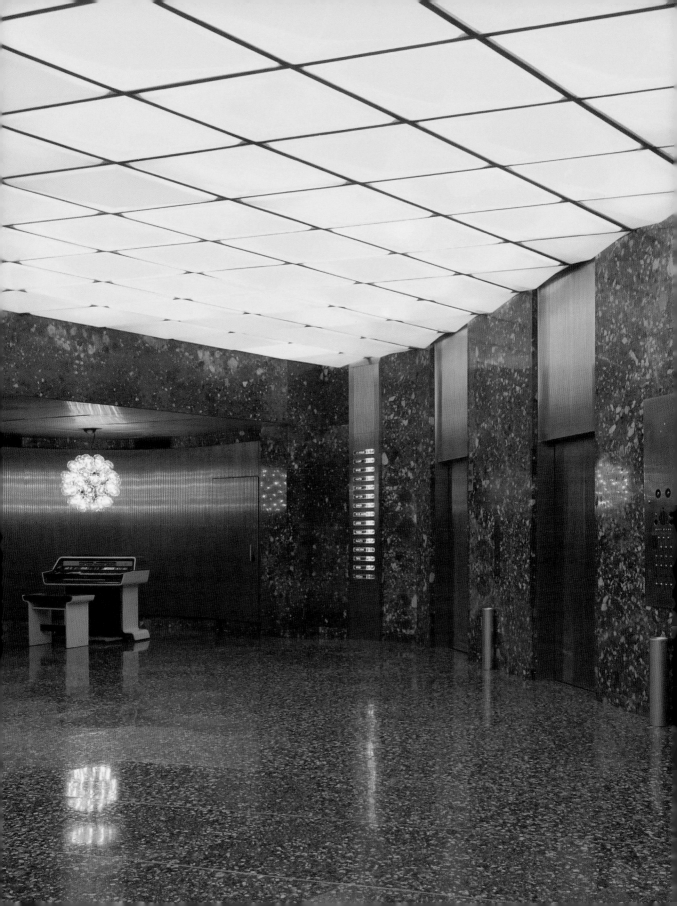

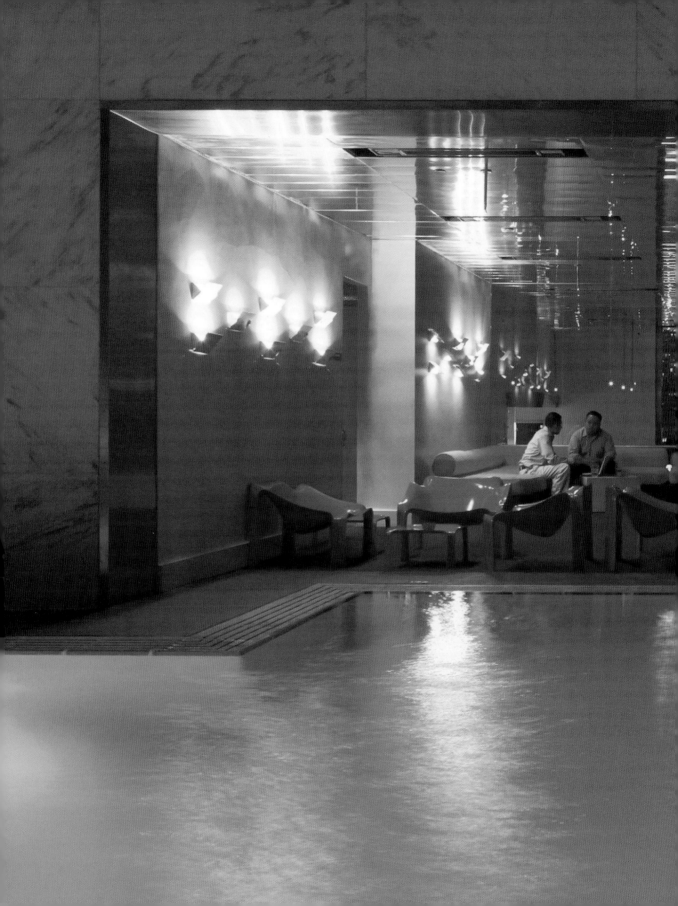

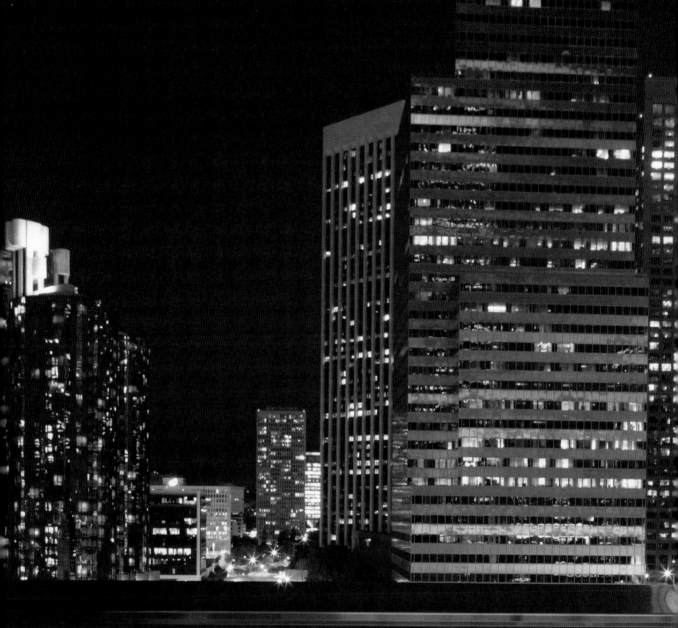

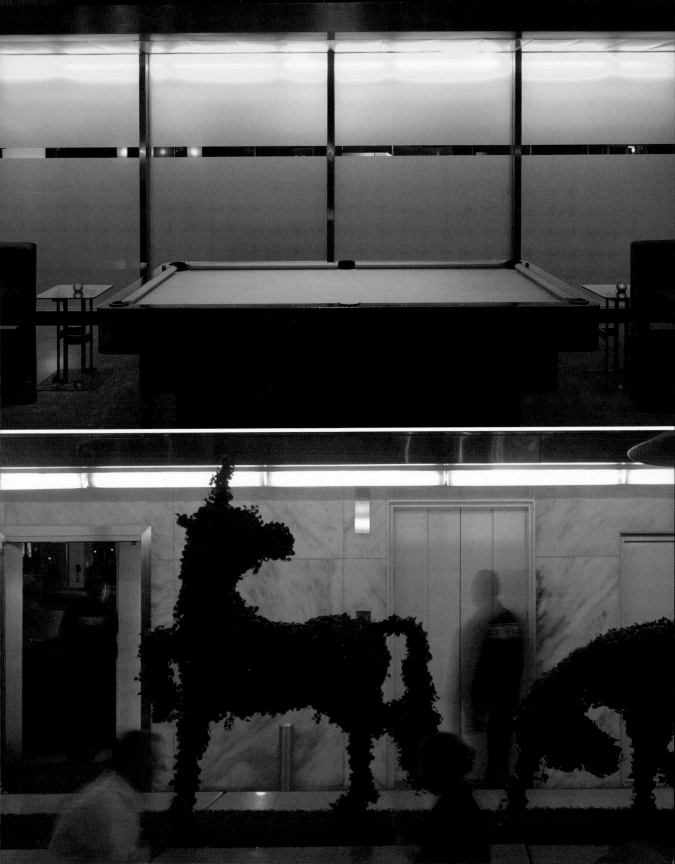

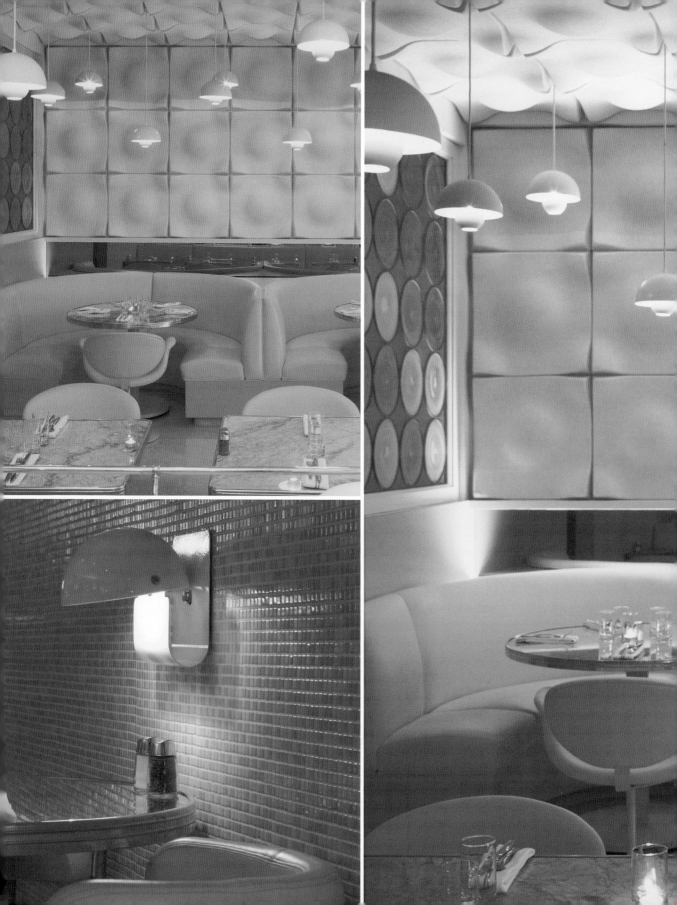

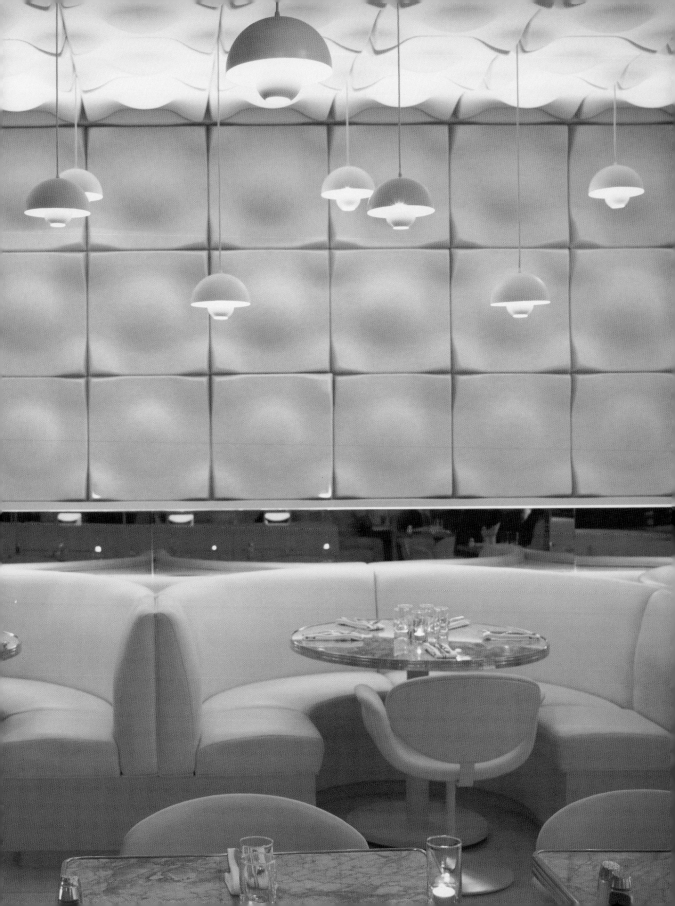

Chateau Marmont

Location: Los Angeles, California, USA
Completed: 1997

Play of light and shadow in the paths leading to the bungalows create a mysterious whimsy, giving the feeling that anything can happen. In general, the exterior lighting is warm, soft, and veiled.

Die Pfade, die zu den Bungalows führen, sind in ein geheimnisvolles Spiel aus Licht und Schatten getaucht. „Hier kann dir alles passieren." wird dem Besucher vermittelt. Die Außenbeleuchtung ist überwiegend warm und verborgen.

Des jeux d'ombre et de lumière servent de guide dans les allées conduisant aux bungalows, créant une mystérieuse fantaisie qui donne l'impression qu'il peut se produire quelque chose. D'une manière générale l'éclairage extérieur est chaud, doux et voilé.

En las sendas que llevan a los bungalows, un juego de luces y sombras crean una misteriosa fantasía, dando la sensación de que puede pasar cualquier cosa. En líneas generales, la iluminación exterior es cálida, suave, y velada.

Gioco di luce ed ombra nei sentieri conducenti ai bungalow creano un misterioso capriccio che dà la sensazione che possa avvenire di tutto. In genere, l'illuminazione esterna è calda, morbida e velata.

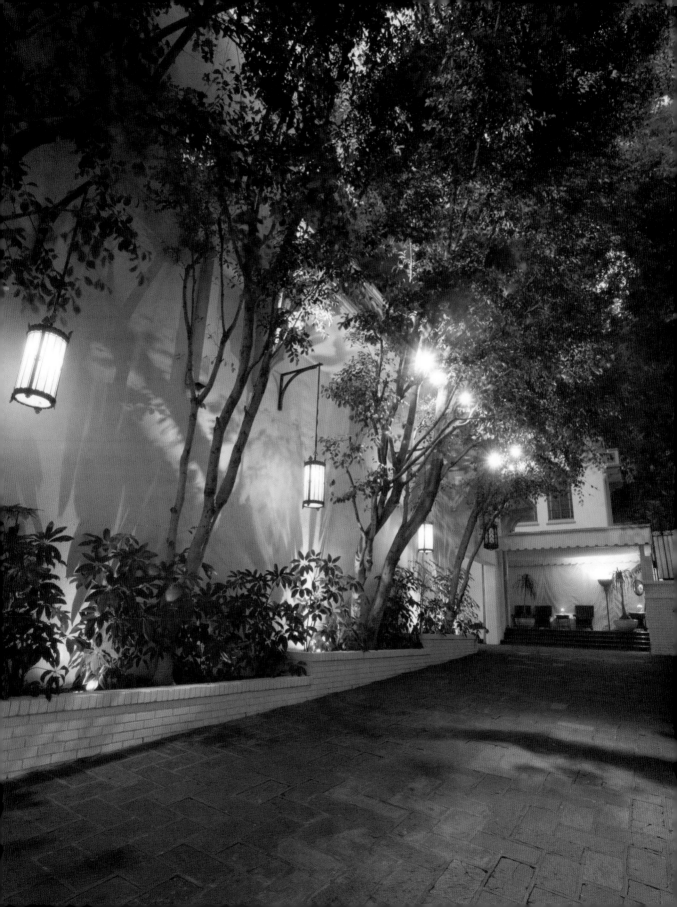

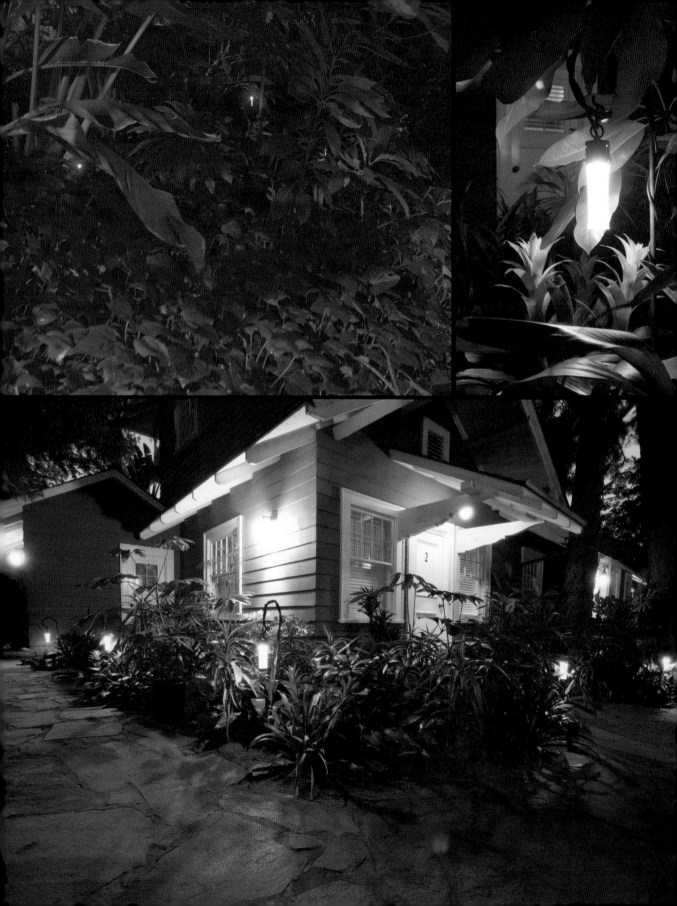

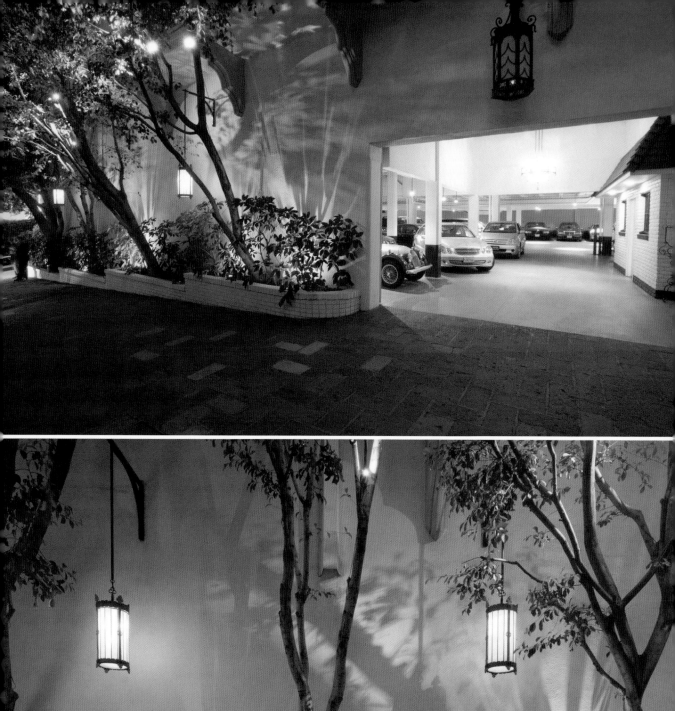

Disneyland Theme Park Entry Esplanade

Location: Anaheim, California, USA
Landscape Architect: Martha Schwartz, Inc., USA
Completed: 1998

The central transportation hub at the entrance of Disneyland includes three distinct areas including the Central Plaza, East Tram or "Hyper-Highway", and West Tram, together comprising 17 acres of streetscape and landscape. The project incorporates the redesign of arrival and departure areas, the public plaza, gateway, bus and shuttle stops. The lighting concept employs a color scheme to emphasize the hierarchy and identity of the space. The color scheme sets the mood for arriving guests, while intuitively enhancing the visitor's awareness of possible safety hazards.

Der Verkehrsknotenpunkt am Eingang zu Disneyland umfasst mit dem Central Plaza, der Straßenbahn Ost oder „Hyper-Highway" und der Straßenbahn West drei klar erkennbare Bereiche, die im Ganzen 7 Hektar Straßen- und Parklandschaft ausmachen. Die neugestalteten Ankunfts- und Abfahrtshallen, der Bahnhofsvorplatz, der Ein-und Ausfahrbereich und die Bus- und Shuttlehaltestellen sind Teil dieses Projekts. Im Beleuchtungskonzept wurde eine Farbzusammenstellung verwendet, die Hierarchie und Identität dieser Orte betont. Sie stimmt die Besucher auf ihren Aufenthalt ein, während ihr Gefahrenbewusstsein im Unterbewusstsein erhöht wird.

La plaque tournante des transports à l'entrée de Disneyland comprend trois zones distinctes qui englobent la grande place centrale, le tram est ou « Artère principale », et le tram ouest, qui ensemble représentent 7 hectares et demi partagés entre paysage urbain et nature. Le projet concerne la nouvelle définition des zones d'arrivée et de départ, la grande place public, la sortie, et les arrêts de bus et de navettes. Le concept d'éclairage fait usage d'un schéma de couleurs destiné à accentuer la hiérarchie et l'identification des espaces. Le schéma des couleurs communique l'atmosphère aux visiteurs à leur arrivée, tout en augmentant intuitivement la vigilance des visiteurs.

El portal central de transporte situado en la entrada de Disneylandia comprende tres áreas distintas que incluyen la Central Plaza, el East Tram o "Hyper-Highway", y el West Tram, y, en conjunto, ocupan una superficie de 17 acres de paisaje urbano y ajardinado. El proyecto incorpora la reestructuración de las zonas de llegada y salida, la plaza pública, la puerta, las paradas de autobús y de la lanzadera. El concepto de iluminación emplea un esquema de color para enfatizar la jerarquía y la identidad del espacio. Con él se crea el ambiente para los huéspedes que llegan, al mismo tiempo que, de forma intuitiva, aumenta la atención del visitante.

La stazione centrale di trasporto all'ingresso di Disneyland comprende tre aree distinte tra cui il Central Plaza, l'East Tram o "Hyper-Highway" e il West Tram, in tutto 17 acri di strade e paesaggio. Il progetto prevede la riprogettazione delle zone di arrivo e di partenza, della piazza pubblica, dell'entrata, delle fermate dell'autobus e della navetta. Il concetto di illuminazione adotta uno schema di colori tale da accentuare la gerarchia e l'identità del posto. Lo schema di colori determina l'atmosfera per gli ospiti in arrivo.

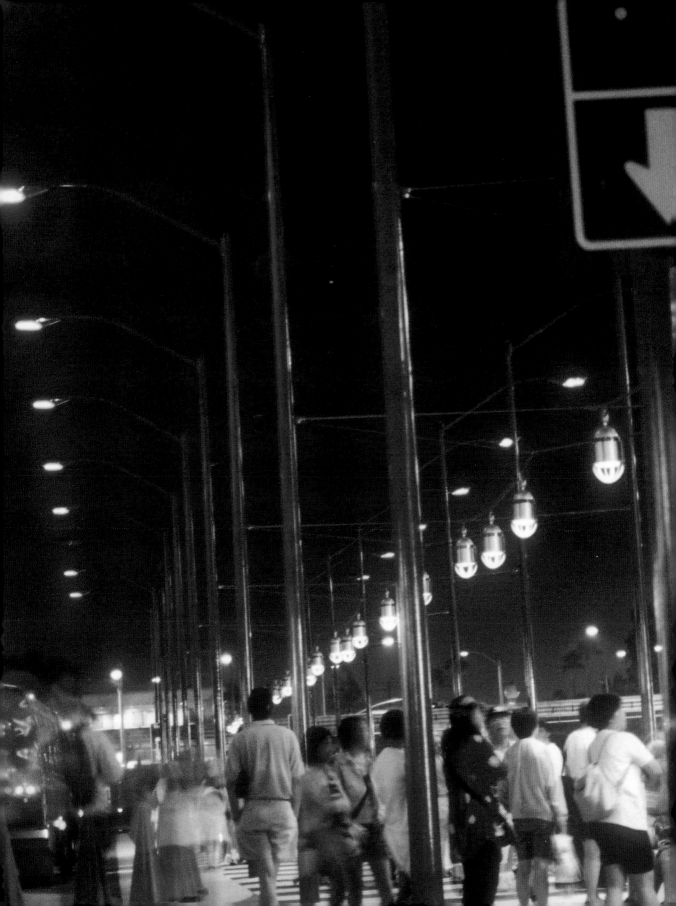

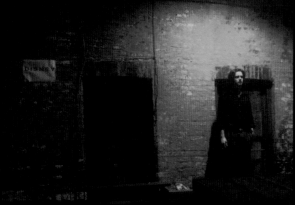

Color lighting mock-ups

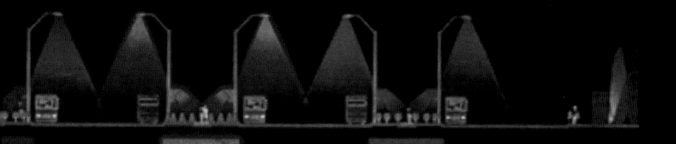

ZONING

LIGHT PLAN

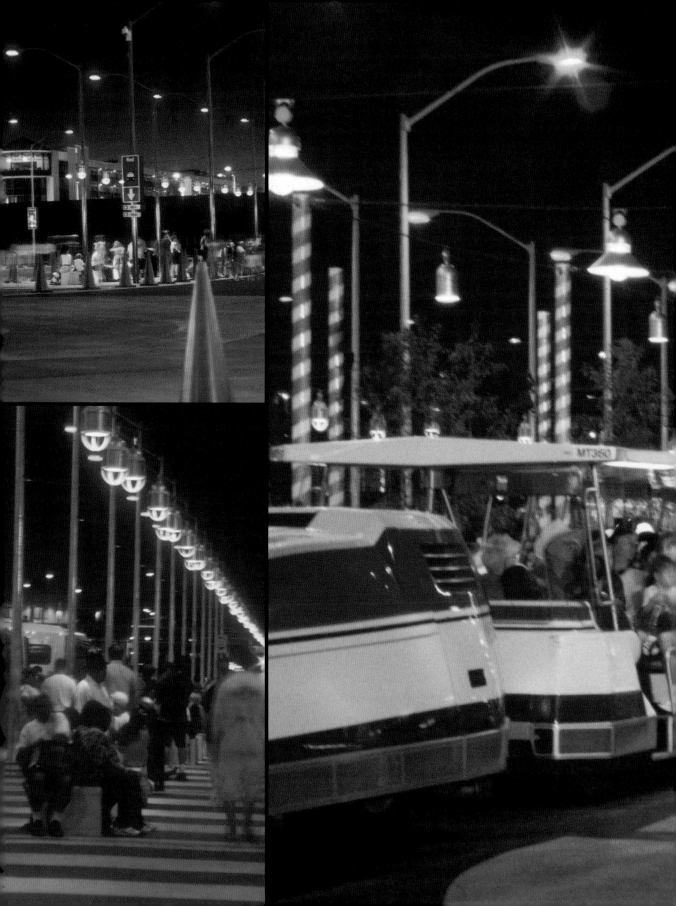

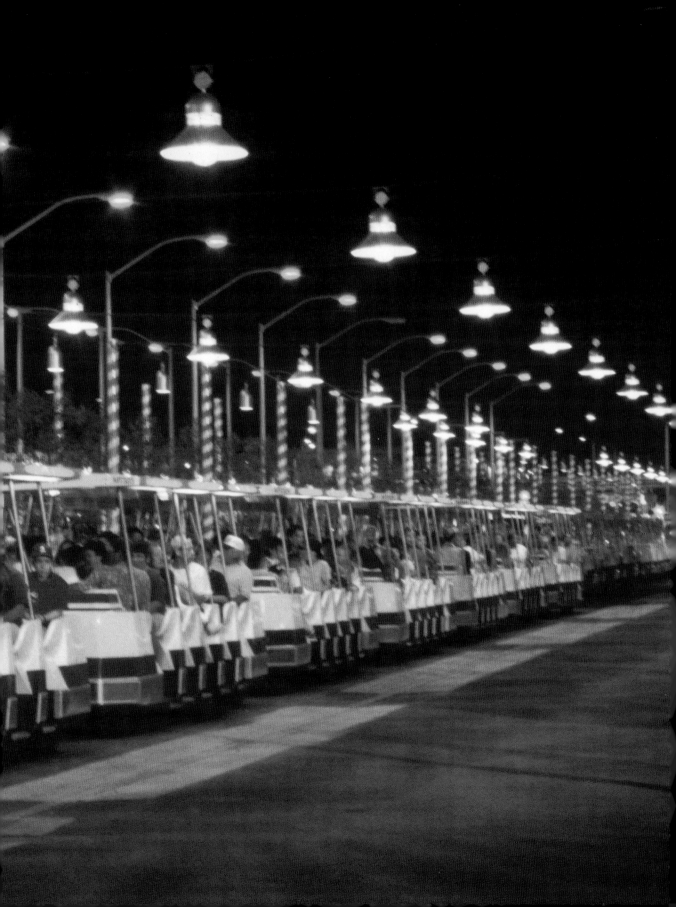

Cranbrook Institute of Science

Location: Bloomfield Hills, Michigan, USA
Architects: Steven Holl Architects, USA
Completed: 1999

For this extension of Eliel Saarinen's building for the Museum of Science from the 1930s, numerous lighting systems are repeated throughout to reflect architect Steven Holl's key design concept of "phase space," a property of Strange Attractors. To do so, lighting radiates through slots of light, it is diffused through glass, and adjustable lights on a track system are employed. Skylights appear like glowing volumes at night.

Dieser Anbau des aus dem Jahre 1930 stammenden und von Eliel Saarinen entworfenen Gebäudes des Naturwissenschaftlichen Museums ist mit einer Vielzahl von Beleuchtungssystemen ausgestattet. Diese sollen das Konzept von „Phase Space", Eigentum der Strange Attractors, widerspiegeln, von dem das Design des Architekten Steven Holl ausging. Um dies zu erreichen, wird Licht durch Beleuchtungsschlitze geworfen und durch Glas gestreut. Zusätzlich sind bewegliche Lampen auf ein Schienensystem montiert. Oberlichter gleichen nachts glühenden Leuchtkörpern.

Pour cette extension de l'immeuble Eliel Saarinen du Musée des sciences des années 30, de nombreux systèmes d'éclairage sont reproduits partout, afin de refléter le concept clé de « phase space » (espaces déclinés par périodes) de l'architecte Steven Holl, c'est la propriété de points d'attraction étranges. Dans cette réalisation la lumière est émise par des gorges de lumière diffusés par du verre dépoli, et à partir de projecteurs ajustables fixés sur un rail. Les verrières apparaissent comme des volumes lumineux dans la nuit.

Para esta extensión del edificio de Eliel Saarinen para el Museum of Science de la década de 1930, se repiten numerosos sistemas de iluminación por todas partes para reflejar el concepto de diseño clave del arquitecto Steven Holl "phase space" (espacio de fase), una propiedad de Strange Attractors. Para llevarlo a cabo, la iluminación se irradia a través de ranuras de luz, se difunde a través de cristal, y se utilizan luces ajustables en un sistema de rieles. Los tragaluces aparecen como volúmenes brillantes por la noche.

Per questa estensione dell'edificio di Eliel Saarinen per il "Museum of Science" (Museo della scienza) degli anni trenta, diversi sistemi di illuminazione sono ripetuti dappertutto per riflettere il concetto chiave di design dell'architetto Steven Holl di "phase space" (spazio di fase), una proprietà di Strange Attractors. A tale fine l'illuminazione viene emanata attraverso fessure, viene diffusa attraverso il vetro e vengono adottate luci regolabili su un sistema a sbarra. Le luci del cielo appaiono di notte come volumi luminosi.

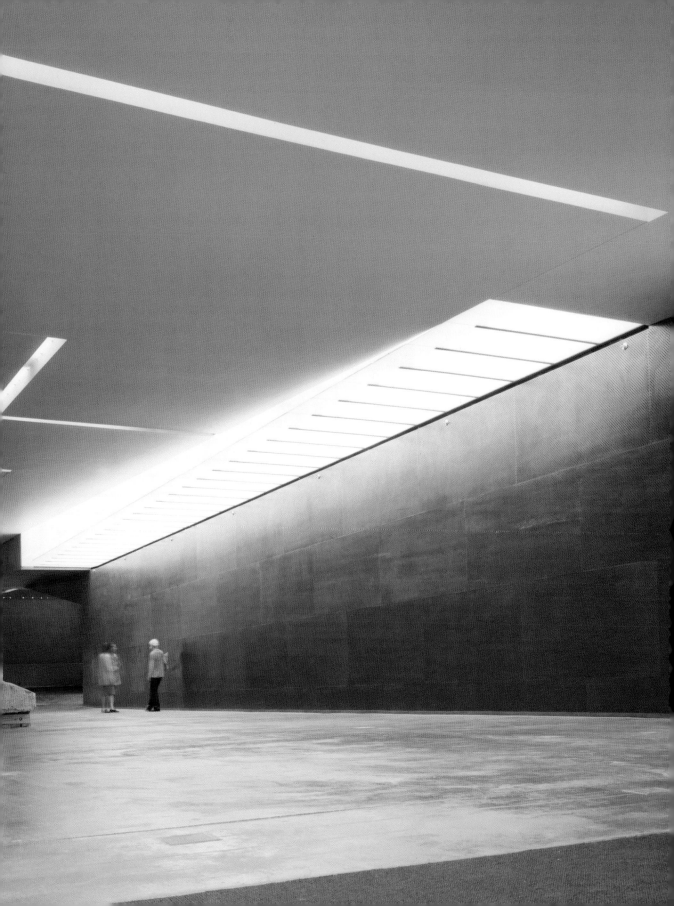

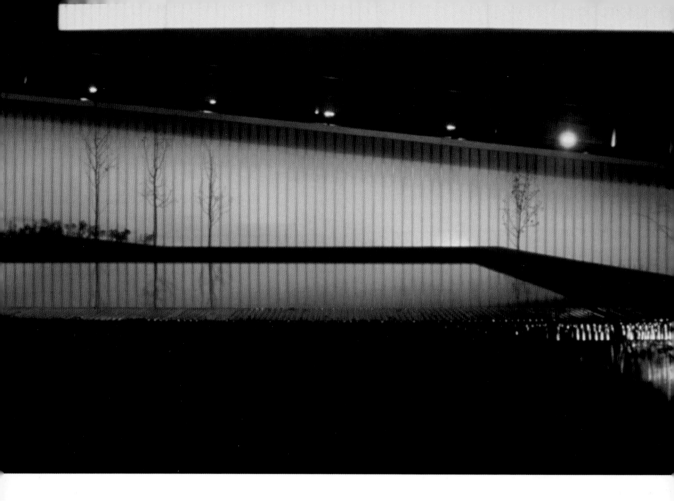

Strange Attractors diagram

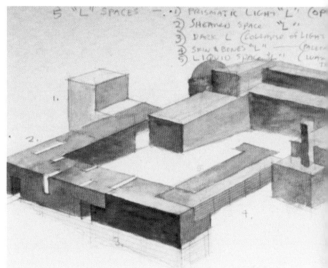

Watercolor by Steven Holl

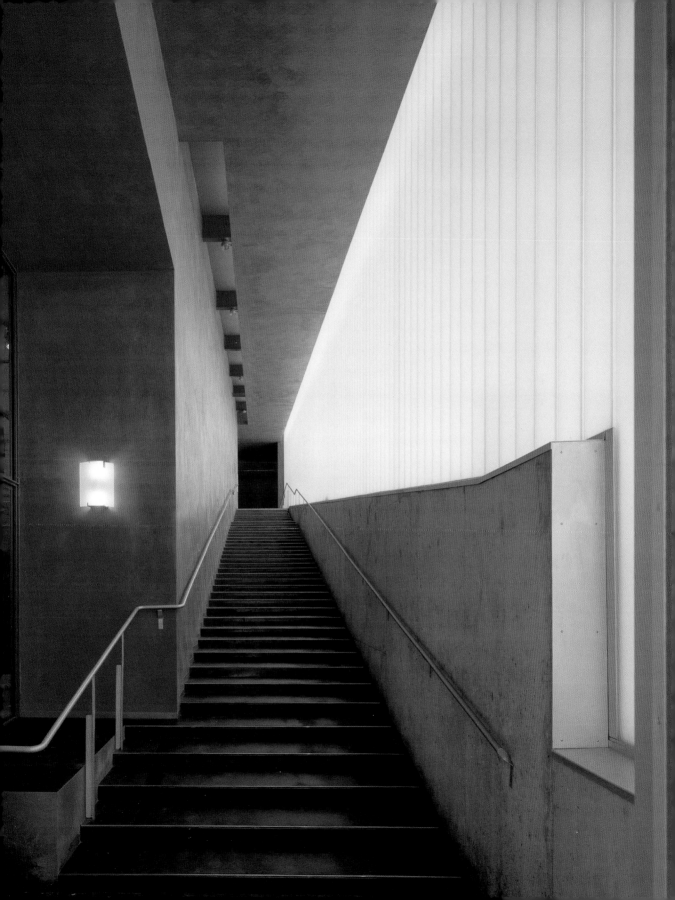

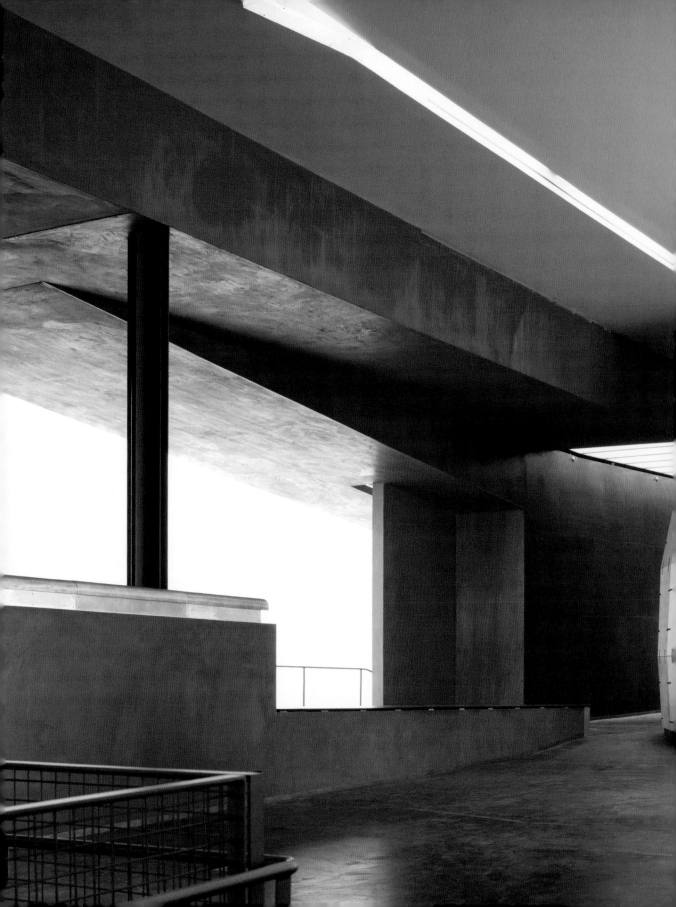

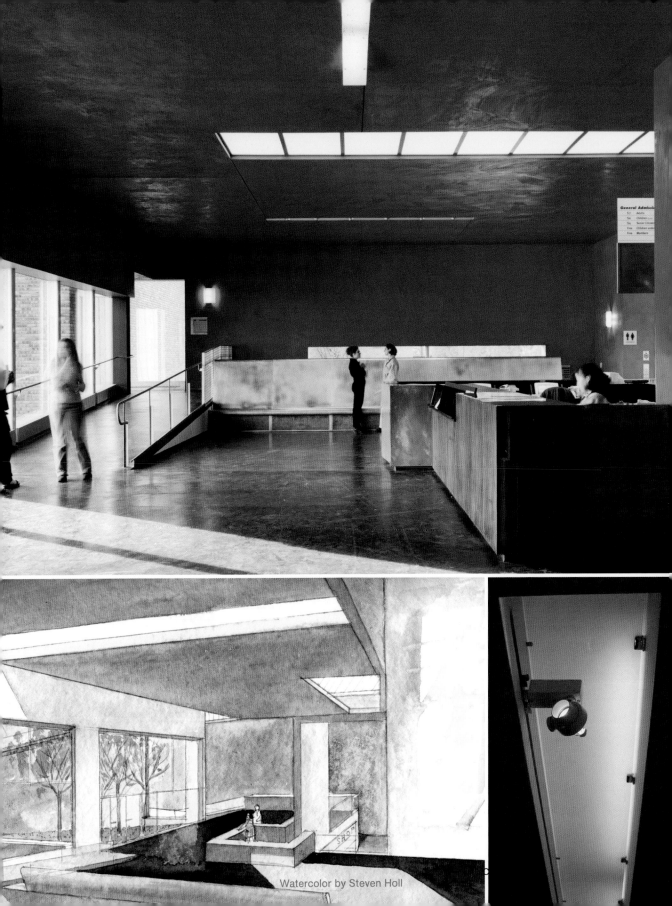

Watercolor by Steven Holl

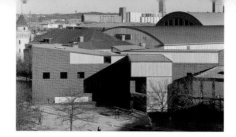

College of Architecture and Landscape Architecture

Location: Minneapolis, Minnesota, USA
Architects: Steven Holl Architects, USA
Completed: 2003

As the building is largely constructed from precast concrete, a lighting vocabulary is created to be easily mounted and applied. Most of the fixtures used are surface mounted and diffuse, using concrete as a reflector. In the auditorium, warmer tones emphasize wooden surfaces.

Das Gebäude besteht größtenteils aus vorgefertigten Betonbauelementen. Die Lichtanlagen wurden so gestaltet, dass sie einfach montiert und eingestellt werden können. Die meisten Lichtvorrichtungen sind an Wänden oder Decken angebracht und streuen ein diffuses Licht, das vom Beton reflektiert wird. Im Hörsaal werden Holzflächen durch wärmere Farbtöne hervorgehoben.

Comme cet immeuble est construit largement à partir de plaques de béton préfabriquées, un langage d'éclairage a été créé pour un montage et une application simplifiés. La plupart des équipements utilisés sont montés en surface et diffusent, en utilisant le béton comme réflecteur. Dans l'auditorium, des tons chauds mettent en valeur les bois.

Como el edificio está construido principalmente con hormigón prefabricado, se ha creado un vocabulario de iluminación para ser fácilmente montado y aplicado. Muchos de los accesorios de iluminación utilizados están montados en la superficie y son difusos porque utilizan el hormigón como reflector. En el auditorio, tonos más cálidos enfatizan las superficies de madera.

Dato che l'edificio è costruito prevalentemente in calcestruzzo prefabbricato, è stata creata un'illuminazione facilmente montabile ed applicabile. La maggior parte degli elementi utilizzati sono montati sulla superficie e diffusi, utilizzando il calcestruzzo come riflettore. Nell'auditorium, tonalità più calde enfatizzano le superfici di legno.

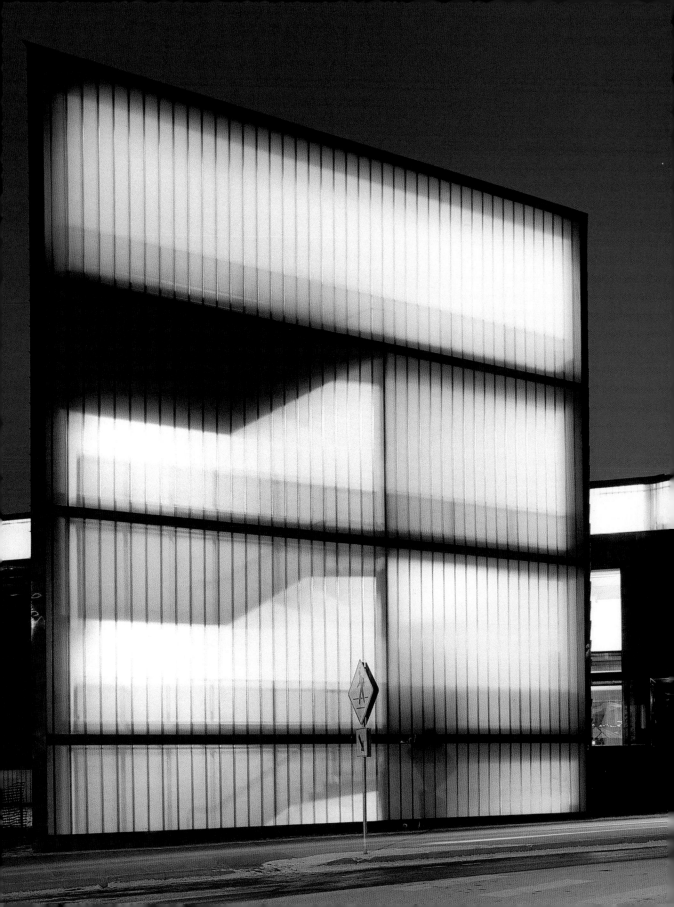

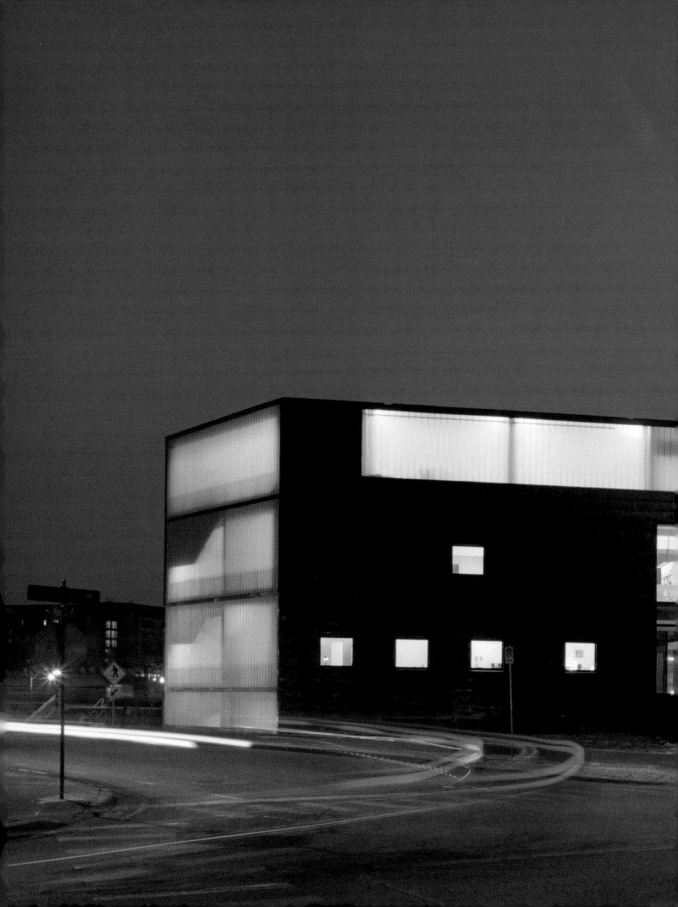

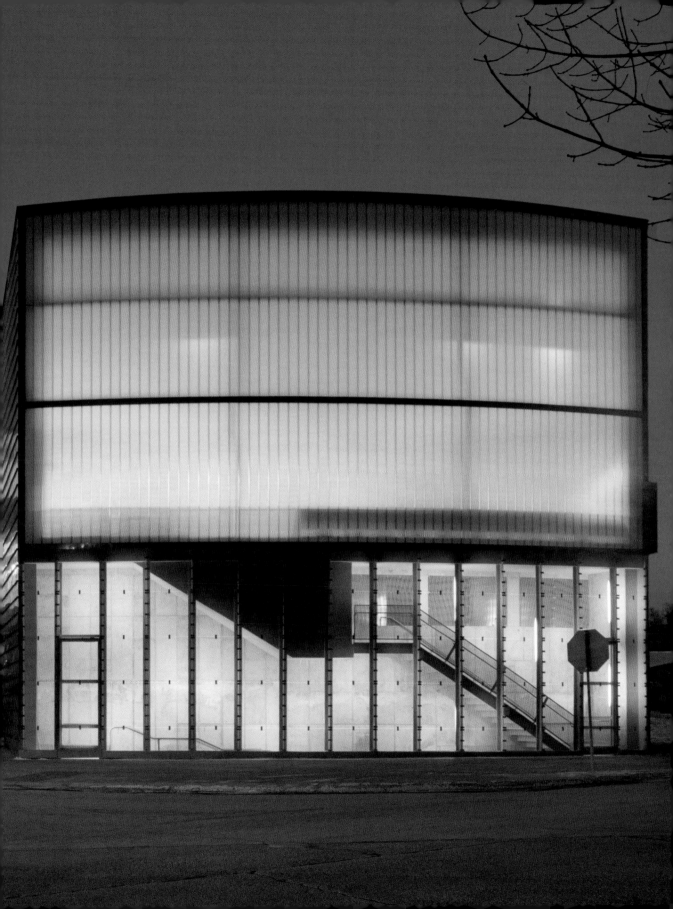

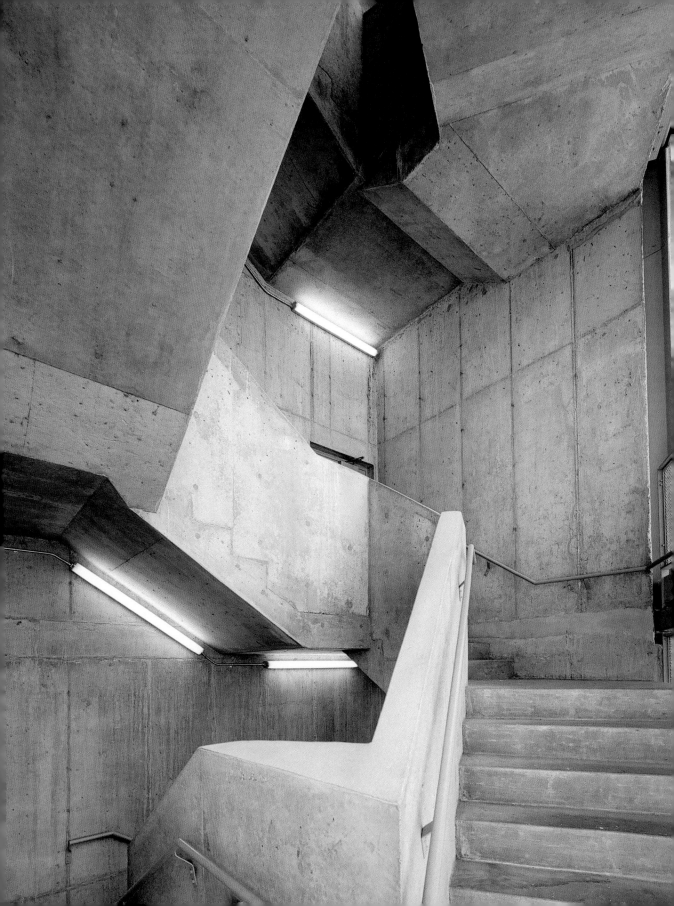

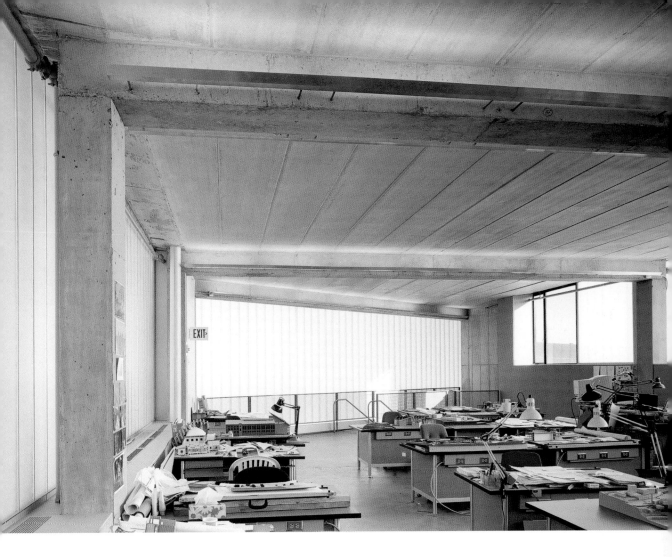

"Light often goes unnoticed but it deeply effects how we feel and what we remember and yearn for." H.D.

„Licht fällt oft nicht auf, kann aber großen Einfluss darauf haben, wie wir uns fühlen, woran wir uns erinnern und wonach wir uns sehnen." H.D.

« Souvent, on ne remarque pas la lumière, mais elle affecte profondément notre expérience, notre sentiment, notre mémoire. » H.D.

"A menudo la luz pasa inadvertida, pero afecta profundamente a nuestro estado de ánimo y a lo que recordamos y añoramos." H.D.

"La luce spesso passa inosservata, ma si ripercuote profondamente su come ci sentiamo, su cosa ci ricordiamo e a cosa aspiriamo." H.D.

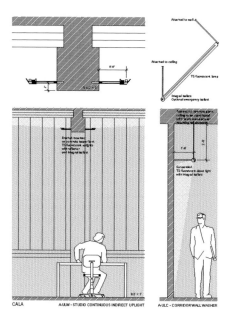

CALA A-ULW · STUDIO CONTINUOUS INDIRECT UPLIGHT A-ULC · CORRIDOR WALL WASHER

Bracket mounted
T5 fluorescent down light
with integral ballast

1'11"

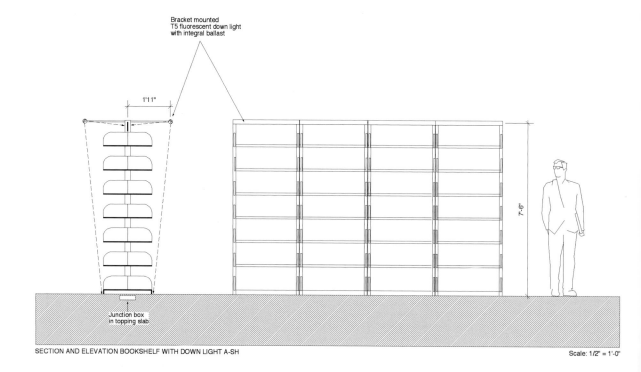

7'-6"

Junction box
in topping slab

SECTION AND ELEVATION BOOKSHELF WITH DOWN LIGHT A-SH Scale: 1/2" = 1'-0"

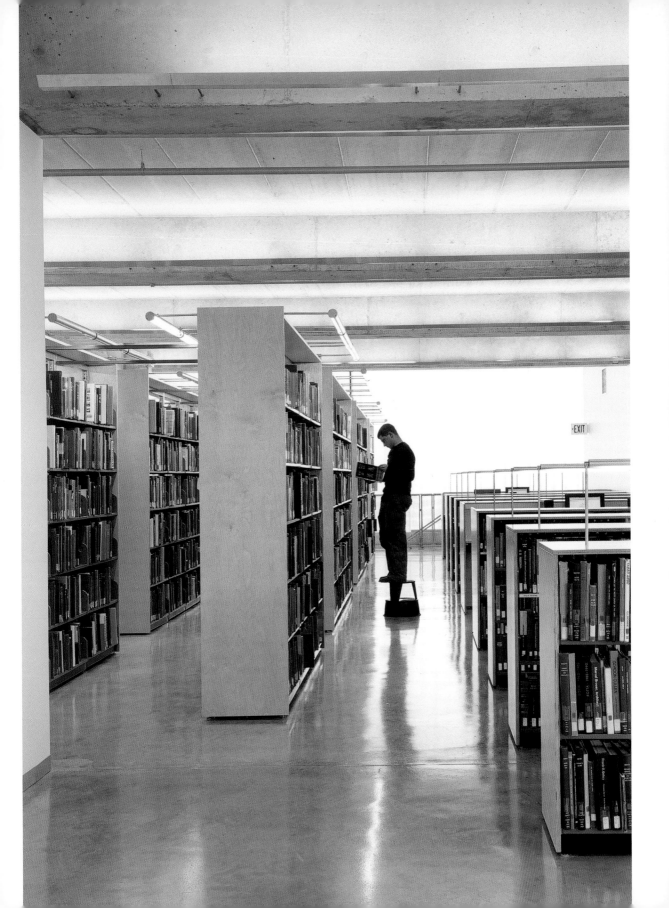

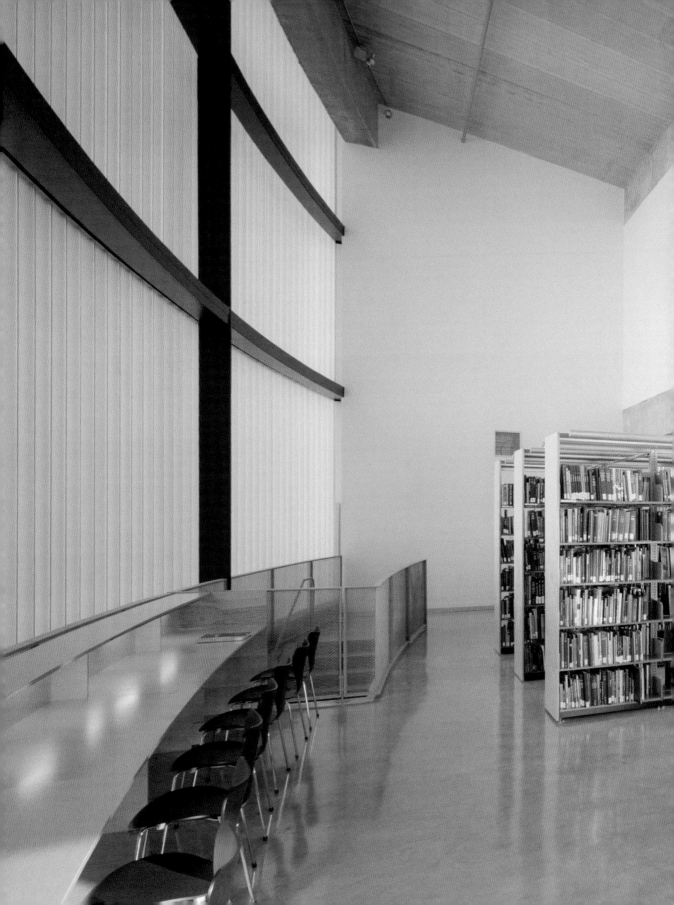

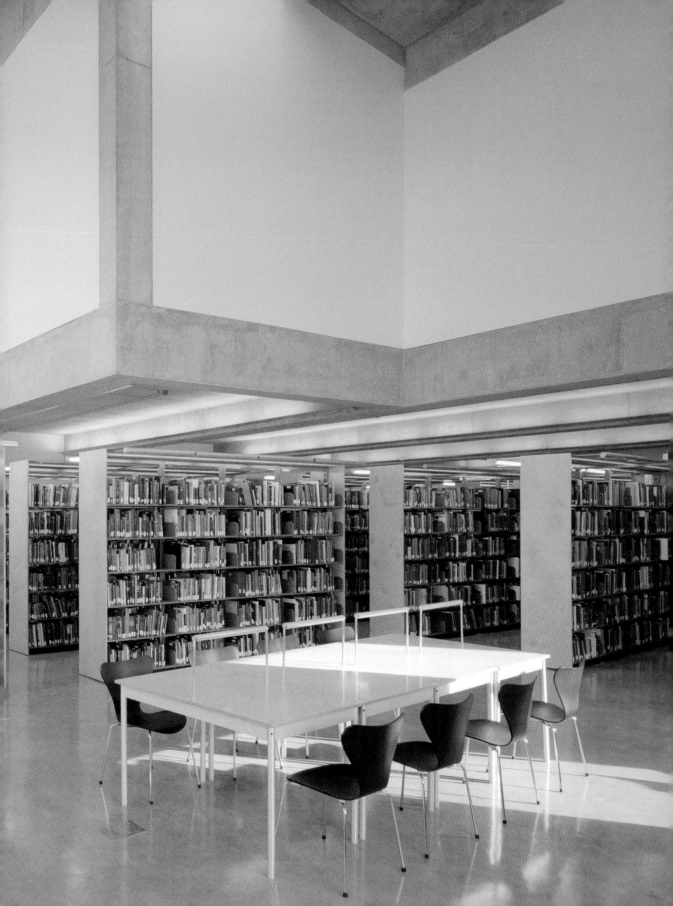

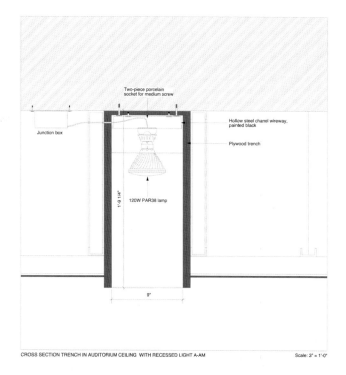

Two-piece porcelain
socket for medium screw

Junction box

Hollow steel chanel wireway,
painted black

Plywood trench

1'-9 1/4"

120W PAR38 lamp

9"

CROSS SECTION TRENCH IN AUDITORIUM CEILING WITH RECESSED LIGHT A-AM Scale: 3" = 1'-0"

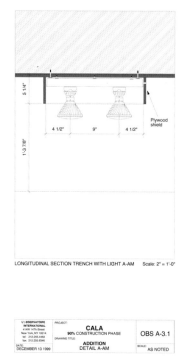

5 1/4"

1'-3 7/8"

4 1/2" 9" 4 1/2"

Plywood
shield

LONGITUDINAL SECTION TRENCH WITH LIGHT A-AM Scale: 2" = 1'-0"

L'OBSERVATOIRE
INTERNATIONAL
41-49 14Th Street
New York, NY 10014
tel: 212.255.4463
fax: 212.255.8546

PROJECT:
CALA
90% CONSTRUCTION PHASE
DRAWING TITLE:
ADDITION
DETAIL A-AM

OBS A-3.1

DATE:
DECEMBER 13 1999

SCALE:
AS NOTED

"Revealing a light source can be a graphic expression, hiding a source emphasizes the material that receives the light and the texture of the surface." H.D.

„Sichtbare Lichtquellen können eine grafische Darstellung sein, während das Verstecken der Lichtquelle das Material, auf das das Licht fällt, und die Beschaffenheit der Oberfläche hervorhebt." H.D.

« Exposer les sources de lumière peut devenir une expression graphique, dissimuler une source lumineuse permet de valoriser le matériau qui la reçoit, la texture de sa surface. » H.D.

"Las fuentes de luz visibles pueden ser una representación gráfica, mientras que, al ocultarlas, se resalta el material sobre el que incide la luz y la textura de la superficie." H.D.

"Le fonti luminose visibili possono essere una rappresentazione grafica, mentre nascondendo una fonte luminosa si enfatizza il materiale sui cui cade la luce e la struttura della superficie." H.D.

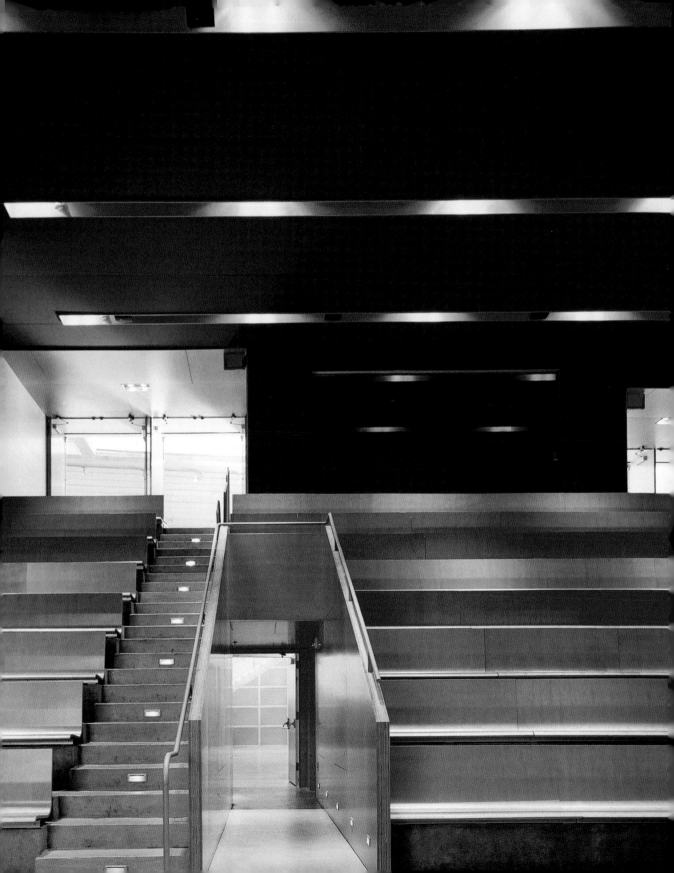

Guthrie Theater

Location: Minneapolis, Minnesota, USA
Architects: Ateliers Jean Nouvel, France
To be completed: 2005

The 255,000 square foot building housing the Guthrie Theater contains three performance spaces including a 1100 seat thrust theater, 700 seat proscenium theater, and 250 seat studio and experimental theater. The lighting respects architect Jean Nouvel's mysterious space, comprised of many layers of darkness and depth. There is a progression of darkness from the relatively bright lobby, to the darker proscenium, to the dark theater.

Das ca. 23.700 m² große Gebäude, in dem das Guthrie Theater untergebracht ist, umfasst drei Bühnen, ein 1100 Besucher fassendes Thrust Theater, dessen Bühne sich in den Zuschauerraum hineinschiebt, ein Proszenium Theater mit 700 Plätzen und ein Studio- und Experimentaltheater mit 250 Plätzen. Der geheimnisvolle Raum von Architekt Jean Nouvel, der aus einer komplexen Dunkelheit und Tiefe besteht, findet im Beleuchtungskonzept Beachtung. Es ist ein Fortschreiten der Dunkelheit wahrnehmbar, von dem relativ hellen Vorraum, über das dunklere Guckkastentheater, bis hin zum dunklen Theater.

L'immeuble de 23.700 mètres carré abritant le théâtre Guthrie, comprend trois salles de spectacle, un théâtre en arène de 1100 sièges, un théâtre à avant-scène de 700 sièges, et un atelier studio et théâtre expérimental de 250 places. Le concept d'éclairage respecte l'espace mystérieux de l'architecte Jean Nouvel, comprenant de nombreux niveaux d'obscurité et de profondeur. Il existe une progression de l'obscurité en partant de l'entrée relativement lumineuse, à l'avant-scène obscure, jusqu'au théâtre encore plus sombre.

El edificio de 23.700 metros cuadrados que alberga el Teatro Guthrie posee tres escenarios que comprenden un teatro del empuje con 1.100 localidades, un teatro de proscenio de 700 localidades y un teatro experimental y estudio de 250 localidades. La iluminación respeta el espacio misterioso del arquitecto Jean Nouvel, compuesto por numerosas capas de oscuridad y profundidad. Existe una progresión de oscuridad desde el relativamente brillante vestíbulo, pasando por el más oscuro proscenio, hasta llegar al oscuro teatro.

L'edificio misurante 23.700 metri quadrato che ospita il Guthrie Theater comprende tre strutture per recitazioni con un teatro tipo thrust (con palcoscenico circondato su tre lati dal pubblico) di 1100 posti a sedere, un teatro a proscenio con 700 posti a sedere ed uno studio e teatro sperimentale con 250 posti a sedere. L'illuminazione rispetta lo "spazio misterioso" dell'architetto Jean Nouvel, comprendente diversi strati di oscurità e profondità. Vi è una progressione di oscurità dal lobby relativamente illuminato al proscenio già più buio, al teatro buio.

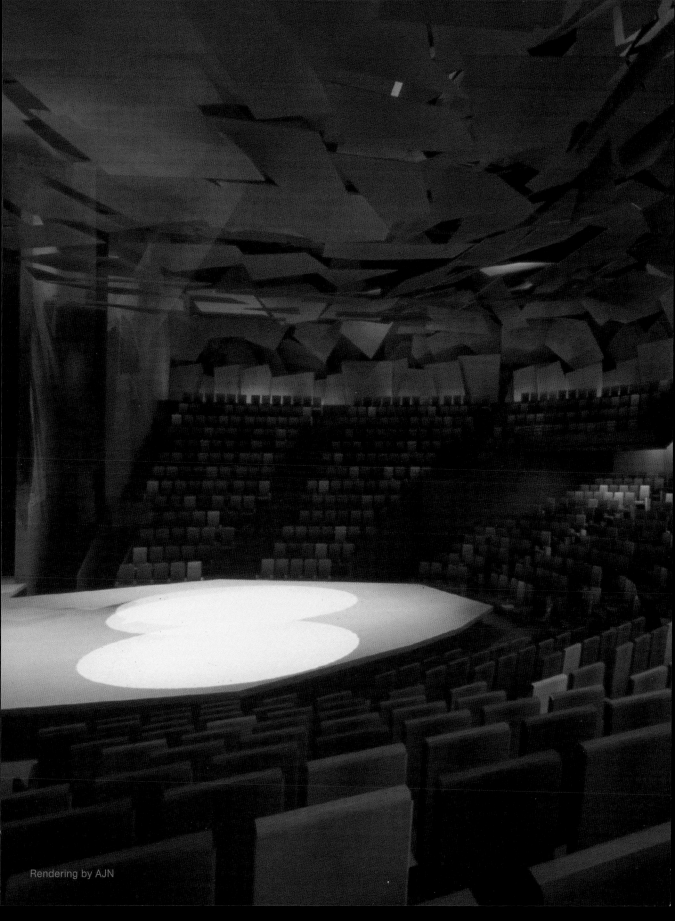

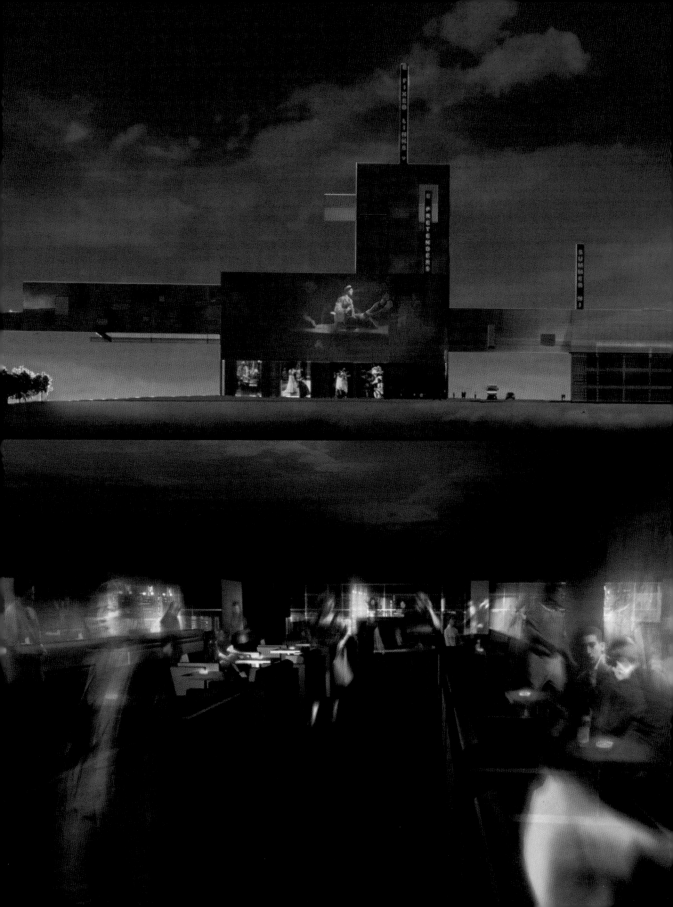

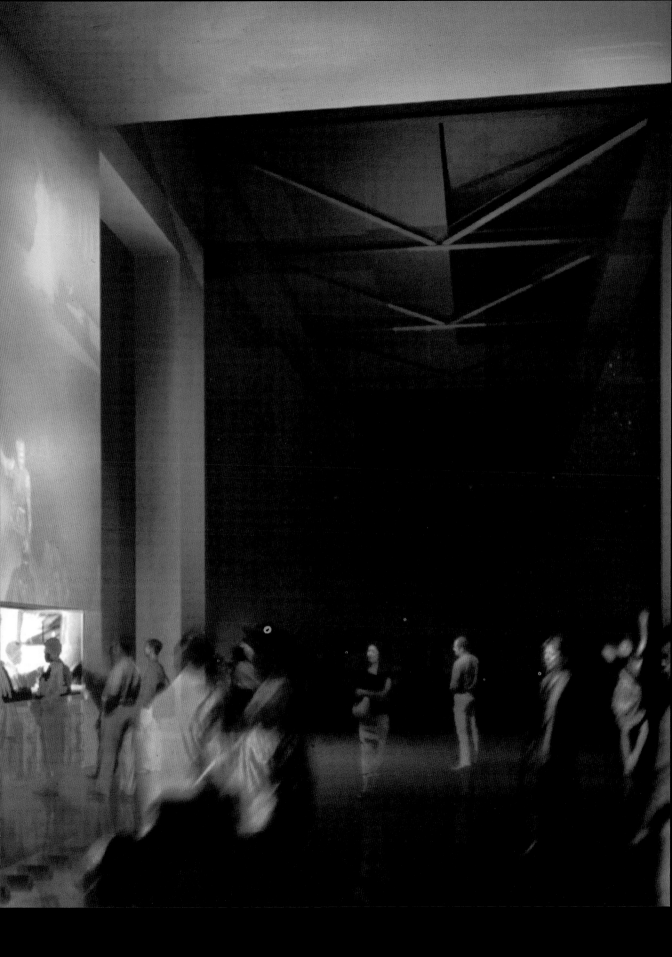

Entrance lobby

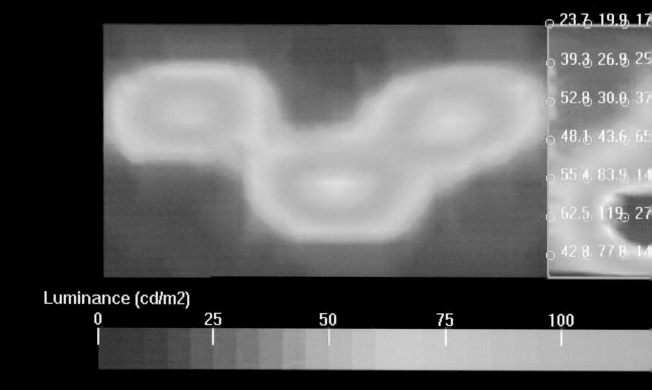

| | | | |
|---|---|---|
| 23.7 | 19.8 | 17 |
| 39.3 | 26.8 | 29 |
| 52.8 | 30.0 | 37 |
| 48.1 | 43.6 | 65 |
| 55.4 | 83.9 | 14 |
| 62.5 | 119 | 27 |
| 42.8 | 77.8 | 14 |

Luminance (cd/m2)

0 25 50 75 100

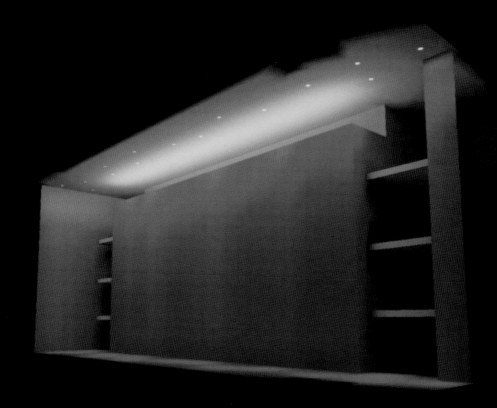

Proscenium lobby

19.6 20.3 14.8 11.8 12.0 16.1 23.6 31.6 36.1 31.5 20.8 15.4 15.7

75.4 54.6 28.4 19.5 20.1 30.5 61.8 113 144 108 51.2 28.9 37.7

240 120 39.8 21.1 21.6 40.5 114 280 355 224 95.5 41.4 41.5

240 103 38.2 21.1 21.7 36.5 80.2 155 191 183 146 80.6 61.9

98.0 52.0 26.5 18.4 19.3 27.4 45.3 73.2 120 243 305 191 96.9

56.6 30.0 19.2 16.3 17.4 21.8 29.4 39.8 76.5 168 254 207 106.

41.8 21.4 15.8 14.6 15.2 17.1 20.0 24.4 36.2 56.6 74.8 69.6 46.9

150 175 200 225 250

Lighting calculations for the entrance lobby

Art Gallery of Ontario

Location: Toronto, Ontario, Canada
Architects: Gehry International LLC, USA
To be completed: 2008

As a multiuse facility and complex programming venue, the Art Gallery caters to a very broad audience through a mandate maintaining the permanent collection for the people of Ontario as an educational institution. Layered lighting applications increase current museum light levels while revealing important architectural features. There is recessed star-patterned down and accent lighting in public spaces. In the galleries, completely removable Power Bar track lighting allows for ultimate flexibility for rotating exhibits. Uplights graze the façade's curving structural elements, and exterior flood lighting highlights facade graphics.

Die Kunstgallerie kann mehreren Zwecken dienen und ist ein vielseitiger Veranstaltungsort. Sie hat die Aufgabe, die ständige Kunstsammlung für die Einwohner von Ontario als Bildungsinstitution aufrecht zu erhalten, und das Besucherspektrum ist entsprechend weit gefächert. Vielschichtige Beleuchtungsvorrichtungen verstärken die im Museum herrschenden Lichtverhältnisse und unterstreichen besondere Architekturelemente. In öffentlichen Räumen befinden sich sternförmige, in die Decke eingelassene Ober- und Akzentleuchten. In den Gallerieräumen sorgen vollständig abnehmbare Power Bar Lichtschienen für ein Höchstmaß an Flexibilität, was bei wechselnden Ausstellungsstücken von großem Vorteil ist. Bodenscheinwerfer streifen die geschwungenen Strukturelemente der Fassade und Flutlichter betonen die Grafik der Front.

Conçu comme un complexe de rencontres programmées à usages polyvalents, le musée d'art draine un très large public grâce à un mandat qui prévoit la mise à disposition de la collection permanente aux populations de l'Ontario, en tant qu'institution éducative. Des applications d'éclairage dégradé augmentent les niveaux de lumière actuels du musée, tout en révélant certains détails architecturaux essentiels. On trouve un éclairage encastré en forme d'étoiles et un éclairage d'accentuation dans les espaces publics. Dans les galeries sont situés des spots amovibles montés sur un « Power Bar track lighting » qui permettent une extrême flexibilité pour l'éclairage des expositions temporaires. Des éclairages supérieurs effleurent les courbes des éléments structurels de la façade, et des projecteurs diffus extérieurs mettent en valeur les reliefs de la façade.

Como instalación de usos múltiples y lugar de reunión de programaciones complejas, la Galería de Arte ofrece sus servicios a un público muy variado a través de un mandato que mantiene la colección permanente para la gente de Ontario como una institución educativa. Las aplicaciones de luz en capas incrementan los actuales niveles de luz del museo mientras que revelan importantes características arquitectónicas. En los espacios públicos existe una iluminación proyectada hacia abajo con dibujos de estrellas y una iluminación de acento. En las galerías, el cañón de luz completamente desmontable del Power Bar permite ultimar la flexibilidad para las obras de arte giratorias. Luces orientadas hacia arriba rozan los elementos estructurales curvos de la fachada, y una iluminación en forma de inundación resalta los gráficos de la fachada.

Quale struttura multiuso e complesso centro programmatico, la galleria d'arte si rivolge ad un pubblico molto vasto per forza di un incarico di conservazione della collezione permanente per il popolo dell'Ontario come istituzione educativa. Applicazioni luminose stratificate incrementano i livelli di luce attuali del museo rivelando nel contempo importanti caratteristiche architettoniche. Vi sono sagome di stelle incassate volte in basso e illuminazione d'accento in spazi pubblici. Nelle gallerie un'illuminazione a sbarra collettrice completamente rimovibile consente la massima flessibilità per ruotare i pezzi esposti. Luci volte in alto radono gli elementi strutturali incurvati della facciata e l'illuminazione esterna da proiettori esalta le grafiche della facciata.

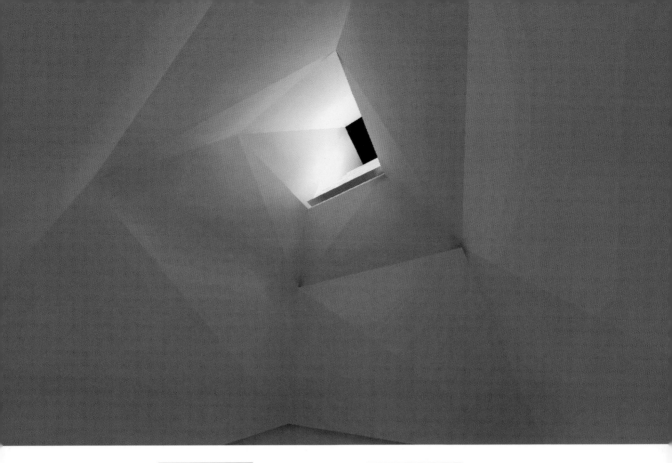

NORTH WALL ELEVATION

SOUTH WALL ELEVATION

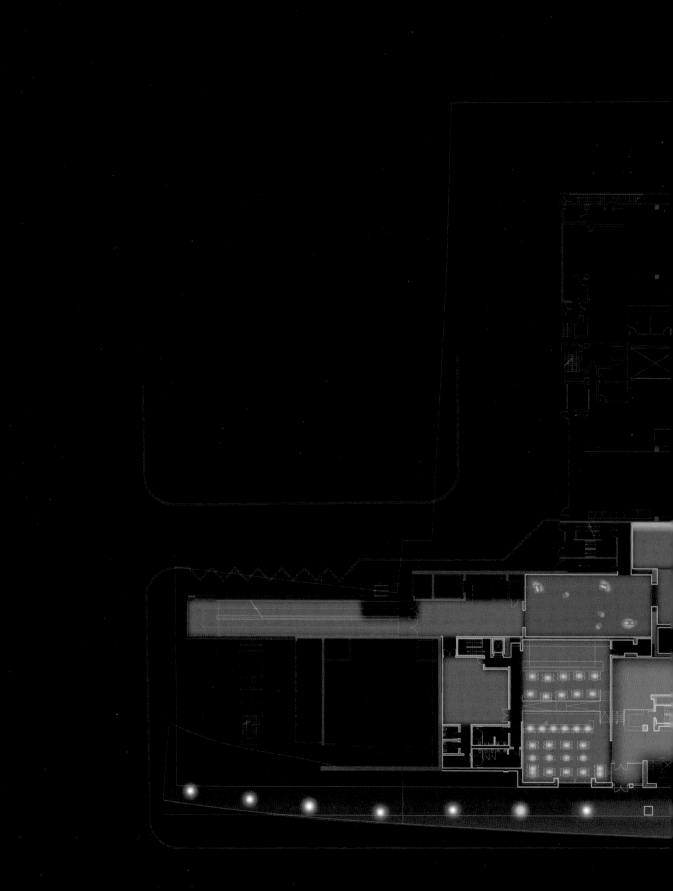

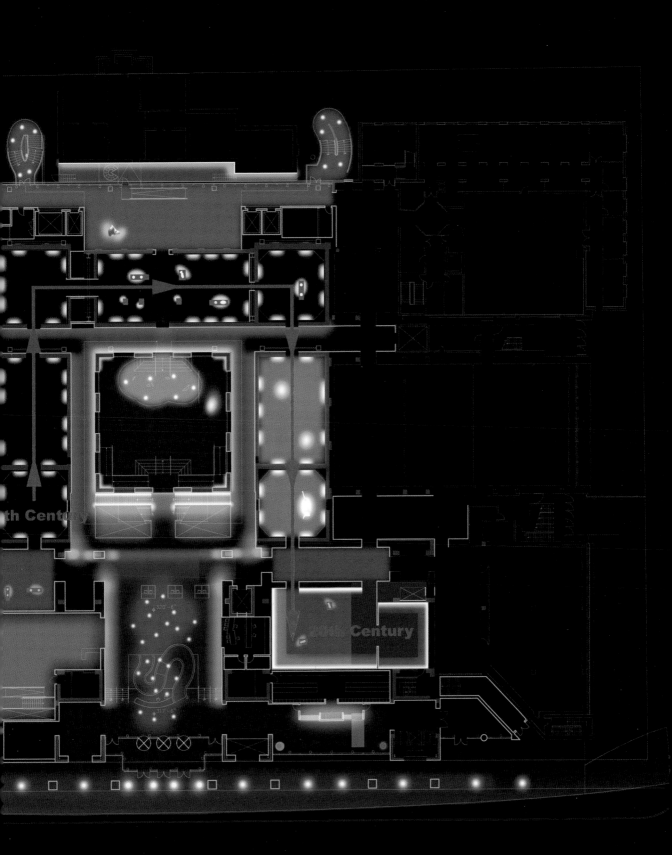

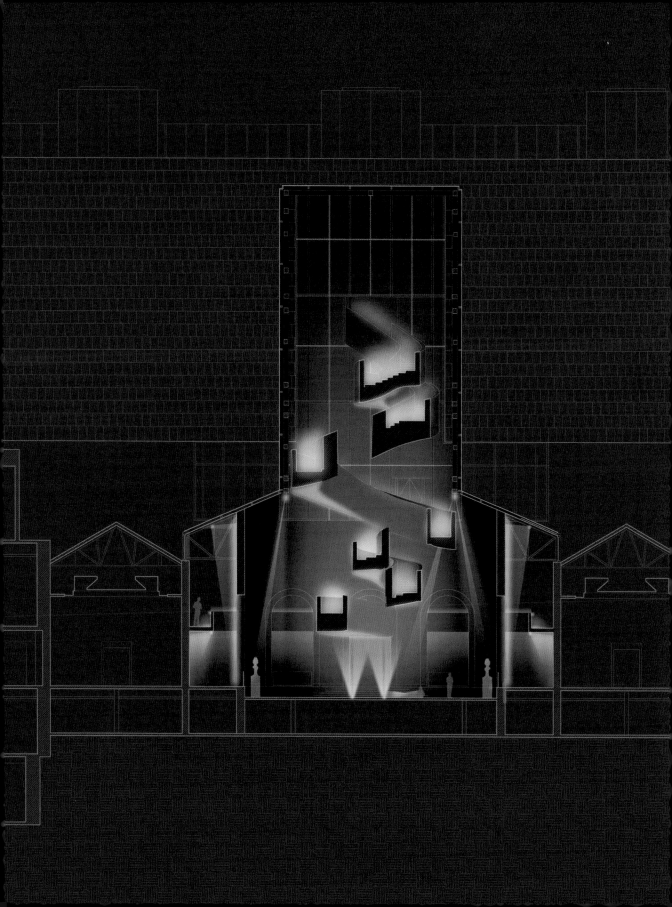

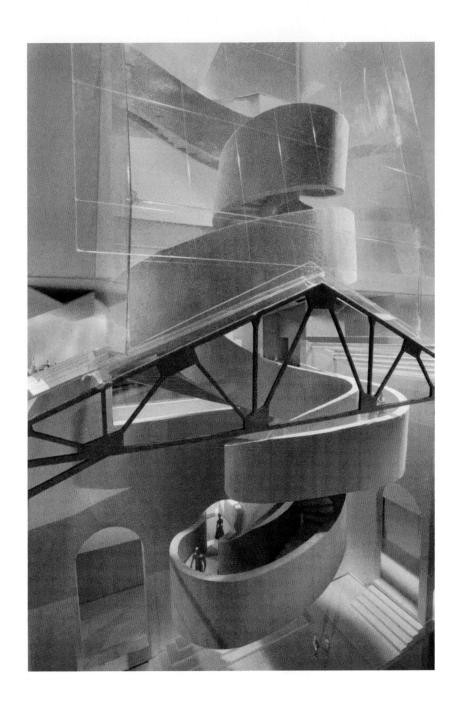

Mix Restaurant

Location:	Las Vegas, Nevada, USA
Designer:	Agence Patrick Jouin, France
Completed:	2005

Patrick Jouin designed a dining space evoking the inside of a chandelier, dripping with crystal bubbles. In keeping with the metaphor of a restaurant in the sky, the bubbles refract light like water droplets in a cloud.

Patrick Jouin hat diesen Speisesaal so konzipiert, dass sich der Besucher durch herabhängende Kristalltropfen an das Innere eines Kronleuchters erinnert fühlt. In Einklang mit der Methapher „Restaurant über den Wolken" brechen diese Tropfen aus Kristall das Licht, wie Wassertropfen in einer Wolke.

Patrick Jouin a conçu un espace de restauration qui évoque l'intérieur d'un lustre, ruisselant de boules de cristal. En conservant la métaphore d'un restaurant dans le ciel, les boules réfléchissent la lumière comme les gouttelettes d'eau d'un nuage.

Patrick Jouin diseñó un espacio evocando el interior de una lámpara de araña, cayendo gota a gota con burbujas de cristal. Manteniendo la metáfora de un restaurante en el cielo, las burbujas refractan la luz como si fueran pequeñas gotas de agua en una nube.

Patrick Jouin ha progettato un ristorante evocante l'interno di un lampadario da cui sgorgano bolle di cristallo. Nel rispetto della metafora del ristorante in cielo, le bolle riflettono la luce come le gocce d'acqua in una nuvola.

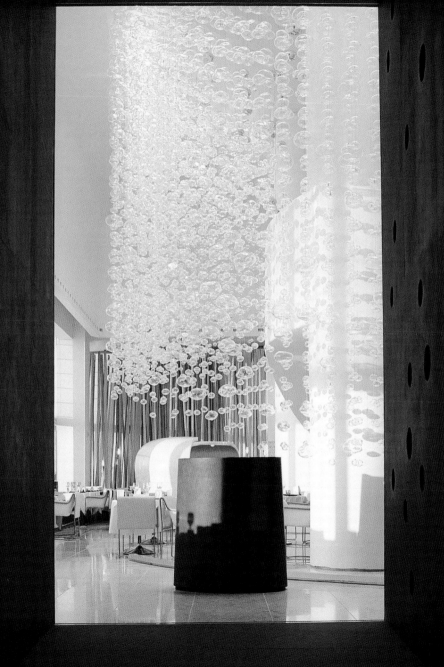

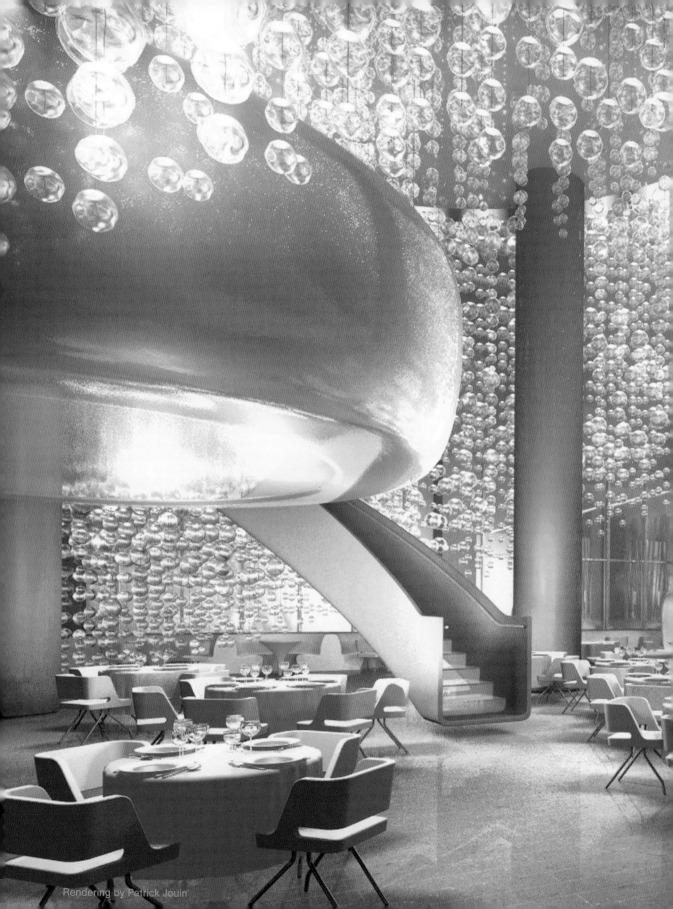

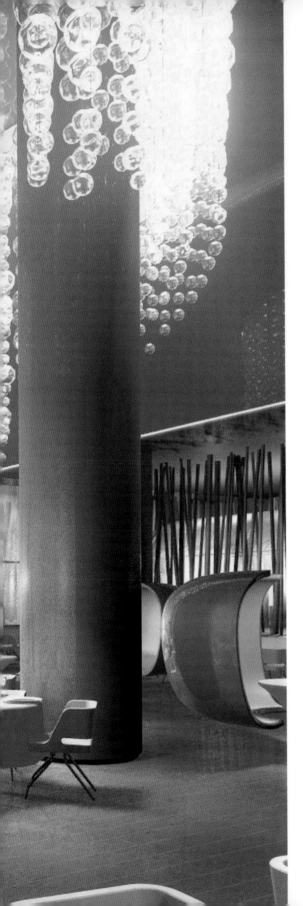

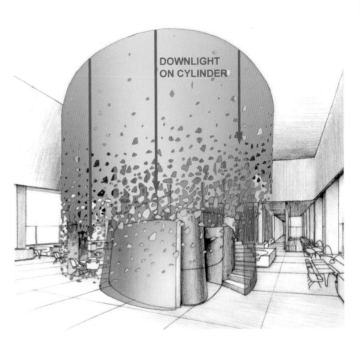

DOWNLIGHT
ON CYLINDER

Mix Restaurant

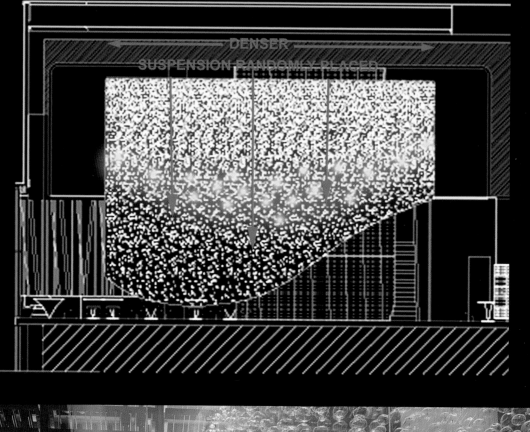

DENSER
SUSPENSION RANDOMLY PLACED

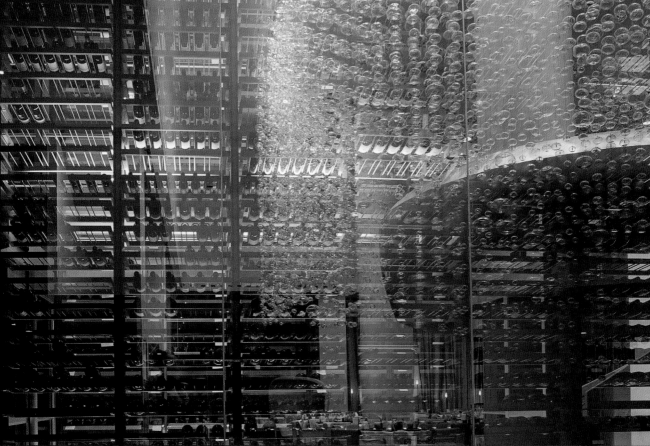

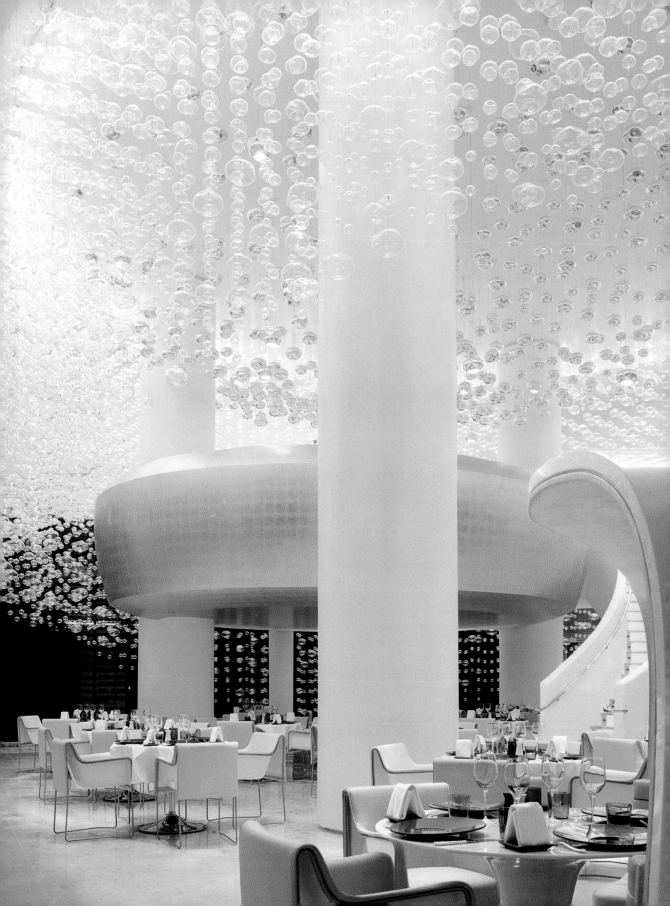

Mix Lounge

Location: Las Vegas, Nevada, USA
Designer: Agence Patrick Jouin, France
Completed: 2005

The bar is located in the sky, high above Las Vegas. The lighting is designed so that clients reflect in large bay windows, but can simultaneously see the vista of the city below. The effect is a superposition of them onto this view, as if they were floating above the city.

Eine Bar hoch über den Wolken, hoch über Las Vegas. Die Beleuchtung ist so konzipiert, dass Gäste sich in den großen Fensterfronten spiegeln, gleichzeitig aber auch die Aussicht auf die Stadt unter ihnen genießen können. Der so erzeugte Effekt ist eine Projektion ihrer selbst auf die Skyline, als schwebten sie über der Stadt.

Le bar est situé dans le ciel, très haut au-dessus de Las Vegas. L'éclairage est conçu de telle sorte que les clients se miroitent dans les larges baies vitrées, et simultanément peuvent profiter de la vie de la citée tout en bas. Cet effet est une superposition de leur propre image sur cette vue, comme s'ils étaient en train de flotter au-dessus de la ville.

El bar está situado en el cielo, muy por encima de Las Vegas. La iluminación está diseñada de tal forma que los clientes se reflejan en grandes ventanas saledizas, pero al mismo tiempo pueden ver la vista panorámica de la ciudad abajo. El efecto es una superposición de ellos mismos en su perspectiva, como si se encontrasen flotando sobre la ciudad.

Il bar si trova in cielo, in posizione sovrastante Las Vegas. L'illuminazione è realizzata in modo tale che i clienti si riflettano in grandi finestre a bovindo ma abbiano modo di ammirare contemporaneamente il panorama della città sottostante. L'effetto è quello di una sovrapposizione dei clienti stessi su questo panorama, come se fossero sospesi sulla città.

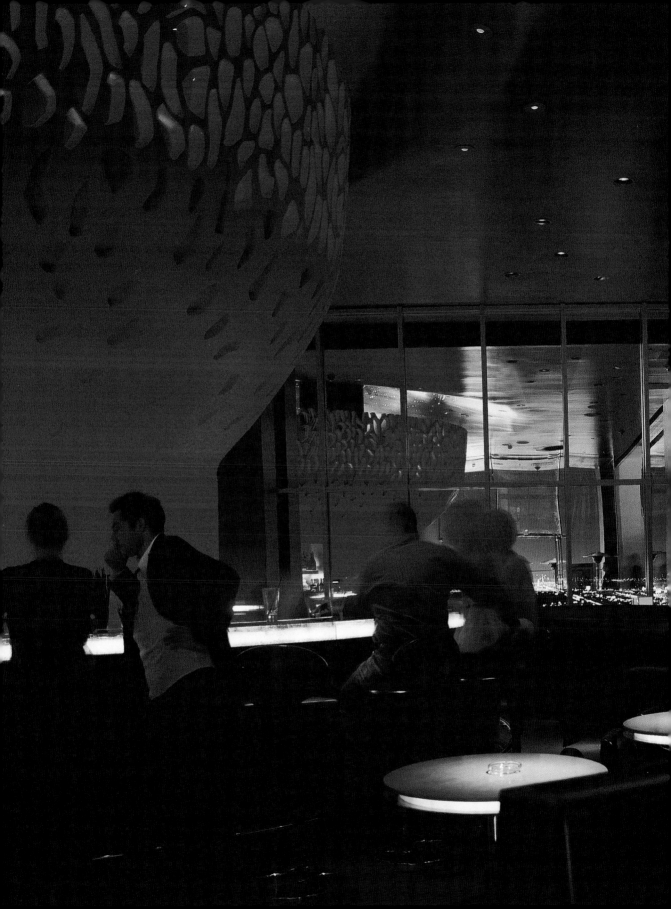

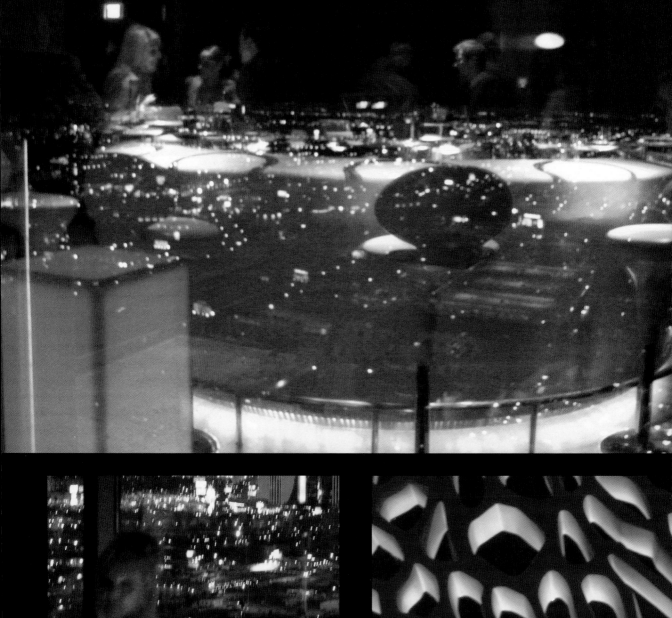
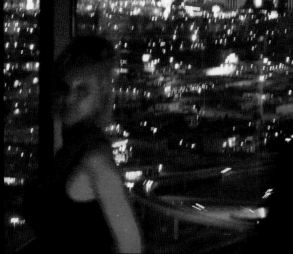

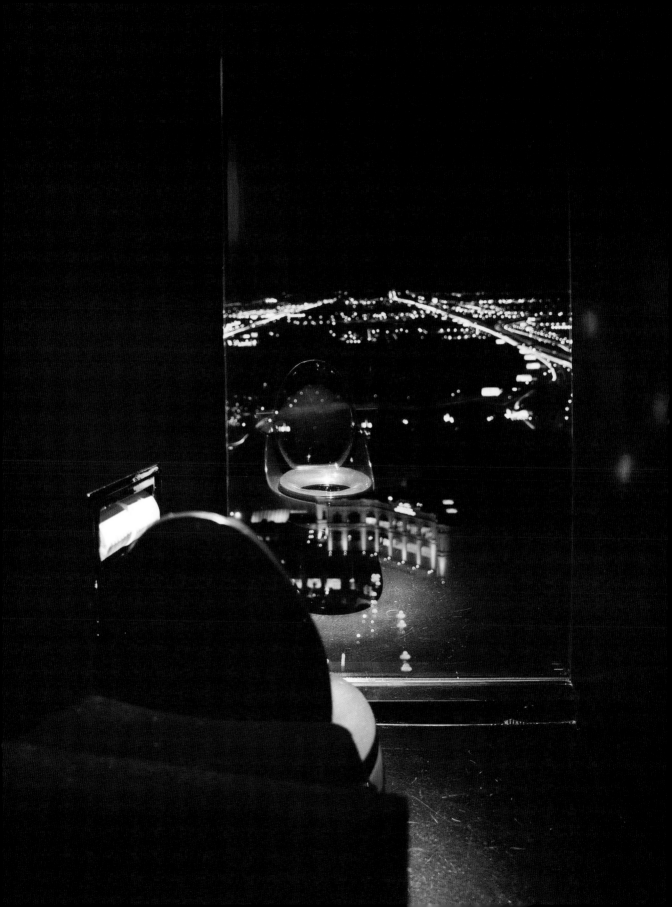

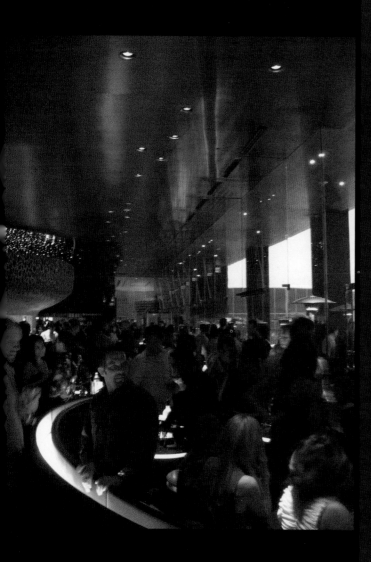

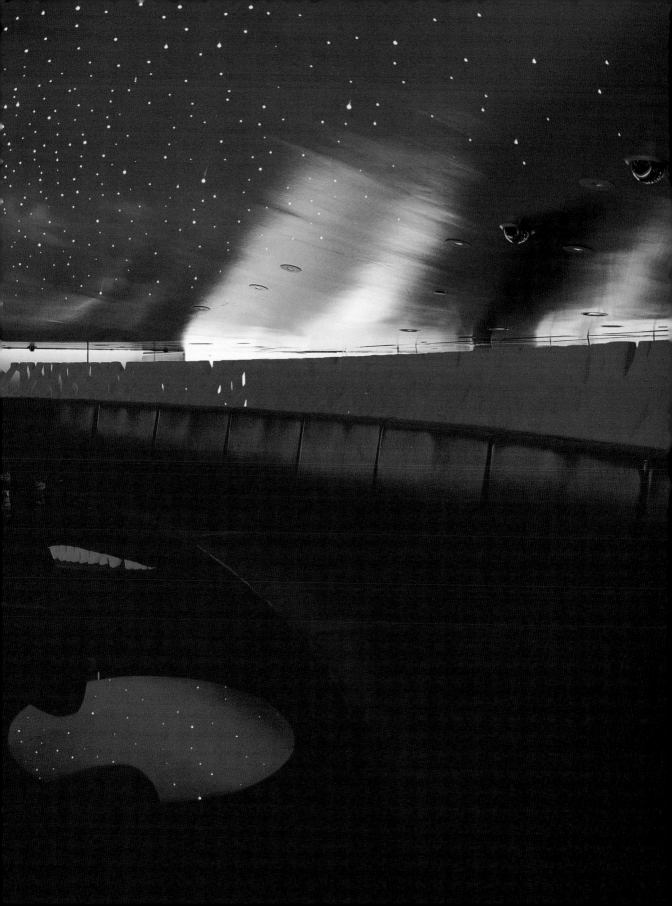

Parade Exhibition

Location: São Paulo, Brazil
Designers: Agence Patrick Jouin, Stéphane Maupin, Julien Monfort,
 France
Completed: 2001

For the temporary exhibition of 20th-century artifacts of the Bebo collection, the lighting concept provides a dramatic scenographic ambiance. The effect is achieved with extensive color lighting that additionally provides orientation for the viewer, while intensifying the didactic aspect of displays.

Bei der Sonderausstellung von Artefakten aus dem zwanzigsten Jahrhundert der Bebo Sammlung bildet das Lichtkonzept eine dramatische, an Filmdekorationen erinnernde Atmosphäre. Der Effekt wird durch weitläufige, farbige Beleuchtung erreicht, die dem Betrachter gleichzeitig Orientierungspunkte bietet und den didaktischen Aspekt der Ausstellungsgegenstände verstärkt.

Pour l'exposition temporaire des artefacts du XXme siècle de la collection Bebo, apporte le concept d'éclairage une atmosphère scénographique dramatique. Cet effet est réalisé à l'aide d'éclairages colorés intensifs qui d'autre part indiquent l'orientation au spectateur, tout en intensifiant l'aspect didactique des objets exposés.

Para la exposición temporal de los artefactos de siglo XX de la colección de Bebo, el concepto de iluminación proporciona un ambiente escenográfico dramático. El efecto se logra con una gran iluminación de color que además proporciona orientación al espectador, mientras que aumenta el aspecto didáctico de los mostradores.

Per l'esposizione temporanea di oggetti d'uso comune del XX secolo della collezione Bebo, il concetto d'illuminazione crea un ambiente scenografico drammatico. L'effetto viene raggiunto con un'estensiva illuminazione a colori che produce addizionalmente un orientamento per l'osservatore, intensificando l'aspetto didattico degli oggetti esposti.

Parade Exhibition

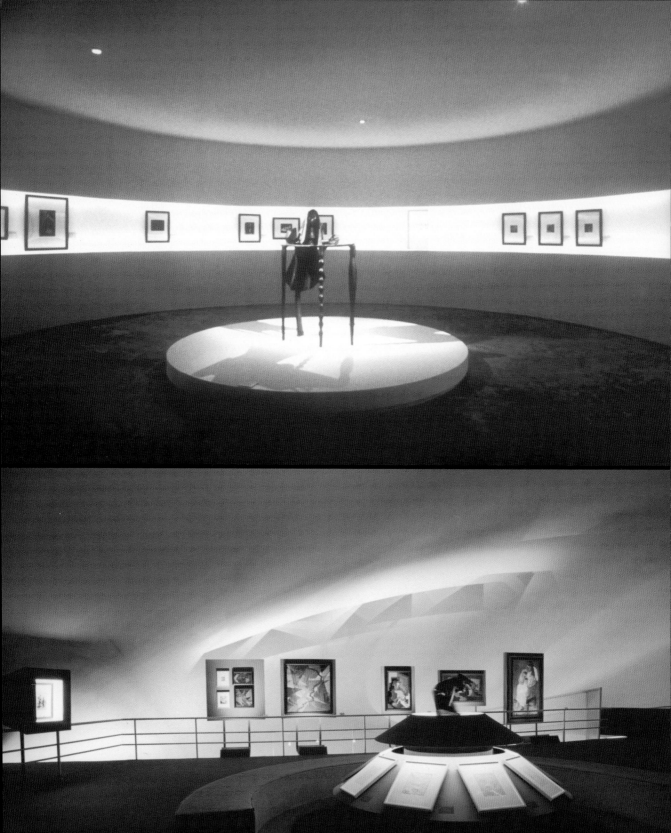

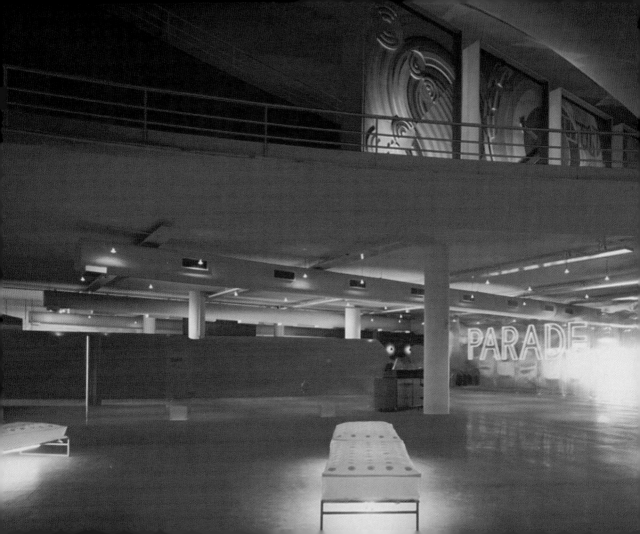

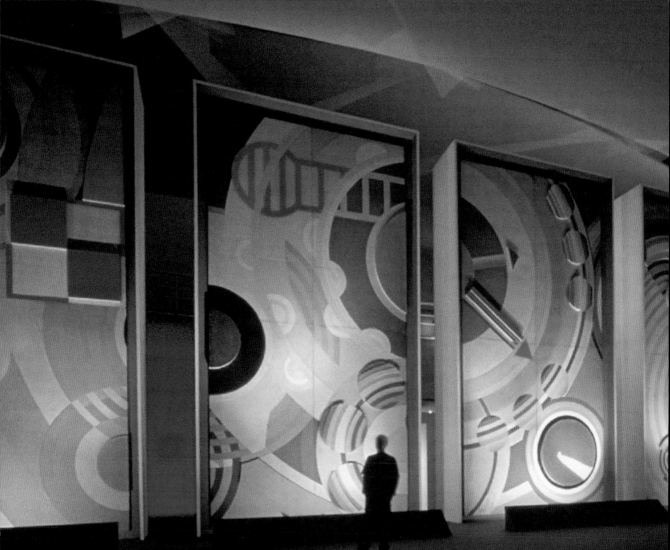

JVC Omnilife Headquarters

Location: Guadalajara, Mexico
Architects: Ateliers Jean Nouvel, France
Design Year: 2001

For this office complex, architect Jean Nouvel proposed a color scheme which is reinforced by the lighting concept. Here, colored lights reflect onto the grid from rooftop fixtures. Light also coruscates downward through the grid, providing dramatic shadows.

Architekt Jean Nouvel hat für diesen Bürokomplex eine Farbkombination gewählt, die durch das Beleuchtungskonzept noch verstärkt wird. Hier werden farbige Lichter von auf dem Dach angebrachten Lampen auf das Gitter geworfen. Licht fließt auch durch das Gitter nach unten und erzeugt damit dramatische Schatteneffekte.

Pour ce complexe l'architecte Jean Nouvel a proposé un schéma de coloris qui est renforcé par le concept d'éclairage. Ici, des lumières colorées se reflètent sur la grille à partir d'installations situées sur les toits. La lumière rayonne également vers le bas au travers de la grille en créant des ombres fantastiques.

Para este complejo de oficinas, el arquitecto Jean Nouvel propuso un esquema de color que se refuerza con el concepto de iluminación. Aquí, las luces de color se reflejan en la red de los accesorios luminosos del tejado. La luz también cae en forma de cascada hacia abajo a través de la red, proporcionando sombras dramáticas.

Per questo complesso di uffici, l'architetto Jean Nouvel ha proposto uno schema di colori potenziato dal concetto di illuminazione. Qui luci colorate si riflettono sulla griglia da elementi posti in cima al tetto. La luce illumina anche verso il basso attraverso la griglia, producendo drammatiche ombreggiature.

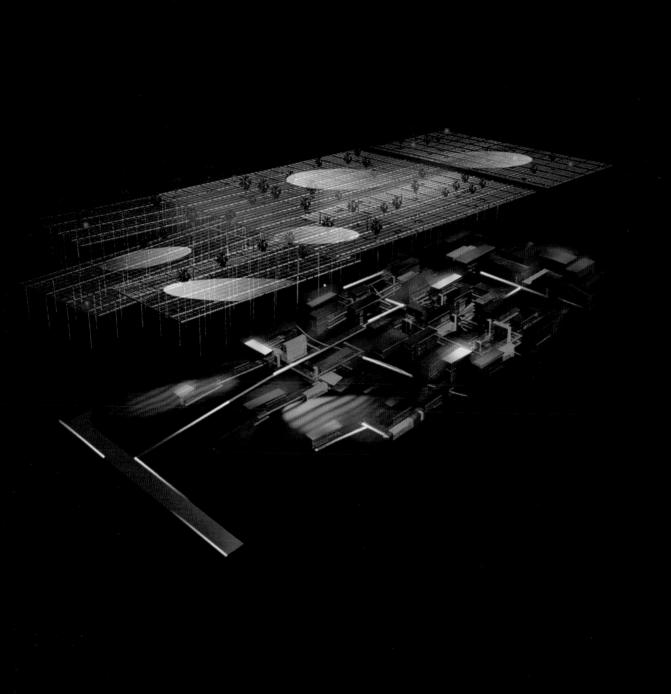

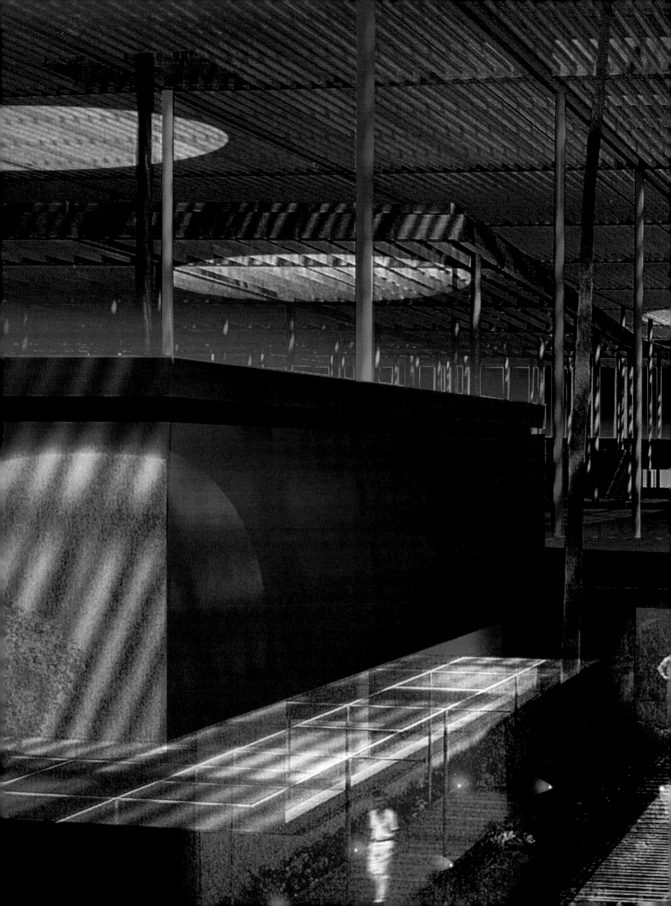

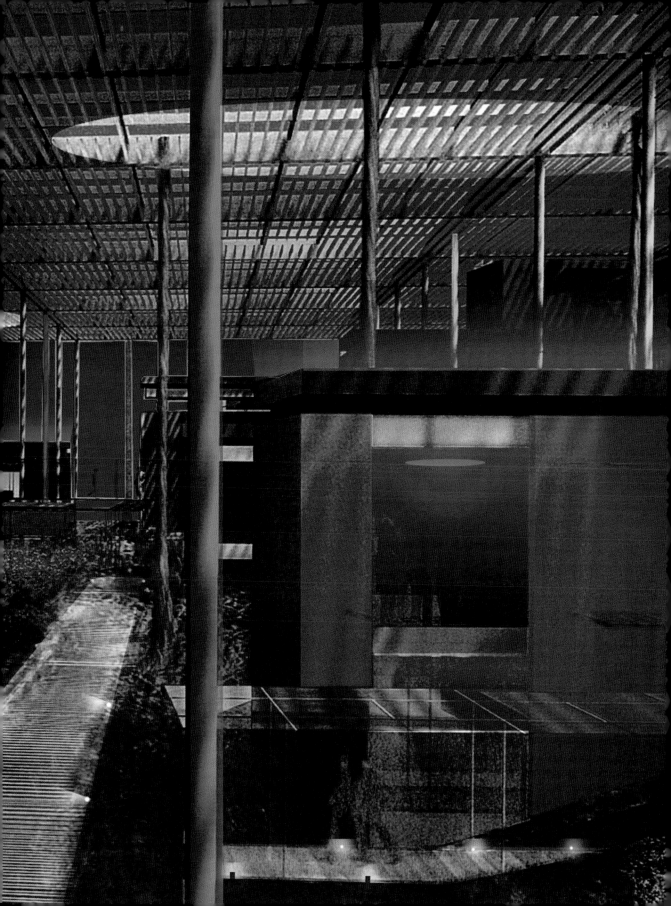

Langston Hughes Library

Location: Clinton, Tennessee, USA
Architects: Maya Lin Studio, USA
Completed: 1998

Lighting emphasizes the reflective atmosphere of the library by architect Maya Lin. Diffuse light and lights embedded inside of the walls create shadow, further accentuated with warm light.

Dass die von Architektin Maya Lin entworfene Bibliothek ein Ort der Reflektion und Nachdenklichkeit ist, wird durch die Beleuchtung noch hervorgehoben. Durch den Einsatz diffusen Lichts sowie in die Wand eingelassener Lichtquellen entstehen Licht und Schatten, was durch warmes Licht noch akzentuiert wird.

L'éclairage met en valeur l'atmosphère méditative créée par l'architecte Maya Lin pour la librairie. Une lumière diffuse et des éclairages encastrés dans les murs créent de l'ombre, encore accentuée par une lumière chaude.

La iluminación acentúa el ambiente reflexivo de la biblioteca realizada por la arquitecto Maya Lin. La luz difusa y las luces encastradas en las paredes crean sombras, más acentuadas con luz cálida.

L'illuminazione enfatizza l'atmosfera riflessiva della biblioteca realizzata dall'architetto Maya Lin. Luce diffusa e lumi incassati nelle pareti creano ombre, accentuate ulteriormente da una luce calda.

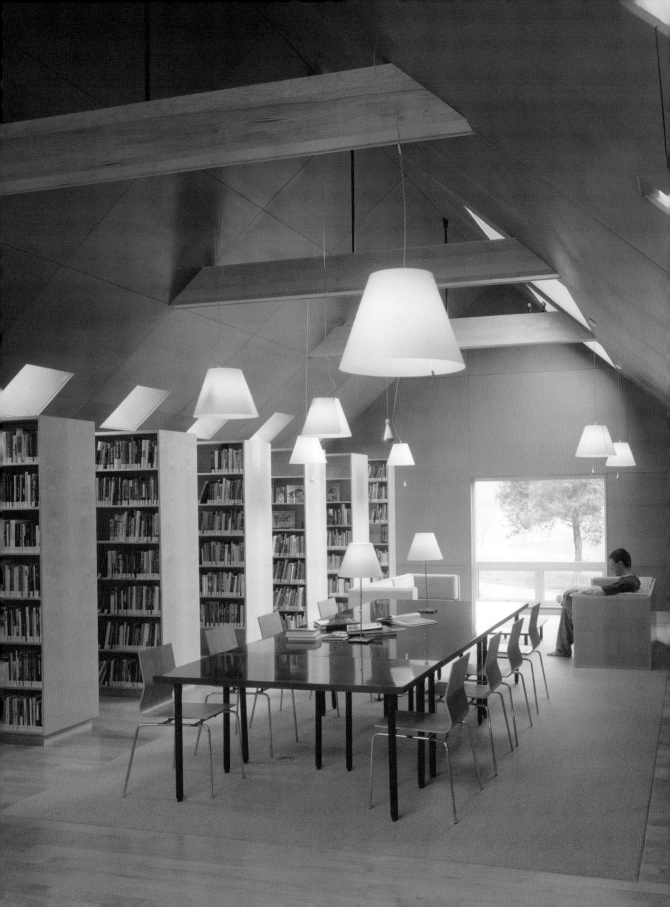

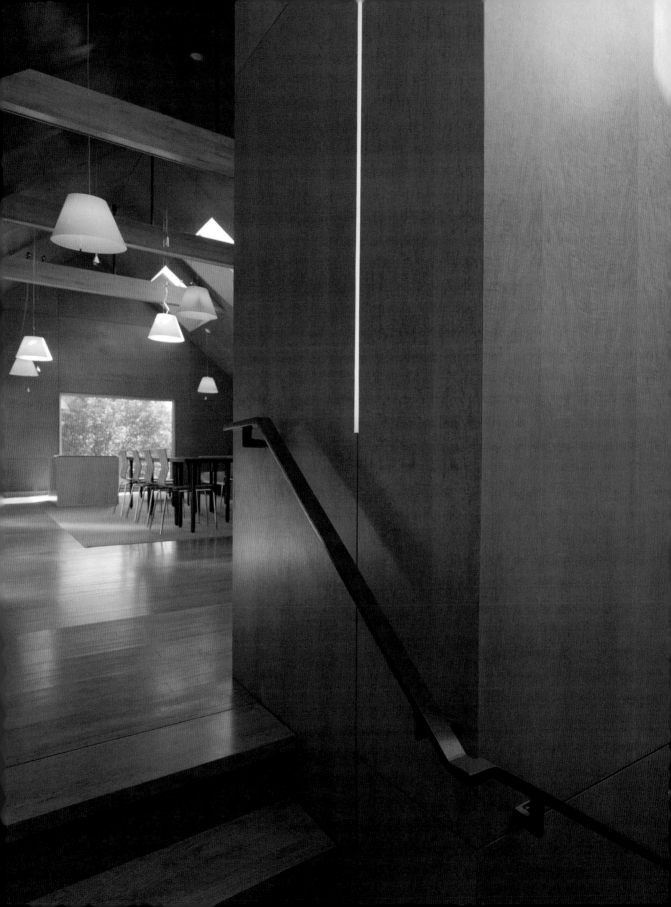

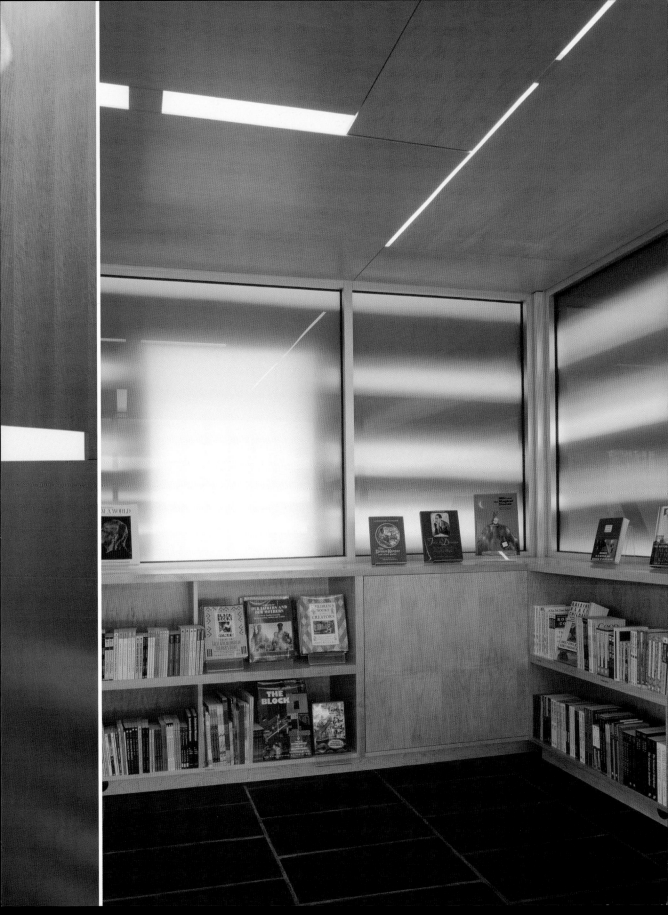

Edison School Distance Learning Centers

Location: USA
Architects: Leslie Gill, USA
Completed: 2002

The classrooms provide a dual service: they function as standard classrooms with human instructors, or as virtual classrooms in which students gain instruction by computers linked to the internet. In the former case, brighter light comes from the perimeter around the walls, thereby furnishing general lighting for the teacher, blackboard, and student desks. In the virtual classroom situation, perimeter lighting is dimmed, and light coming from under the tables is brightened, to reduce glare on the computer screens.

Diese Unterrichtsräume haben eine zweifache Funktion: Sie dienen als normale Schulzimmer mit einem Lehrer aus Fleisch und Blut, oder aber auch als virtuelles Klassenzimmer, wo Schüler ihre Anleitungen von Computern mit Internetzugang erhalten. Im ersten Fall erhellen Lichtquellen entlang der Wände den Außenbereich der Räume und bilden so eine Allgemeinbeleuchtung für Lehrer, Tafel und Tische der Lernenden. Im virtuellen Klassenzimmer ist diese Beleuchtung gedämpft und die Lampen unterhalb der Tische sind heller eingestellt, um Reflektionen auf den Bildschirmen zu vermeiden.

Les salles de cours possèdent une double fonctionnalité : une fonction de salle de classe standard avec des professeurs réels et une fonction de salle de classe virtuelle où les étudiants reçoivent leur enseignement par des ordinateurs reliés à l'Internet. Dans sa fonction standard l'éclairage très lumineux rayonne depuis l'ensemble du pourtour des murs, en fournissant une lumière générale pour le professeur, le tableau noir et les bureaux d'étudiants. Dans la fonction de salle de classe virtuelle l'éclairage de périmètre est diminué et une lumière provenant de dessous les tables augmentée, afin de réduire l'éblouissement des écrans d'ordinateurs.

Las aulas proporcionan un doble servicio: funcionan como clases normales con profesores humanos, o como clases virtuales en las que los estudiantes sacan provecho de los ordenadores conectados a la red. En el primer caso, una luz más brillante procede del perímetro que rodea las paredes, suministrando así una iluminación general para el profesor, la pizarra y las mesas de los alumnos. En el caso del aula virtual, la iluminación del perímetro es más tenue, y la luz procedente de debajo de las mesas es más viva, para reducir el reflejo en las pantallas de los ordenadores.

Le aule hanno una doppia funzione: fungono da aule standard con istruttori umani o da aule virtuali in cui gli studenti ricevono istruzioni da computer connessi a Internet. Nel primo caso, luce più chiara proviene dal perimetro attorno alle pareti, erogano illuminazione generale per l'insegnante, la lavagna ed i banchi degli studenti. Nella situazione dell'aula virtuale, l'illuminazione perimetrale è dimmerata e viene accesa la luce proveniente da sotto i tavoli per ridurre i riflessi sugli schermi dei computer.

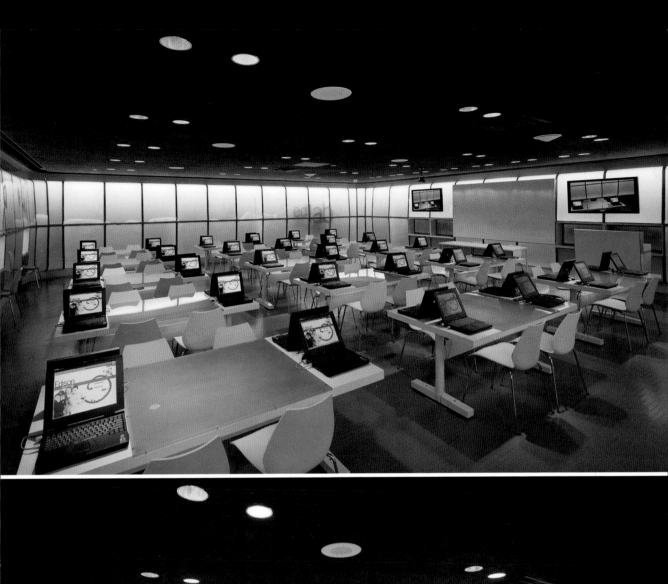
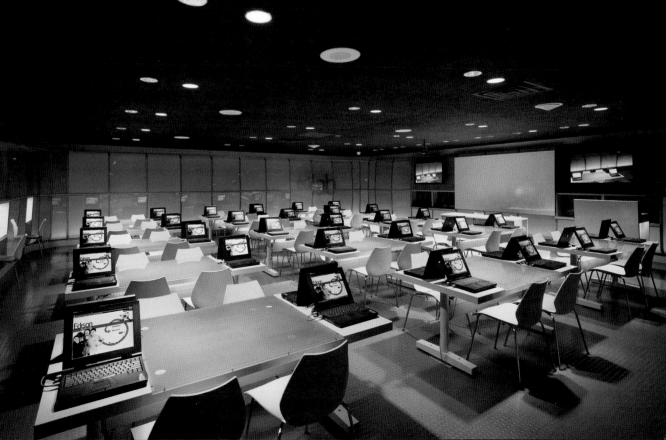

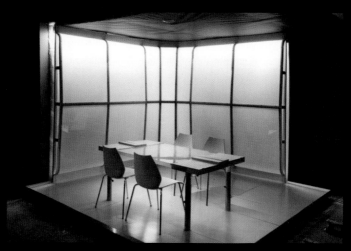

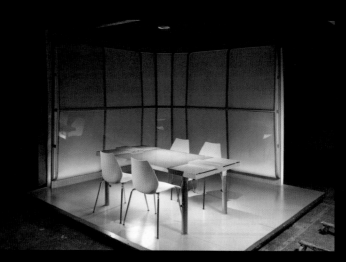

Lighting mock-ups of the three scenarios

Buffalo Bayou

Location: Houston, Texas, USA
Landscape Architects: SWA Group, USA
To be completed: 2008

The Buffalo Bayou Lighting and Public Art Master Plan is a larger initiative enhancing public appreciation, access, and use of the Buffalo Bayou in Houston. Lighting elements located in the bayou change from white to blue to reflect changes in the moon's cycle. The twentynine-day lunar cycle is expressed with white and blue accent lighting throughout the entire downtown area, progressing on an axis related to the Buffalo Bayou in a pattern similar to the phases of the moon (including the new moon, first quarter, first half, and so on). Lighting design suggests that the source of city-wide lighting is wholly provided by the Buffalo Bayou.

Der „Buffalo Bayou Lighting and Public Art Master Plan" ist eine Initiative, die Wertschätzung, Zugang und Nutzung des Buffalo Flußarms in Houston von und für die Öffentlichkeit fördert. Im Flußarmbereich angebrachte Beleuchtungselemente verändern ihren Farbton von weiß nach blau und spiegeln so die Mondphasen wider. Mittels weißer und blauer Akzentlichter wird die neunundzwanzig Tage dauernde Mondphase im gesamten Innenstadtbereich abgebildet. Die Beleuchtung verläuft entlang einer Achse, die in einem den Mondphasen ähnlichen Muster (einschließlich Neumond, Viertelmond, Halbmond etc) auf den Flußarm ausgerichtet ist. Das Lichtdesign erweckt den Eindruck, dass die Beleuchtung der Stadt gänzlich vom Buffalo Bayou ausgeht.

Les éclairages du bayou Buffalo et le schéma directeur de l'art public représentent une grande initiative destinée à améliorer le jugement du public, l'accès et l'usage du bayou Buffalo à Houston. Des éléments d'éclairage situés dans le bayou varient du blanc au bleu pour refléter les changements du cycle lunaire. Le vingt-neuvième jour du cycle lunaire est exprimé par des lumières accentuées blanches et bleues dans toute la zone du centre ville, et progressant sur un axe qui se rattache au bayou Buffalo, et possédant une forme similaire à celle des phases lunaires (incluant la nouvelle lune, le premier quartier, la première moitié, etc.). La structure de l'éclairage suggère que la source de tous les éclairages de la ville provient du bayou Buffalo.

El Plan Maestro de Arte Público y de Iluminación de Buffalo Bayou es una ambiciosa iniciativa que aumenta el aprecio, el acceso y el uso público del Buffalo Bayou en Houston. Los elementos de iluminación situados en el pantano cambian del blanco al azul para reflejar los cambios en el ciclo lunar. El calendario lunar de veintinueve días se expresa con acentos de iluminación blanca y azul a lo largo de toda la zona del centro de la ciudad, avanzando en un eje relacionado con el Buffalo Bayou de un modo similar al de las fases de la luna, que abarca la luna nueva, cuarto creciente, cuarto menguante, etc. El diseño de iluminación sugiere que la fuente de iluminación de toda la ciudad es completamente proporcionada por el Buffalo Bayou.

L'illuminazione del Buffalo Bayou e il Public Art Master Plan rappresentano un'iniziativa di ampie dimensioni volta ad incrementare l'apprezzamento, l'accesso e l'utilizzo del Buffalo Bayou (emissario di Buffalo) a Houston da parte del pubblico. Elementi di illuminazione situati nell'emissario passano dal bianco al blu per riflettere le variazioni del ciclo lunare. Il ciclo lunare di ventinove giorni viene espresso tramite un'illuminazione d'accento bianca e blu nell'intero centro città, progredendo su di un asse riferito al Buffalo Bayou seguendo un modello simile alle fasi lunari (includenti la luna nuova, il primo quarto, la mezzaluna eccetera). La struttura dell'illuminazione da l'impressione che la fonte dell'illuminazione di tutto il centro città scaturisca interamente dal Buffalo Bayou.

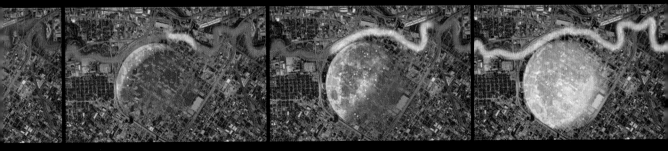

Concept rendering: the lighting changes from white to blue following the phases of the moon

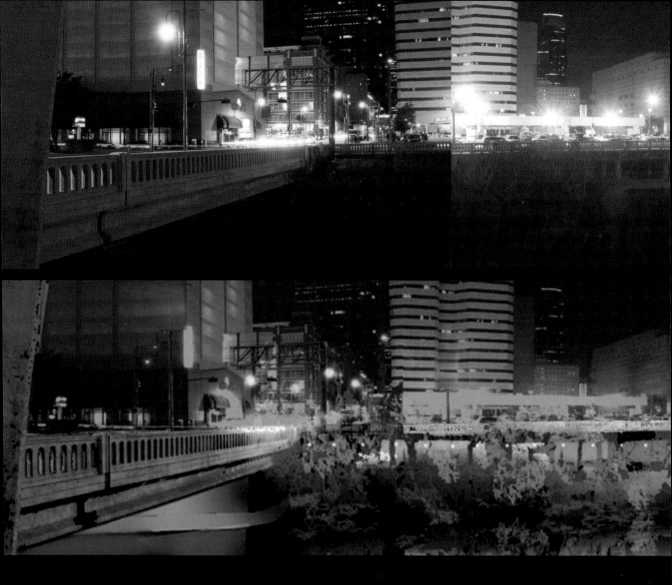

"It's incorrect to assume that more light means more safety. The important thing is to bring a sense of hierarc[hy]
bear on a particular situation. It's a matter of putting things in order."

„Es stimmt nicht, dass mehr Licht automatisch mehr Sicherheit bedeutet. Das Wichtigste ist, das Gefühl von Hiera[rchie]
in einer bestimmten Situation zu vermitteln. Es geht darum, Dinge zu ordnen."

« Il est faux de penser que plus de lumière assure plus de sécurité. Le plus important est d'apporter un sens [de la]
hiérarchie adaptée à chaque situation. Il est question de placer les choses dans le bon ordre. »

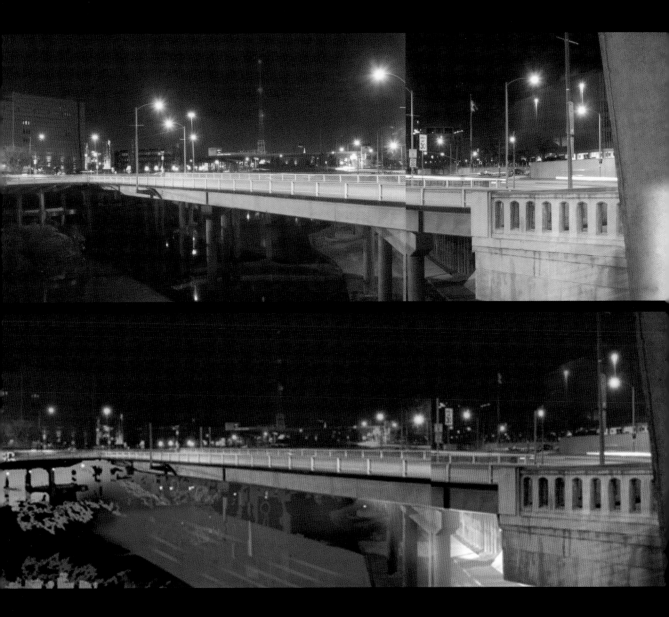

o es correcto dar por hecho que más luz significa más seguridad. Lo importante es aportar una sensación de arquía relacionada con una determinada situación. Es cuestión de poner las cosas en orden."

on è giusto presupporre che più luce significhi più sicurezza. L'importante è conferire un senso di gerarchia da servare in una particolare situazione. Si tratta di mettere le cose in ordine."

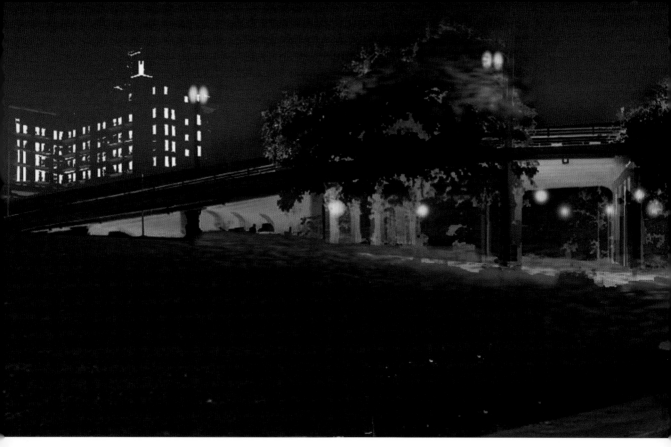

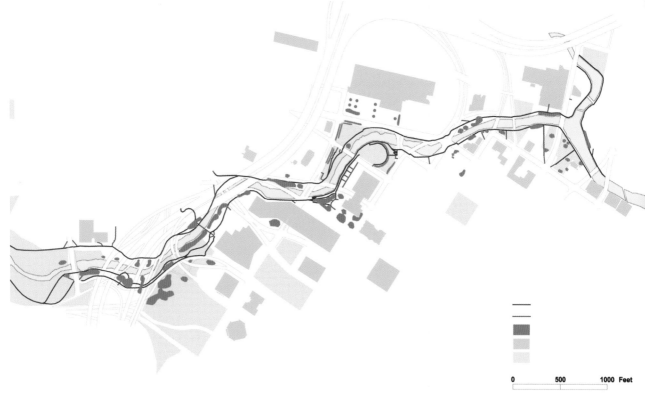

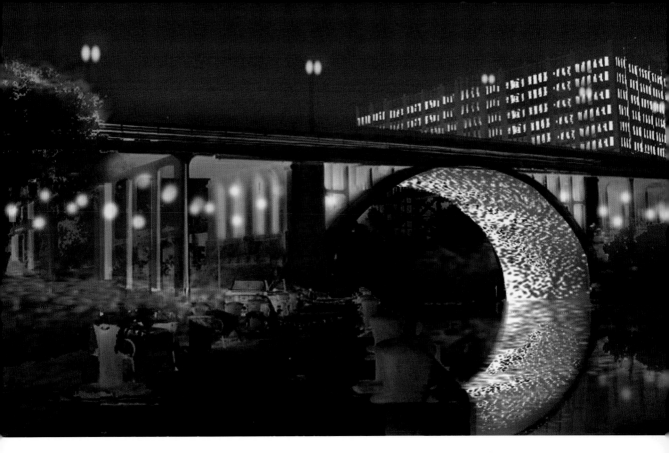

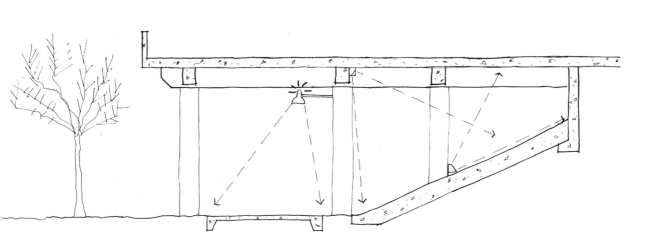

Buffalo Bayou

AmericanAirlines Arena

Location: Miami, Florida, USA
Architects: Arquitectonica, USA
Completed: 2000

The facade lighting of the arena expresses the identity of the team, the Miami Heat, and brings the energy of the games inside to the exterior. On the interior, each quadrant of the building has a specific design identity to help visitors orientate themselves.

Die Fassadenbeleuchtung gibt die Identität des Heimteams Miami Heat wieder und transferiert die Energie der Spiele im Innern nach außen. Im Gebäude selbst besitzt jeder Quadrant ein besonderes Design, das dem Besucher hilft, sich leichter zu orientieren.

L'éclairage de la façade de l'arène exprime l'identité de l'équipe, Miami Heat, et transmet vers l'extérieur l'énergie du jeu qui se passe à l'intérieur. Dans les espaces intérieurs, chaque quadrant de l'immeuble possède un concept d'identité spécifique afin d'aider les visiteurs à s'orienter.

La iluminación de la fachada del estadio expresa la identidad del equipo, el Miami Heat, y aporta la energía de los juegos interiores al exterior. En el interior, cada cuadrante del edificio tiene una identidad de diseño específica para ayudar a los visitantes a orientarse ellos mismos.

L'illuminazione della facciata dell'arena esprime l'identità della squadra dei Miami Heat e trasporta l'energia delle partite dall'interno all'esterno. All'interno, ogni quadrante dell'edificio è dotato di una specifica identità del design per aiutare i visitatori ad orientarsi.

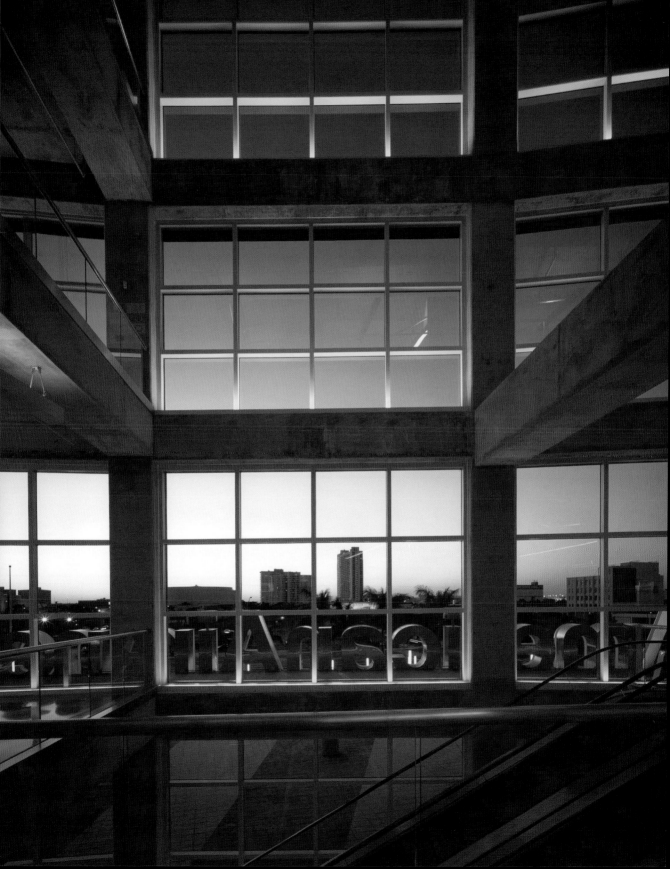

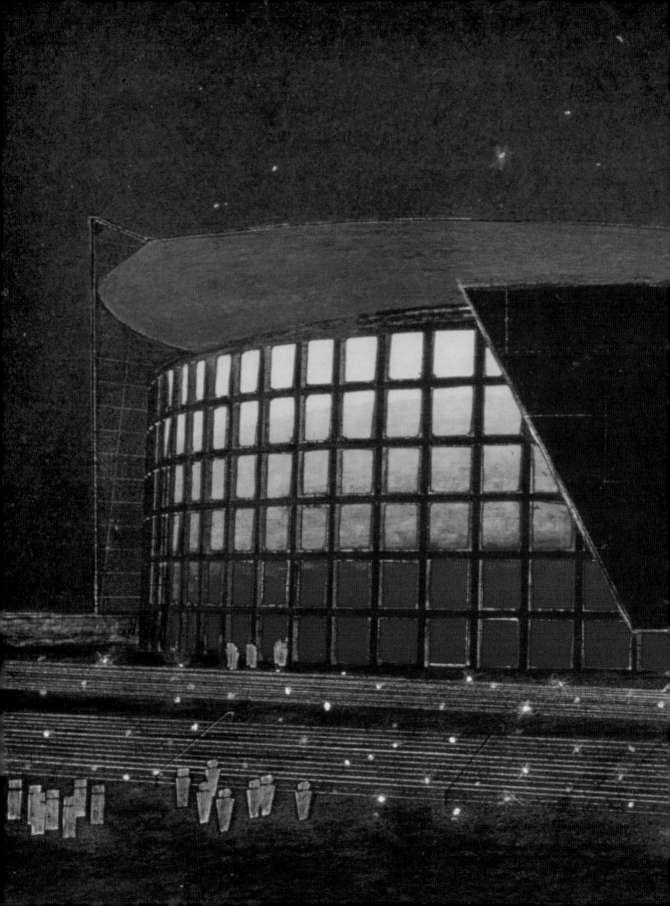

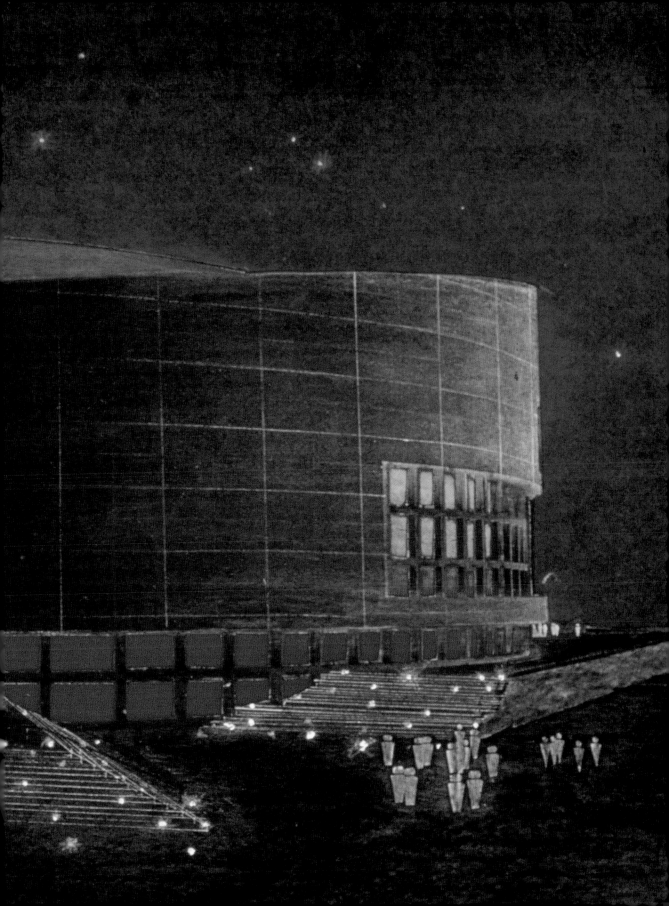

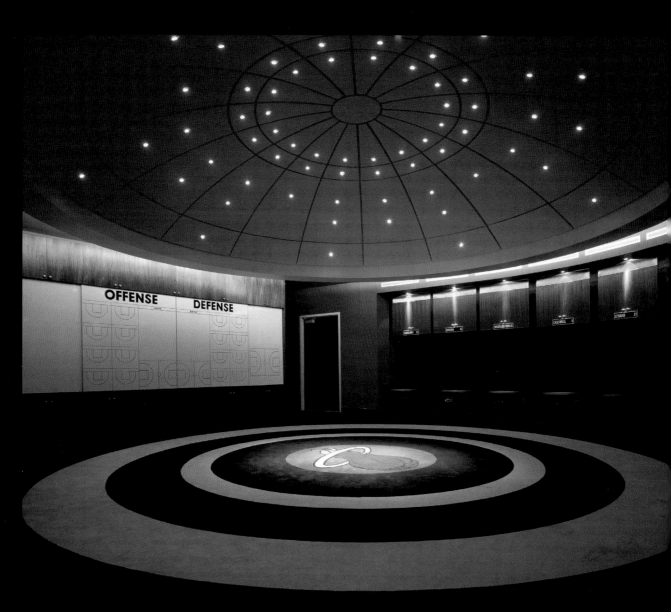

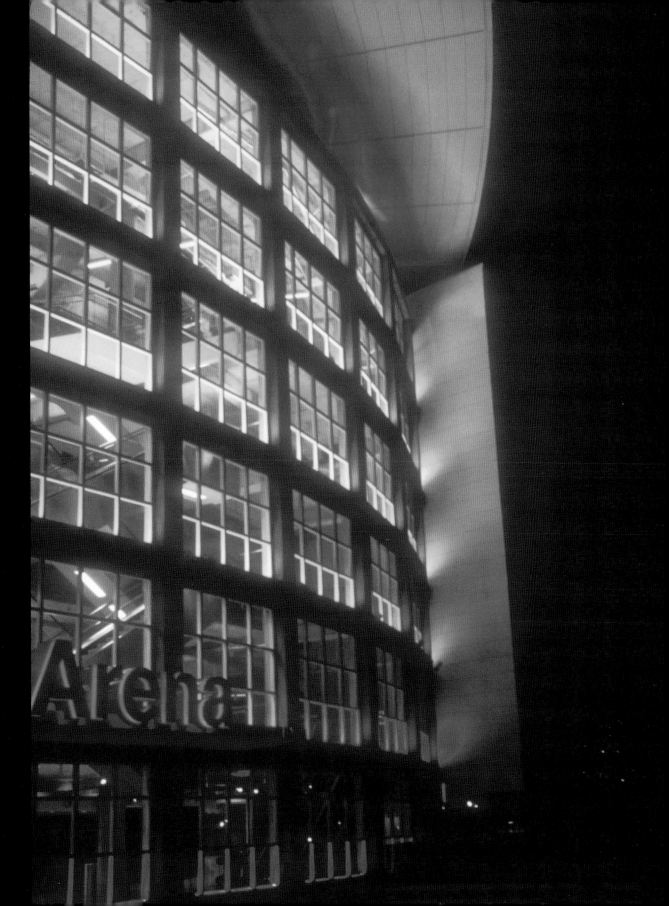

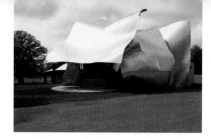

Fisher Center for the Performing Arts

Location: Bard College, Annandale-on-Hudson, New York, USA
Architects: Frank O. Gehry and Associates, USA
Completed: 2003

Fisher Center is located in the picturesque campus of Bard College. The lighting principles direct a visual progression of experiences with the building, from afar as an object, to inside the building where the complexity of the structural form and its textures are revealed. Sources of illumination are concealed within, behind, and above the architectural framework to express the intrinsic melody of space and to reveal its form.

Das Fisher Center liegt auf dem pittoresken Campus des Bard Colleges. Das Beleuchtungskonzept choreografiert ein mit dem Gebäude fortschreitendes visuelles Erleben, wobei das Bauwerk von Weitem als bloßes Objekt wahrgenommen wird, bis hin zum Gebäudeinneren, wo sich die Komplexität der Struktur und ihre Beschaffenheit dem Besucher offenbaren. Lichtquellen sind in, hinter und über dem architektonischen Rahmen verborgen, um die dem Raum innewohnende Komposition auszudrücken und ihre Struktur hervorzuheben.

The Fisher Center est situé dans le pittoresque campus du Bard College. Le principe d'éclairage nous dirige dans une progression d'expériences visuelles avec la construction qui depuis le lointain a l'allure d'un objet, jusqu'à l'intérieur de l'immeuble où se révèlent la complexité de la forme structurelle et sa texture. Les sources d'illumination sont dissimulées à l'intérieur, derrière et au-dessus de la structure architecturale afin d'exprimer la mélodie intrinsèque de l'espace et de révéler sa forme.

El Centro Fisher está situado en el pintoresco campus de Bard College. Los principios de iluminación dirigen una progresión visual de experiencias con el edificio, desde lejos como un objeto, hasta dentro, donde se revelan la complejidad de la forma estructural y sus texturas. Las fuentes de iluminación están encastradas en el interior, en la parte trasera y en la parte superior del marco arquitectónico para expresar la melodía intrínseca del espacio y revelar su forma.

Il centro Fisher è situato nel campus pittoresco del Bard College. I principi d'illuminazione dirigono una progressione visiva di esperienze sull'edificio, da lontano come un oggetto, fino all'interno dell'edificio, dove si rivela la complessità della forma strutturale e le strutture stesse. Le fonti di illuminazione sono nascoste all'interno, dietro e superiormente alla struttura architettonica per esprimere la melodia intrinseca dello spazio e per rivelare la sua forma.

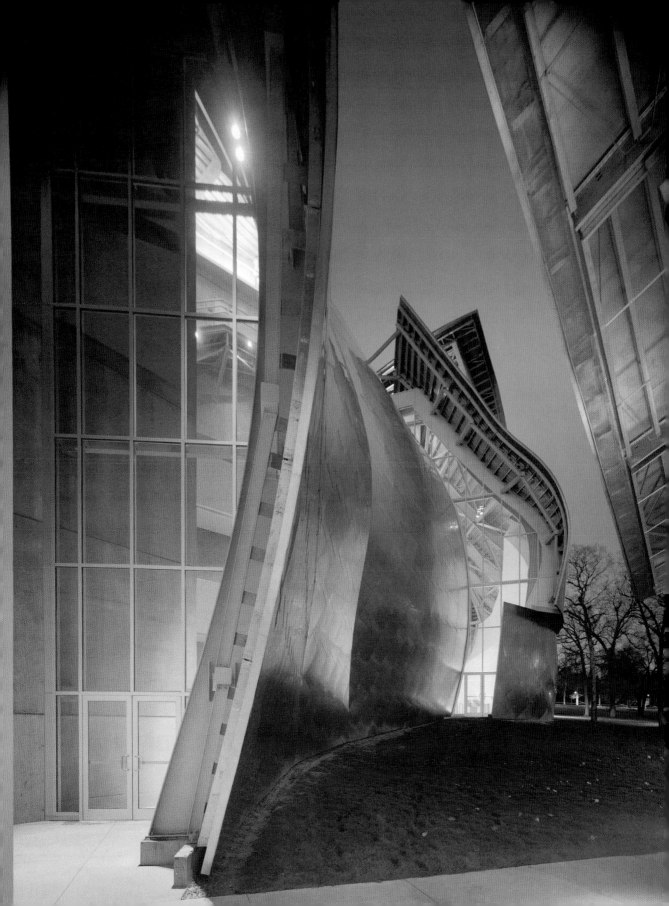

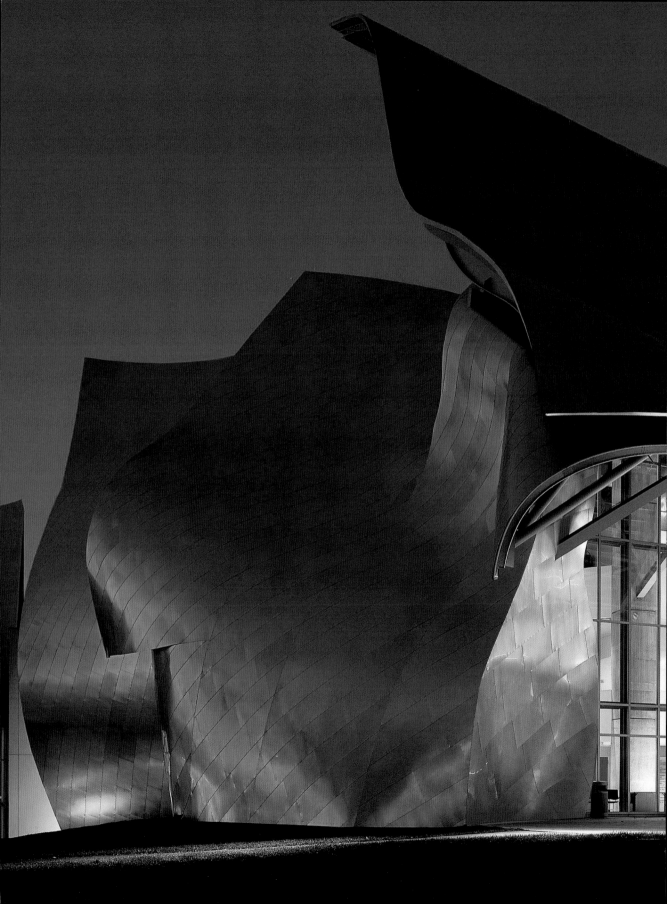

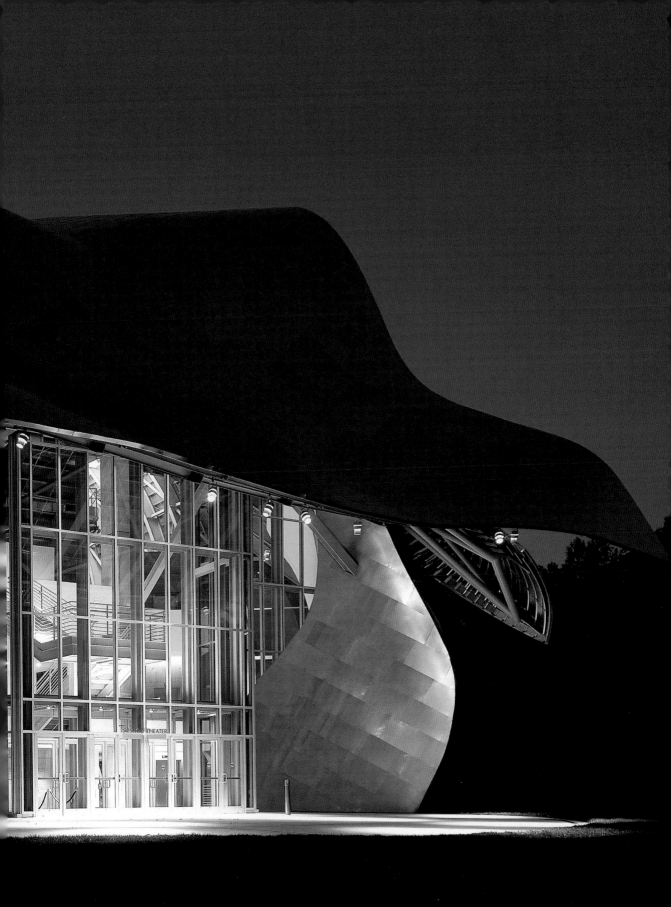

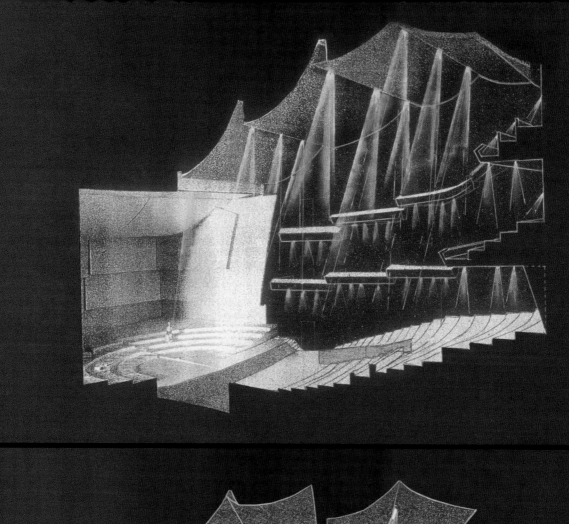

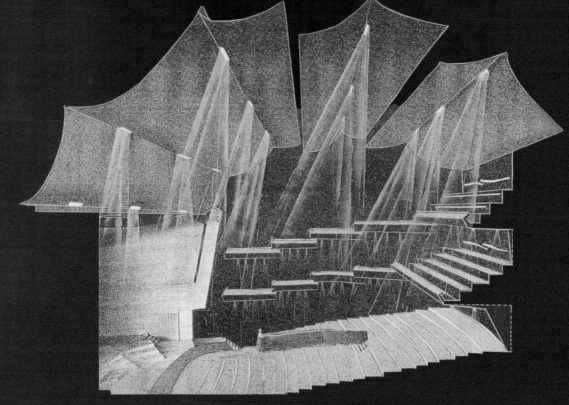

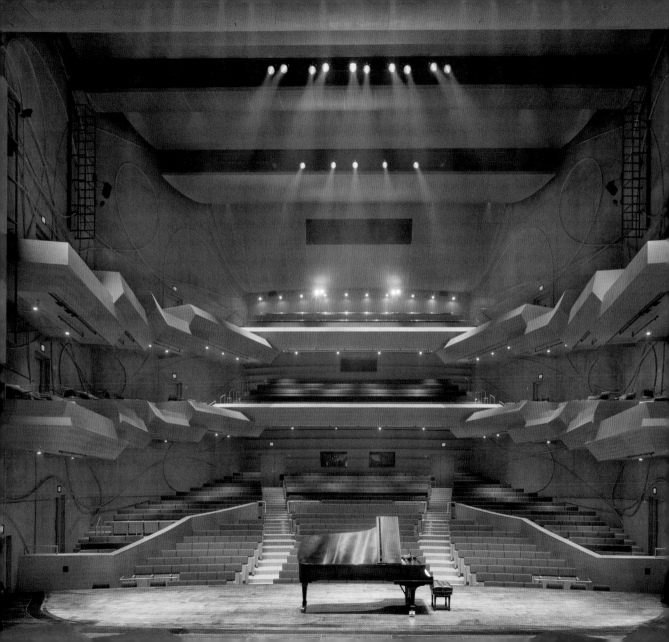

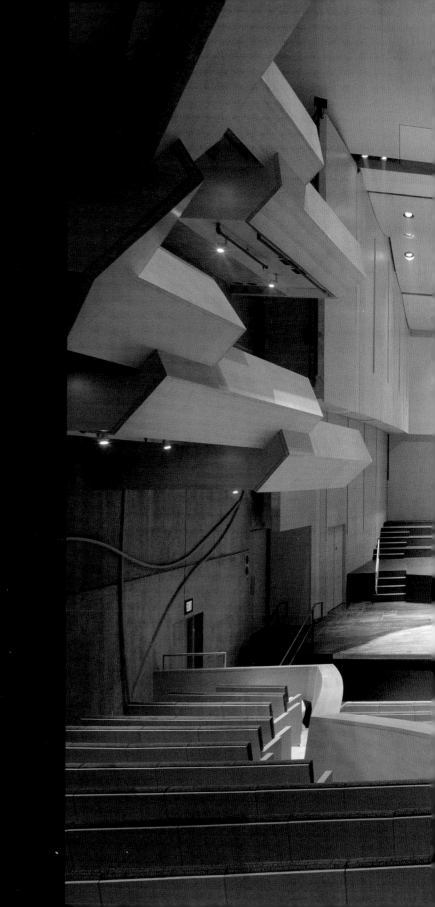

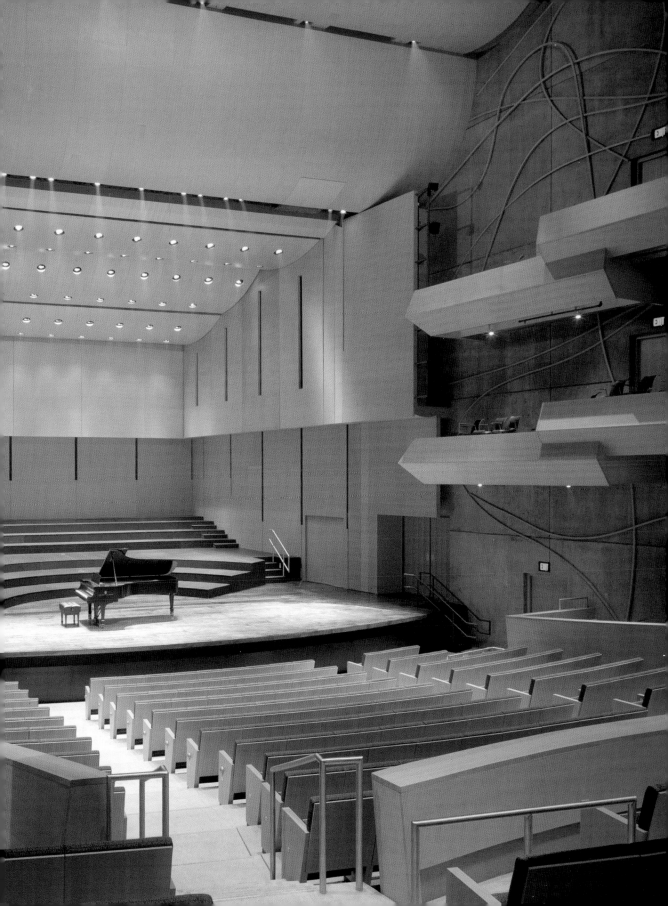

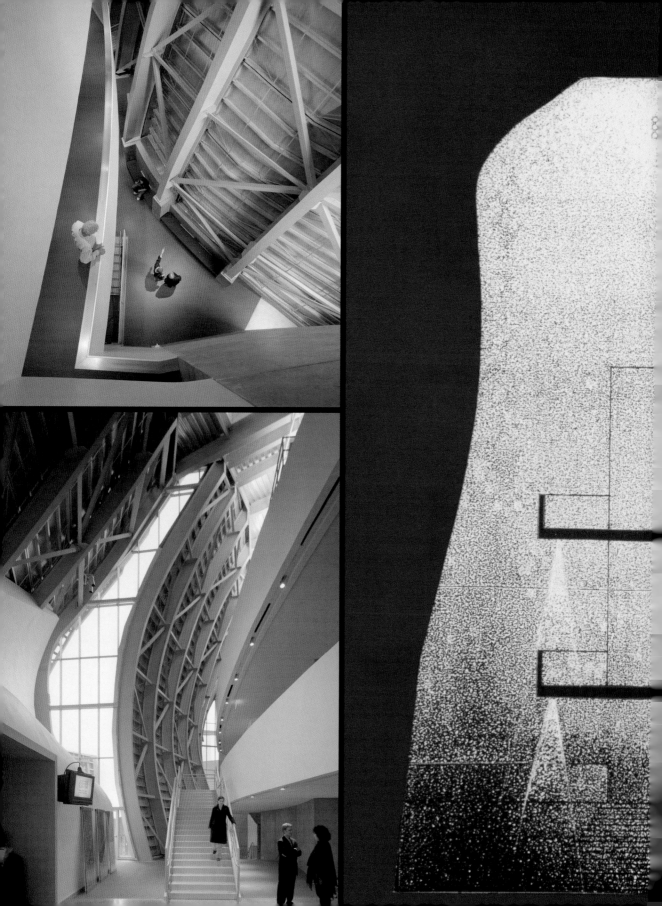

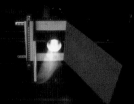
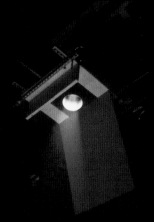

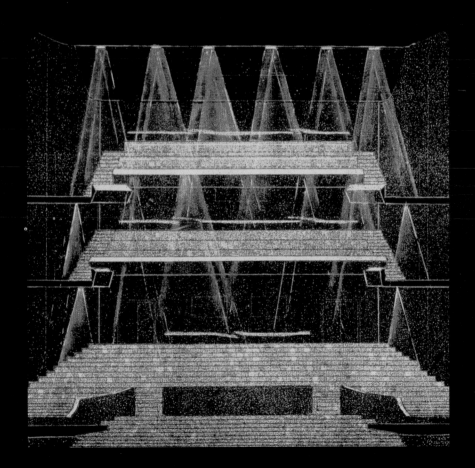

Lincoln Center Redevelopment

Location: New York, New York, USA
Architects: Diller, Scofidio + Renfro, USA
 Fox and Fowle, USA
To be completed: 2009

The Lincoln Center redevelopment includes numerous exterior areas as well as interior ones. The lighting concept unifies and brings a nocturnal identity to the many public spaces, thereby accentuating the vitality of the institution's nightlife. Lighting in interior spaces emphasizes the transparency of glass walls, using surfaces as reflectors or emitters of light.

Das Lincoln Center besteht aus einer Vielzahl von Innen- und Außenbereichen, die durch das Beleuchtungskonzept zu einer Einheit verbunden werden. Außerdem verleiht es den der Öffentlichkeit zugänglichen Orten ein ganz eigenes Flair, was das ohnehin schon geschäftige Nachtleben der Einrichtung noch interessanter macht. Die Transparenz der Glasfassaden wird durch die Innenraumbeleuchtung betont, wo Oberflächen Licht reflektieren oder selbst Lichtquellen sind.

La rénovation à niveau du Lincoln Center comprend un grand nombre de zones extérieures comme intérieures. Le concept d'éclairage unifie et propose une identification nocturne à de nombreux espaces publics, tout en accentuant la vitalité de cette institution de la vie noctambule. L'éclairage des espaces intérieurs rehausse la transparence des murs de verre, en utilisant les surfaces comme réflecteurs ou diffuseurs de lumière.

La reconstrucción del Centro Lincoln comprende varias zonas exteriores e interiores. El concepto de iluminación unifica y aporta una identidad nocturna a la mayor parte de los espacios públicos, acentuando de este modo la vitalidad de la vida nocturna de la institución. La iluminación en las zonas interiores enfatiza la transparencia de las paredes de cristal, utilizando superficies como reflectores o emisores de luz.

La ristrutturazione del Lincoln Center include numerose aree sia esterne che interne. Il concetto d'illuminazione unifica e produce un'identità nottura nei molti spazi pubblici, accentuando in tal modo la vitalità della vita notturna dell'istituzione. L'illuminazione negli spazi interni enfatizza la trasparenza delle pareti di vetro, utilizzando le superfici come riflettori o emittenti di luce.

THE JULLIARD SCHOOL

Paul Hall Morse Hall Drama Theater

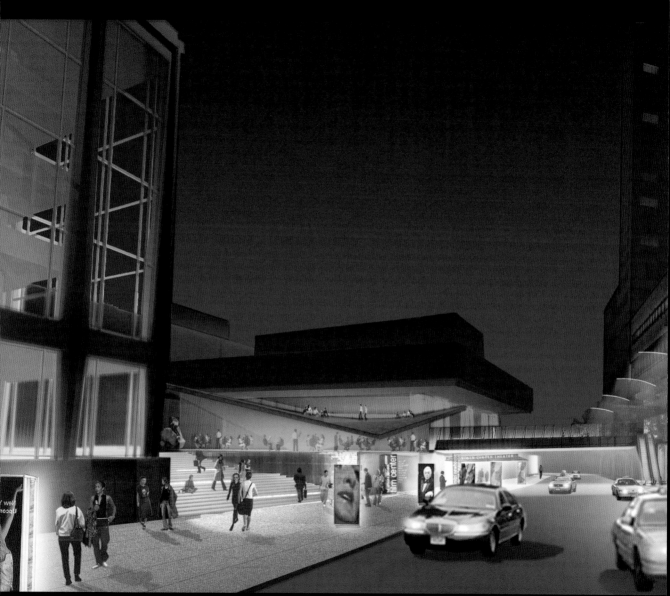

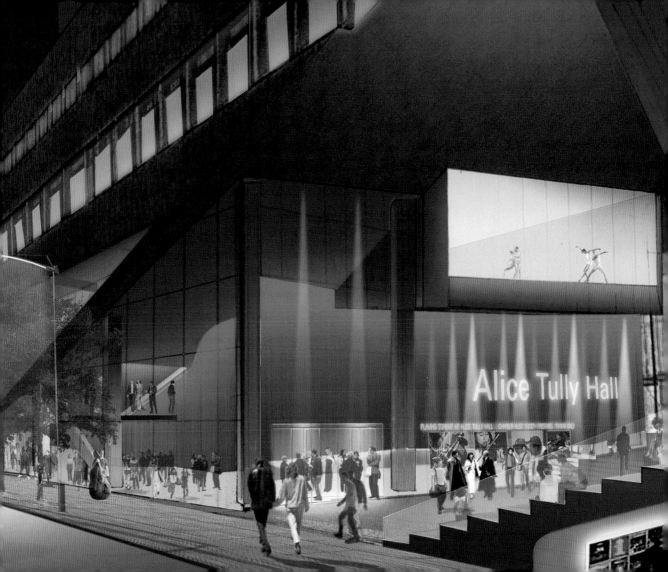

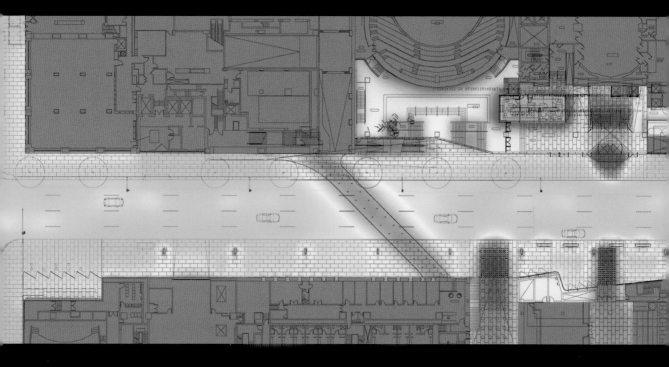

65th Street lighting calculations

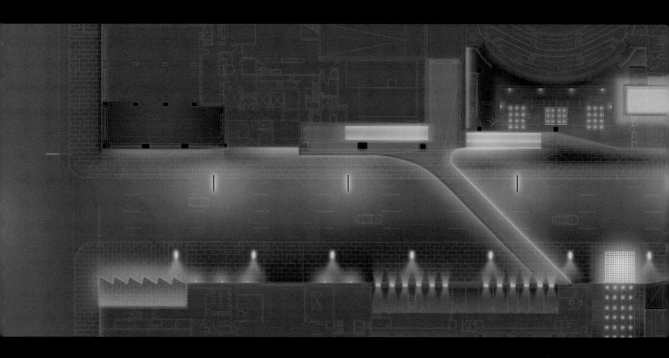

65th Street lighting plan

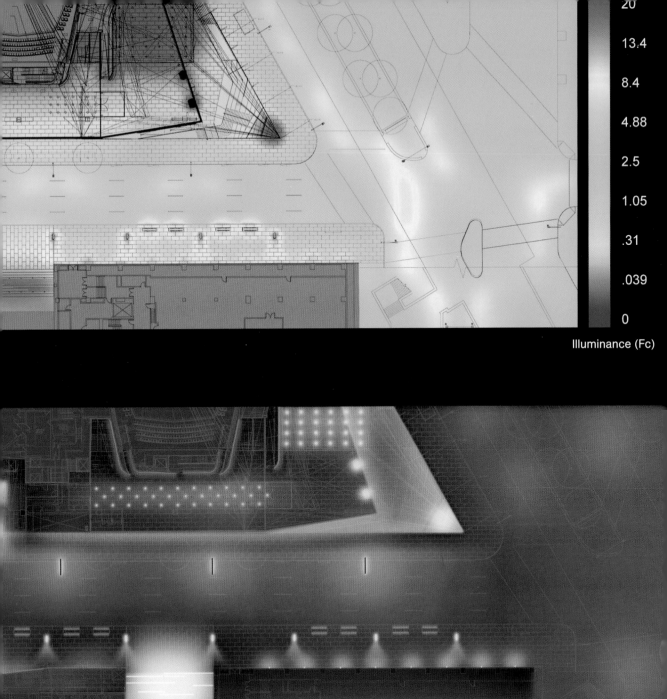

20

13.4

8.4

4.88

2.5

1.05

.31

.039

0

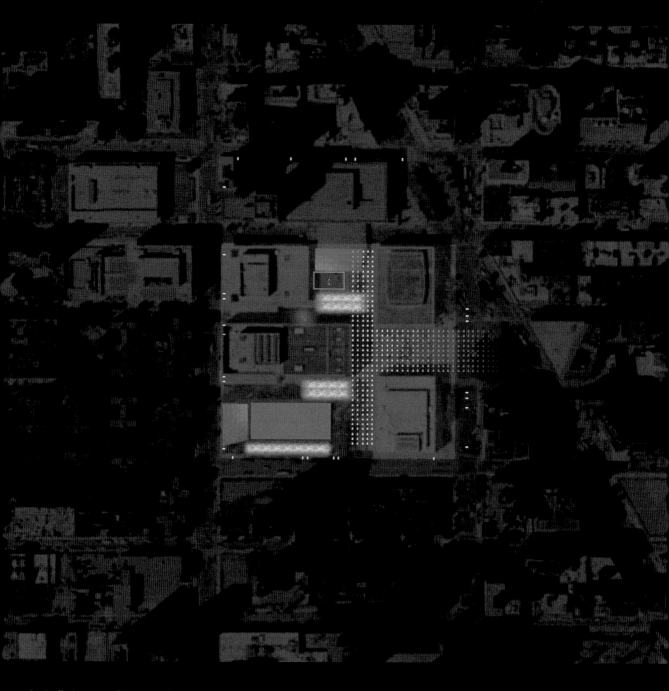

Josie Robertson Plaza lighting proposal

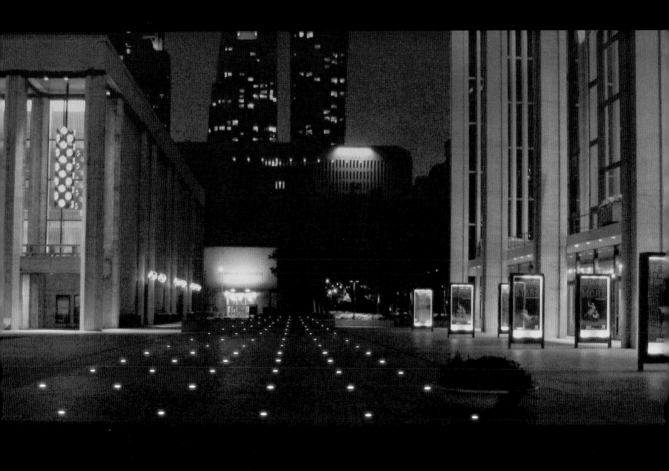

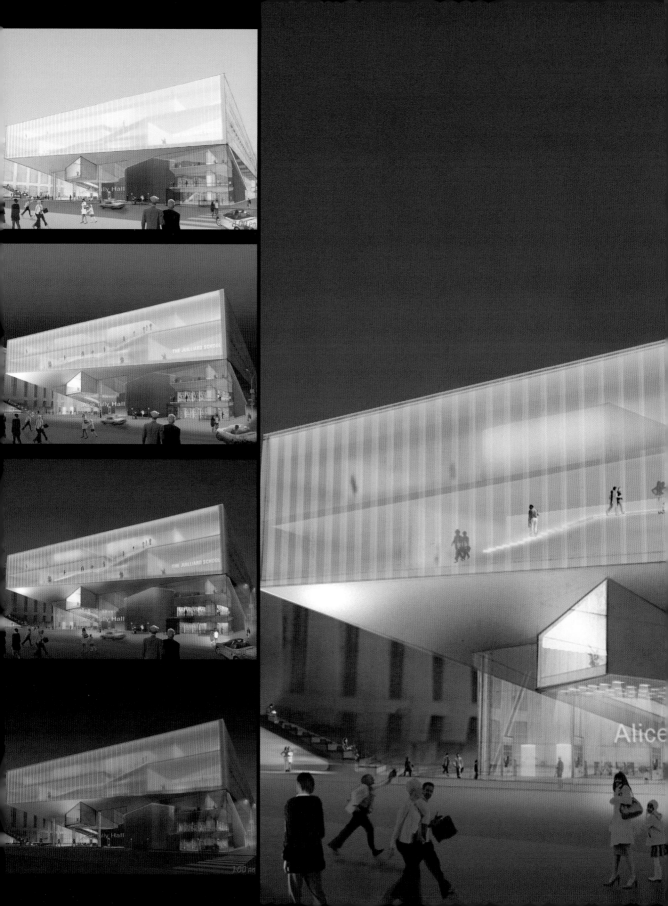

Alice Tully Hall Interior

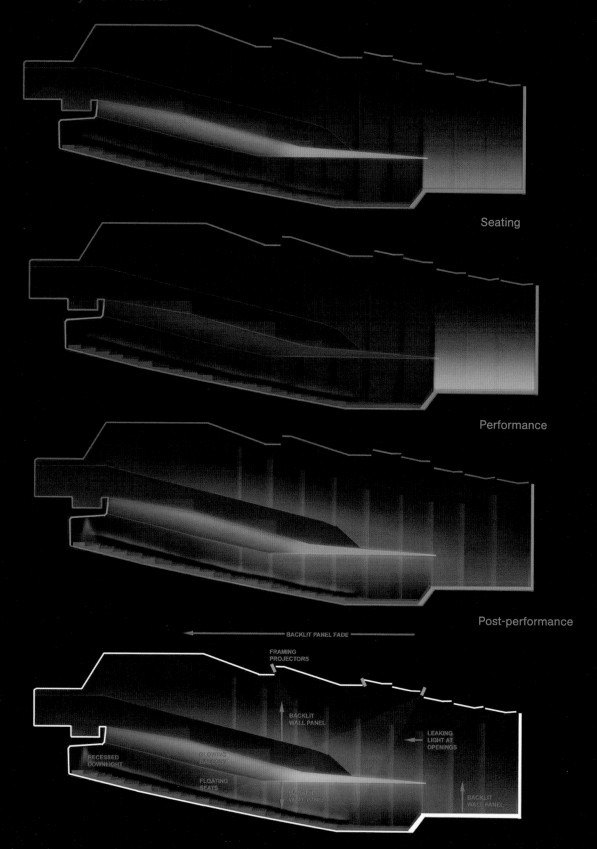

Seating

Performance

Post-performance

BACKLIT PANEL FADE

FRAMING
PROJECTORS

BACKLIT
WALL PANEL

LEAKING
LIGHT AT
OPENINGS

RECESSED
DOWNLIGHT

GLOWING
BALCONY

FLOATING
SEATS

BACKLIT
WALL PANEL

BACKLIT
WALL PANEL

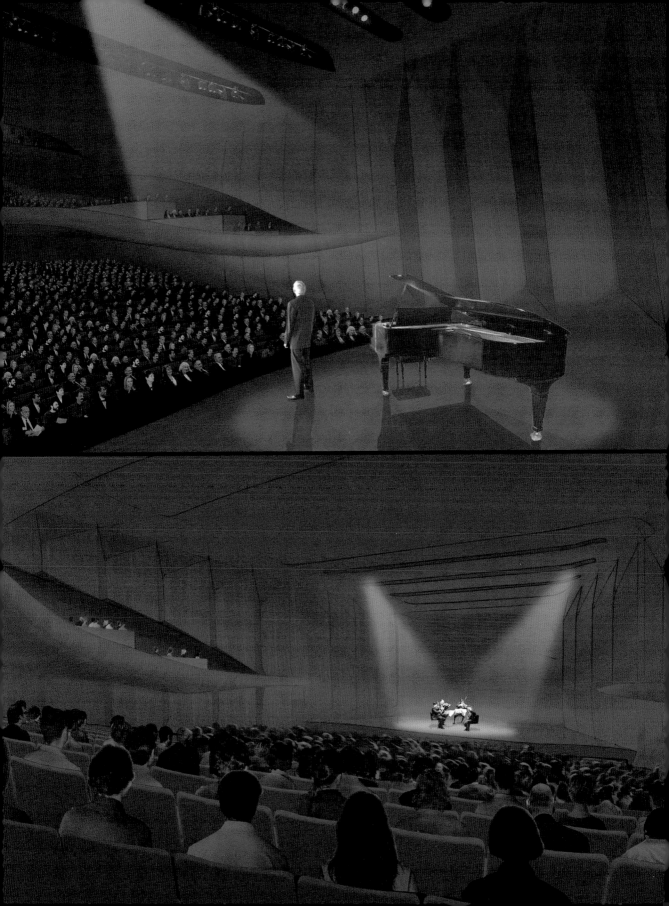

Newtown Creek
Water Pollution Treatment Plant

Location: Brooklyn, New York, USA
Architects: Polshek Partnership, USA
To be completed: 2006

A diaphanous layer of blue light visually identifies the water treatment plant which contrasts with the bright orange lights of the surrounding city. The luminous membrane serves as a protective layer, defining the extent of the entire plant, while also serving as a canvas for the bright white lights that define the plant's various functions. The most active areas, such as the loading docks, blaze in contrast to the blue monochromatic field. Pedestrian walkways carve bright shimmering lines against a background of forms bathed in blue light, and gleaming yellow lines and points of bright white shimmer and animate the blue veil expressing the dynamic building through light.

Eine transparente Schicht blauen Lichts, das im Kontrast zum grellen Orange der umliegenden Stadt steht, grenzt die Kläranlage visuell ab. Die leuchtende Membran dient als Schutzschild, indem sie den Umfang der gesamten Anlage definiert. Sie bildet aber auch eine Art Leinwand, auf der die weißen Lichter, die die verschiedenen Funktionsbereiche innerhalb der Anlage markieren, abgebildet werden. Die betriebsamsten Bereiche, wie beispielsweise die Ladebecken, scheinen im Kontrast zu der monochromatischen Fläche geradezu zu lodern. Fußgängerwege schneiden hell schimmernde Linien in einen Hintergrund aus in blaues Licht getauchten Formen. Schimmernd gelbe Linien und Punkte weißen Lichts glänzen, beleben den blauen Schleier und verleihen dem dynamischen Gebäudekomplex Ausdruck.

Un écran diaphane de lumière bleue identifie visuellement l'usine de traitement des eaux, faisant contraste avec les lumières orange très vives de la ville alentour. La membrane lumineuse sert d'écran de protection, définissant l'étendue de l'ensemble de l'usine, tout en servant simultanément de canevas pour les lumières blanches et brillantes qui définissent les différentes fonctions de l'usine. Les zones les plus actives, comme les docks de chargement, brillent fortement par contraste avec le champ bleu monochrome. Les chemins piétonniers tracent des lignes miroitantes très claires par rapport à un arrière-plan constitué de formes baignées dans une lumière bleue, des lignes jaunes scintillantes et des points brillants d'un blanc chatoyant, animent le voile bleu en exprimant la dynamique de la construction par la lumière.

Una diáfana capa de luz azul identifica visualmente la depuradora, que contrasta con las luces naranja brillante de la ciudad circundante. La membrana luminosa sirve como capa protectora, definiendo la extensión de toda la planta, a la vez que sirve como lienzo para las luces blanco brillante que definen las distintas funciones de la planta. Las zonas de mayor actividad, como los muelles de carga brillan contrastando con el campo monocromático azul. Los paseos peatonales esculpen aceras relucientes y brillantes en un suelo de formas bañadas por una luz azul, y aceras de un amarillo centelleante y puntos en blanco brillante relucen y animan el velo azul expresando la construcción dinámica a través de la luz.

Uno strato trasparente di luce blu identifica visualmente l'impianto depuratore in contrasto con le forti lampade di colore arancione della città circostante. La membrana luminosa funge da strato protettivo, definendo l'estensione dell'intero impianto, mentre serve anche da schermo delle forti luci bianche che definiscono le varie funzioni dell'impianto stesso. Le aree più attive, come i bacini di caricamento, sono illuminate in contrasto con il campo monocromatico blu. Le vie pedonali tracciano marcate linee rilucenti contro uno sfondo di forme immerse in luce blu, linee luminose gialle e punti di luce bianca animano il velo blu che esprime la dinamicità dell'edificio tramite la luce.

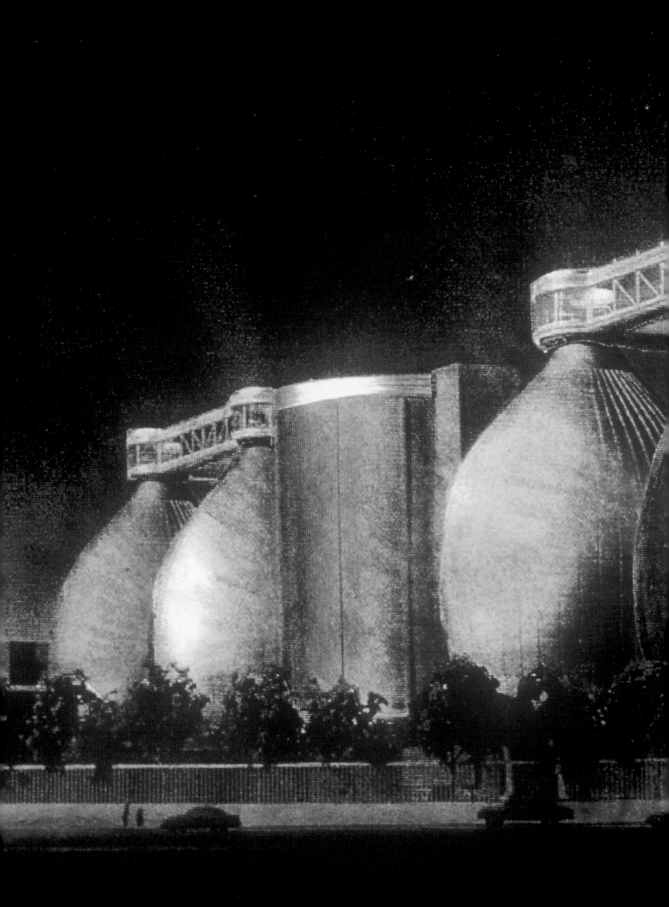

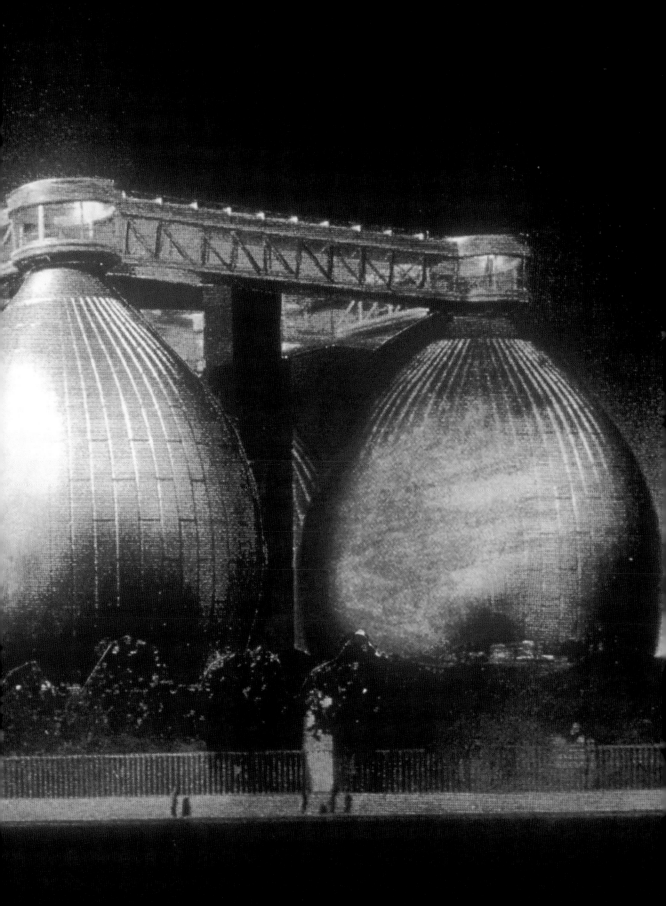

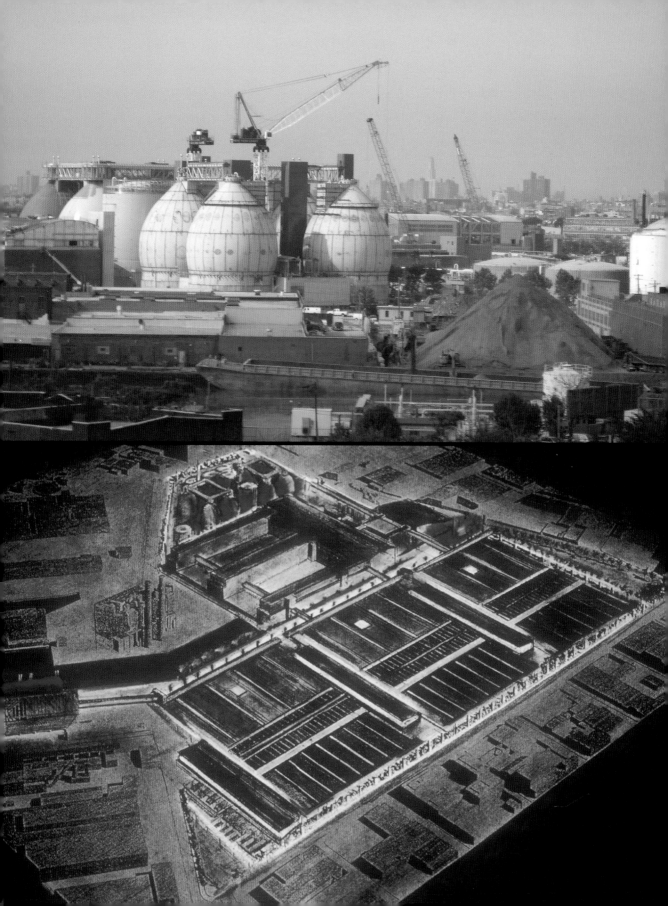

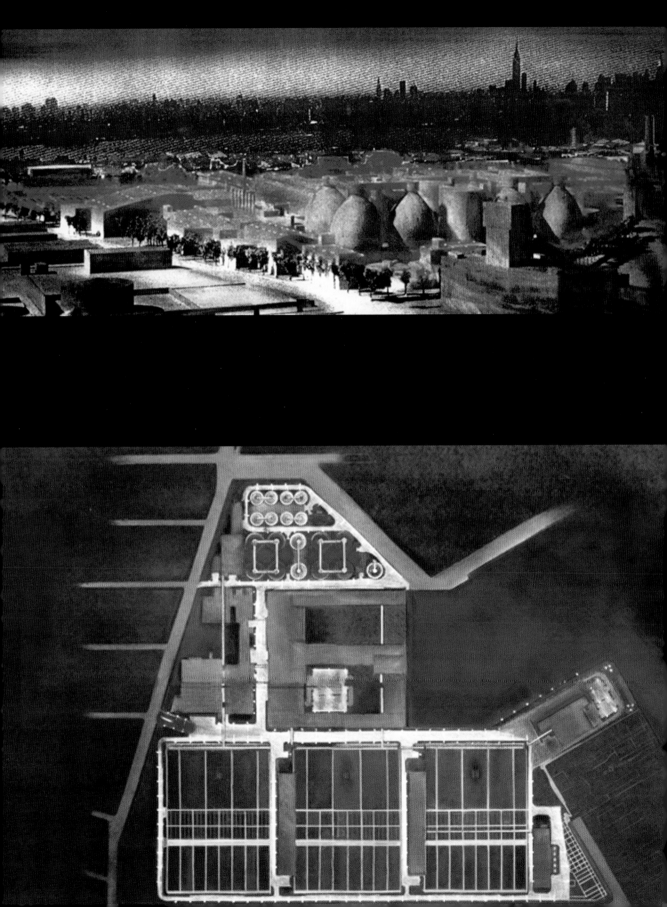

Highline

Location:	New York, New York, USA
Architects:	Diller, Scofidio + Renfro, USA
Landscape Architects:	Field Operations, USA
To be completed:	2008

The Highline is a 1.2-mile long abandoned elevated freight rail line along the west side of lower Manhattan. It spans twenty city blocks from Gansevoort Street through the Meat Packing District and West Chelsea, culminating on 34th Street. The overall lighting strategy is a consistent low-level plane of light along the perimeter, lifting and floating the Highline above the city below. Soft light marks the edge, silhouettes the Highline, and casts light just below eye-level, keeping the Highline safe, visible, and unobtrusive at night, while allowing for the possibility of an intimate experience at night.

Die Highline ist eine stillgelegte Hochbahn, auf der einst Güterzüge fuhren. Sie erstreckt sich über ca. 2 km im Westen von Lower Manhattan. Die Gleise ziehen sich entlang zwanzig Häuserblocks, von der Gansevoort Street, durch das Schlachthofviertel („Meat Packing District") und West Chelsea, und endet schließlich in der 34sten Straße. Entlang der Geländer beleuchtet eine tiefliegende Lichtebene die Highline, auf der die Hochbahn über der darunterliegenden Stadt zu schweben scheint. Weiches Licht markiert die Ränder, unterstreicht die Silhouette der Highline und beleuchtet den Weg unterhalb der Augenhöhe. So ist die Highline bei Nacht sicher, übersichtlich und unaufdringlich und gibt Spaziergängern doch die Möglichkeit, den nächtlichen Himmel zu genießen.

La Highline est une ligne de transport de marchandise surélevée et abandonnée, d'une longueur de 1,2 miles, et située sur le coté ouest du sud de Manhattan. Elle enjambe 20 blocs d'immeubles de la ville, depuis la rue Gansevoort, elle traverse le quartier des abattoirs (le « Meat Packing District ») et l'ouest de Chelsea, puis vient culminer dans la 34eme rue. La stratégie d'ensemble de l'éclairage consiste en un plan de lumière horizontal surbaissé tout le long du périmètre, qui élève et fait flotter la Highline au-dessus de la ville. Des lumières diffuses marquent le sommet, et montrent la silhouette de la Highline, et éclaire juste au dessous du niveau des yeux, permettant que la Highline reste sans danger, visible, et discrète la nuit, tout en offrant, la nuit, la possibilité d'une aventure intimiste.

La Highline es una línea abandonada de ferrocarril de carga elevada de 1,2 millas de longitud que se extiende a lo largo de la zona oeste del bajo Manhattan. Abarca veinte bloques de la ciudad desde Gansevoort Street a través del distrito de los mataderos ("Meat Packing District") y West Chelsea, terminando en la Calle 34. Toda la estrategia de iluminación es un plano consistente de nivel bajo de iluminación que rodea el perímetro, subiendo y haciendo flotar la Highline por encima de la ciudad, situada debajo. Una luz suave marca el límite, dibuja la silueta de la Highline, y lanza la luz justo por debajo de la altura del ojo, manteniendo la Highline a salvo, visible, y discreta por la noche, mientras que permite la posibilidad de una experiencia íntima por la noche.

La Highline è una strada ferrata abbandonata lunga 1,2 miglia per il trasporto di merci lungo il lato occidentale di lower Manhattan. Comprende venti blocchi cittadini da Gansevoort Street attraverso il distretto dei produttori di carni ("Meat Packing District") e West Chelsea, culminando poi nella 34th Street. La strategia di illuminazione complessiva consiste in un omogeneo piano di luce a basso livello lungo il perimetro che eleva e sospende la Highline sopra la città sottostante. Luce morbida demarca gli spigoli, forma la Highline ed illumina fino ad appena sotto il livello dell'occhio, facendo sì che la Highline rimanga sicura, visibile e non risulti ostrusiva di notte, assicurando nel contempo che ci si senta a proprio agio di notte.

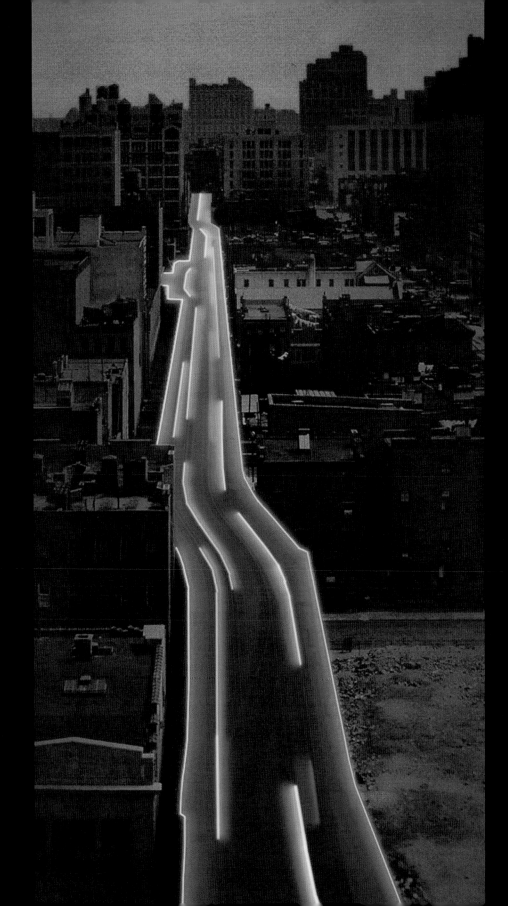

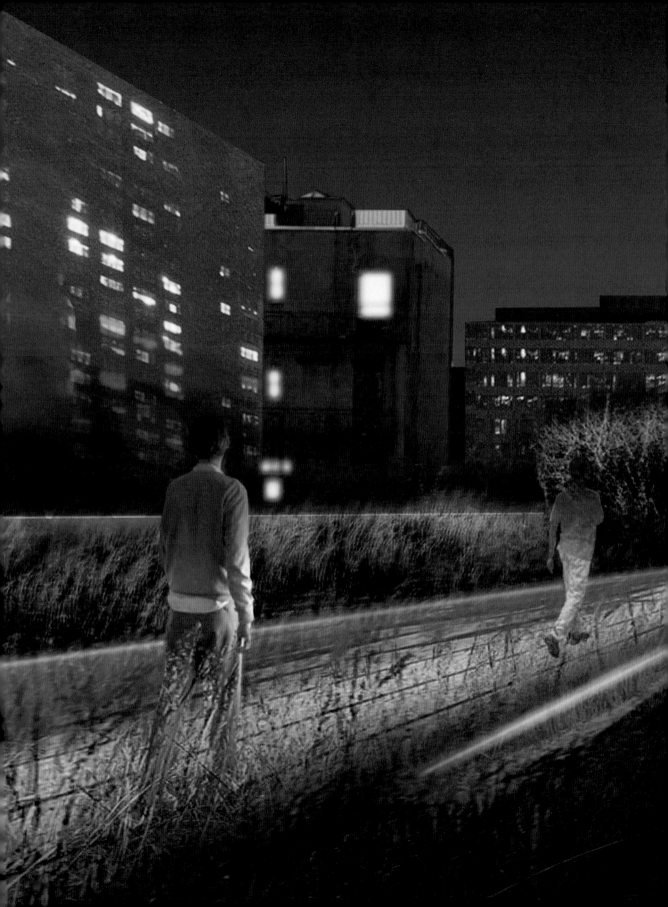

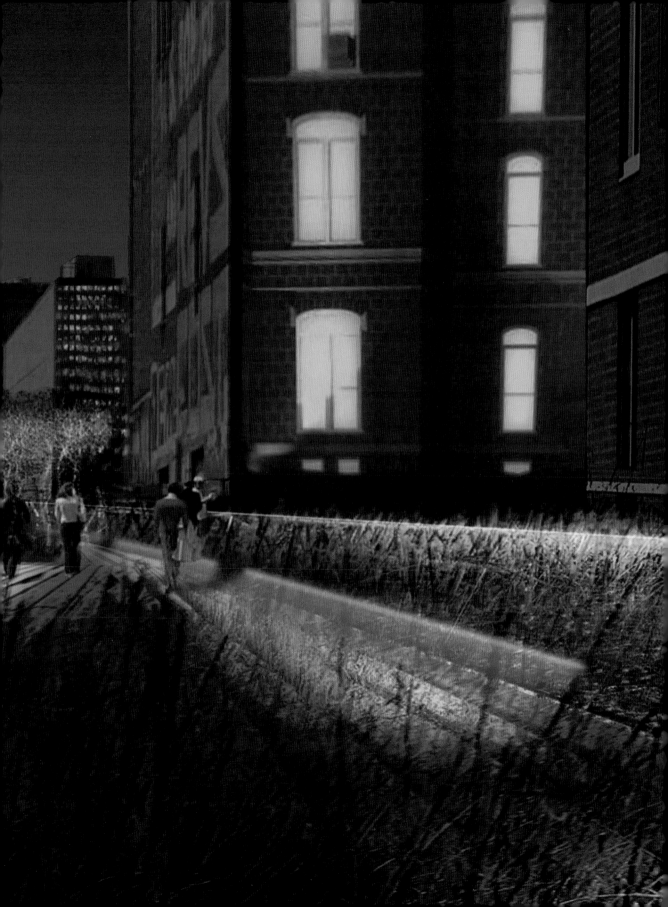

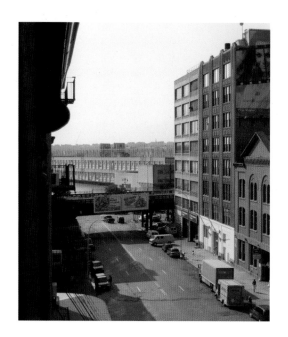

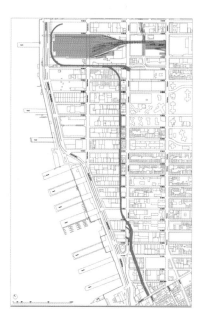

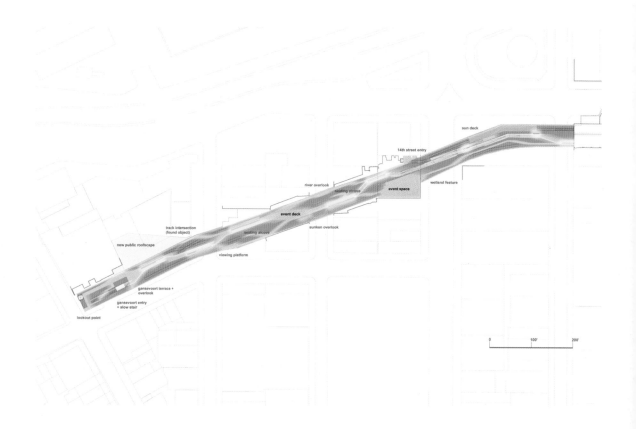

lookout point

new public roofscape

gansevoort entry
+ slow stair

gansevoort terrace +
overlook

track intersection
(found object)

viewing platform

seating alcove

sunken overlook

event deck

river overlook

seating alcove

event space

14th street entry

wetland feature

sun deck

0 100' 200'

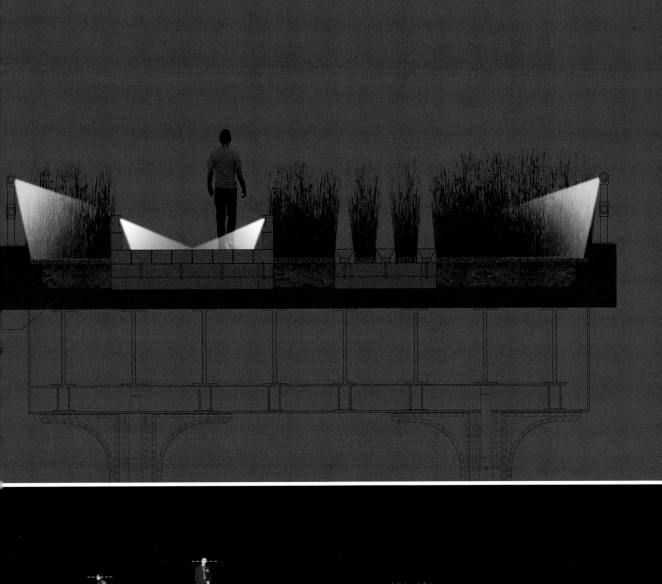
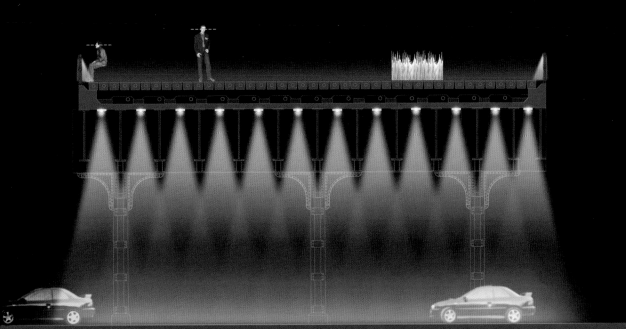

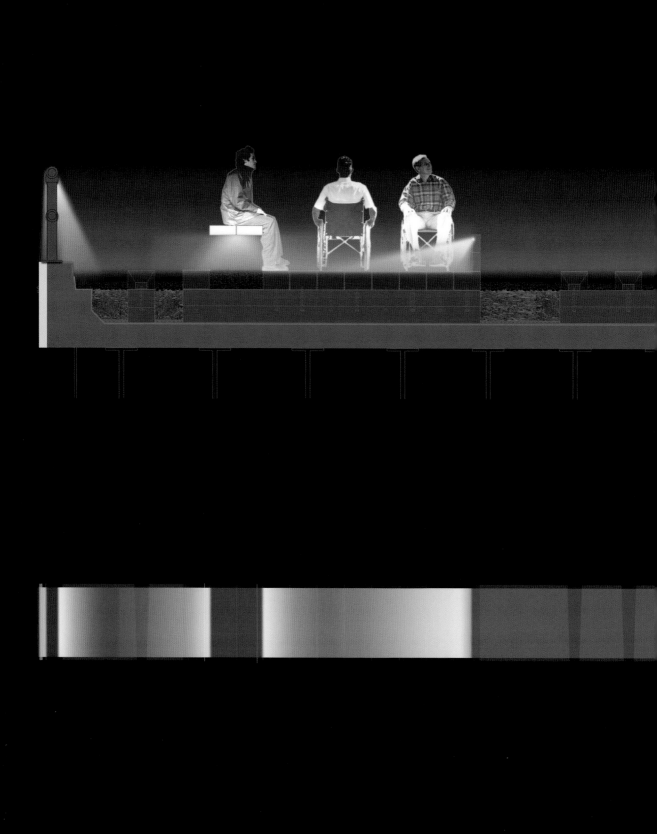

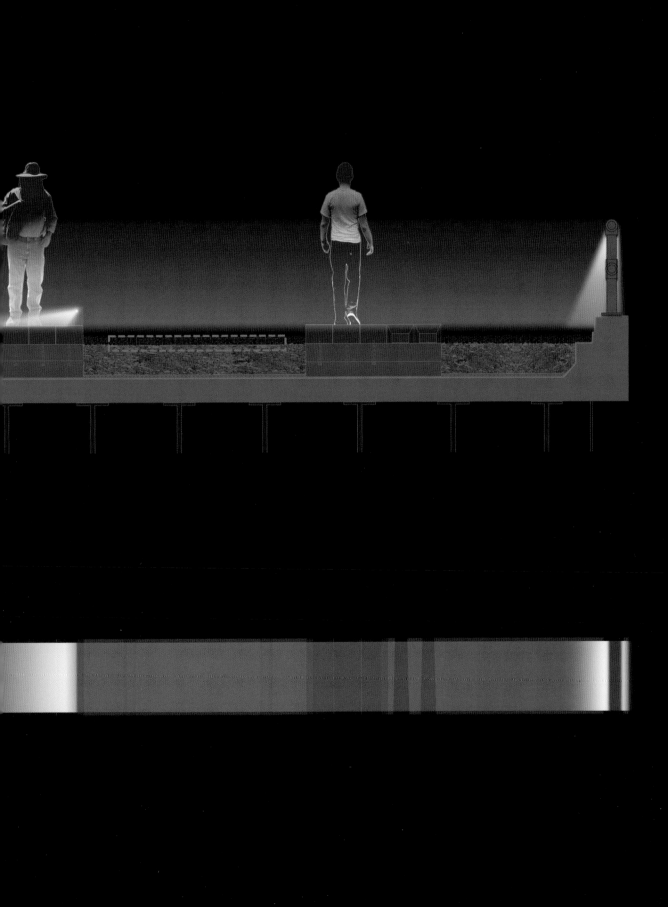

French Consulate Garden

Location: New York, New York, USA
Landscape Architects: Field Operations, USA
Completed: 2003

This intimate garden on 5th Avenue in New York City provides a magical site for entertainment. For the space, small blue stars are embedded into the floor, causing the ground to glimmer. In addition, vertical light pipes provide diffuse light and engender a surreal atmosphere.

Dieser ruhige und beschauliche Garten in der 5th Avenue in New York ist ein zauberhafter, wie für das Vergnügen gemachter Ort. Um ein Gefühl von Raum zu schaffen, wurden kleine, blaue Sterne in den Boden eingelassen, die einen glitzernden Schimmer erzeugen. Zusätzlich streuen vertikale Lichtröhren diffuses Licht und erzeugen so eine surreale Atmosphäre.

Ce jardin intime sur la 5th Avenue de New York City est un site de détente magique. Pour l'espace, des petites étoiles bleues sont encastrées dans le sol, faisant ainsi scintiller le sol. De plus des tubes lumineux verticaux apportent une lumière diffuse qui engendre une atmosphère irréelle.

Este recoleto jardín de la 5th Avenue en la Ciudad de Nueva York proporciona un entorno mágico para el ocio. Para el espacio, pequeñas estrellas azules están empotradas en el suelo, con lo que se consigue una luz tenue. Además, cañones de luz vertical proporcionan luz difusa y crean un ambiente surrealista.

Questo giardino raccolto situato nella 5th Avenue a New York rappresenta un luogo magico per intrattenersi. Le piccole stelle blu incassate nel pavimento fanno brillare il suolo. Addizionalmente a ciò, tubi luminosi verticali assicurano un'illuminazione diffusa e generano un'atmosfera surreale.

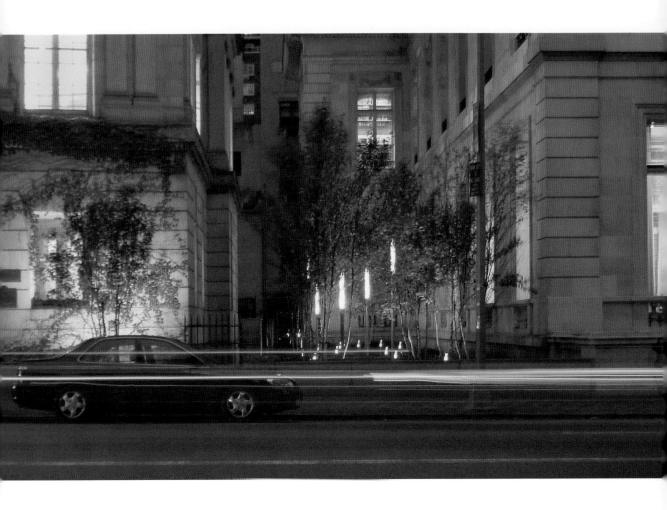

French Consulate Garden

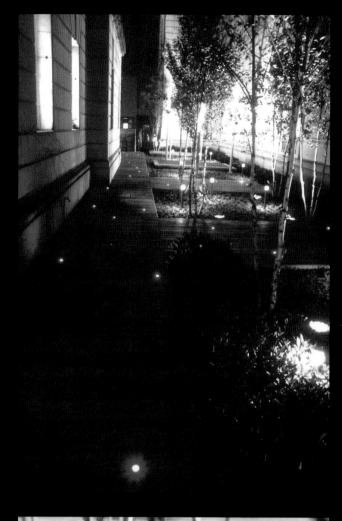

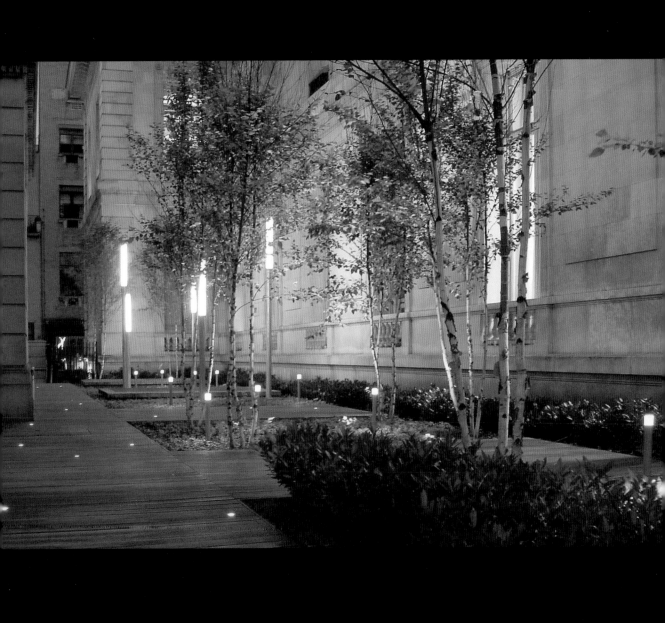

Columbus Circle

Location: New York, New York, USA
Landscape Architects: Olin Partnership, USA
To be completed: 2005

The redesign of this prominent historical and monumental site remains a unique axis in New York where three streets intersect. The lighting concept focuses on the central monument which glows at night. From this marker, a series of oscillating rings of light emanate out to the perimeter of the circular site.

Die Neugestaltung dieser historisch berühmten und imposanten Stätte, an der Kreuzung dreier Straßen gelegen, bildet in New York nach wie vor eine wichtige Achse. Das Lichtkonzept betont das Monument, das nachts erleuchtet ist, in der Mitte. Von dort breiten sich pulsierende Ringe aus Licht bis an den Rand der kreisförmigen Anlage aus.

La rénovation de ce site historique marquant et monumental qui reste un axe unique dans la ville de New York où trois rues se rencontrent. Le concept d'éclairage est focalisé sur le monument central qui s'illumine la nuit. Depuis ce repère, une série d'anneaux de lumière oscillants sont diffusés vers la périphérie de ce site circulaire.

El nuevo diseño de este lugar de importancia histórica y monumental sigue siendo un eje único en Nueva York donde se cruzan tres calles. El concepto de iluminación se concentra en el monumento central, que se ilumina por la noche. Desde este punto, una serie de anillos oscilantes de luz emanan hacia afuera del perímetro de la zona circular.

La ristrutturazione di questo prominente sito storico e monumentale preserva un asse unico a New York in cui le strade si incrociano. Il concetto di illuminazione si concentra sul monumento centrale che è illuminato di notte. Da questo punto di riferimento una serie di anelli luminosi oscillanti emana luce verso il perimetro del sito circolare.

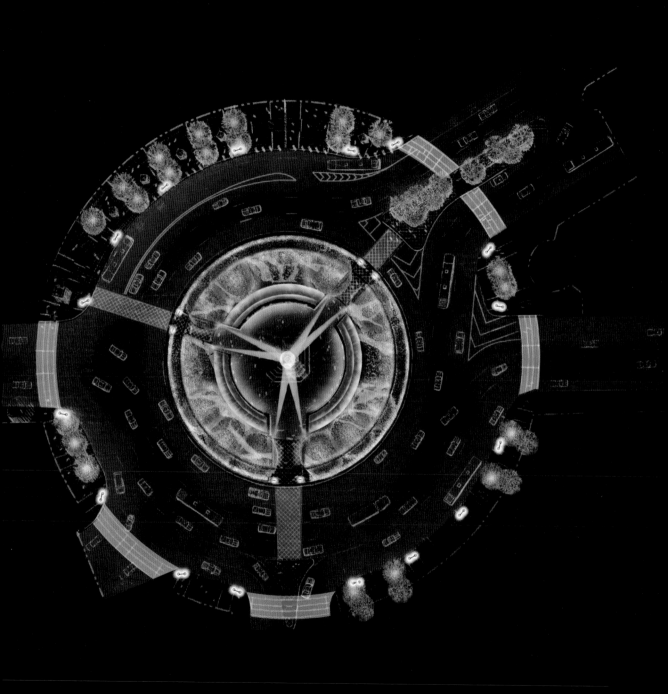

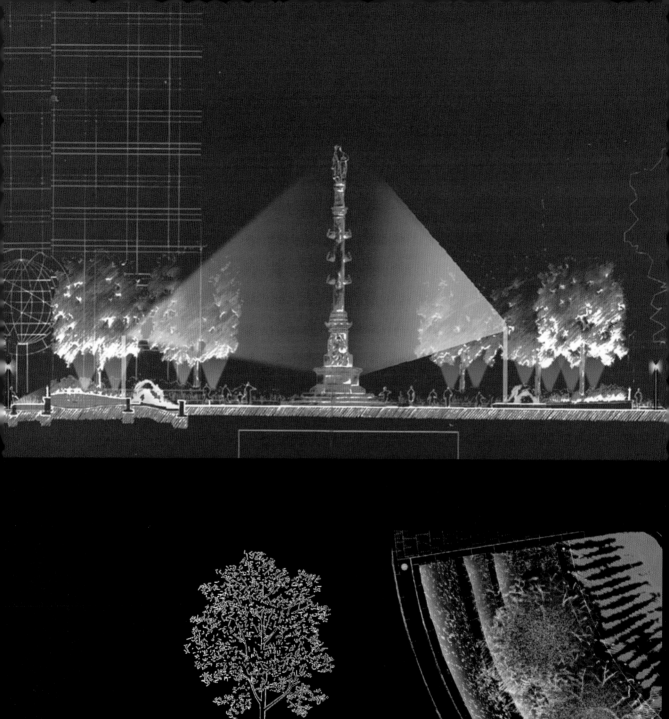
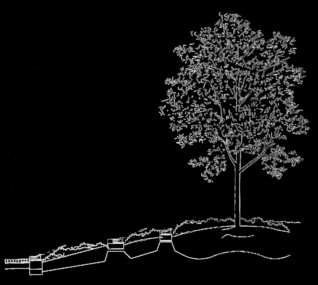

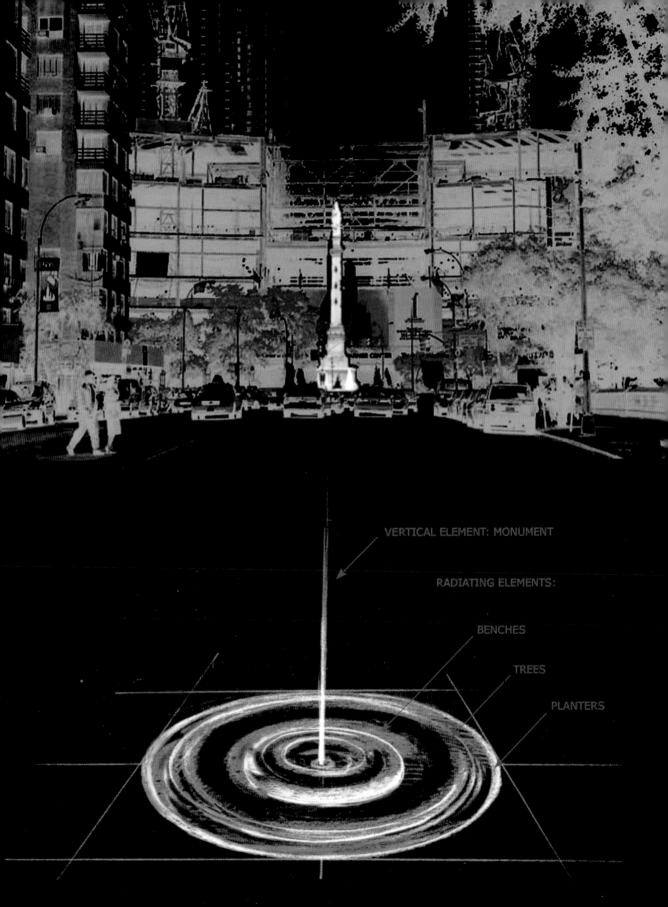

VERTICAL ELEMENT: MONUMENT

RADIATING ELEMENTS:

BENCHES

TREES

PLANTERS

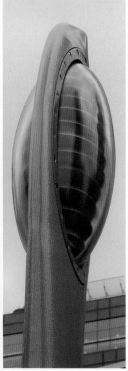

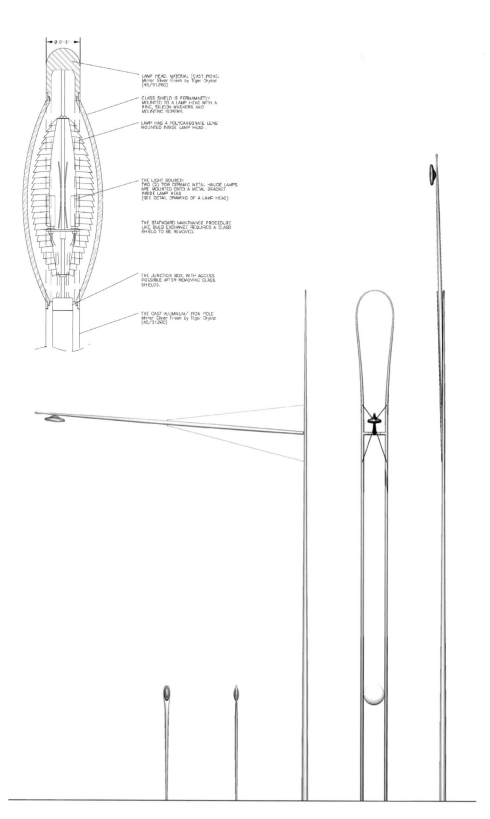

LAMP HEAD. MATERIAL (CAST IRON);
Mirror Silver Finish by Tiger Drylac
(49/31260)

GLASS SHIELD IS PERMANENTLY
MOUNTED TO A LAMP HEAD WITH A
RING, SILICON WASHERS AND
MOUNTING SCREWS.

LAMP HAS A POLYCARBONATE LENS
MOUNTED INSIDE LAMP HEAD.

THE LIGHT SOURCE:
TWO (2) 70W CERAMIC METAL HALIDE LAMPS
ARE MOUNTED ONTO A METAL BRACKET
INSIDE LAMP HEAD
(SEE DETAIL DRAWING OF A LAMP HEAD)

THE STANDARD MAINTNANCE PROCEDURE
LIKE BULB EXCHANGE REQUIRES A GLASS
SHIELD TO BE REMOVED.

THE JUNCTION BOX, WITH ACCESS
POSSIBLE AFTER REMOVING GLASS
SHIELDS.

THE CAST ALUMINUM/ IRON POLE
Mirror Silver Finish by Tiger Drylac
(49/31260)

Columbus Circle

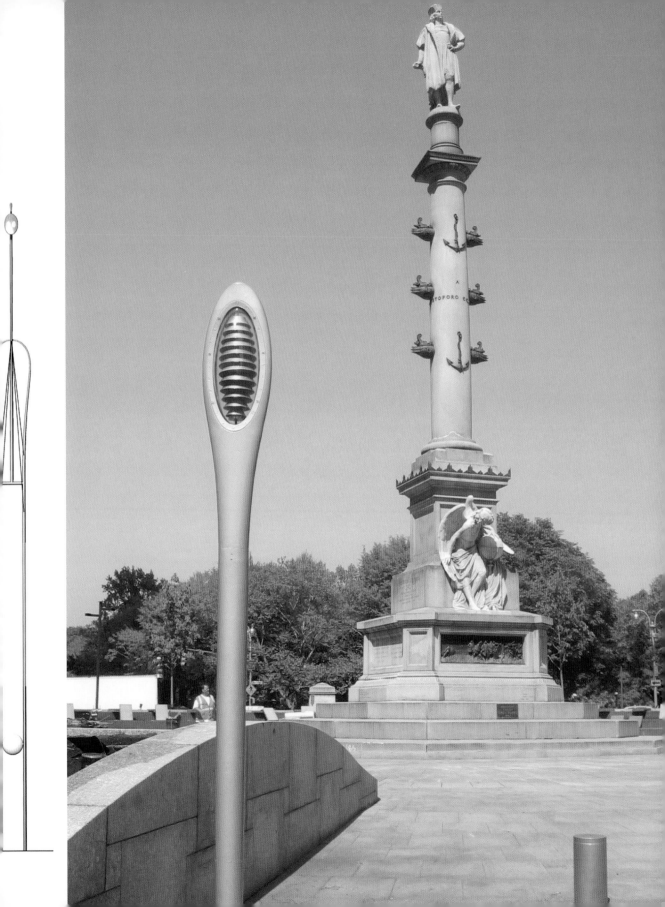

Fresh Kills Landfill

Location: Staten Island, New York, USA
Landscape Architects: Field Operations, USA
To be completed: 2030

The former landfill is being renovated as a new public landscape, with amenities for recreation, sports, equestrian uses, fishing, and canoeing. The main concept is to retain as much of the vast scale of darkness as possible. In a surrounding sea of urban glow, Fresh Kills is reminiscent of a dark void, but one full of spectral effects. Screens around flare stations will glow from the ground up. Scattered elsewhere, like wildflowers in a meadow, very small points of colored light create a sense of expanse. Carefully controlled and environmentally reactive white light on roadways and pathways highlight lines of movement.

Die ehemalige Mülldeponie wird zur Zeit als öffentliche Parkanlage neu gestaltet. Dem Besucher werden sich dort verschiedene Möglichkeiten der Freizeitgestaltung, wie Sportplätze, Reitwege, Angelplätze oder Wasserwege für Kanufahrten, bieten. Grundlegend soll so viel wie möglich von der Dunkelheit erhalten bleiben. Umgeben vom städtischen Lichtermeer erscheint Fresh Kills wie ein schwarzes Loch, eines voller gespenstischer Effekte. Von Leuchtstationen aus werden Projektionsflächen Licht in den Himmel strahlen. Wie Wildblumen auf einer Wiese verstreut, schaffen kleine, bunte Lichtpunkte ein Gefühl von Weite. Sorgfältig kontrollierte und auf Umweltbedingungen reagierende, weiße Beleuchtung auf Pfaden und Straßen erhellt den Verlauf der Wege.

L'ancien site d'enfouissement des déchets doit être réhabilité sous la forme d'un nouveau parc paysager public avec des aménagements pour la détente, le sport, l'équitation, la pêche et le canoë. Le concept principal consiste à conserver une surface d'ombre la plus vaste possible. Dans une mer environnante de luminosité urbaine, Fresh Kills est la réminiscence d'un vaste espace d'obscurité, mais chargé d'effets spectraux. Des écrans situés sur les stations de récupération de méthane vont éclairer depuis le sol. En d'autres endroits, comme des fleurs sauvages dans une prairie, de très petits points de lumière colorés donnent l'idée d'expansion. Soigneusement contrôlées et réactives à l'environnement, des lumières blanches sont placées sur les voies routières et les voies piétonnes et soulignent les voies de déplacement.

El primer terraplén está siendo renovado como un nuevo paisaje público, con comodidades para el recreo, los deportes, usos ecuestres, pesca y la práctica de canoa. El principal concepto es conservar todo lo que se pueda de la amplia gama de oscuridad. En un mar circundante de brillo urbano, Fresh Kills recuerda a un oscuro hueco, pero lleno de efectos espectrales. Las pantallas de las estaciones de llamaradas de alrededor brillarán desde el suelo hacia arriba. Desparramadas por todas partes, como flores silvestres en una pradera, unos puntos muy diminutos de luz de color crean una sensación de expansión. Una luz blanca controlada con cuidado y ambientalmente reactiva marca las líneas de movimiento en las calles y los senderos.

La discarica di una volta viene rinnovata come nuovo paesaggio pubblico, con strutture per la ricreazione, lo sport, l'ippica, la pesca e la canoa. Il concetto principale è quello di mantenere la maggiore misura possibile di oscurità. In un mare circostante di luci urbane, Fresh Kills ricorda un vuoto buio, ma un vuoto pieno di effetti spettrali. Schermi attorno a stazioni di segnalazione luminosa si illumineranno dal suolo in su. Distribuiti altrove, come fiori selvatici in un prato, piccolissimi punti di luce a colori generano un senso di spaziosità. Luce bianca accuratamente controllata ed ambientalmente reattiva nelle strade e nei sentieri demarca le linee di movimento.

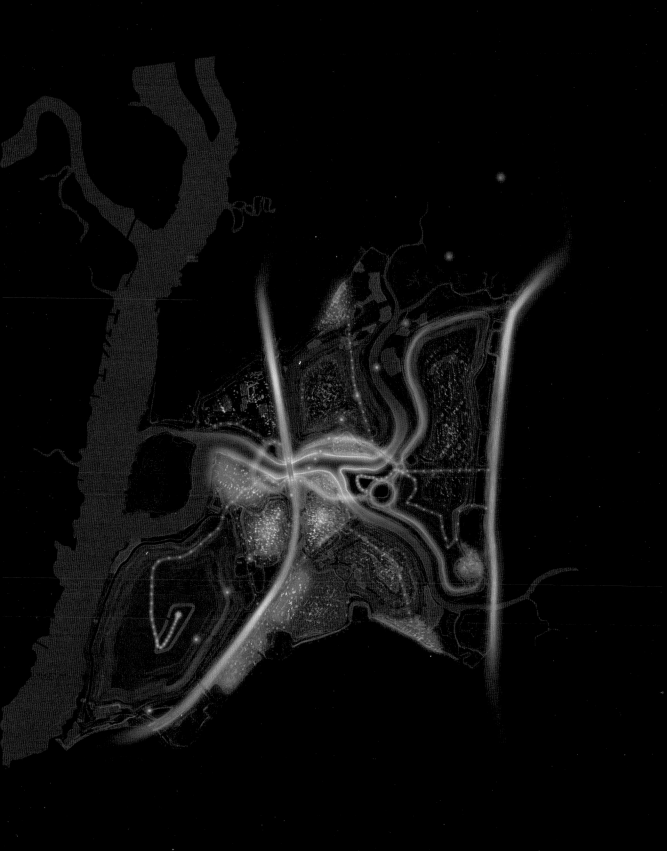

"When I was a young teenager, I had the amazing experience of going with my small motorb
into the woods in the middle of the night. I switched off my headlights and the forest closed
and absorbed me. After a little while my eyes adapted to the darkness and the forest opened
opened up, and opened up again. And I began to see the sky and the stars through the forest.
experience was absolutely magical, with the effect of one switch!

It's very interesting, because you believe that you're safe with your light, safe because you s
clearly in a narrow area. And you're afraid to lose that light, afraid of being absorbed, but th
it's the opposite: you actually see more, you see better, you see farther and, instead of see
something very focused, you see everything."
H.D.

„Als Jugendlicher hatte ich ein erstaunliches Erlebnis, als ich mit meinem kleinen Motorrad mit
in der Nacht in den Wald fuhr. Ich schaltete die Scheinwerfer aus, und der Wald schloss sich
mich herum und verschluckte mich. Nach einer Weile gewöhnten sich meine Augen an die Dunk
heit. Der Wald öffnete sich plötzlich, immer weiter und weiter. Ich sah den Himmel und die Ste
durch die Baumwipfel. Es war ein vollkommen magisches Erlebnis. Und alles nur mit einem Lic
schalter!

Interessant, wenn man glaubt, dass man im Licht sicher ist, sicher, weil man in einem engen
reich gut sehen kann. Und man hat Angst davor, dass dieses Licht aus geht, dass man verschlu
wird, aber dann passiert das Gegenteil: man sieht tatsächlich mehr, man sieht besser und weit
und statt sich auf eine Sache zu konzentrieren, sieht man plötzlich alles."
H.D.

« Quand j'étais jeune adolescent, j'ai souvent fait l'expérience extraordinaire de traverser
bois en pleine nuit avec ma petite mobylette, j'éteignais les phares, la forêt se repliait sur moi
m'absorbait. Après quelques instants, mes yeux s'adaptaient à la pénombre et la forêt s'ouvra
s'ouvrait et s'ouvrait encore. Je commençais alors à voir le ciel et les étoiles à travers les bo
Cette expérience était absolument magique, il fallait simplement appuyer sur le bouton !

C'est très intéressant parce que vous croyez que vous êtes sécurisé par votre lampe, sécurisé
le fait que vous voyez bien dans un certain périmètre. Et vous avez peur de perdre cette lumiè
d'être absorbé, mais en fait, c'est l'opposé : en fait, vous voyez plus, vous voyez mieux, vous voy
plus loin et, au lieu d'avoir une vision concentrée sur un point, vous voyez tout. »
H.D.

"uando era un adolescente, tuve la agradable experiencia de ir con mi modesta moto por los bos-
es en mitad de la noche. Apagaba las luces y el bosque desaparecía y me absorbía. Después de
rato mis ojos se adaptaban a la oscuridad y el bosque aparecía, aparecía y volvía a aparecer.
mpezaba a ver el cielo y las estrellas a través del bosque. La experiencia era completamente
gica, ¡con el efecto de un interruptor!

muy interesante porque crees que estás a salvo con tu luz, seguro porque ves con claridad en
área estrecha. Y te asusta perder esa luz, te asusta ser absorbido, pero después sucede lo
ntrario: realmente ves más, ves mejor, ves más lejos y, en lugar de ver algo muy concreto, lo
todo."
.

"uando ero un giovane teenager, feci un'esperienza sorprendente andando in motorino nel bosco
otte fonda. Spensi le luci, la foresta si chiuse e mi assorbì. Dopo un breve periodo i miei oc-
si adattarono al buio e la foresta si aprì, si aprì e si riaprì ancora di più. E io iniziai a vedere
cielo e le stelle attraverso la foresta. Questa esperienza fu assolutamente magica, l'effetto di
r semplicemente azionato un interruttore!

esto è molto interessante, perché si pensa di stare al sicuro con la propria luce, vedendo chia-
nente in uno spazio ristretto. E si ha paura di perdere questa luce, paura di essere assorbiti,
poi avviene il contrario: si finisce per vedere in effetti di più, si vede meglio, si vede più lon-
o e, invece di vedere solo qualcosa in modo molto nitido, si vede tutto."
.

PRIMARY PATH WOODED

SECONDARY PATH WOODED

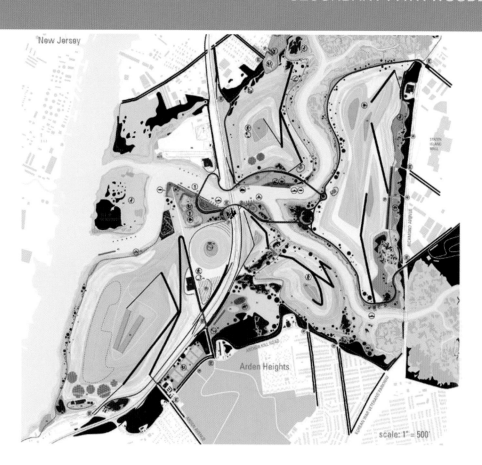

PRIMARY PATH OPEN

SECONDARY PATH OPEN

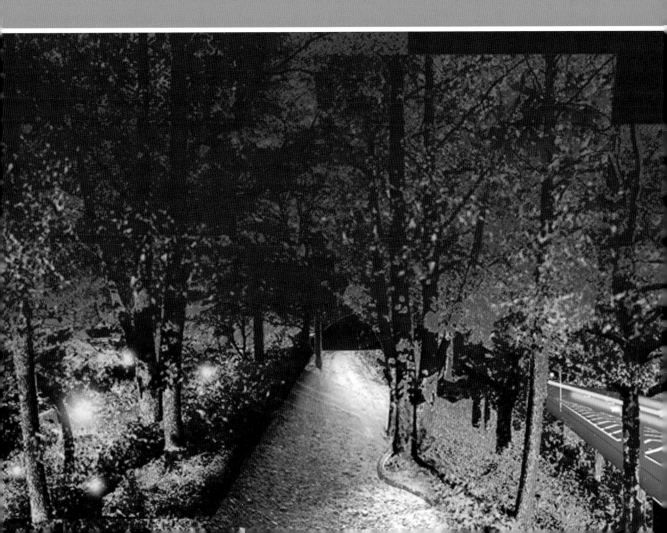

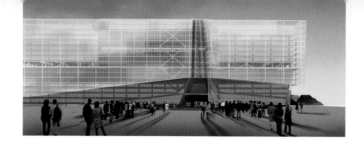

New York Sports and Convention Center

Location: New York, New York, USA
Architects: Kohn Pederson Fox, USA
Design Year: 2004

The lighting concept engages the building's curtain wall to create layers which both disclose and mask interior activity. Lighting plays with the ostensible transparency of the glass facade by projecting shadows of interior visitors onto to it, resulting in different scales cast on the exterior.

Das Lichtkonzept befasst sich mit der Vorhangfassade des Gebäudes, Vorgänge im Inneren werden zum einen offenbart, zum anderen aber auch verborgen gehalten. Die Beleuchtung spielt mit der scheinbaren Transparenz der Glasfassade, indem Schatten von Personen im Gebäude auf die Glasfront projiziert werden und so verschieden große Umrisse auf dem Gebäudeäußeren erscheinen lassen.

Le concept d'éclairage utilise le mur rideau de la construction pour créer des écrans qui servent simultanément à dévoiler et à cacher les activités à l'intérieur. L'éclairage joue avec la transparence ostensible du verre de la façade en projetant sur elle des ombres de visiteurs qui se trouvent à l'intérieur, ce qui de l'extérieur, a pour résultat, différentes échelles de reproduction.

El concepto de iluminación une el telón del edificio para crear capas que revelan y enmascaran al mismo tiempo la actividad interior del mismo. La iluminación juega con la ostensible transparencia de la fachada de cristal porque proyecta en ella las sombras de los visitantes de su interior, lo que produce distintos tonos proyectados en el exterior.

Il concetto di illuminazione adotta la parete divisoria dell'edificio per creare strati che svelano e mascherano rispettivamente l'attività interna. L'illuminazione gioca con la palese trasparenza della facciata di vetro proiettandovi le ombre dei visitatori presenti all'interno, con il risultato di ottenere diverse dimensioni proiettate all'esterno.

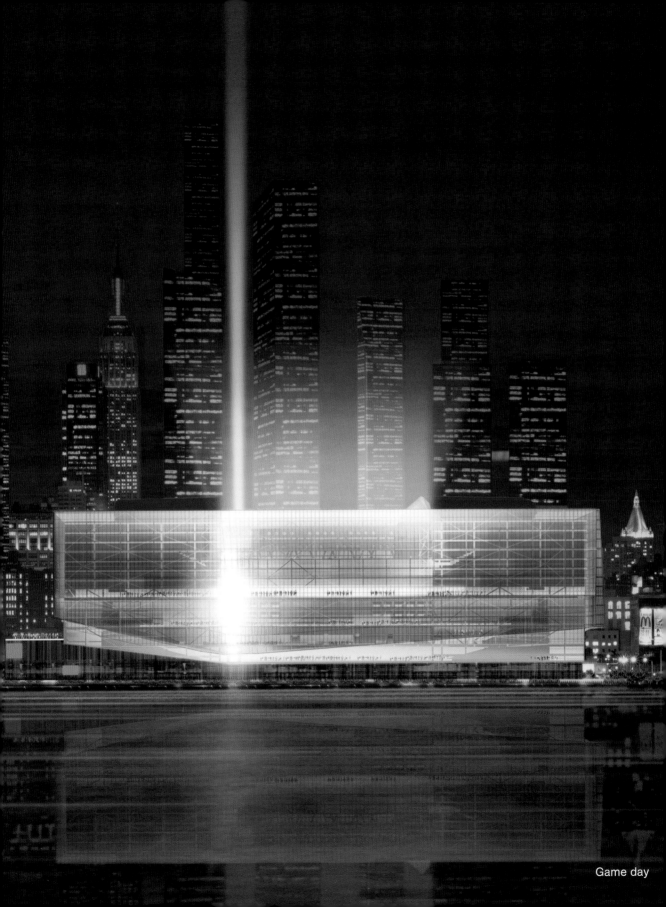

Game day

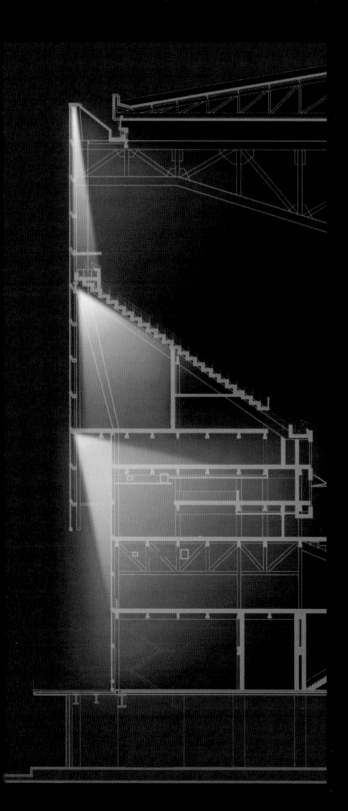

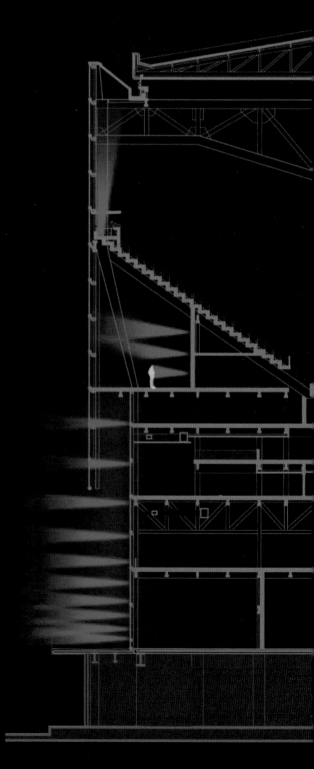

Downlighting with no cast shadows

Horizontal lighting to project shadows

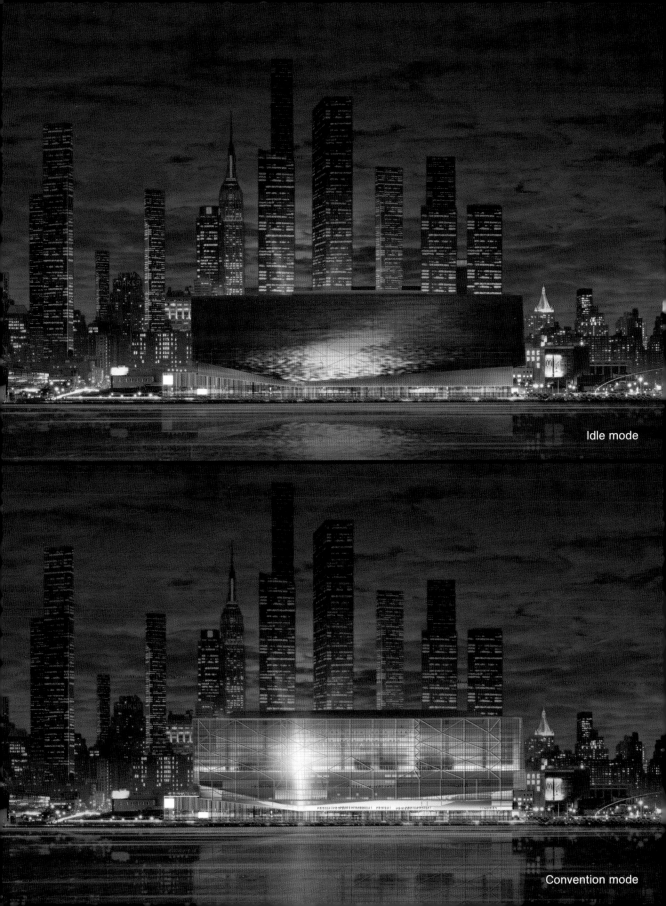

Idle mode

Convention mode

Museum of the Moving Image

Location: Queens, New York, USA
Architects: Ali Hocek, USA
Completed: 1996

The museum contains computer-based interactive exhibits as well as the nation's largest collection of objects related to the film and television. Glowing objects bring light to otherwise dark exhibits, causing space to disappear into the dark. Colored lights highlighting the walls subtly underline the space's perimeter. Deep blue lights, embedded in the walls, accentuate interactive displays and make them easily recognizable.

In dem Museum ist neben computergestützten, interaktiven Installationen Amerikas umfangreichste Sammlung an Gegenständen aus Film und Fernsehen zu sehen. Objekte mit eigener Lichtquelle erhellen andere Ausstellungsstücke und lassen den Raum so in der Dunkelheit verschwinden. Die farbige Beleuchtung der Wände betont die Begrenzung des Raumes. Interaktive Installationen werden durch tiefblaue, in den Wänden versenkte Lampen betont und so leicht erkennbar.

Le musée comprend des expositions interactives basées sur l'ordinateur, de même que la plus grande exposition nationale consacrée aux objets concernant le film et la télévision. Des objets lumineux apportent de la lumière sur des objets d'exposition qui autrement seraient sombres, et font que l'espace disparaît dans l'obscurité. Des éclairages de couleur rehaussent les murs, en soulignant discrètement l'espace périphérique. Des lumières d'un bleu profond, encastrées dans les murs, accentuent la présence des écrans interactifs, et les rendent plus facilement reconnaissables.

El museo posee obras expuestas interactivas computerizadas, además de la mayor colección nacional de objetos relacionada con la industria del cine y la televisión. Objetos brillantes aportan luz a lo que de otra forma serían obras expuestas a oscuras, lo que provoca que el espacio desaparezca en la oscuridad. Unas luces de colores que destacan sutilmente las paredes, delimitan el perímetro del espacio. Luces de color azul oscuro, empotradas en las paredes, acentúan los escaparates interactivos y los hacen fácilmente identificables.

Il museo contiene pezzi d'esposizione computerizzati interattivi nonché la maggiore collezione nazionale di oggetti concernenti il film e la televisione. Oggetti lucenti conferiscono luce ad altri pezzi d'esposizione che resterebbero altrimenti al buio, con la conseguenza che lo spazio sparisce nel buio. Luci colorate illuminanti le pareti sottolineano delicatamente il perimetro dello spazio. Profonde luci blu, incorporate nelle pareti, accentuano i display interattivi e li rendono facilmente riconoscibili.

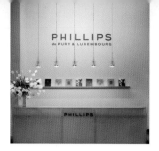

Phillips de Pury & Luxembourg

Location: New York, New York, USA
Architects: Patrick Mauger, France
Completed: 2002

Lighting accommodates the many social functions of the space, including auctions, rotating exhibitions, and fêtes. Hidden track lighting, as well as diffuse light provide flexible lighting options to accommodate these activities.

Die Beleuchtung kann an die verschiedenen Nutzungsbereiche der Räumlichkeiten, wie beispielsweise Auktionen, Wanderausstellungen und Festlichkeiten angepasst werden. Nicht sichtbare Beleuchtungsleisten und diffuse Lichtquellen bieten flexible Beleuchtungsmöglichkeiten, die den Anforderungen der jeweiligen Veranstaltung entsprechen.

L'éclairage accommode les nombreuses fonctions sociales de cet espace, qui comprennent des ventes aux enchères, des expositions temporaires et des fêtes. Des éclairages sur rail, cachés, et aussi des diffuseurs de lumière permettent des options d'éclairage flexibles pour accommoder ces activités.

La iluminación alberga la totalidad de las funciones sociales del espacio, incluyendo subastas, exposiciones itinerantes y fiestas. La iluminación de trayectoria oculta y la luz difusa, proporcionan opciones de iluminación flexibles para alojar esas actividades.

L'illuminazione favorisce le numerose funzioni sociali del luogo, come le aste pubbliche, le esposizioni rotanti e le feste. Un'illuminazione a sbarra nascosta nonché luce diffusa assicurano opzioni di illuminazione flessibili adeguate a tali attività.

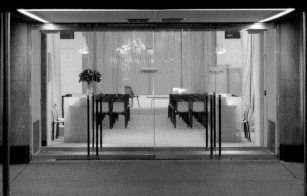

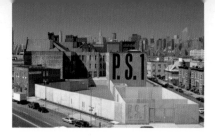

P.S.1 Contemporary Art Center

Location: Queens, New York, USA
Design Year: 2004

With the restoration of P.S.1's historic brick facade, lighting unifies the historic nature of the building with the imaginative edge of P.S.1. A continuous, brushed, stainless steel valance, cantilevered off of the façade, mirrors the building's decorative terracotta cornice and reflects the sky. At night, the valance washes colored light over the brick. The color of the light complements the natural color of the brick, but is also oversaturated to add a layer of singular poetry identifying the building. High-powered spotlights on the facade seemingly stretch the building vertically, and remaining terracotta ornaments along the roofline are highlighted with linear uplights and spotlights.

Bei dem Restaurierungsprojekt der historischen Backsteinfassade wird die historische Vergangenheit des Gebäudes mit dem kreativen Schwung des P.S.1 zu einer Einheit verbunden. Eine durchgehende, aus poliertem Stahl gearbeitete Blende ragt aus der Fassade hervor, spiegelt das dekorative Terracottasims des Gebäudes und den Himmel wider. Bei Nacht taucht die Blende die Backsteinmauern in farbiges Licht. Der natürliche Ton des Ziegelsteins wird durch die Farbnuance des Lichts ergänzt. Das Gemäuer scheint von diesem Licht fast übersättigt, was einen Hauch einzigartiger Poesie über das Gebäude legt und ihm so eine ganz besondere Persönlichkeit verleiht. Leistungsstarke Spotlights an der Fassade scheinen das Gebäude in die Höhe zu strecken, und noch erhaltene Terracottaornamente am oberen Gebäuderand werden durch geradlinige Bodenstrahler und Spotlights betont.

Avec la restauration de la façade de brique historique du P.S.1, l'éclairage relie la nature historique de l'immeuble avec le sommet très imaginatif du P.S.1. Une bordure en acier inoxydable brossé, montée sur la façade reprend la forme de la corniche décorative en terre cuite de l'immeuble et du ciel. La nuit, la bordure éclaire la brique d'une lumière colorée. La couleur des lumières complète la couleur naturelle de la brique, mais elle est aussi sursaturée afin d'ajouter une couche de poésie singulière qui identifie l'immeuble. Des spots à grande puissance dirigés sur la façade semblent étirer l'immeuble dans le sens vertical, et les ornements de terre cuite conservés le long de la ligne du toit sont soulignés par des éclairages supérieurs et des spots.

Con la restauración de la histórica fachada de ladrillo del P.S.1, la iluminación unifica la naturaleza histórica del edificio con el borde imaginativo del P.S.1. Una cenefa continua, cepillada, de acero inoxidable y en voladizo respecto a la fachada, refleja la decorativa cornisa de terracota del edificio y el cielo. Por la noche, la cenefa lava la luz de color sobre el ladrillo. El color de la luz complementa el color natural del ladrillo, pero también lo sobresatura para añadir una capa de original poesía que caracteriza al edificio. Unos focos de alta potencia colocados en la fachada parecen estilizar el edificio verticalmente, y los ornamentos de terracota que quedan a lo largo del tejado son resaltados con iluminaciones lineales orientadas hacia arriba y proyectores.

Con il restauro della facciata in mattoni storica del P.S.1, l'illuminazione unisce la natura storica dell'edificio con il bordo immaginario del P.S.1. Una balza continua in acciaio inossidabile, sgrossata, realizzata a sbalzo sulla facciata, rispecchia la decorativa cornice di terracotta dell'edificio e riflette il cielo. Di notte, la balza riversa luce a colori sui mattoni. Il colore della luce integra il colore naturale del mattone, ma è inoltre sovrassatura in modo tale da aggiungere uno strato di singolare poesia identificante l'edificio. Fari ad alta potenza sulla facciata sembrano estendere l'edificio verticalmente, e i rimanenti ornamenti di terracotta lungo la linea del tetto sono esaltati con luci rivolte verso l'alto e fari lineari.

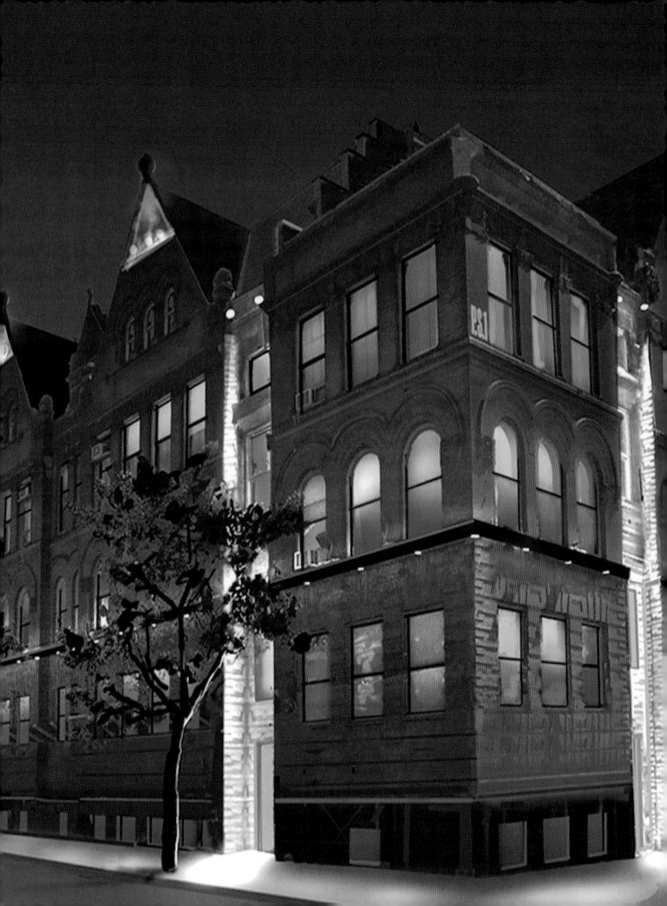

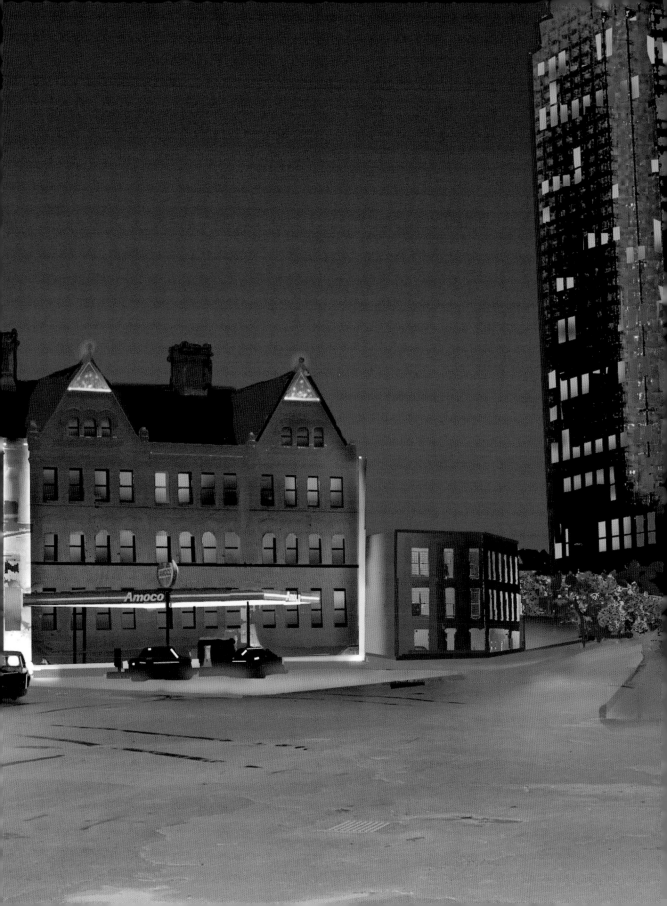

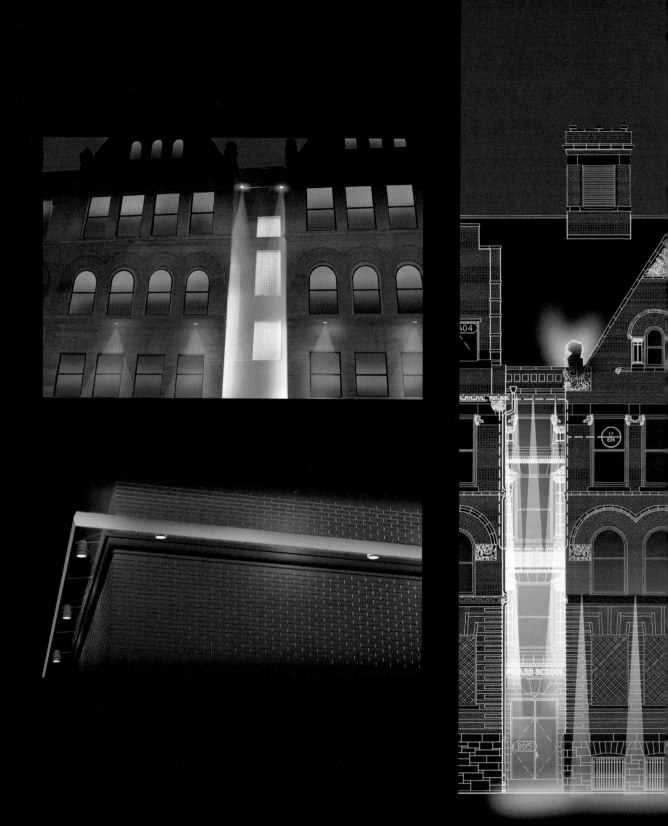

"Rendez-vous" at the Guggenheim

Location: New York, New York, USA
Exhibition Designer: Andrée Putman, France
Completed: 1998

For this temporary exhibition, most of the lighting in the ceiling is removed, and replaced with glowing pedestals and floor-mounted theatrical lighting. This provides a playful approach creating unexpected revelations from the objects on display, while maintaining a respectful attitude towards the architecture.

Für diese temporäre Ausstellung wurde die Deckenbeleuchtung größtenteils entfernt und durch leuchtende Sockel und am Boden angebrachte Theaterbeleuchtung ersetzt. Durch diesen verspielten Ansatz werden unerwartete Aspekte der Ausstellungsobjekte offenbart, während gleichzeitig die Architektur des Gebäudes respektiert wird.

Pour cette exposition temporaire, la plupart de l'éclairage de plafond a été retiré et remplacé par des lumières sur piédestal et des projecteurs de théâtre montés dans le sol. Ce qui constitue une approche très enjouée, créant des révélations très inattendues des objets exposés, tout en maintenant une attitude de respect envers l'architecture.

Para esta exposición temporal, la mayoría de los elementos de iluminación del techo se desmonta, y se reemplaza con pedestales brillantes e iluminación de teatro montada en el suelo. Esto proporciona un lúdico acercamiento que crea revelaciones inesperadas de los objetos en los expositores, mientras que se mantiene una actitud respetuosa hacia la arquitectura.

Per questa esposizione temporanea la maggior parte dell'illuminazione dal soffitto è rimossa e sostituita da piedistalli lucenti ed illuminazione teatrale montata sul pavimento. Ciò produce un approccio svagato creante rivelazioni inattese dagli oggetti esposti, conservando tuttavia un'attitudine di rispetto verso l'architettura.

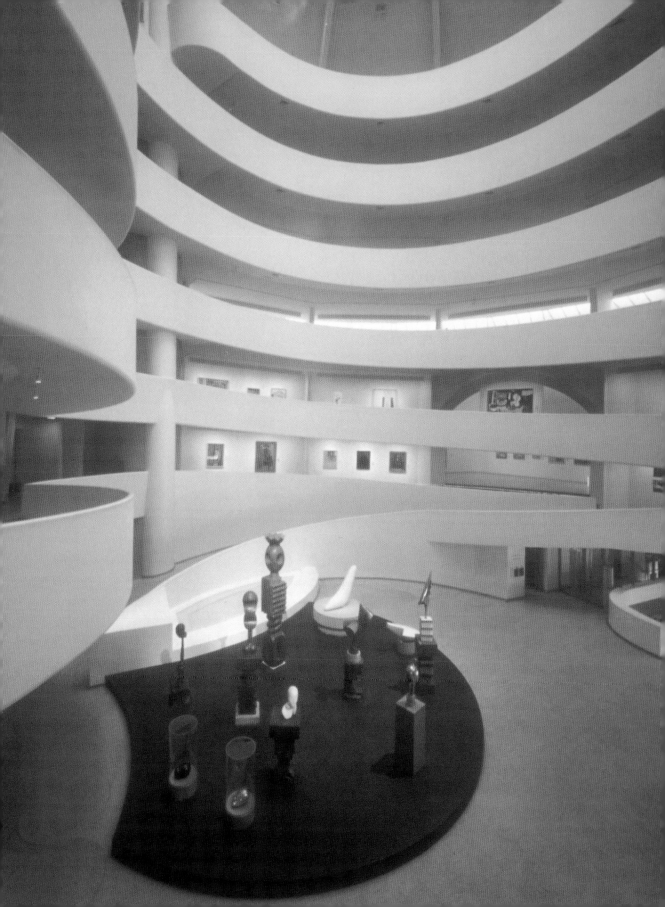

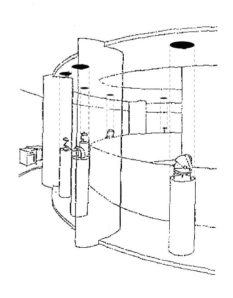

Bioscleave House

Location: Long Island, New York, USA
Artists: Arakawa and Gins, USA
To be completed: 2006

The artists and philosophers Arakawa and Gins executed extensive interdisciplinary research which engendered atypical solutions for domestic space. In response, the lighting is made mobile and changeable. Light for various rooms comes from sources in the walls, floors, and ceilings. Lighting for common spaces is integrated with the exterior scheme.

Die Künstler und Poeten Arkawa und Gins unternahmen weitläufige, interdisziplinäre Forschungen und entwickelten einen sehr untypischen Lösungsansatz für Wohnbereiche. Die Beleuchtung wurde daher beweglich und auswechselbar gestaltet. In verschiedenen Räumen sind Lichtquellen in Wand, Fußboden oder Decke integriert. Die Beleuchtung für Gemeinschafträume ist mit dem Plan der Außenanlage abgestimmt.

Les artistes et poètes Arakawa et Gins ont réalisé d'intensives recherches interdisciplinaires qui ont engendré des solution atypiques dans les espaces domestiques. En réponse, l'éclairage est rendu mobile et modifiable. La lumière pour différentes pièces provient de sources dans les murs, les sols et les plafonds. L'éclairage des espaces communs est intégré au schéma extérieur.

Los artistas y poetas Arakawa y Gins llevaron a cabo una investigación interdisciplinar extensa que creó soluciones atípicas para los espacios domésticos. Como respuesta, la iluminación se hace móvil y variable. La luz de varias estancias procede de fuentes situadas en las paredes, los suelos y los techos. La iluminación de las zonas comunes se integra en el esquema exterior.

Ricerca interdisciplinare estensiva applicata dagli artisti e poeti Arakawa e Gins generando soluzioni atipiche per ambienti domestici. A tale fine l'illuminazione è realizzata in modo mobile ed intercambiabile. Luce per diversi vani proviene da fonti situate nelle pareti, nei pavimenti e nei soffitti. L'illuminazione per gli spazi comuni è integrata nel sistema esterno.

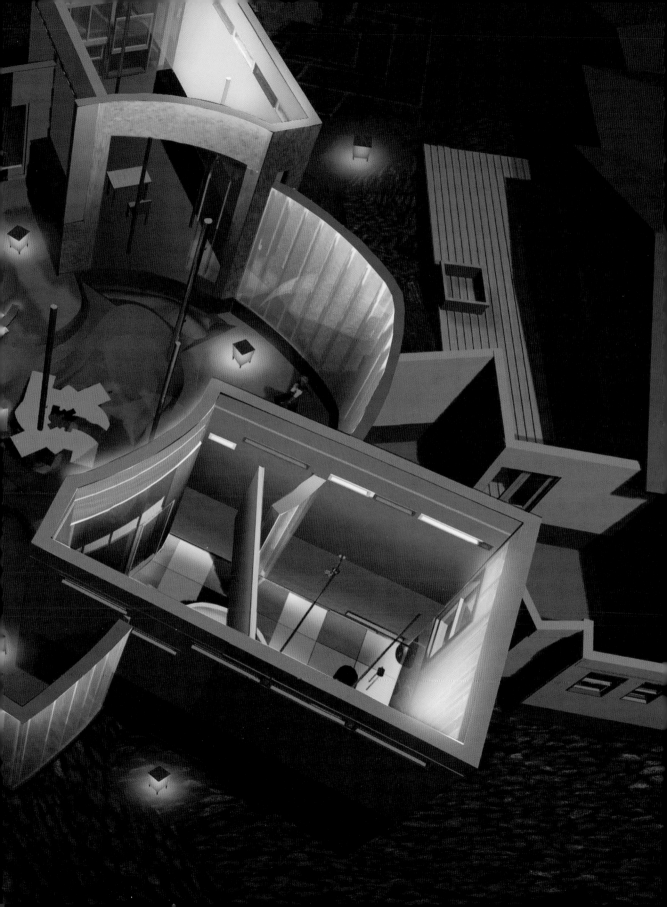

Olympic Village Competition

Location: Queens, New York, USA
Architects: Zaha Hadid Architects, UK
Design Year: 2004

For this multi-tower project, the lighting contrasts the tower's verticality with the horizontality of the pathways. The towers taper at their bases and are submerged into recessed wells. Light emanates from this source, making the building appear to rest on cushions of light off of which the towers seemingly hydroplane.

Bei dieser aus mehreren Türmen bestehenden Anlage wird der Kontrast zwischen der senkrechten Ausrichtung der Türme und der waagerechten Ausrichtung der Übergänge durch das Licht verstärkt. Die Türme werden nach unten hin enger und tauchen schließlich in in den Boden eingelassene Wasserbecken ein. Licht erstrahlt aus dem Wasser, was ihnen den Anschein verleiht, auf einer Art Lichtkissen zu schweben.

Dans ce projet à tours multiples, l'éclairage réalise un contraste entre la verticalité des tours et l'horizontalité des allées. Les tours sont effilées vers leur base et enfoncées dans des puits encastrés. La lumière émane de ces puits, donnant l'impression que l'immeuble repose sur des coussins de lumière sur lesquelles les tours semblent flotter.

Para este proyecto de varias torres, la iluminación contrasta la verticalidad de la torre con la horizontalidad de los senderos. Las torres se afilan en sus bases y se sumergen en fuentes escondidas. La luz emana de esta fuente, haciendo que el edificio parezca que descansa en almohadones de luz apagada en los que las torres parecen deslizarse.

Per questo progetto dalle molte torri, l'illuminazione contrasta la verticalità delle torri con l'orizzontalità dei sentieri. Le torri si assottigliano alla loro base e sono immerse in fonti incassate. Da queste fonti emana luce, dando l'impressione che l'edificio sia adagiato su cuscini di luce, dai quali le torri sembrano "idroplanare".

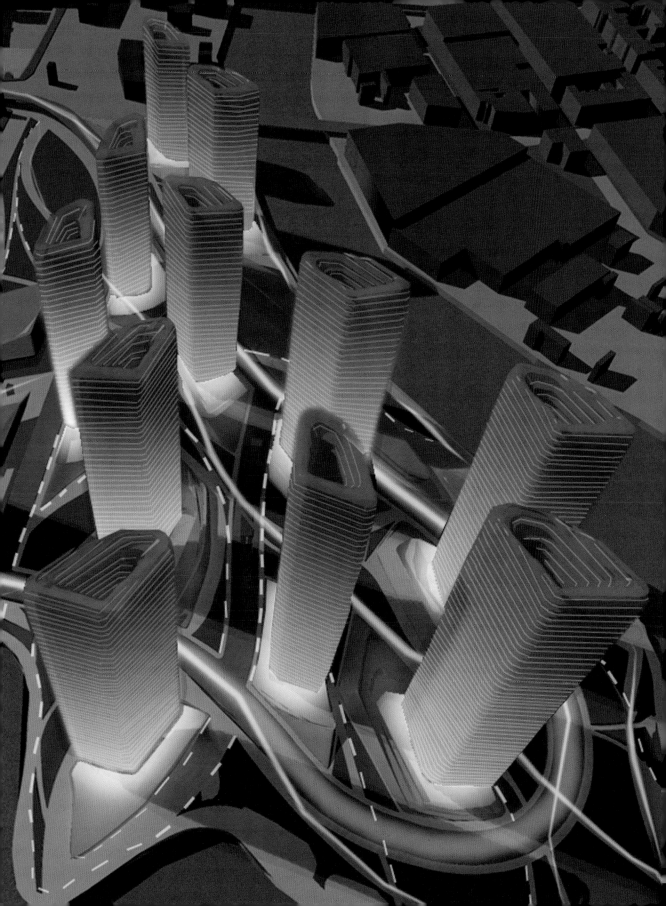

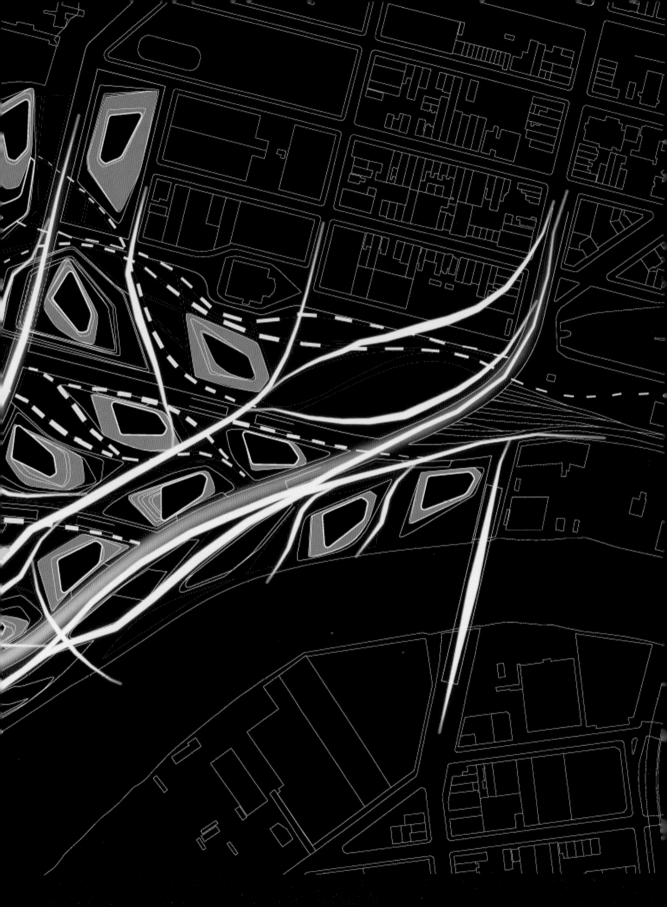

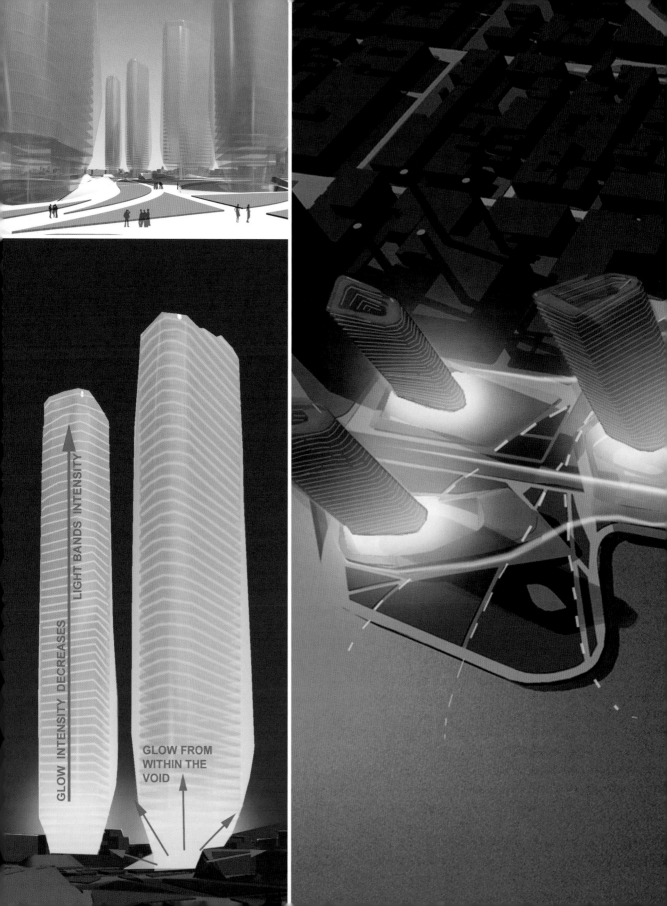

LIGHT BANDS INTENSITY

GLOW INTENSITY DECREASES

GLOW FROM
WITHIN THE
VOID

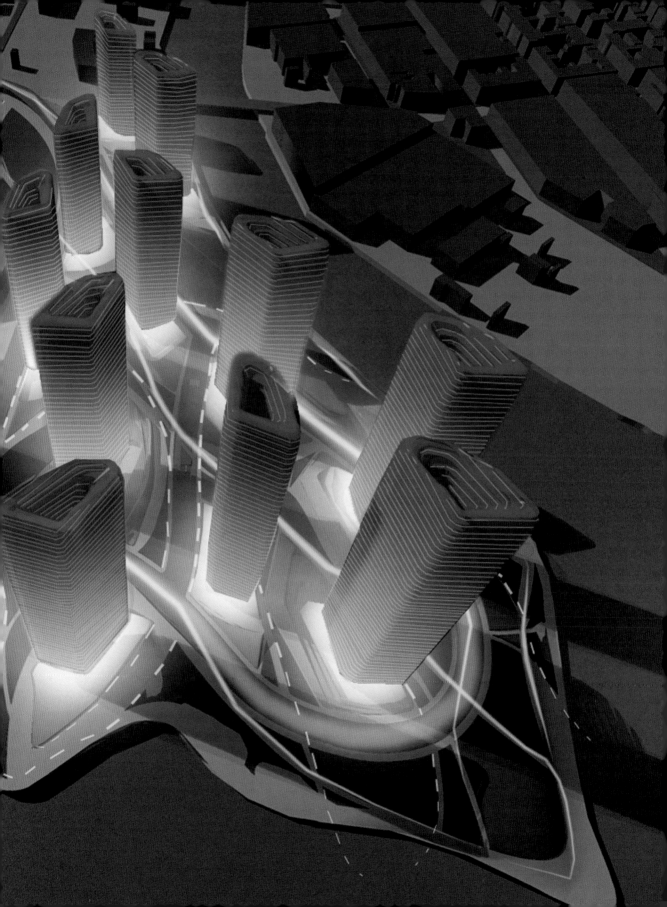

Trading Floor Operations Center at the New York Stock Exchange

Location: New York, New York, USA
Architects: Asymptote Architecture, USA
Completed: 2001

The project includes the renovation and redesign of the existing ramp area on the trading floor of the Stock Exchange. It includes a virtual environment displaying activities and events on the trading floor for interactive users in real-time. The lighting, integrated into the architectural design, consists of an undulating glass wall with flat screen monitors on the surface. The wall glows with a blue light that simulates the background color of the screens when they are idle. There are also work surfaces lit by fibre optics, a large recessed elliptical light source above the main platform area, and an illuminated large scale graphic wall.

Das Projekt umfasst die Renovierung und Neugestaltung der bereits existierenden Rampe auf dem Börsenparkett. In einer virtuellen Umgebung wird das Geschehen auf dem Parkett für interaktive Nutzer in Echtzeit wiedergegeben. Die in das Bauplandesign integrierte Beleuchtung besteht aus einer gewellten Glaswand, in die Flachbildschirme eingelassen sind. Die blau leuchtende Wand nimmt die Hintergrundfarbe der Bildschirme in Stand-by-Modus auf. Es gibt mit Glasfaserkabeln beleuchtete Arbeitsflächen, eine großformatige, beleuchtete Grafikwand und über dem Hauptparkett wurde eine überdimensionale, ovale Lampe in die Decke eingelassen.

Le projet comprend la rénovation et la remise à niveau de la zone de l'actuelle rampe d'accès au niveau des transactions commerciales de la bourse. Le projet comprend un environnement virtuel retransmettant les activités et les évènements du niveau des transactions pour des utilisateurs interactifs en temps réel. L'éclairage, intégré à l'architecture, est constitué d'un mur de verre ondulé portant sur sa surface des moniteurs à écran plat. Le mur diffuse une lumière bleue qui simule la couleur de fond des écrans quand ceux-ci sont arrêtés. On découvre également des plans de travail éclairés par des fibres optiques, une grande source de lumière elliptique encastrée au dessus de l'espace de la plateforme principale, et un mur graphique illuminé de grand format.

El proyecto incluye la renovación y reestructuración de la zona de la rampa existente en el parqué de comercio de la Bolsa. Incluye un entorno virtual que muestra actividades y eventos en el parqué de comercio para usuarios interactivos en tiempo real. La iluminación, integrada en el diseño arquitectónico, está compuesta por una pared de cristal ondulado con monitores de pantalla plana en la superficie. La pared brilla con una luz azul que simula el color de fondo de las pantallas cuando están desenchufadas. También hay superficies de trabajo iluminadas con fibra óptica, una gran fuente de luz de forma elíptica escondida encima de la zona de la plataforma principal, y un muro de gráfico a gran escala iluminado.

Il progetto comprende il rinnovo ed il ridisegno della zona rampa esistente nella sala della borsa. Include un ambiente virtuale visualizzante attività ed eventi nella sala della borsa per utenti interattivi in tempo reale. L'illuminazione, integrata nel design architettonico, consiste in una parete di vetro ondulata con monitor a schermo piatto sulla superficie. La parete emana una luce blu che simula il colore di sfondo degli schermi quando sono spenti. Esistono anche superfici di lavoro illuminate con ottiche in fibra, una grande fonte luminosa ellittica incassata al di sopra dell'area della piattaforma centrale, ed un'ampia parete grafica illuminata.

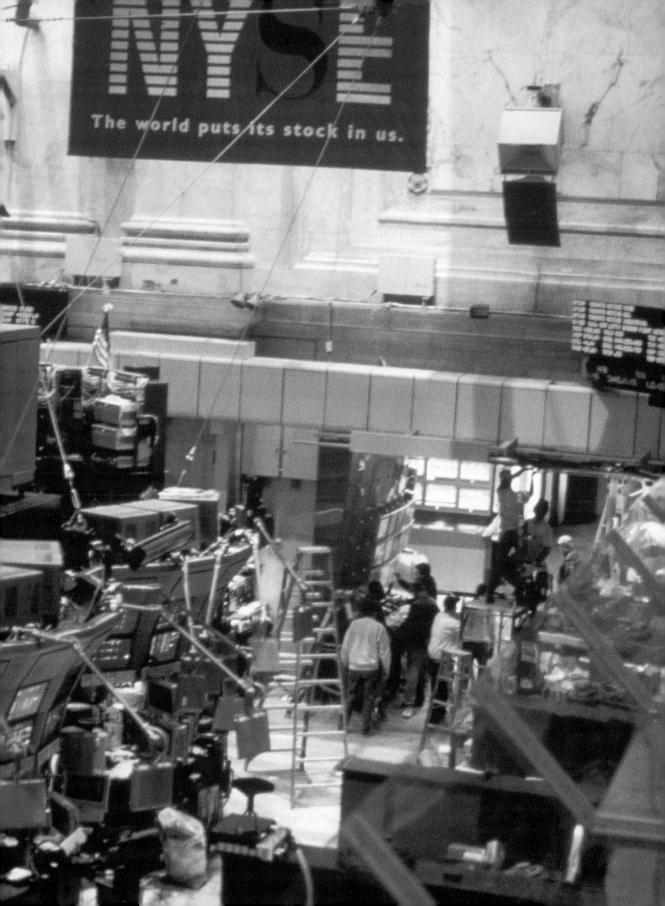

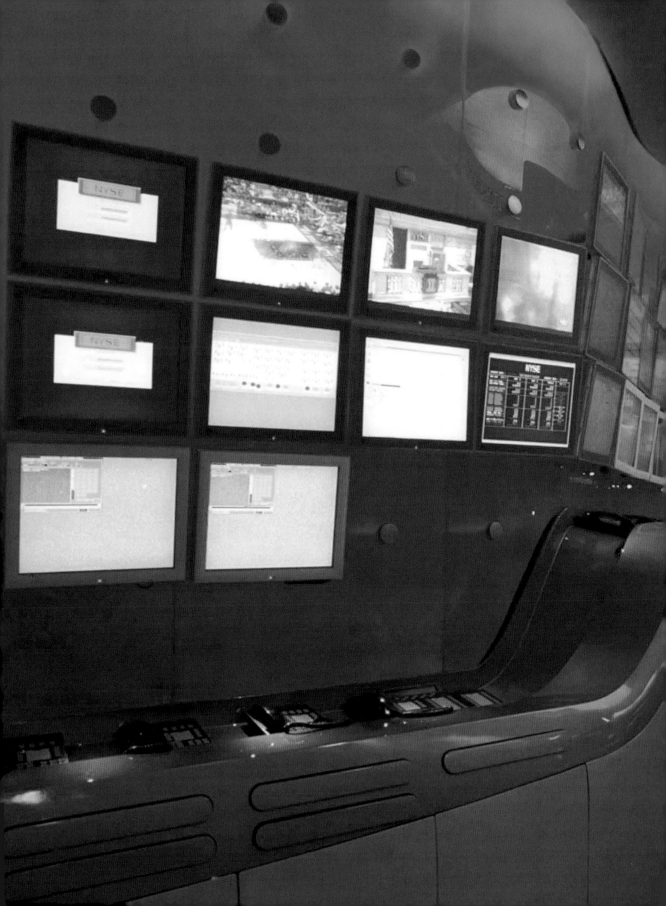

66

Location: New York, New York, USA
Architects: Richard Meier Architects, USA
Completed: 2002

Jean-Georges Vongerichten's restaurant serves up Southeast Asian cuisine in a uniquely modern atmosphere. Evocative of a gallery space, light coruscates through large bay windows in the day. At night, the mood is created by four different types of light sources, including ones embedded in architectural elements used as reflectors and diffusers, large silk glowing fixtures half-recessed in the ceiling, an intimate series of floor-lamps providing soft light, and accent lighting creating a dynamic layered screen-like effect. Chef and owner Vongerichten explains that "in my field, feeling good in one's space is of the utmost importance, and Hervé has shown me how to achieve this every time."

Im Restaurant von Jean-Georges Vongerichten werden in einzigartig moderner Atmosphäre Gerichte der südostasiatischen Küche serviert. Bei Tage strömt Licht durch große Fenster, was die Räumlichkeiten wie eine Kunstgallerie erscheinen lässt. Abends wird das Ambiente durch vier verschiedene Arten von Lichtquellen erzeugt. Darunter befinden sich das Licht reflektierende und streuende Elemente, die in die Gebäudestruktur eingelassen sind, sowie große, seidig schimmernde Stimmungsleuchten, die halb in der Decke versenkt sind. Eine Reihe von Fußbodenlampen wirft ein weiches, intimes Licht und dynamisch vielschichtige Akzentbeleuchtung teilt den Raum optisch auf. Chefkoch und Restaurantbesitzer Vongerichten erklärt, dass „es in der Gastronomie das Allerwichtigste ist, sich an einem Ort wohlzufühlen. Hervé hat mir jedesmal wieder gezeigt, wie ich das erreichen kann."

Le restaurant de Jean-Georges Vongerichten sert une cuisine de l'Asie du Sud-est dans une atmosphère particulièrement moderne. Dans un style évoquant une salle d'exposition, la lumière pénètre pendant le jour par de larges baies vitrées. La nuit, l'ambiance est crée par quatre différents types de lumière, qui sont intégrés dans les éléments architecturaux qui sont utilisés comme réflecteurs et comme diffuseurs, de grandes étoffes de soie lumineuses à demi encastrées dans le plafond, toute une série de lampes de sol donnent un éclairage tamisé, et un éclairage accentué créant un effet dynamique comme des écrans superposés. Le chef et propriétaire Vongerichten explique que « dans mon domaine, se sentir bien dans son propre espace est une des choses les plus importantes, et Hervé m'a montré comment l'obtenir en toutes circonstances. »

El restaurante de Jean-Georges Vongerichten sirve cocina del sudeste asiático en un ambiente moderno único. Evocando el espacio de una galería, la luz cae en forma de cascada a través de grandes ventanas saledizas durante el día. Por la noche, el ambiente lo crean cuatro tipos distintos de fuentes de luz que incluyen unas luces empotradas en elementos arquitectónicos que se utilizan como reflectores y difusores, grandes accesorios luminosos con brillos de seda semiocultos en el techo, unas líneas independientes de lámparas de pie que proporcionan luz tenue, y acentos de iluminación que crean una especie de efecto de pantalla a capas dinámico. Vongerichten explica como chef y propietario que "en mi profesión, sentirse a gusto en el lugar donde se trabaja es lo más importante, y Hervé me ha mostrado cómo lograrlo siempre."

Il ristorante di Jean-Georges Vongerichten serve cucina sudestasiatica in un'atmosfera moderna unica. Evocando un ambiente di galleria, la luce brilla attraverso grandi finestre a bovindo durante il giorno. Di sera l'atmosfera viene crata da quattro tipologie di fonte luminosa diverse, di cui alcune sono incorporate in elementi architettonici utilizzati come riflettori e diffusori, grandi corpi illuminanti a lucentezza serica semi-incassati nel soffitto, una simpatica serie di lampade nel pavimento emananti una luce morbida ed un'illuminazione d'accento creante un dinamico effetto tipo schermo stratificato. Il capocuoco e titolare Vongerichten spiega: "Nel mio mestiere il sentirsi a proprio agio nei propri spazi è della massima importanza, e Hervé mi ha mostrato come riuscirvi ogni volta."

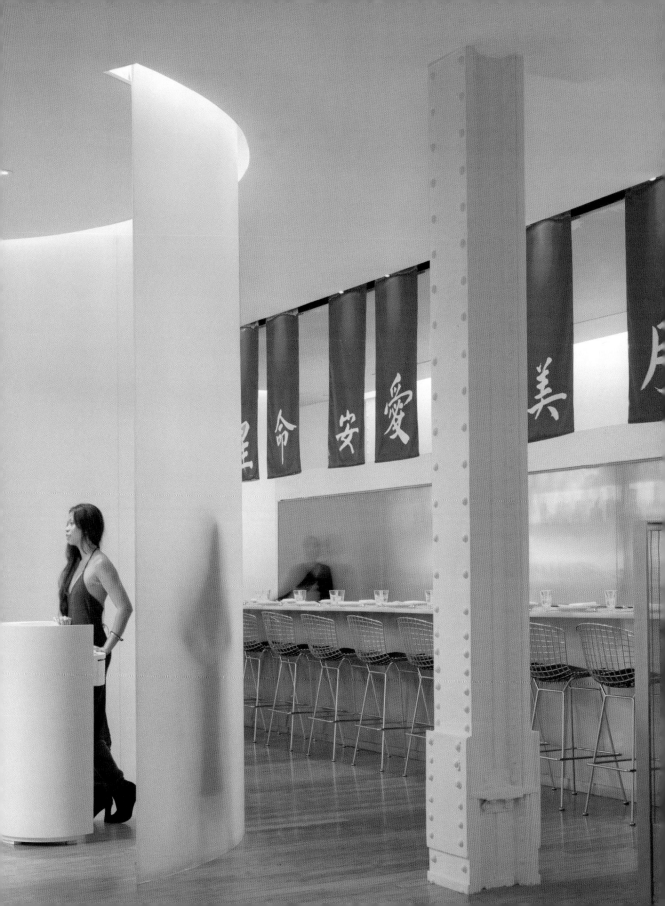

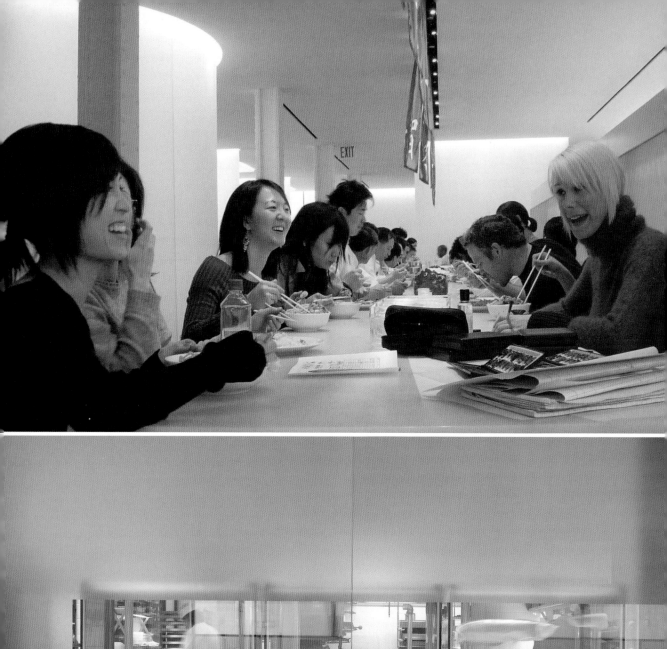
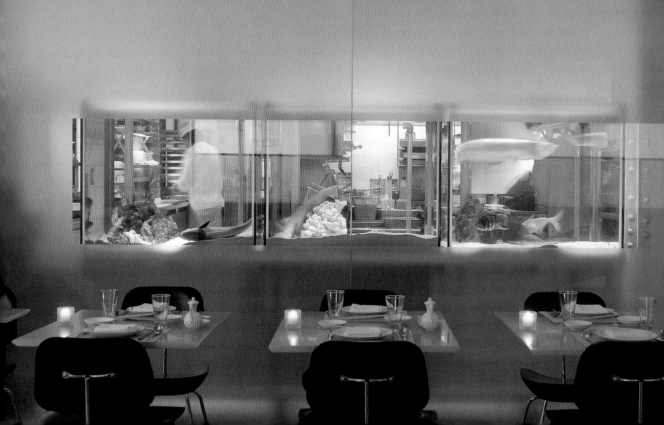

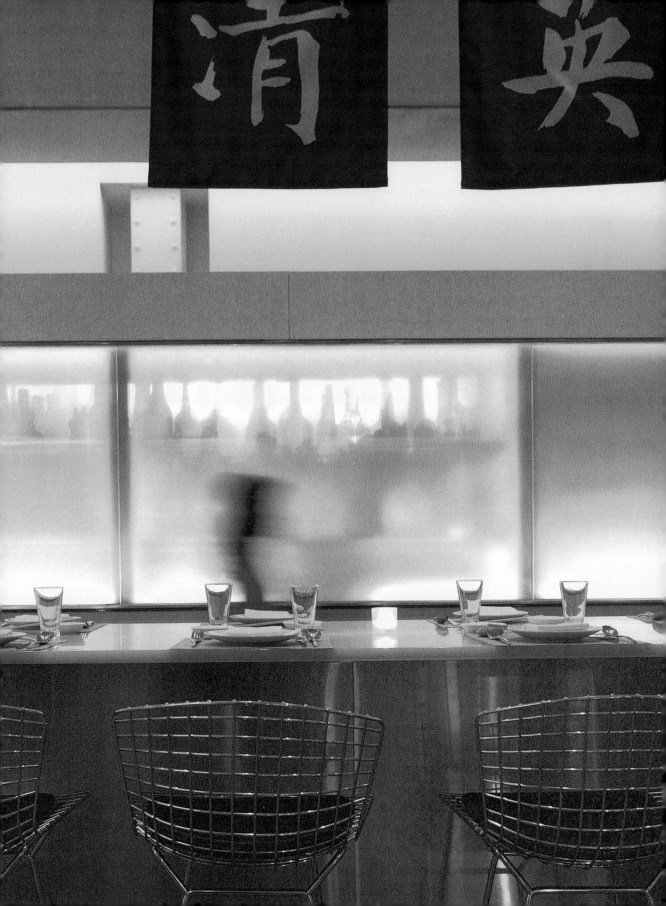

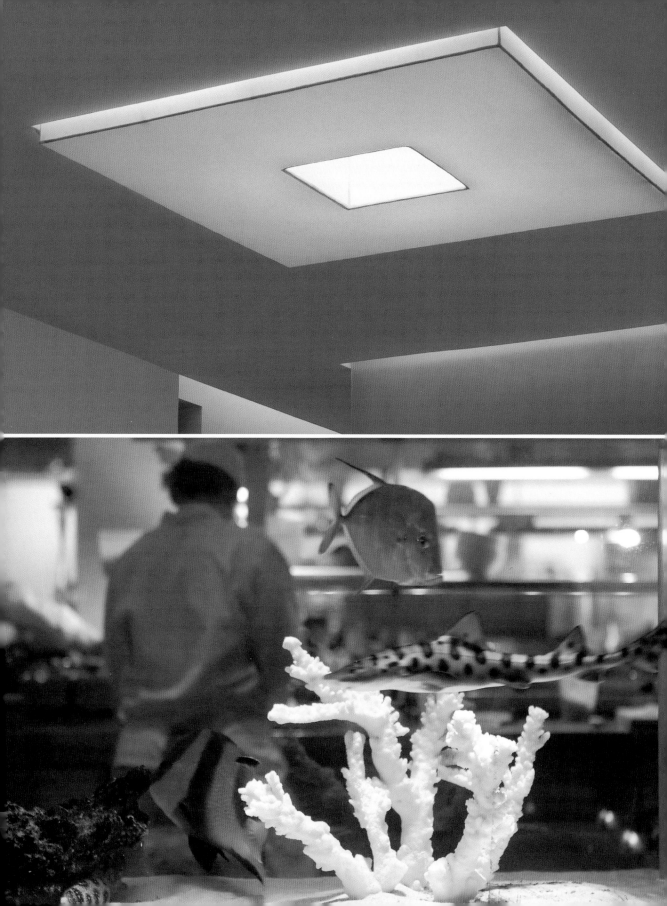

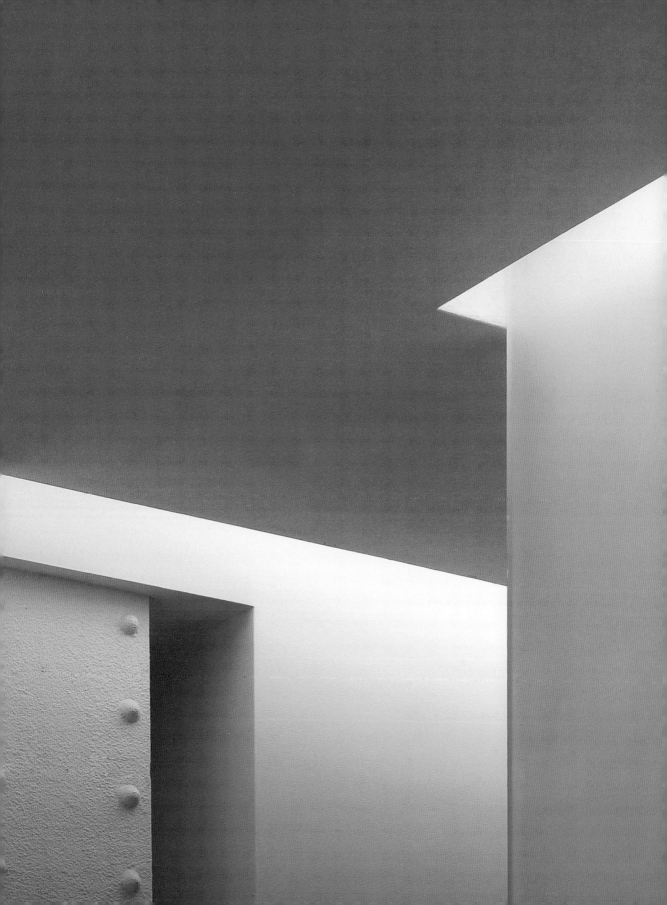

Lever House Restaurant

Location: New York, New York, USA
Designer: Marc Newson, Australia
Completed: 2002

At the restaurant, the lighting concept is derived from the futuristic nostalgia of its interior design. A balance of light comes from floor and ceiling and changes throughout the night. Moreover, alcove spaces provide a more intimate atmosphere for diners.

Das Beleuchtungskonzept in diesem Restaurant wurde aus der futuristischen Nostalgie seiner Innenarchitektur abgeleitet. Ein sich im Laufe der Nacht veränderndes Licht kommt zu gleichen Teilen aus Boden- und Deckenstrahlern. Darüber hinaus bieten Nischenplätze dem Gast eine etwas privatere Atmosphäre.

Dans le restaurant le concept d'éclairage est dérivé de la nostalgie futuriste de son décor intérieur. L'équilibre lumineux est partagé entre des éclairages de sol et de plafond, et il varie au cours de la soirée. De plus les espaces d'alcôves fournissent une atmosphère plus intime pour les convives.

En este restaurante, el concepto de iluminación deriva de la nostalgia futurista de su diseño interior. Un equilibrio de luces proviene del suelo y del techo y cambia a lo largo de la noche. Además, los espacios huecos proporcionan un ambiente más íntimo para las cenas.

Al ristorante, il concetto di illuminazione deriva dalla nostalgia futuristica del suo design interno. Dal pavimento e dal soffitto viene emessa un'illuminazione equilibrata che cambia per tutta la notte. Inoltre, spazi di alcova creano un'atmosfera più intima per i ristoranti.

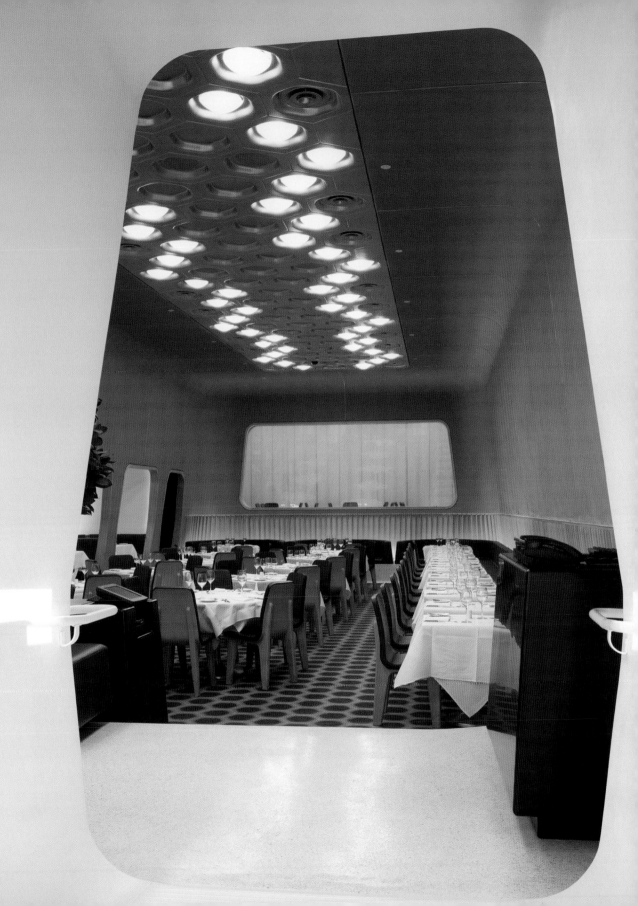

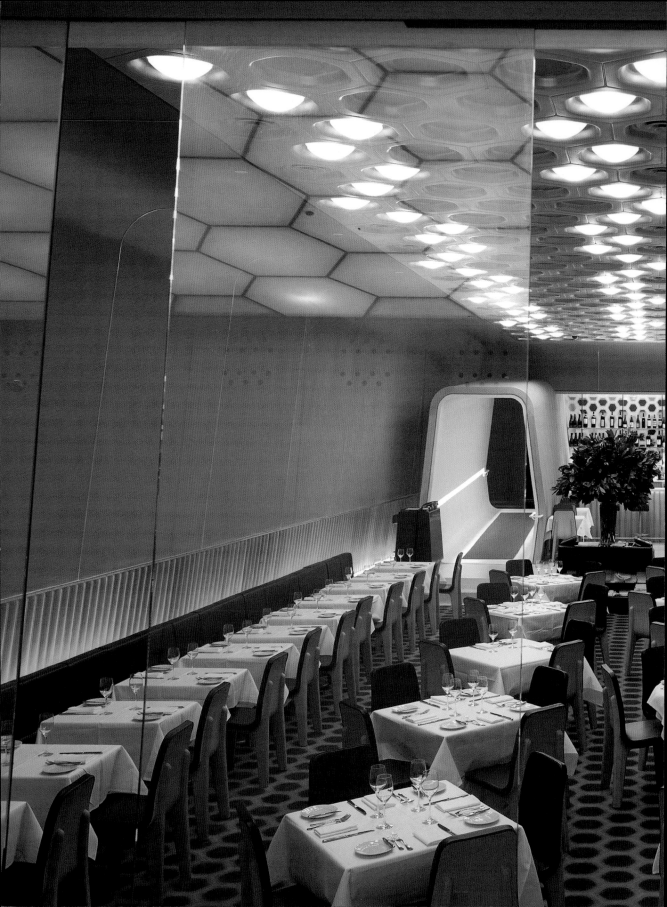

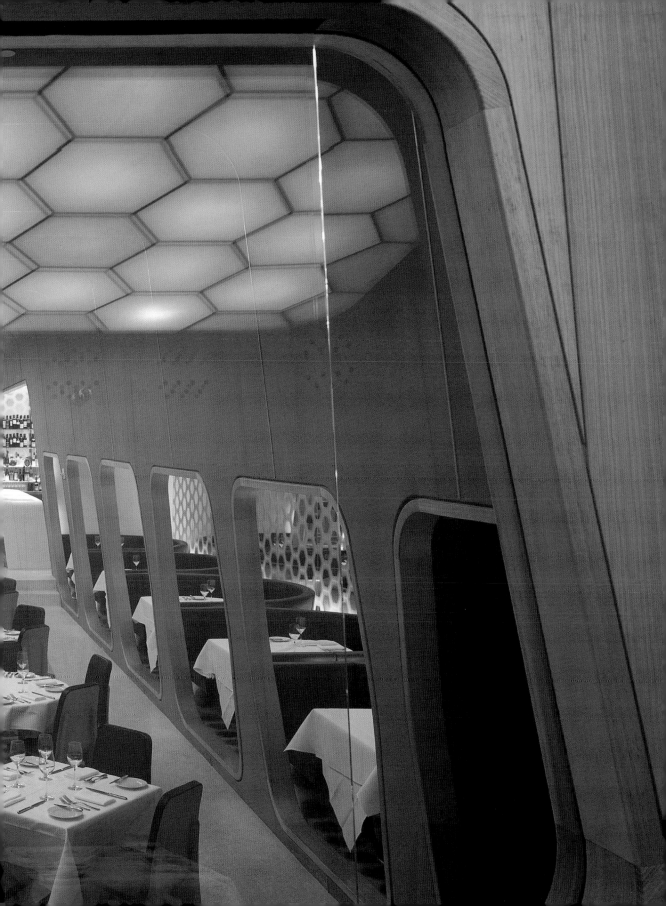

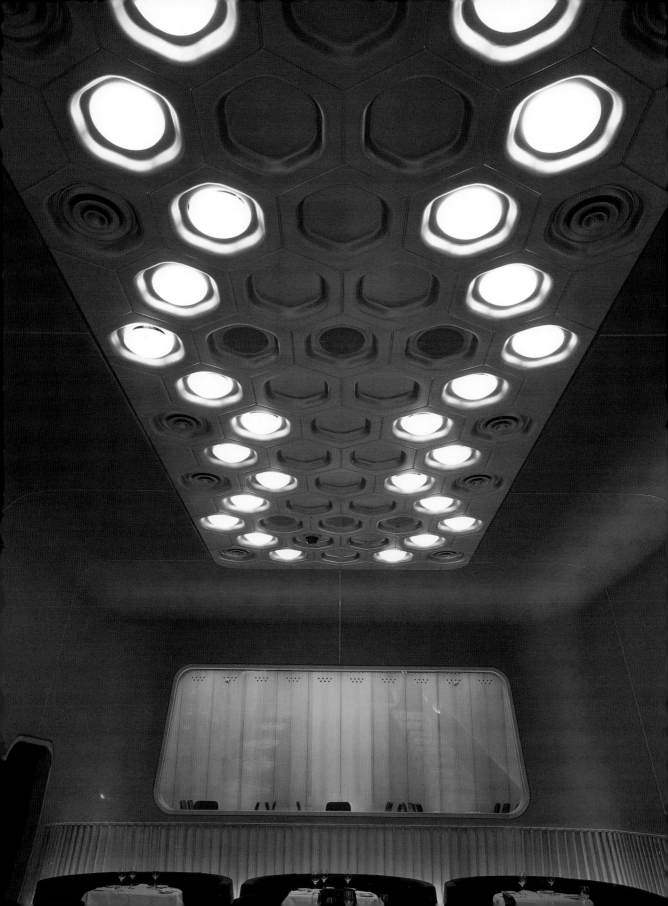

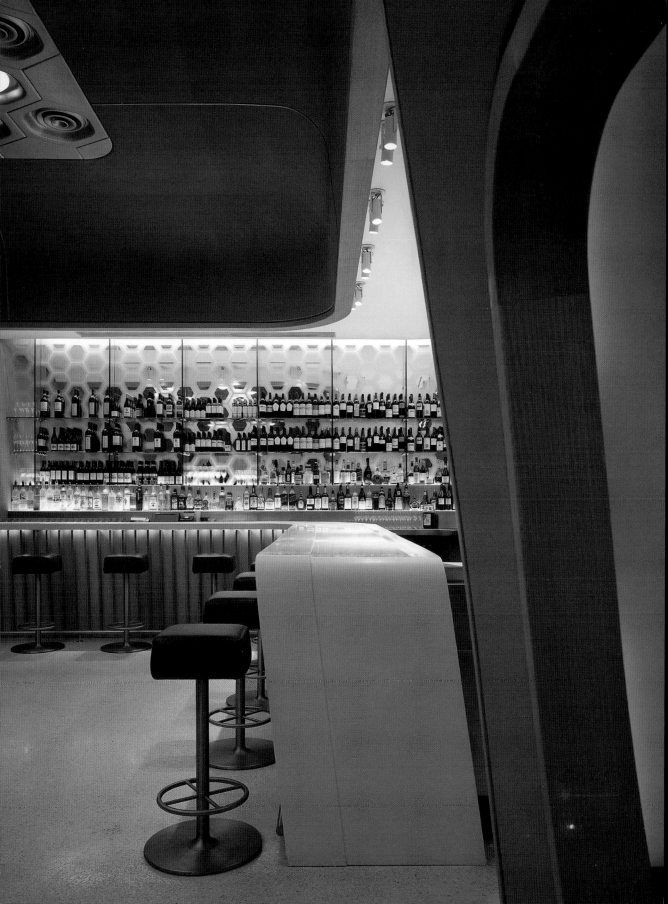

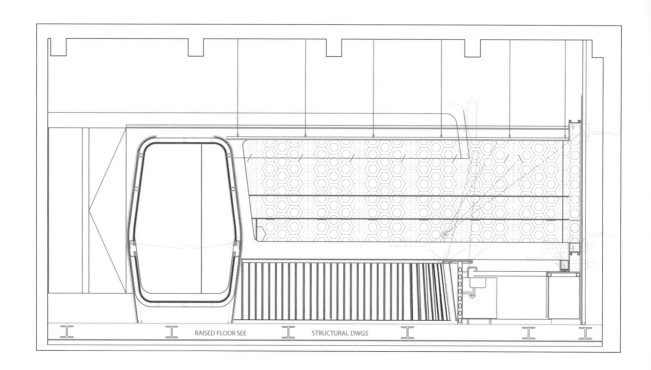

RAISED FLOOR SEE STRUCTURAL DWGS

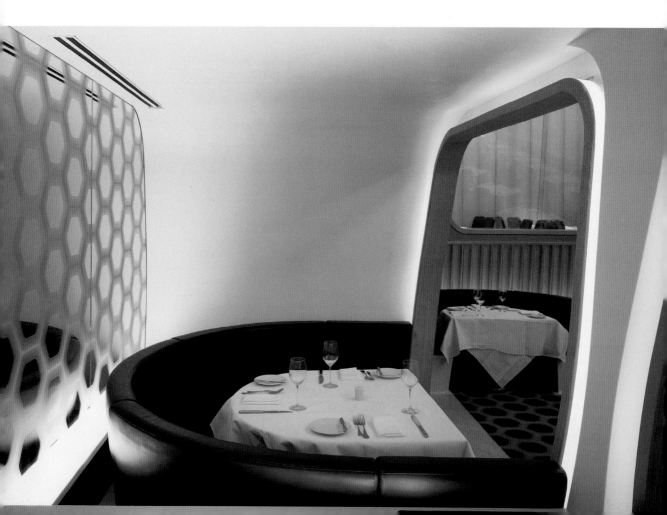

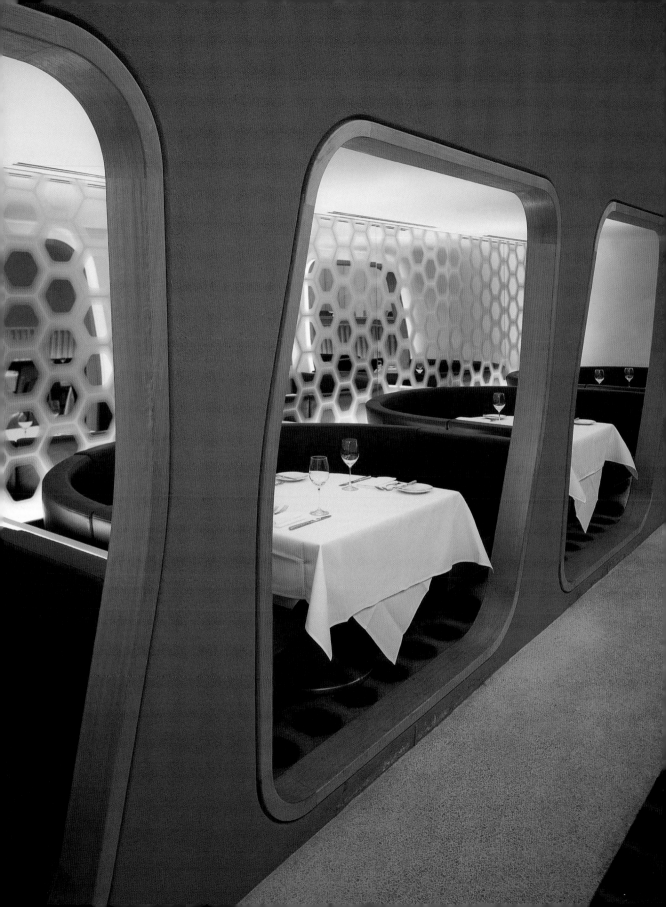

Mercer Hotel and Mercer Kitchen

Location: New York, New York, USA
Interior Architects: Christian Liaigre, France
Completed: 1998

The 75 room hotel is located the heart of Soho in New York City. The space has an industrial flavor characteristic to the neighborhood, so the lighting is designed to be intimate and warm. In the restaurant, with its long, communal tables, intimacy was achieved by keeping the fixtures very low, creating warm pockets of light above individual dining parties.

Dieses 75 Zimmer große Hotel liegt im Herzen Sohos in New York City. Das Hotel sieht wie eine alte Fabrikanlage aus, was für die Gegend sehr charakteristisch ist. Die Beleuchtung wurde so ausgewählt, um eine persönlichere Atmosphäre zu schaffen. Im Restaurant, wo Gäste an langen Gemeinschaftstischen Platz finden, wurde Intimität dadurch erreicht, dass tiefhängende Beleuchtungselemente warme Lichtfelder über einzelnen Gästegruppen bilden.

Cet hôtel de 75 chambres est situé dans le cœur de Soho à New York City. Cet espace possède un flair industriel caractéristique du voisinage, l'éclairage est donc conçu pour être chaleureux et intimiste. Dans le restaurant, avec ses longues tables communes, l'intimité est réalisée en conservant l'éclairage faible, et en créant des poches de lumière chaudes au-dessus de plaisirs culinaires individuels.

El hotel de 75 habitaciones está situado en el corazón del Soho en la ciudad de Nueva York. La zona posee un aire industrial característico del vecindario, por lo que la iluminación está diseñada para ser íntima y cálida. En el restaurante, con sus grandes mesas compartidas, la privacidad se consigue manteniendo los accesorios de iluminación con baja intensidad, creando cálidas linternas encima de cada uno de los comensales.

L'albergo con 75 camere è situato nel cuore di Soho a New York. L'ambiente ha un carattere industriale corrispondente alla zona circostante, quindi si ricerca un'illuminazione accogliente e calda. Nel ristorante, con i suoi lunghi tavoli collettivi, l'accoglienza è stata creata tenendo gli elementi molto bassi, realizzando calde tasche di luce su zone individuali del ristorante.

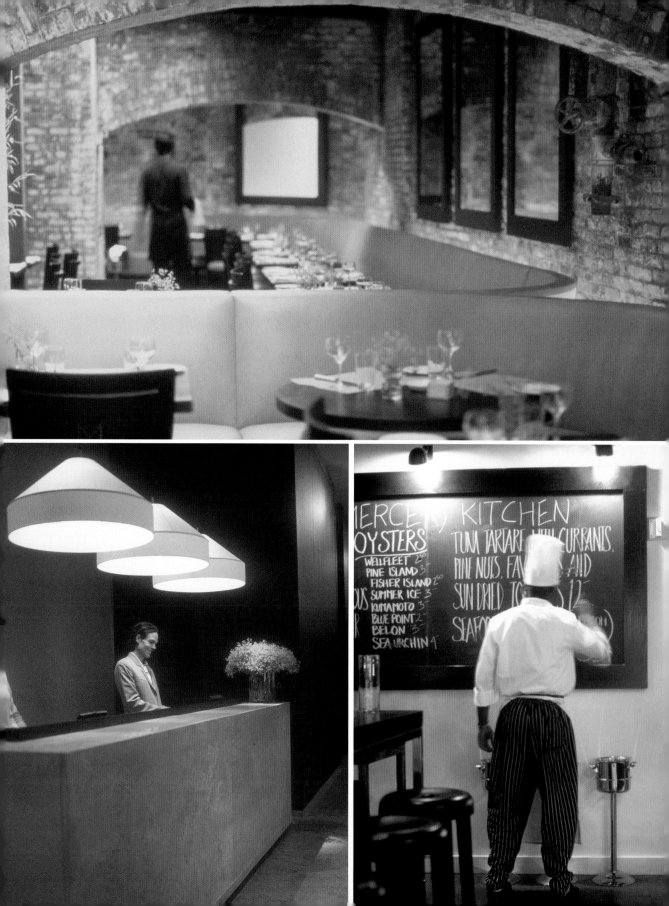

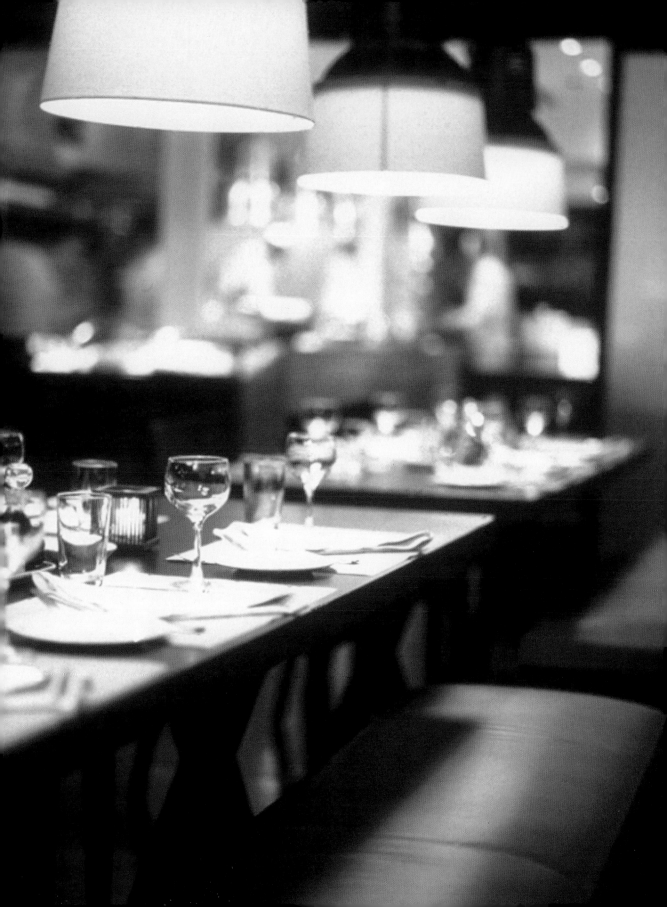

Hotel QT

Location: New York, New York, USA
Architect: ROY Co., USA
Completed: 2005

Warm and sexy lighting highlights the subtle divisions among a myriad of hidden spaces. Lighting assists to obfuscate the natural divisions of day and night inside of the hotel. A nautical ambiance is additionally created with lighting to further associate both spa and hotel lobby.

Warmes, sexy Licht betont die raffiniert angebrachten Abtrennungen unzähliger versteckter Nischen und Plätze. Die Beleuchtung trägt dazu bei, die natürliche Teilung zwischen Tag und Nacht im Inneren des Hotels verschwimmen zu lassen. Zusätzlich wurde mit Hilfe von Licht eine maritime Atmosphäre geschaffen, um Schwimmbad und Lobby noch stärker miteinander zu verbinden.

Un éclairage chaud et sexy met en valeur les cloisonnements subtils parmi une myriade de coins cachés. L'éclairage contribue à masquer les divisions naturelles du jour et de la nuit à l'intérieur de l'hôtel. En supplément on peut créer une atmosphère maritime à l'aide d'éclairages afin d'associer également les bains et le salon de l'hôtel.

La iluminación cálida y sexy destaca las divisiones sutiles entre una miríada de espacios ocultos. La iluminación contribuye a ofuscar las divisiones naturales del día y la noche dentro del hotel. Un ambiente náutico se crea de forma adicional con una iluminación que vincula en mayor medida el balneario con el recibidor del hotel.

Un'illuminazione calda e seducente esalta le divisioni raffinate in una miriade di spazi nascosti. L'illuminazione contribuisce a celare le divisioni naturali tra il giorno e la notte all'interno dell'albergo. Inoltre, con l'illuminazione è stato creato un ambiente nautico per unire addizionalmente le terme e l'atrio dell'albergo.

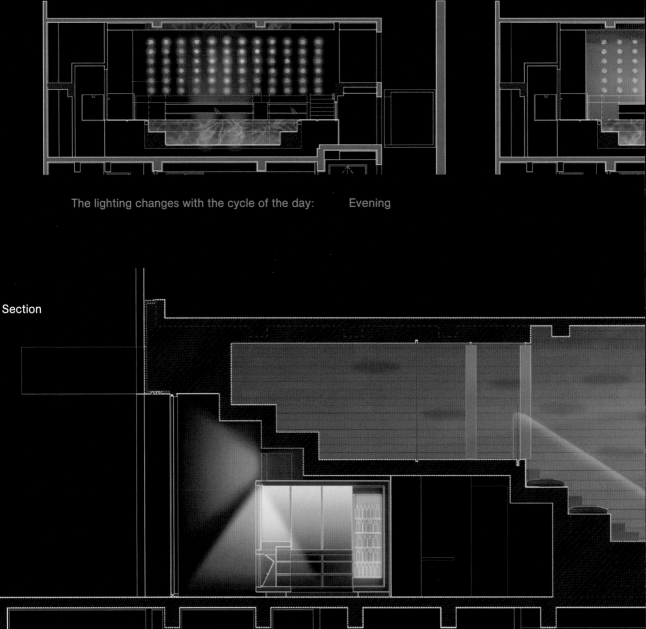

The lighting changes with the cycle of the day:　　Evening

Section

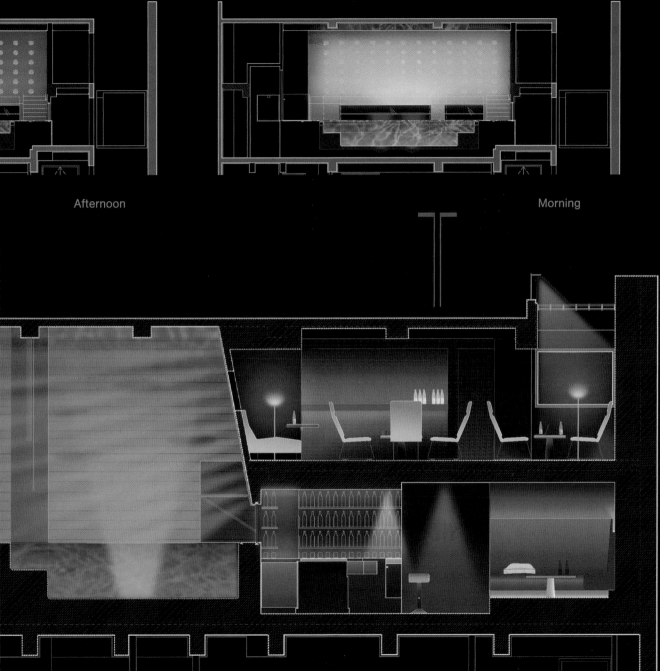

Afternoon

Morning

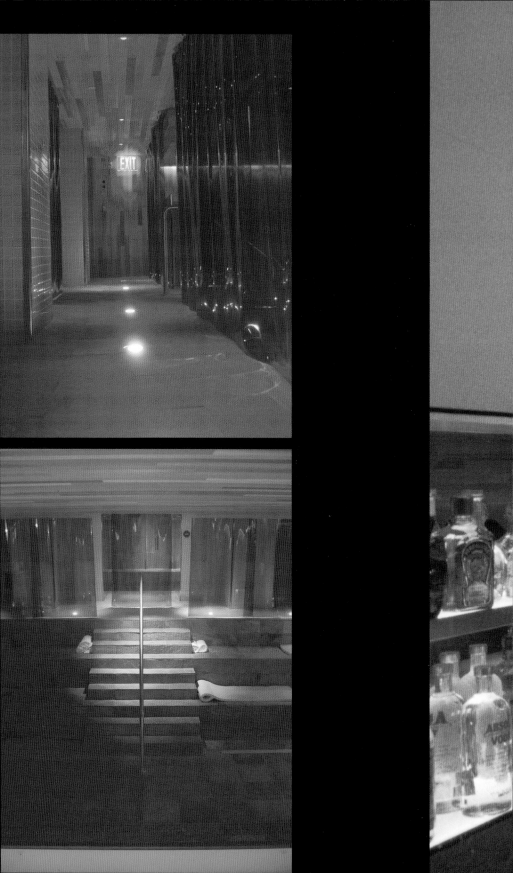

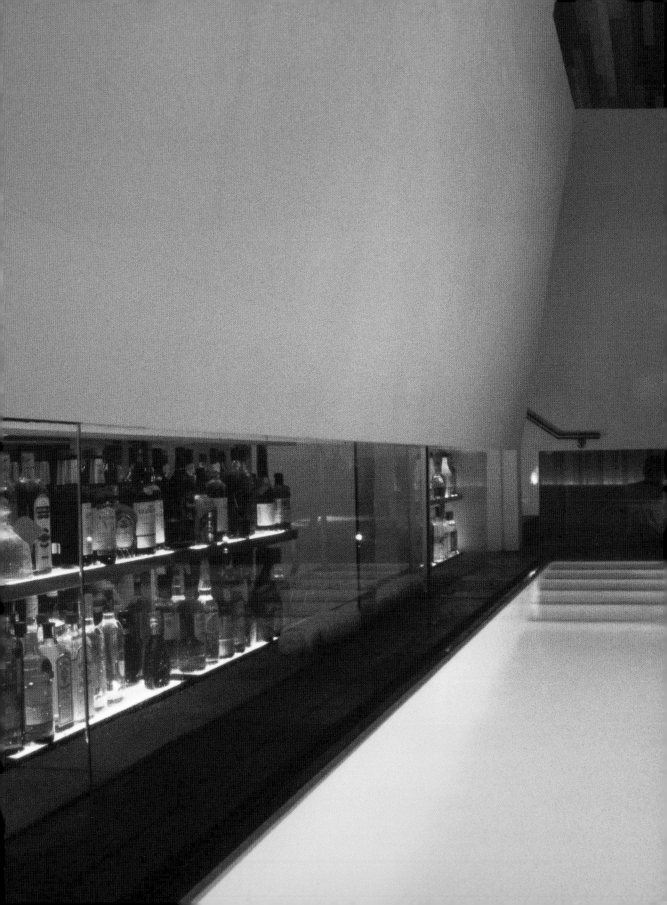

Issey Miyake Boutique

Location: New York, New York, USA
Architects: Frank O. Gehry and Associates, USA
 G-Tects, USA
Completed: 2001

Architect Frank Gehry conceived of a dramatic intervention in the space by creating a tornado simulated out of stainless steel, which links basement to street level. The general lighting plays with reflections off the steel, and the light illuminating the merchandise is hidden in ceiling joists.

Architekt Frank Gehry gelang durch die Gestaltung eines aus Stahl geformten Tornados ein dramatischer Eingriff in die Gebäudestruktur. Die skulpturartige Konstruktion verbindet das Unter- mit dem Erdgeschoss. Die Hauptbeleuchtung spielt mit dem Spiegeleffekt des Stahls, und das die einzelnen Artikel beleuchtende Licht liegt in den Deckenbalken verborgen.

L'architecte Frank Gehry est le concepteur d'une intervention dramatique dans l'espace en introduisant une tornade imitée à l'aide d'acier inoxydable qui relie le rez-de-chaussée au niveau de la rue. L'éclairage général est un jeu de réflexions sur l'acier, l'éclairage illuminant les marchandises est caché dans les poutres du plafond.

El arquitecto Frank Gerhy concibió una intervención radical en el espacio creando un tornado simulado con acero inoxidable, que une el sótano con el nivel de calle. La iluminación general juega con los reflejos en el acero, y la luz que ilumina el género está escondida en las viguetas del techo.

L'architetto Frank Gehry ha concepito un'invenzione drammatica nello spazio creando un tornado simulato in acciaio inossidabile collegante il piano interrato con il pianterreno. L'illuminazione generale gioca con le riflessioni provenienti dall'acciaio e la luce illuminante la merce è nascosta in travi portanti del soffitto.

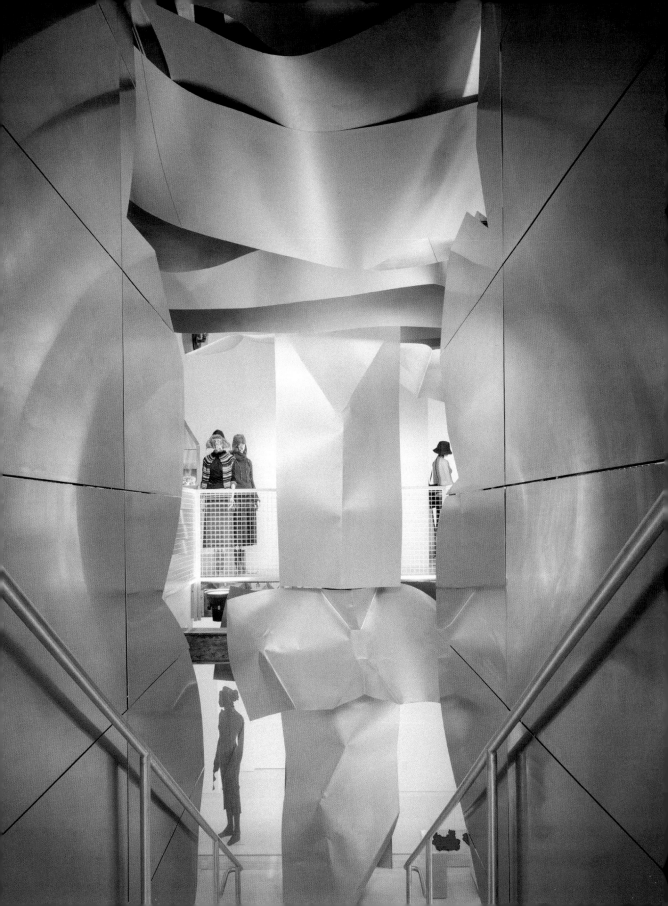

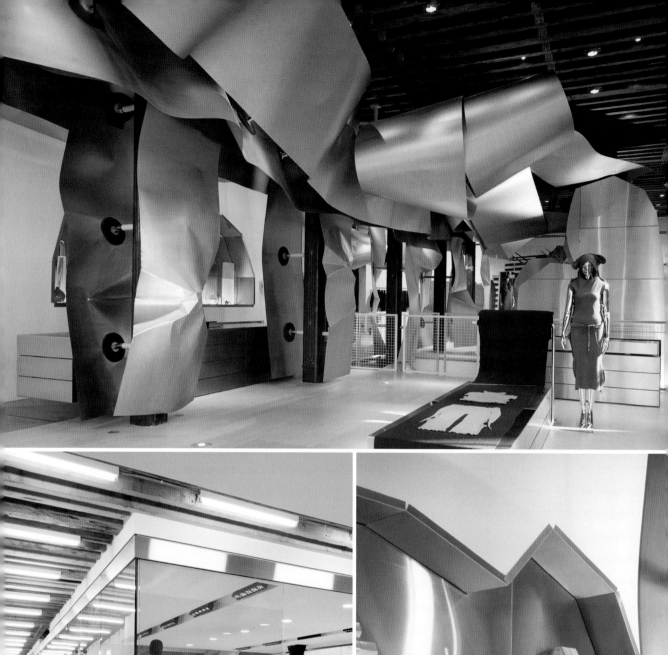

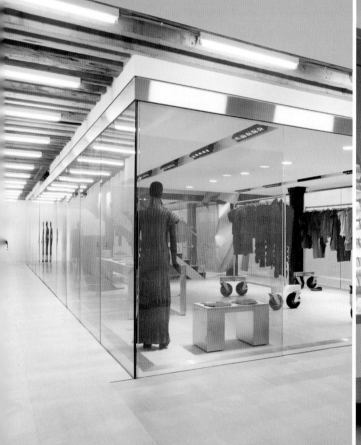

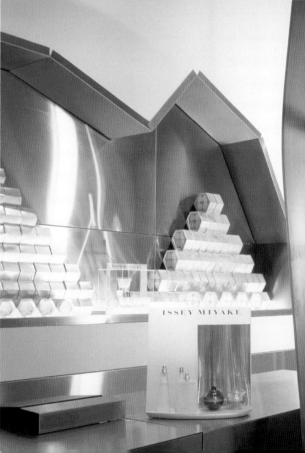

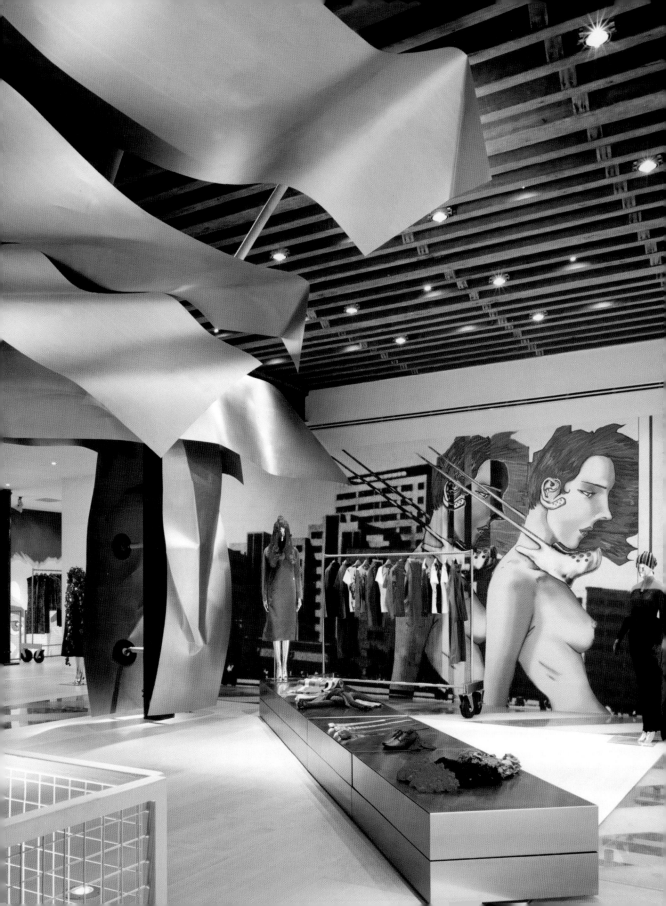

Europe

Kiasma Museum of Contemporary Art

Location: Helsinki, Finland
Architects: Steven Holl Architects, USA
 Juhani Pallasmaa, Finland
Completed: 1998

Hervé Descottes explains that "I met Steven for the first time for this project. He showed me the watercolors he had made of how he imagined the space, and told me that he wanted the mood exactly as it is in the paintings, with no visible fixtures. A few weeks later I met the director of the museum, who said he loved the mood, but that he needed the flexibility to adjust fixtures for the exhibits. I found a solution by embedding all the general and wall lighting in light pockets in the ceiling, and adding a secondary system of removable monopoints. In the non-exhibition spaces, we used lighting objects to create a warmer mood on a human scale."

Hervé Descottes erklärt: „Ich habe Steven bei der Arbeit an diesem Projekt kennengelernt. Er zeigte mir die Aquarelle, auf denen er seine Vorstellung von diesem Raum festgehalten hatte, und sagte, er wolle die Stimmung genauso wie auf den Bildern, ohne sichtbare Beleuchtungsvorrichtungen. Einige Wochen später traf ich den Direktor des Museums, der mir mitteilte, dass ihm die Stimmung sehr gefiele, er aber die Flexibilität bräuchte, Beleuchtungselemente individuell auf die Ausstellungstücke auszurichten. Ich fand die Lösung in einer Kombination zweier Beleuchtungskonzepte. Die Haupt- und Wandbeleuchtung ließ ich in Nischen in der Decke integrieren und zusätzlich ein zweites System aus abnehmbaren Einzelleuchten anbringen. In Räumen, die nicht zu Ausstellungszwecken dienen, verwendeten wir Leuchtobjekte, um eine wärmere und persönlichere Stimmung zu erzeugen."

Hervé Descottes déclare : « J'ai rencontré Steven la première fois pour ce projet. Il me montra les aquarelles qu'il avait peintes pour imaginer l'espace, et il me dit qu'il désirait une atmosphère exactement comme sur ses peintures, avec aucun dispositif visible. Quelques semaines plus tard, je rencontre le conservateur du musée qui me dit adorer cette atmosphère, mais qu'il nécessite une certaine flexibilité pour ajuster les éclairages en fonction des expositions. Je trouvais alors une solution en encastrant tout l'éclairage général et l'éclairage mural dans des poches à lumière dans le plafond, et en y ajoutant un second système de points individuels amovibles. Dans les espaces n'appartenant pas aux expositions nous avons utilisé des objets d'éclairage permettant de créer une atmosphère chaude à échelle humaine. »

Hervé Descottes explica que "La primera vez que coincidí con Steven se debió a este proyecto. Me mostró las acuarelas que había creado para el espacio que había imaginado, y me dijo que quería el ambiente exactamente tal y como está en las pinturas, sin accesorios de iluminación visibles. Unas semanas más tarde, me reuní con el director del museo, quien me comentó que le gustaba el ambiente, pero que necesitaba la flexibilidad para ajustar los accesorios de iluminación a las obras de arte. Encontré una solución empotrando toda la iluminación general y la de las paredes en linternas en el techo, y añadiendo un segundo sistema de tomas individuales desmontables. En los espacios no dedicados a la exposición, utilizamos objetos luminosos para crear un ambiente más cálido en un plano humano".

Hervé Descottes spiega "Incontrai Steven per la prima volta in occasione di questo progetto. Mi mostrò gli acquarelli che aveva realizzato raffiguranti il modo in cui egli aveva immaginato lo spazio e mi disse che desiderava che l'atmosfera corrispondesse esattamente a quella delle pitture, senza alcun elemento visibile. Qualche settimana dopo incontrai il direttore del museo che disse che l'atmosfera gli piaceva, ma che aveva bisogno della flessibilità di aggiustare gli elementi per le esposizioni. Trovai una soluzione incorporando tutta l'illuminazione generale e delle pareti in tasche di luce nel soffitto e aggiungendo un sistema secondario di monopunti rimovibili. Negli spazi non adibiti ad esposizione utilizzammo oggetti illuminanti per creare un'atmosfera più calda a misura umana."

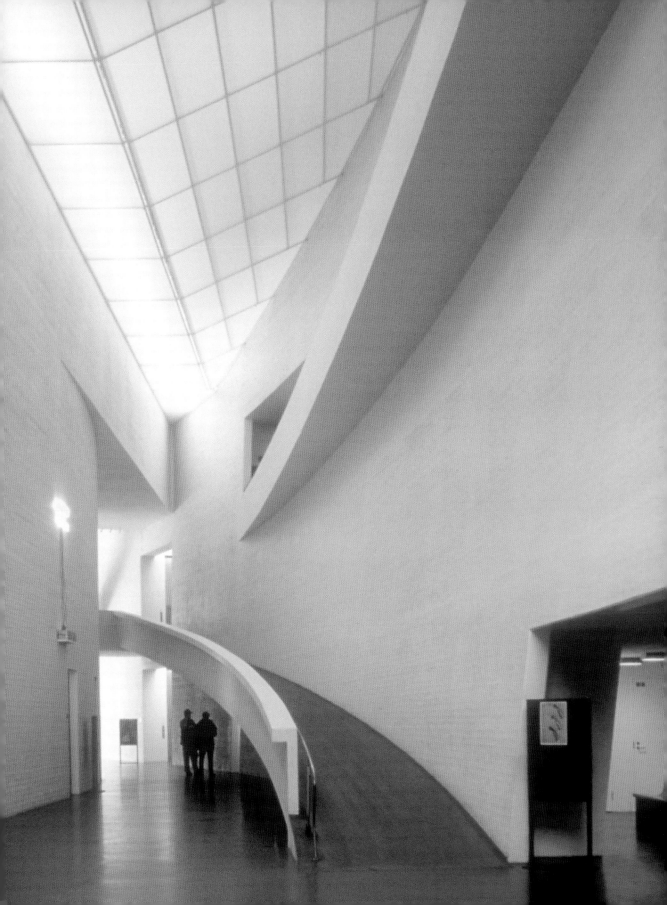

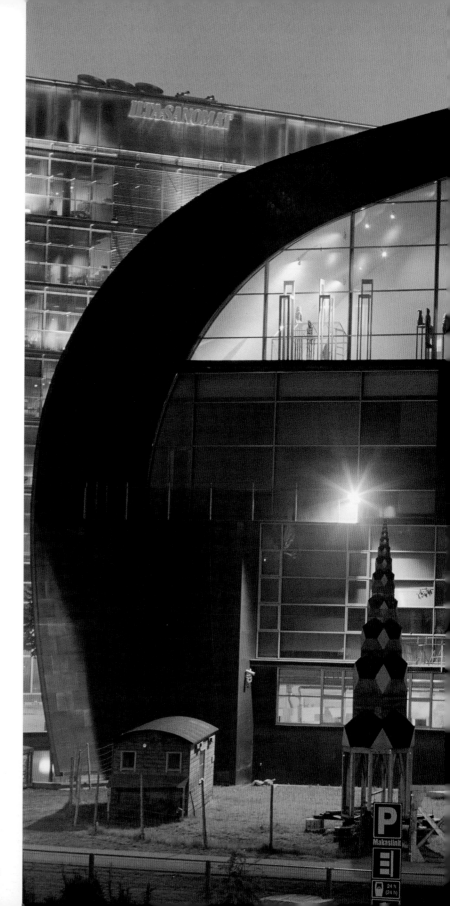

Kiasma Museum of Contemporary Art

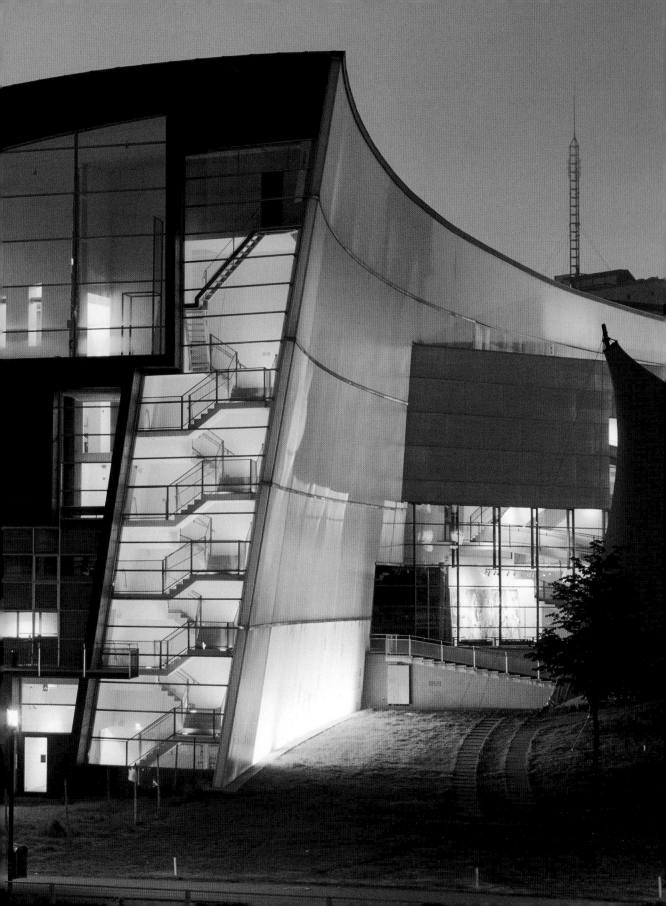

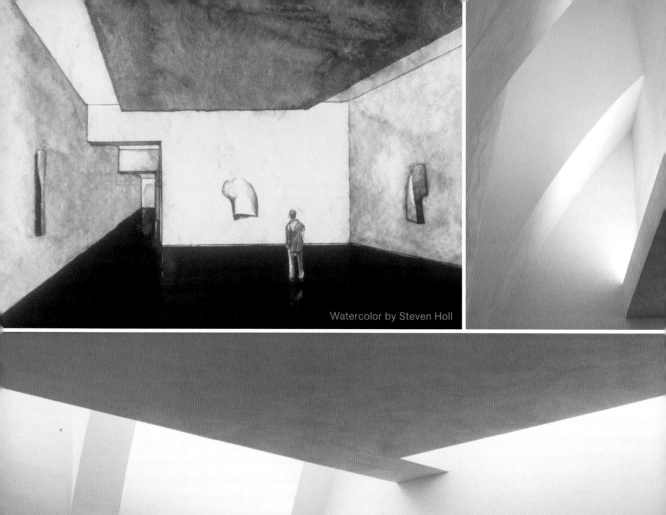

Watercolor by Steven Holl

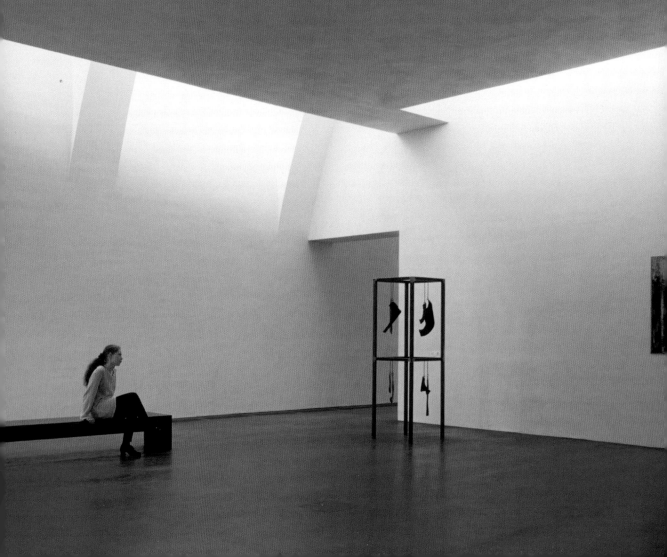

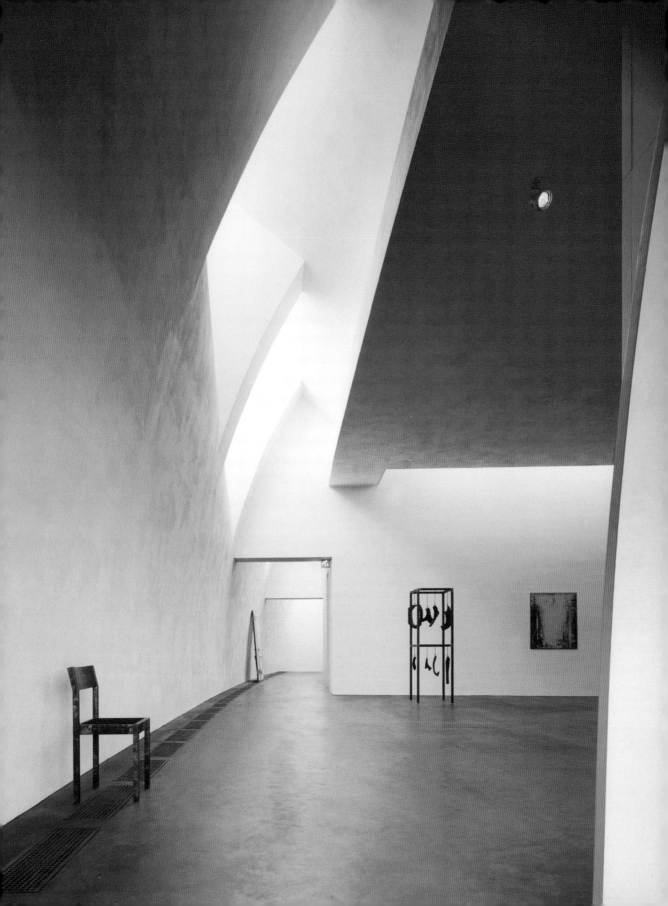

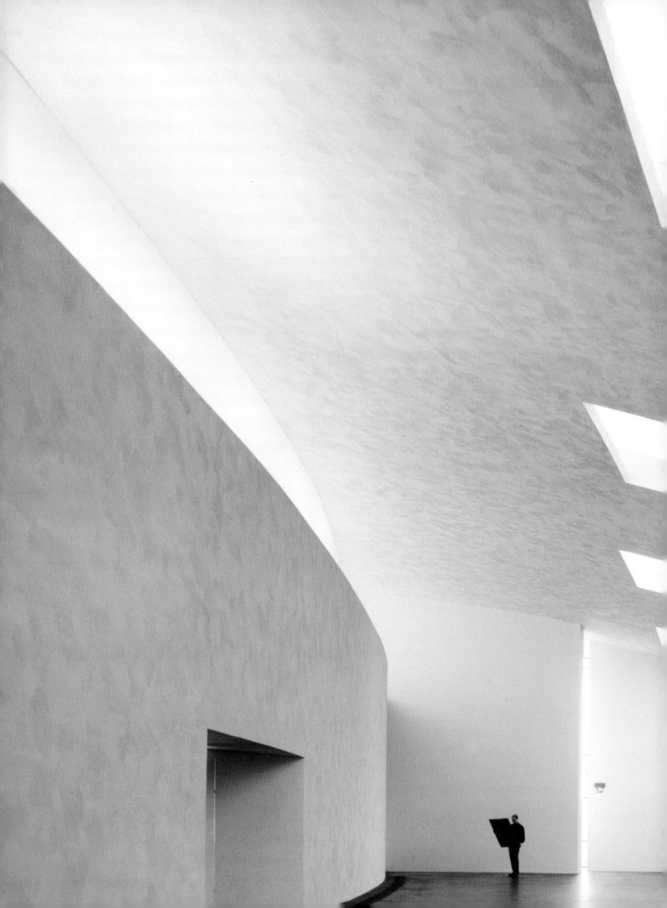

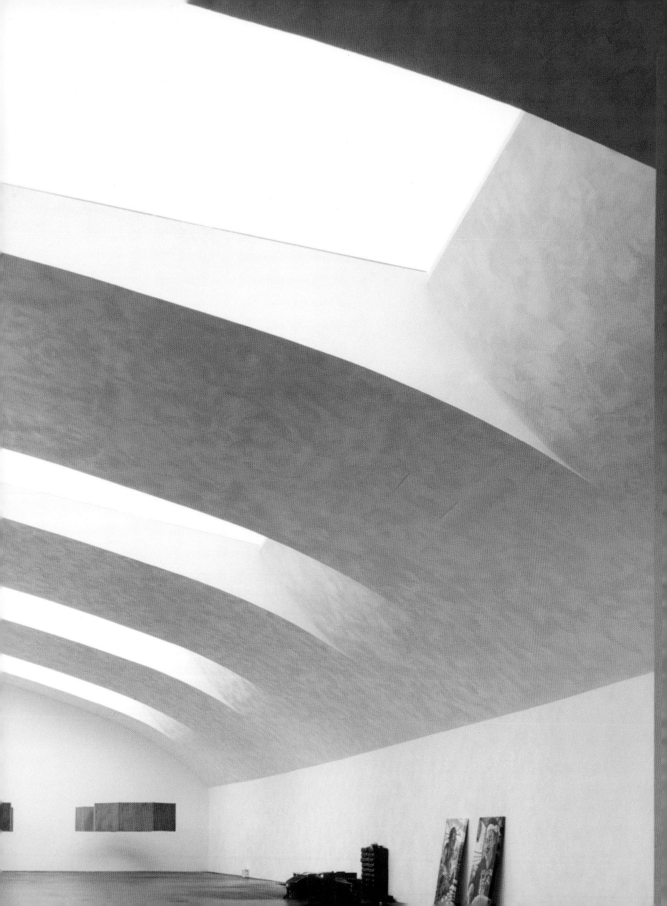

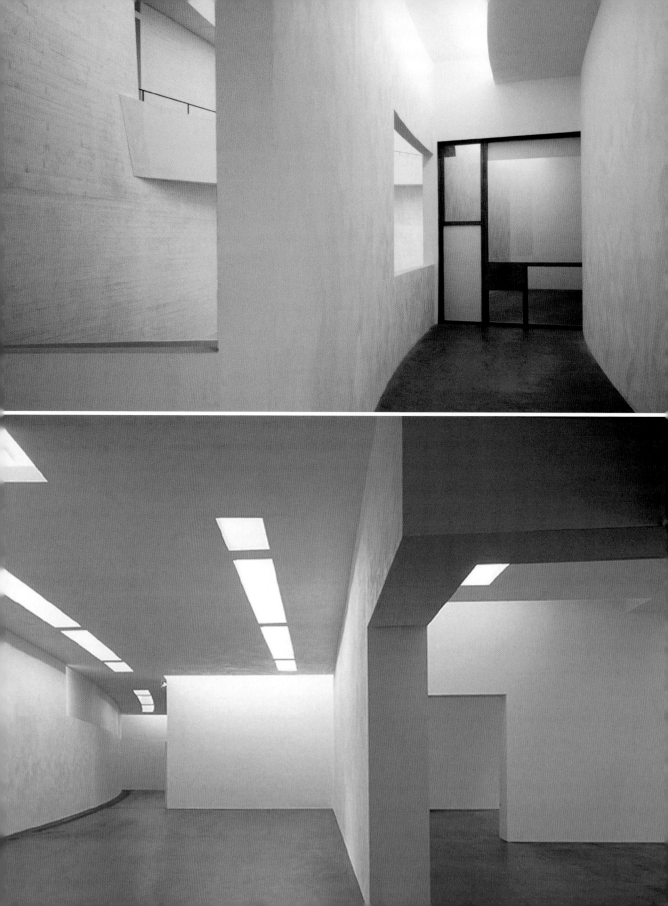

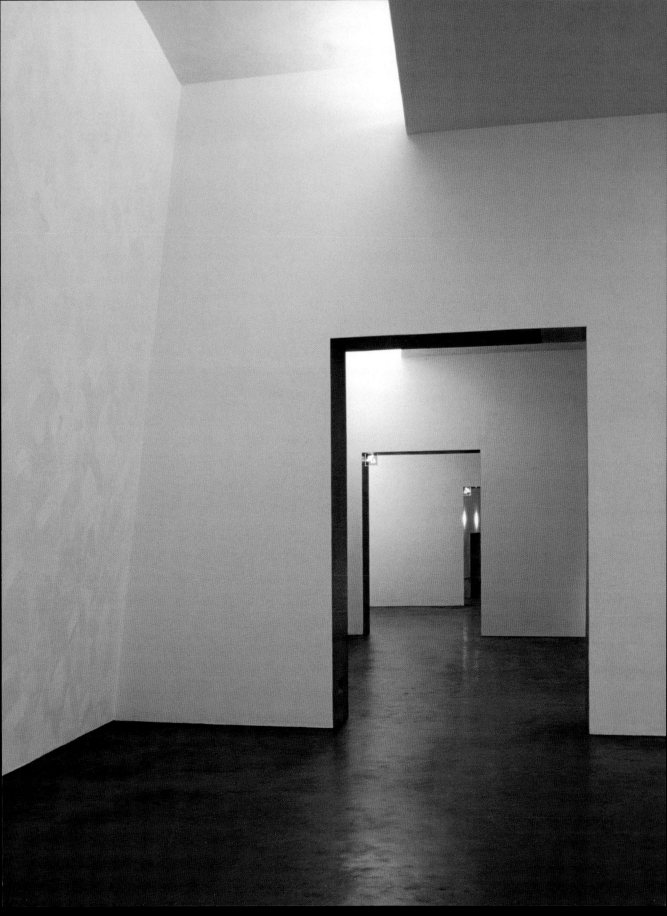

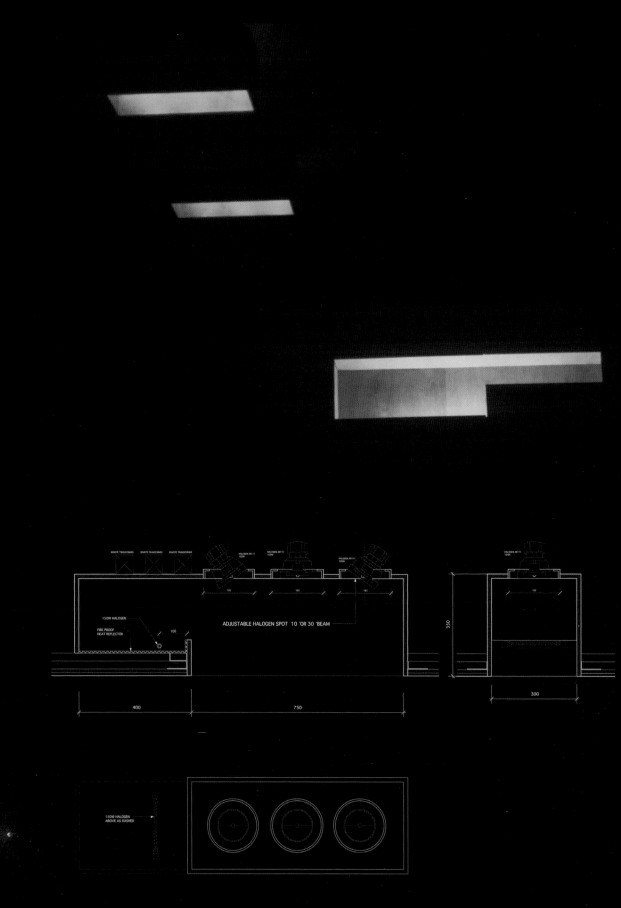

REMOTE TRANSFORMER REMOTE TRANSFORMER REMOTE TRANSFORMER HALOGEN AR111 100W HALOGEN AR111 100W HALOGEN AR111 100W HALOGEN AR111 100W

150W HALOGEN

FIRE PROOF
HEAT REFLECTOR

100

ADJUSTABLE HALOGEN SPOT 10 ˚OR 30 ˚BEAM

350

400 750 300

150W HALOGEN
ABOVE AS DASHED

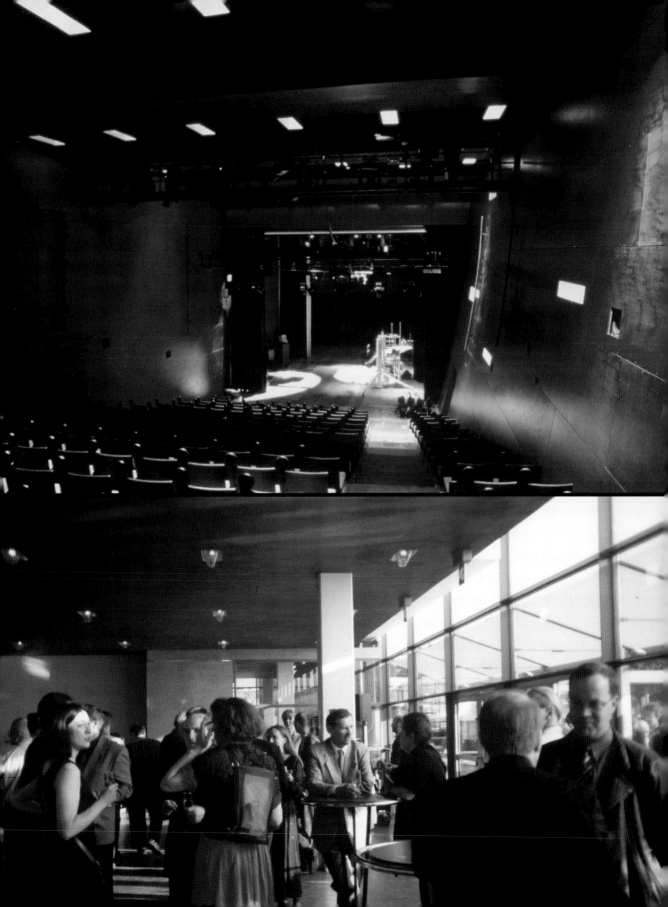

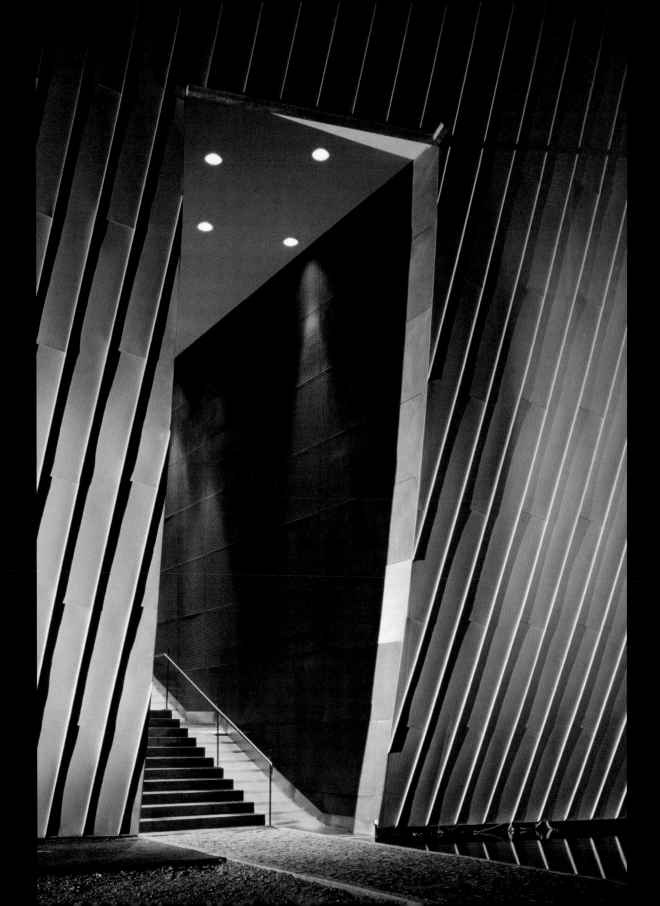

Sarphatistraat Offices

Location: Amsterdam, The Netherlands
Architects: Steven Holl Architects, USA
Completed: 2000

For this intimate office building, light sources are intentionally kept hidden, while lighting effects are made visible. At night, lighting emphasizes the stratification of the facade's many porous skins comprised of copper, concrete, and perforated wood.

Die Lichtquellen in diesem wohnlich wirkenden Bürogebäude wurden bewusst verdeckt gehalten, die Lichteffekte hingegen sichtbar gemacht. Bei Nacht wird die Vielschichtigkeit der Fassade betont, die aus mehreren porösen Lagen aus Kupfer, Beton und perforiertem Holz besteht.

Pour cet immeuble de bureaux discret, les sources d'éclairage sont intentionnellement cachées, tandis que les effets de lumière sont rendus visibles. La nuit, l'éclairage rehausse la stratification de la façade constituée de nombreux revêtements poreux intégrant du cuivre, du béton et du bois perforé.

Para este íntimo edificio de oficinas, las fuentes de luz se mantienen escondidas de forma intencionada, mientras que los efectos de iluminación se hacen visibles. Por la noche, la iluminación acentúa la estratificación de las capas muy porosas de la fachada compuestas de cobre, hormigón y madera perforada.

Per questo accogliente edificio adibito ad uffici, le fonti di luce sono tenute intenzionatamente nascoste mentre gli effetti di illuminazione sono resi visibili. Di notte, l'illuminazione enfatizza la stratificazione dei numerosi rivestimenti porosi della facciata, realizzati in rame, calcestruzzo e legno perforato.

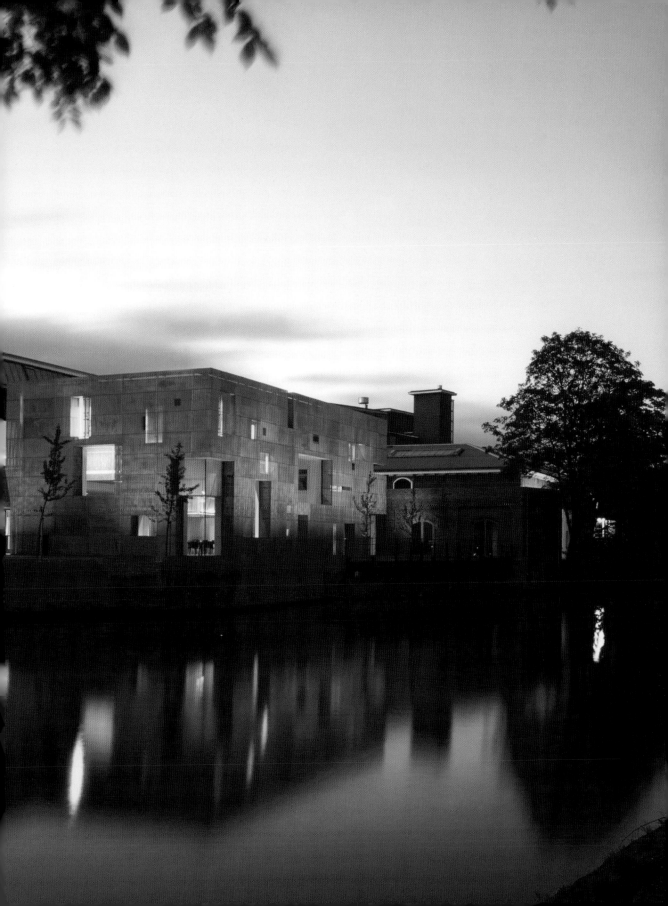

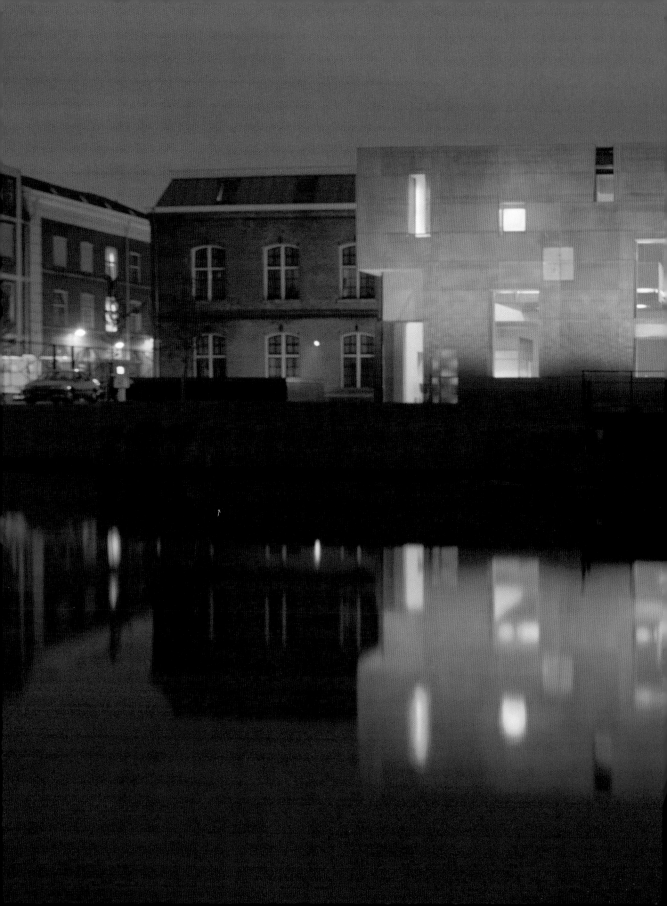

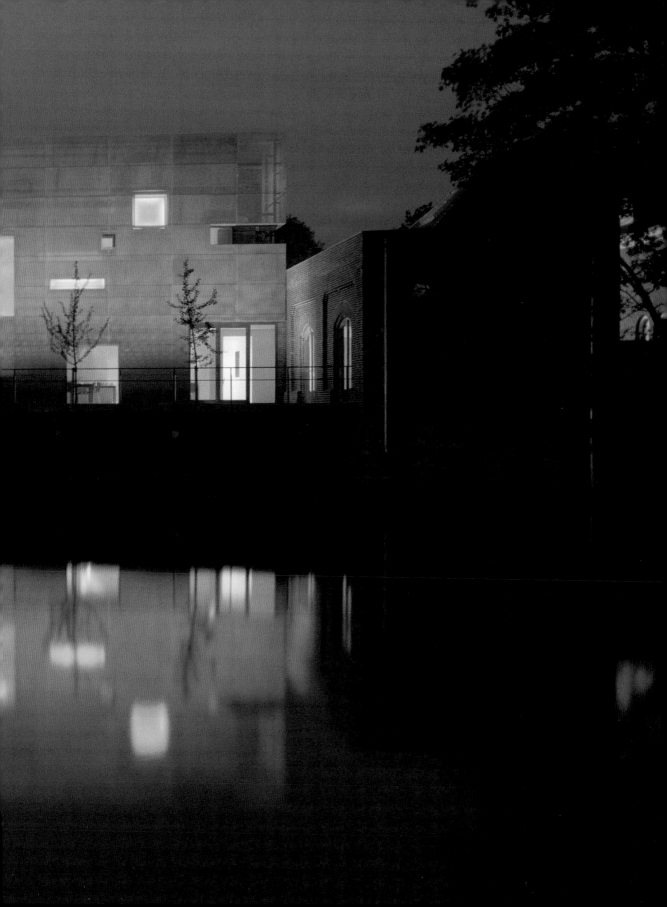

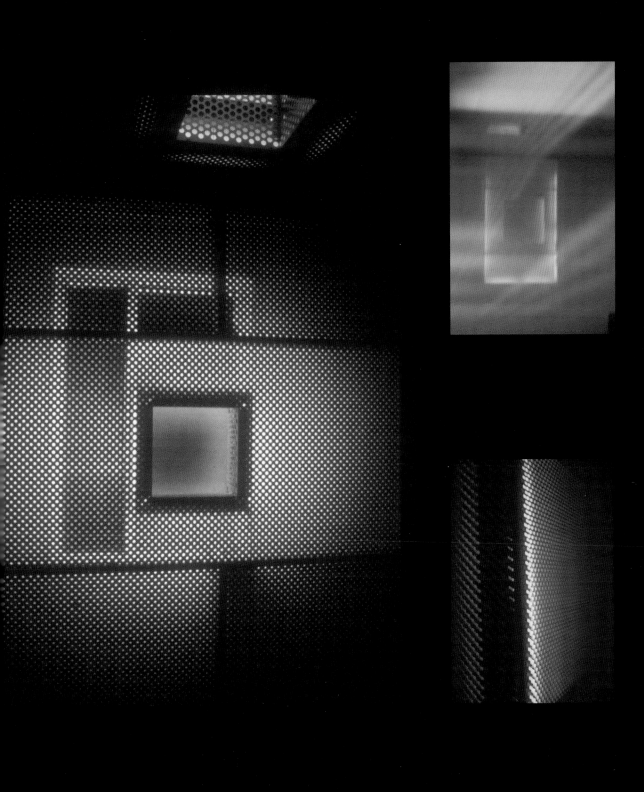

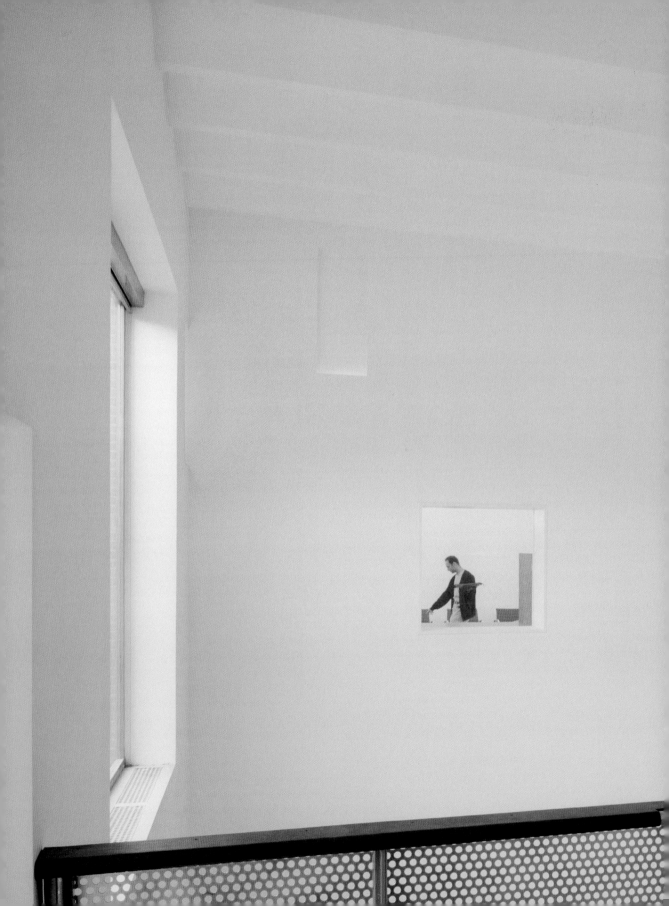

Sarphatistraat Offices

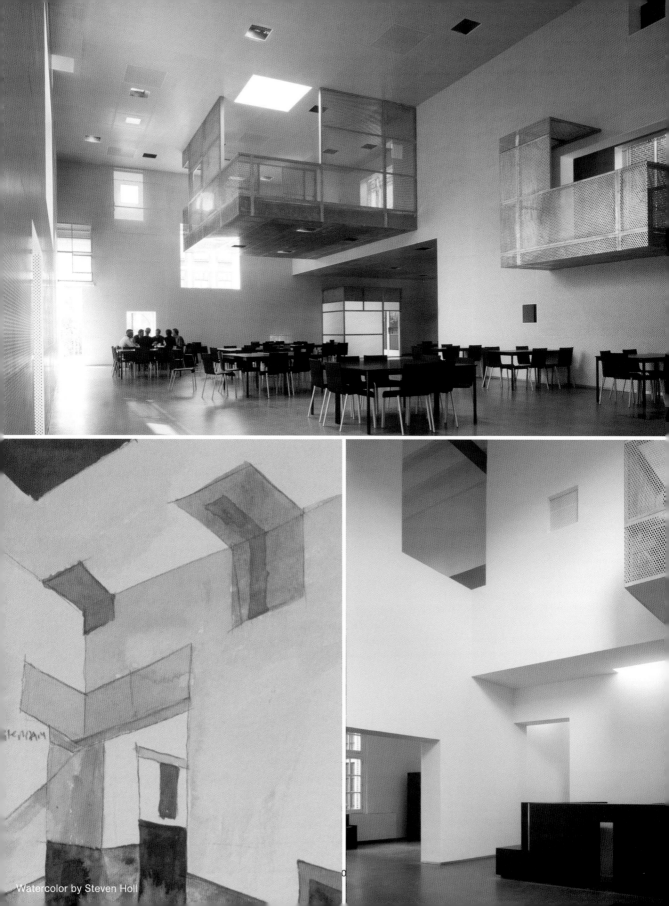

Watercolor by Steven Holl

Sony Center

Location: Berlin, Germany
Architects: Murphy / Jahn Architects, USA
Completed: 2000

An overall lighting scheme unifies the office, residential, commercial, and public spaces as well as the facade. In the daytime, light emphasizes the building's transparency, while at night, light intensifies the reflective quality of glass. Lighting further compliments the architecture's high-tech vocabulary, by exposing such elements as nuts and bolts.

Büros, Wohn- und Gewerbebereiche, öffentliche Anlagen sowie Fassaden werden durch die Beleuchtung zu einer Einheit verbunden. Tageslicht betont die Tranparenz der Gebäude, wohingegen bei Nacht künstliches Licht die Glasfassaden als Spiegel erscheinen lässt. Weiterhin werden architektonische High-Tech-Elemente, wie Stahlkabel und -bolzen hervorgehoben.

Un schéma d'éclairage général unifie les espaces de bureaux, résidentiels, commerciaux et publics, de même que la façade. Dans la journée la lumière rehausse la transparence de l'immeuble, tandis que la nuit elle intensifie les propriétés réflectives du verre. L'éclairage fait également honneur au langage de haute technologie de l'architecture en mettant en valeur des éléments tels que câble et boulons.

Un esquema de luz completo une los espacios de oficinas, residenciales, comerciales y públicos así como la fachada. Durante el día, la luz resalta la transparencia del edificio, mientras que por la noche, la luz intensifica la cualidad reflectora del cristal. La iluminación piropea el vocabulario de alta tecnología de la arquitectura, exponiendo elementos como los cables de acero y los pernos.

Uno schema di illuminazione complessivo unisce gli spazi adibiti ad ufficio, quelli residenziali, commerciali e pubblici nonché la facciata. Di giorno la luce enfatizza la trasparenza dell'edificio, mentre di notte la luce intensifica la qualità di riflessione del vetro. L'illuminazione integra ulteriormente il carattere high tech dell'architettura esponendo elementi come i cavi d'acciaio e i bulloni.

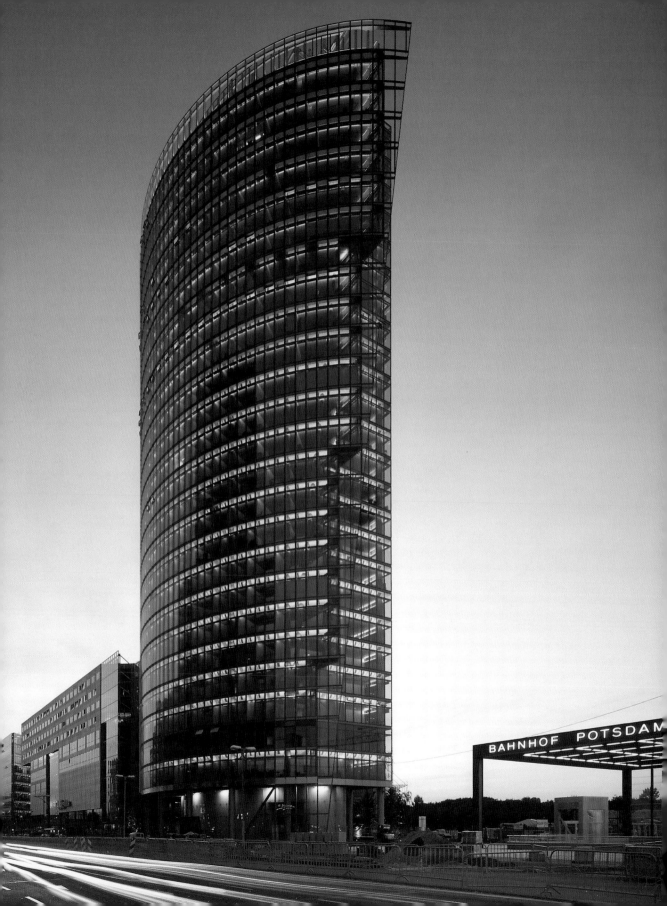

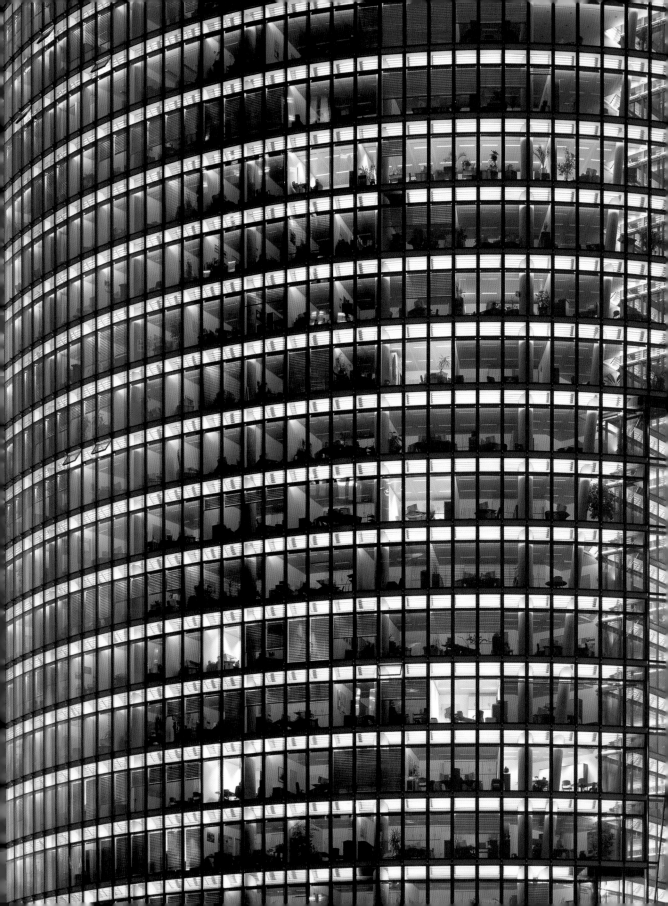

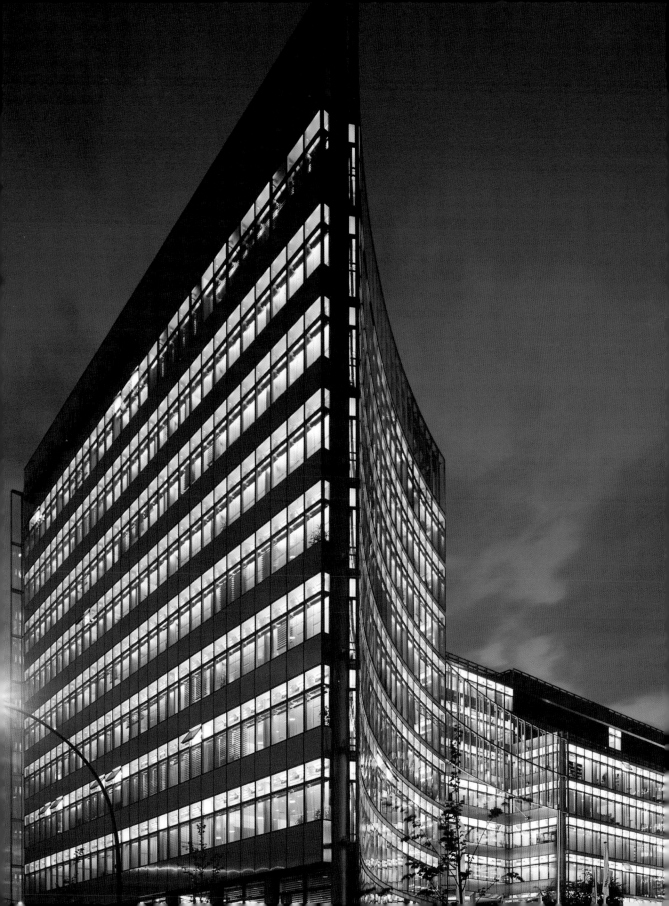

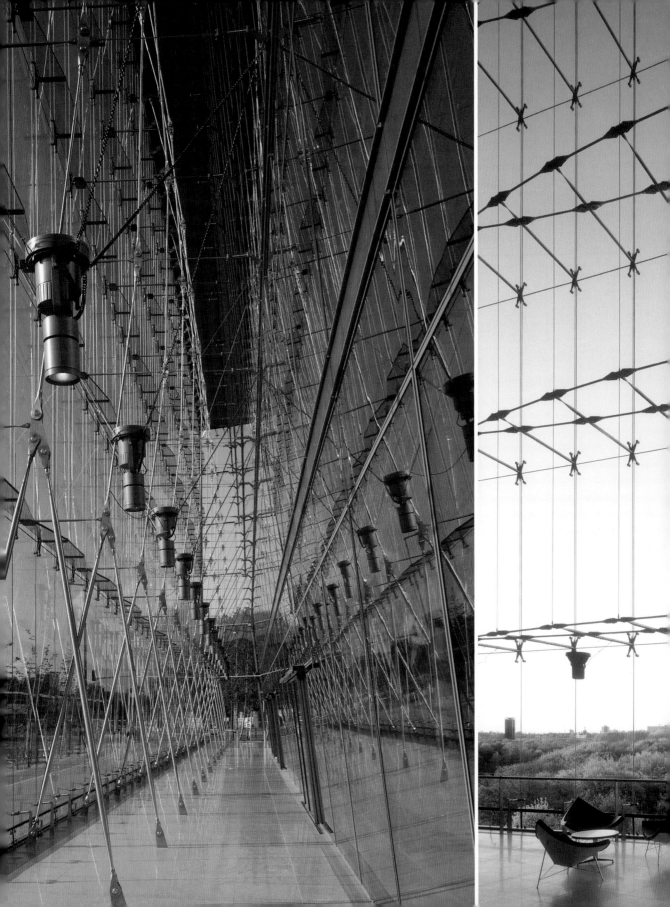

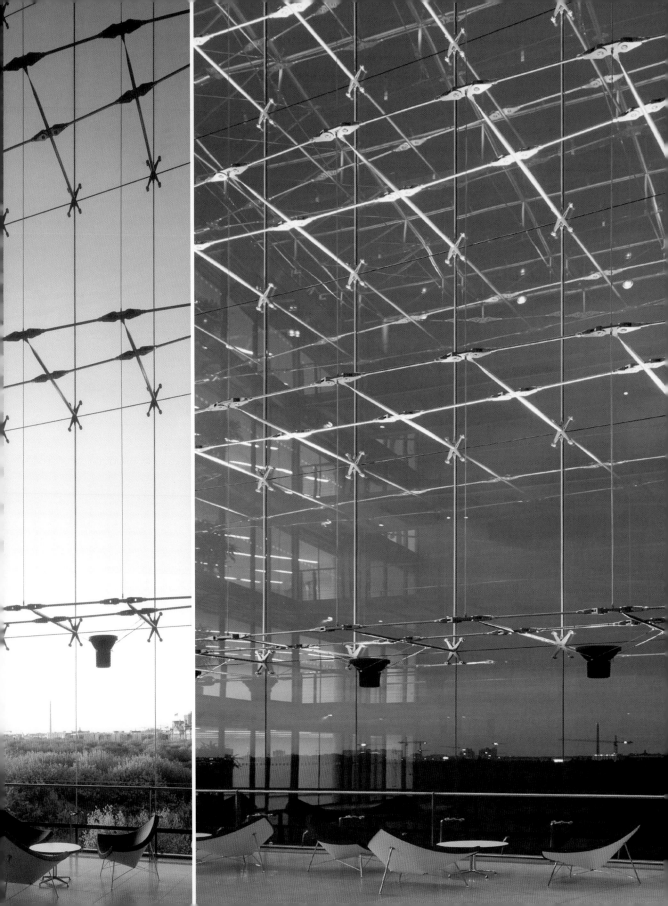

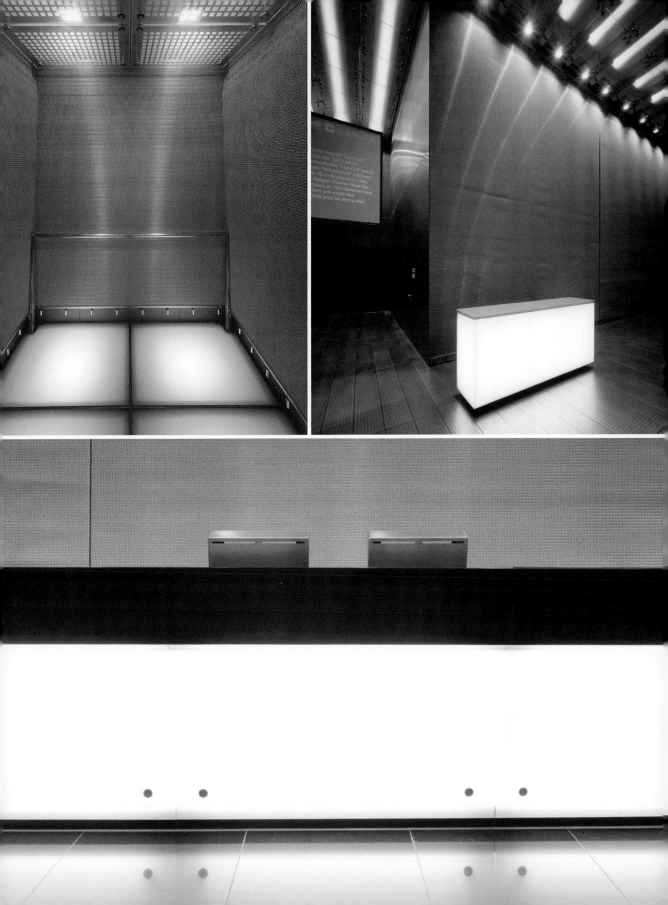

Lille 2004

Location:	Lille, France
Designer:	Agence Patrick Jouin, France
Completed:	2004

Built in celebration of Lille's selection as the cultural capital of Europe in 2004, the station is a radiating icon of the city. From inside the building, a glowing pink box at once greets travelers before meeting Lille's often overcast skies, and moreover emanates throughout the city at night, providing a key orientation point.

Der Bahnhof wurde zur Feier anlässlich der Wahl Lilles zur Kulturhauptstadt Europas 2004 gebaut und ist heute das strahlende Juwel der Stadt. Schon im Inneren des Gebäudes werden Reisende von einer leuchtend pinken Box begrüßt, bevor sie auf Lilles oft bewölkten Himmel stoßen. Zudem bestrahlt das Licht den nächtlichen Himmel und bildet so einen wichtigen Orientierungspunkt.

Construite à l'occasion de la sélection de Lille pour devenir la capitale culturelle de l'Europe en 2004, la gare devient un symbole rayonnant de la ville. Depuis l'intérieur du bâtiment les voyageurs sont accueillis dans une grande bonbonnière lumineuse rose avant de se retrouver sous le ciel de Lille qui est souvent couvert, et simultanément cet éclairage est visible partout dans la ville, ce qui en fait un point d'orientation efficace dans la nuit.

La estación, construida en conmemoración de la elección de Lille como la capital cultural de Europa en 2004, es un icono de iluminación de la ciudad. Desde dentro del edificio, una caja rosa brillante da enseguida la bienvenida a los viajeros antes que de se encuentren con los a menudo encapotados cielos de Lille. Además se extiende por toda la ciudad durante la noche, proporcionando un punto de orientación clave.

Costruita in celebrazione della selezione di Lille quale capitale culturale d'Europa nel 2004, la stazione è un'icona radiante della città. Dall'interno dell'edificio, un box rosa luminoso saluta improvvisamente i viaggiatori prima di incontrare i cieli spesso nuvolosi di Lille, inoltre emana luce attraverso il centro di notte, costituendo un punto chiave di orientamento.

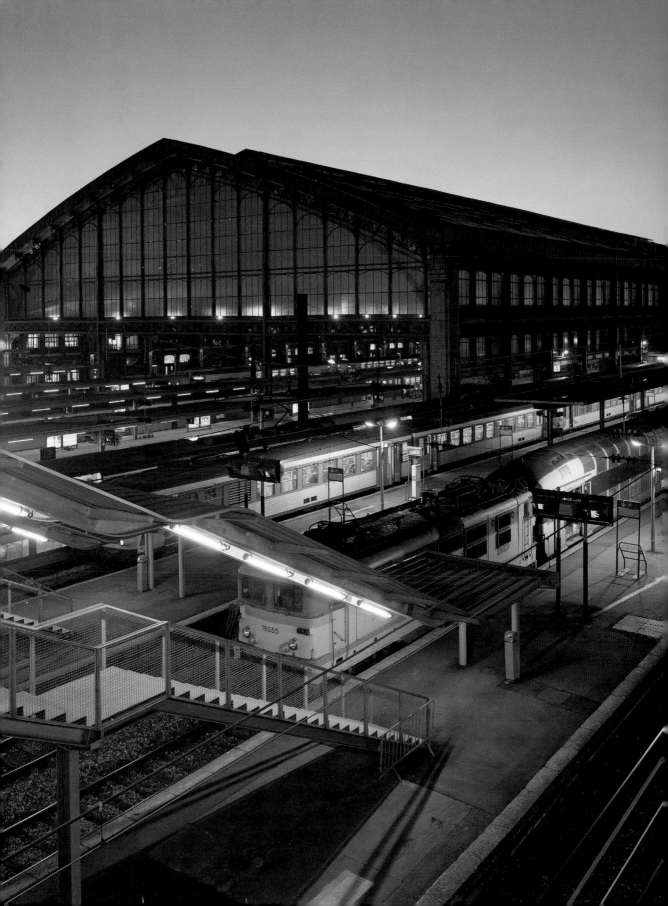

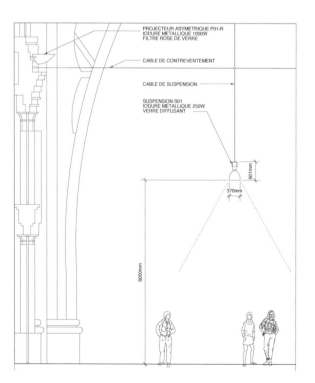

PROJECTEUR ASYMETRIQUE P01-R
IODURE METALLIQUE 1000W
FILTRE ROSE DE VERRE

CABLE DE CONTREVENTEMENT

CABLE DE SUSPENSION

SUSPENSION S01
IODURE METALLIQUE 250W
VERRE DIFFUSANT

601mm

370mm

6000mm

Proposed dynamic sequence for train arrivals and departures: a wave of blue light follows the movement of the trains

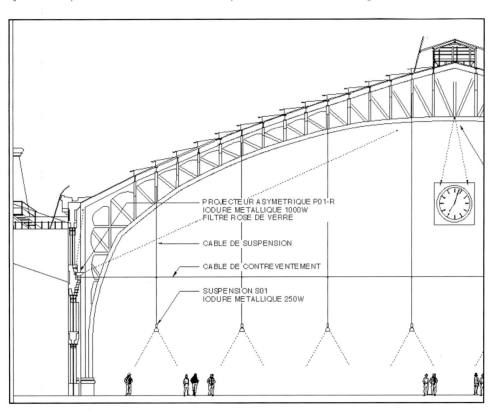

PROJECTEUR ASYMETRIQUE P01-R
IODURE METALLIQUE 1000W
FILTRE ROSE DE VERRE

CABLE DE SUSPENSION

CABLE DE CONTREVENTEMENT

SUSPENSION S01
IODURE METALLIQUE 250W

Mont Saint-Eloi

Location: Saint-Eloi, France
Completed: 2005

The illumination of the ruins of the cathedral of Mont Saint-Eloi is part of Lille's celebration as the cultural capital of Europe in 2004, revitalizing northern France. The principal facade is immersed in a uniform blue light, which engenders a surreal, even phantasmagorical presence in the edifice from a distance. From close-up, the same light blurs the scars left by wars and revolutions, while also revealing the intricate stone-work and textures of the building. Where the nave used to stand, a group of luminous curves float up towards the sky, emulating floating votive candles.

Die Beleuchtung der Ruinen der Kathedrale von Mont Saint-Eloi ist Teil der Feierlichkeiten zu Lilles Wahl zur Kulturhauptstadt Europas 2004. Das Projekt hat Nordfrankreich neu belebt. Die Hauptfassade ist in einheitlich blaues Licht getaucht, was dem Gebäude aus der Entfernung ein surreales, wenn nicht sogar gespenstisches Erscheinungsbild verleiht. Von Nahem betrachtet lässt dasselbe Licht die Narben, die Kriege und Revolutionen hinterlassen haben, verschwimmen und betont gleichzeitig die Komplexität des Gemäuers und die Oberflächenstruktur des Gebäudes. Wo früher das Hauptschiff stand, strecken sich heute mehrere Lichtkurven gegen den Himmel, die an schwebende Votivkerzen erinnern.

L'illumination des ruines de la cathédrale du Mont Saint-Eloi fait partie de la célébration de Lille comme capitale culturelle de l'Europe en 2004, devant servir à revitaliser la région Nord de la France. La façade principale est immergée dans une lumière bleue uniforme, ce qui engendre, à distance, une présence irréelle et même fantasmagorique de l'édifice. De plus près, cette même lumière estompe les cicatrices laissées par les guerres et révolutions, et en même temps révèle l'imbrication complexe des pierres et la structure de l'édifice. A l'emplacement où se trouvait la nef, un groupe d'arcs lumineux s'élèvent en flottant vers le ciel, évoquant des cierges votifs flottants.

La iluminación de las ruinas de la catedral del Mont Saint-Eloi forma parte de la conmemoración del nombramiento de Lille como la capital cultural europea en 2004, lo que ha revitalizado el norte de Francia. La fachada principal está inmersa en una luz azul uniforme, que crea una presencia surrealista, incluso fantasmagórica en el edificio desde la lejanía. Desde un primer plano, la misma luz enturbia las cicatrices ocasionadas por las guerras y las revoluciones, mientras que también revela los complicados trabajos en piedra y las texturas del edificio. Donde solía estar la nave, un grupo de curvas luminosas flotan hacia el cielo, simulando velas votivas suspendidas.

L'illuminazione delle rovine della cattedrale di Mont Saint-Eloi fa parte della celebrazione di Lille quale capitale culturale europea del 2004, rivitalizzante la Francia settentrionale. La facciata principale è immersa in una luce blu uniforme che genera nell'edificio da lontano una presenza surreale, se non addirittura fantasmagorica. Da vicino, la medesima luce sfuma i segni lasciati da guerre e rivoluzioni rivelando anche le intricate costruzioni di pietra e strutture dell'edificio. Laddove in passato si trovava la navata centrale, un gruppo di curve luminose fluttua verso il cielo emulando la luce vacillante di candele votive.

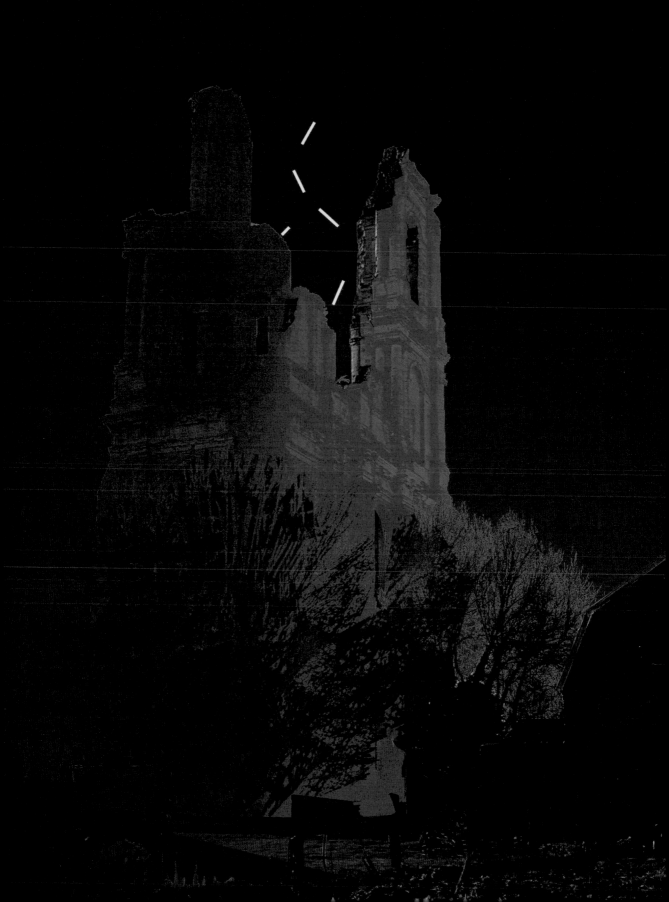

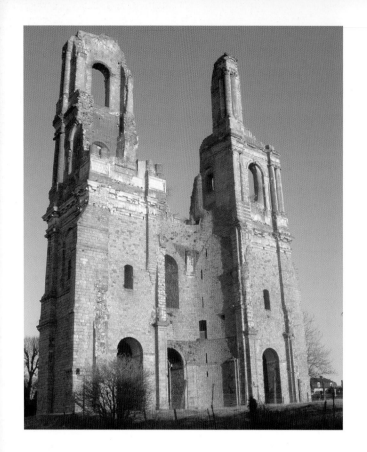

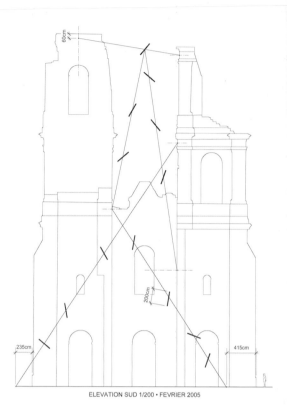

ELEVATION SUD 1/200 • FEVRIER 2005

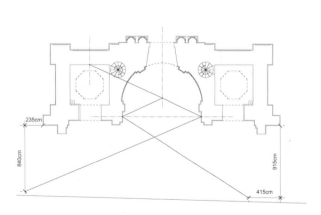

PLAN DE CABLAGE 1/200 • FEVRIER 2005

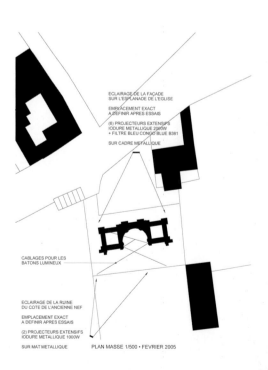

ECLAIRAGE DE LA FAÇADE
SUR L'ESPLANADE DE L'EGLISE

EMPLACEMENT EXACT
A DEFINIR APRES ESSAIS

(6) PROJECTEURS EXTENSIFS
IODURE METALLIQUE 2000W
+ FILTRE BLEU CONGO BLUE B381

SUR CADRE METALLIQUE

CABLAGES POUR LES
BATONS LUMINEUX

ECLAIRAGE DE LA RUINE
DU COTE DE L'ANCIENNE NEF

EMPLACEMENT EXACT
A DEFINIR APRES ESSAIS

(2) PROJECTEURS EXTENSIFS
IODURE METALLIQUE 1000W

SUR MAT METALLIQUE PLAN MASSE 1/500 • FEVRIER 2005

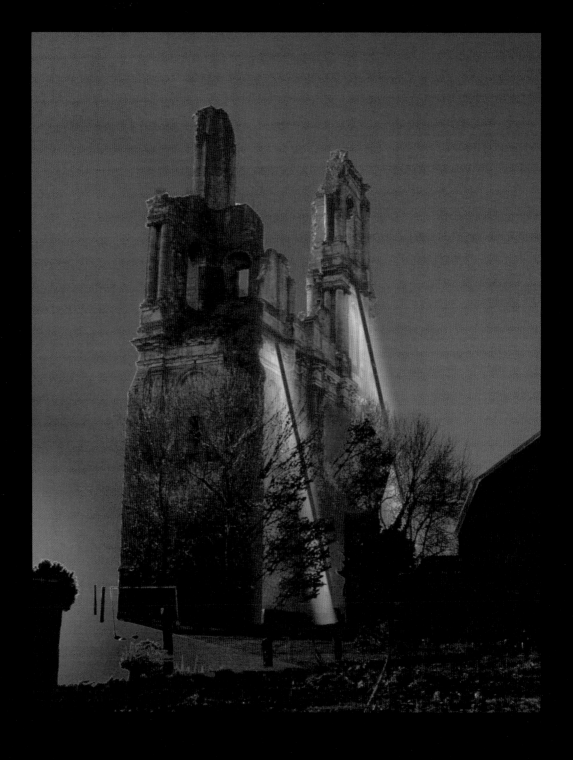

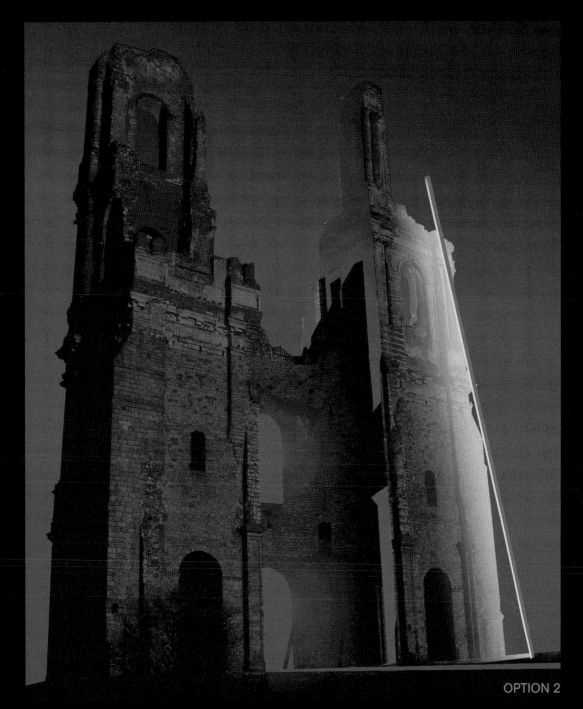

OPTION 2

An alternate schematic design sought to support the ruins of Mont Saint-Eloi with poles of light

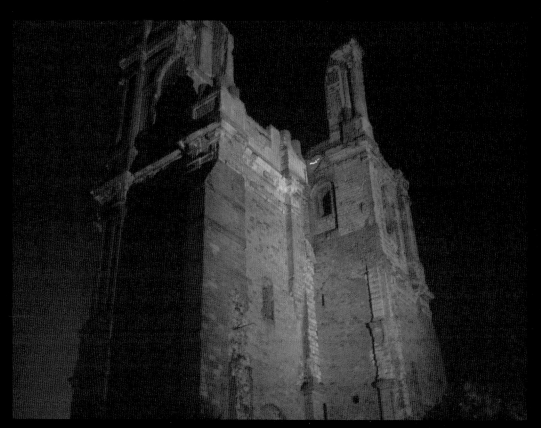

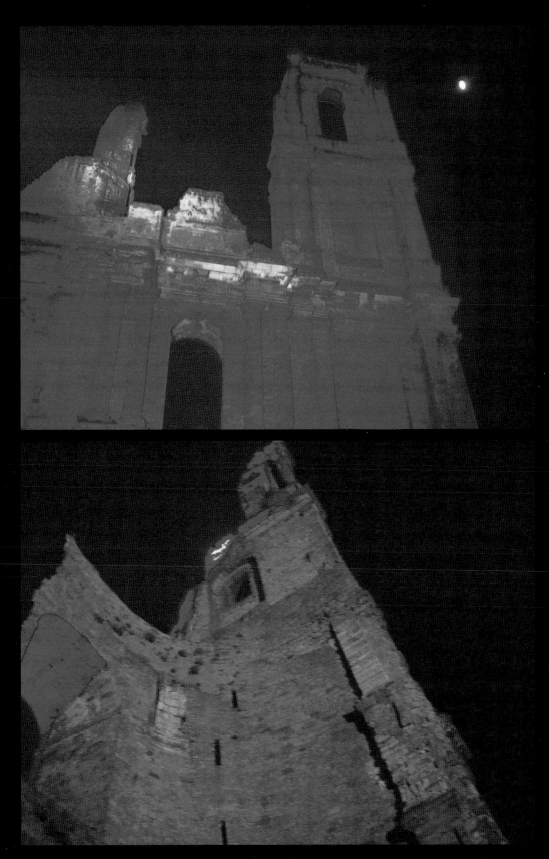

On-site mock ups

Brancusi Ensemble:
The Park of the Table and the Gate
The Park of the Endless Column

Location: Targu-Jiu, Romania
Landscape Architects: Olin Partnership, USA
Completed: 2004

Two parks comprise a memorial to the soldiers who perished in World War I. There is a symbolic progression through the parks, which the lighting underscores. The path begins at the Table of Silence, where one gathers to honor the fallen. The visitor follows the path through the Gate of the Kiss, past the stone seating along the Voice of Heroes all the way to the Endless Column, which leads the way for the fallen souls to climb to heaven. Lighting is emotionally charged, capturing intimate encounters with the sculptures. It casts dramatic shadows and emphasizes the seemingly endless column.

Zwei Parkanlagen bilden zusammen ein Denkmal für die gefallenen Soldaten des Ersten Weltkriegs. Durch die Anlagen verläuft ein Pfad, an dem verschiedene Monumente, die einen symbolischen Wert tragen, zu finden sind. Die Monumente sind konzeptuell miteinander verbunden, was durch die Beleuchtung unterstrichen wird. Der Pfad beginnt am Tisch der Stille, wo dem Besucher die Möglichkeit geboten wird, der Gefallenen zu gedenken. Dann folgt er dem Pfad durch das Tor des Kusses, vorbei an den Steinbänken entlang der Heldenstimmen, bis hin zur Endlosen Säule, die den gefallenen Seelen den Weg in den Himmel weist. Emotionsgeladenes Licht macht die Betrachtung der Skulpturen zu einem intensiven, persönlichen Erlebnis. Es lässt dramatische Schatten entstehen und betont die scheinbar endlose Säule.

Deux parcs comprennent un monument aux soldats morts de la première guerre mondiale. Il existe une progression symbolique à travers les parcs, que souligne l'éclairage. Le trajet débute à la table du silence, où l'on se recueille pour honorer les disparus. Le visiteur continue le chemin par la porte du baiser, dépasse la pierre sise au long de la voix des héros et continue tout le trajet jusqu'à la colonne de l'infini qui montre le chemin pour que les âmes de ceux qui sont tombés puissent grimper au paradis. L'éclairage est chargé d'émotions, provoquant des rencontres intimes avec les sculptures. Il projette des ombres importantes et rehausse le coté interminable de la colonne.

Dos parques componen el monumento de recuerdo a los soldados que murieron en la Primera Guerra Mundial. Existe una progresión simbólica a través de los parques, acentuada por la iluminación. El camino comienza en la Mesa del Silencio, donde se rinde honor a todos los caídos. El visitante continúa el camino a través de la Puerta del Beso, pasa el asiento de piedra a lo largo de la Voz de los Héroes hasta la Columna Interminable, que marca el camino a las almas caídas para subir al cielo. La iluminación está cargada de emoción, capturando los encuentros íntimos con las esculturas. La luz arroja sombras dramáticas y enfatiza la aparentemente interminable columna.

Due parchi comprendono un monumento alla memoria dei soldati caduti nella Prima guerra mondiale. I parchi sono disposti in una progressione simbolica accentuata dall'illuminazione. Il sentiero inizia alla cosiddetta "Tavola del silenzio" dove ci si raccoglie per onorare i caduti. Il visitatore segue il sentiero attraverso il "Varco del bacio", passando per i posti a sedere di pietra lungo la "Voce degli eroi" per arrivare alla "Colonna infinita", indicante la via delle anime dei caduti dirette verso il cielo. L'illuminazione ha un carattere emotivo e cattura incontri raccolti con le sculture. Getta ombre drammatiche ed enfatizza una colonna che sembra infinita.

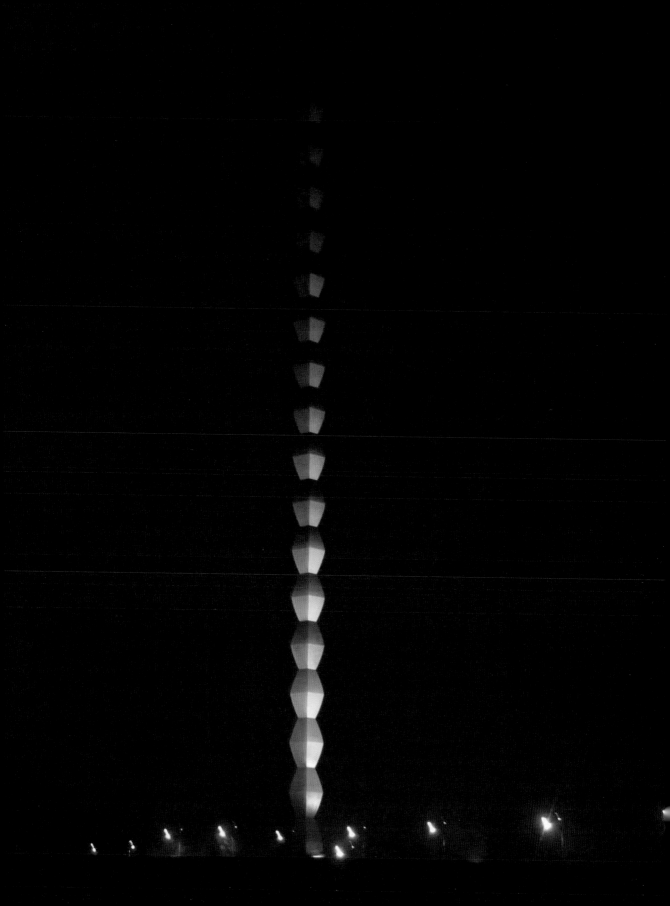

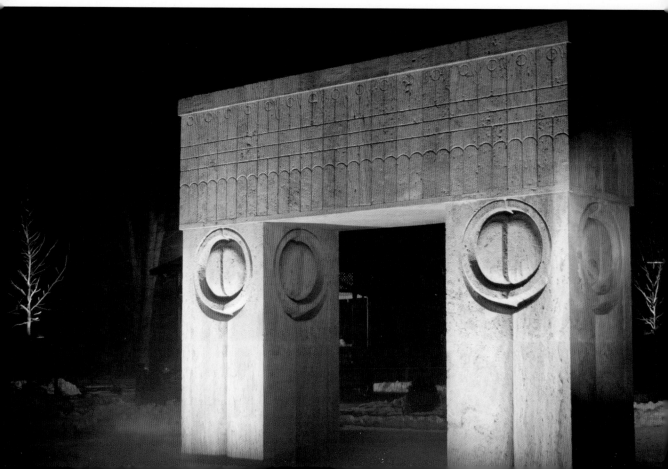

Brancusi Ensemble: Targu -Jiu, Romania

Park of the Table and Gate

Basilica

Endless Column Park

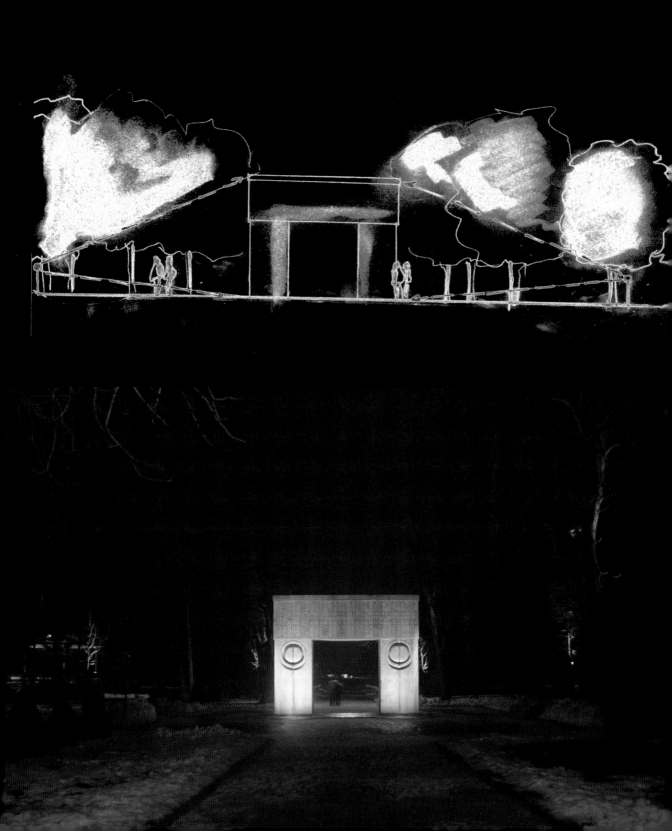

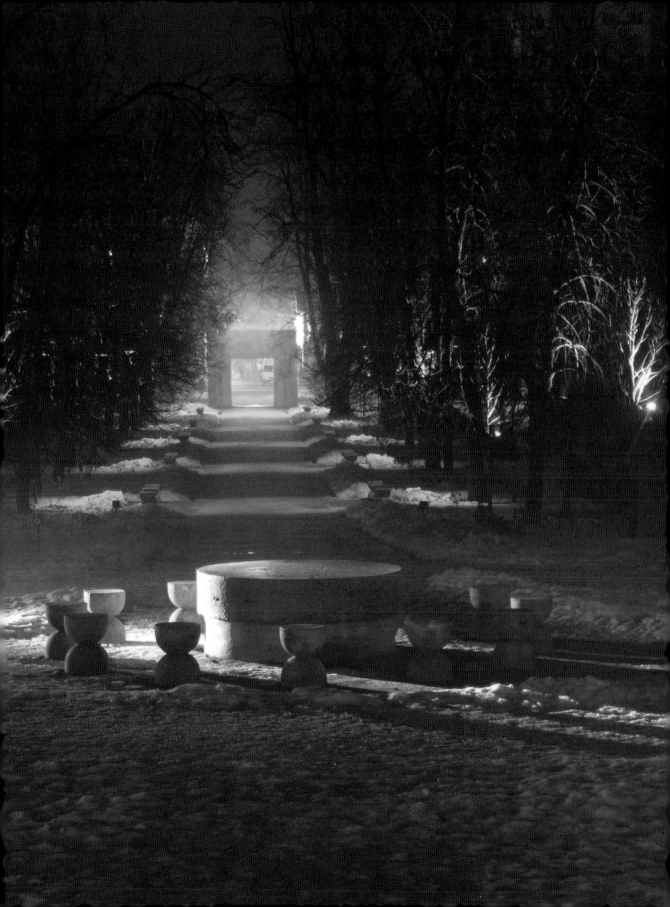

Pont du Gard

Location: Vers Pont du Gard, France
Artist: James Turrell
Completed: 2002

Artist James Turrell wanted the lighting system to alternately reveal different volumetric aspects of the space. In a cycle lasting fortyfive minutes, the lighting shifts from revealing only the flat surface of the aqueduct, to the entire three dimensional volume, to only the undersides of the arches, thus making the entire structure disappear by mimicking the blue of the night sky.

Der Künstler James Turrell wollte durch das Beleuchtungssystem verschiedene volumetrische Aspekte des Bauwerks im Wechsel betonen. In einem fünfundvierzig Minuten dauernden Kreislauf verändert sich das Licht, so dass es erst die flache Fassade des Aquädukts hervorhebt, dann das Gebäude in seiner ganzen Dreidimensionalität zeigt und schießlich nur die Unterseiten der Bögen beleuchtet und so das gesamte Konstrukt verschwinden lässt, indem es an das Blau des nächtlichen Himmels angeglichen wird.

L'artiste James Turrell désirait un système d'éclairage révélant alternativement différents aspects de volumes dans l'espace. Pendant un cycle d'une durée de quarante-cinq minutes, l'éclairage se déplace pour montrer au départ uniquement la surface plane de l'aqueduc, puis le volume tridimensionnel entier, ensuite uniquement le dessous des arches, et ce faisant l'ensemble de la structure disparaît imitant le bleu du ciel nocturne.

El artista James Turrell quería que el sistema de iluminación revelase de forma alterna distintos aspectos volumétricos del espacio. En un ciclo de cuarenta y cinco minutos de duración, la iluminación va desde la sola aparición de la superficie plana del acueducto, pasando por la aparición del volumen tridimensional completo, hasta la iluminación de las partes inferiores de los arcos solamente, haciendo desaparecer así toda la estructura por medio de la imitación del azul del cielo nocturno.

L'artista James Turrell desiderava che il sistema d'illuminazione rivelasse alternativamente diversi aspetti volumetrici dello spazio. In un ciclo di quarantacinque minuti l'illuminazione passa dal rivelare la sola superficie piatta dell'acquedotto all'intero volume tridimensionale al solo lato inferiore degli archi, facendo sparire in tal modo l'intera struttura imitante il blu del cielo notturno.

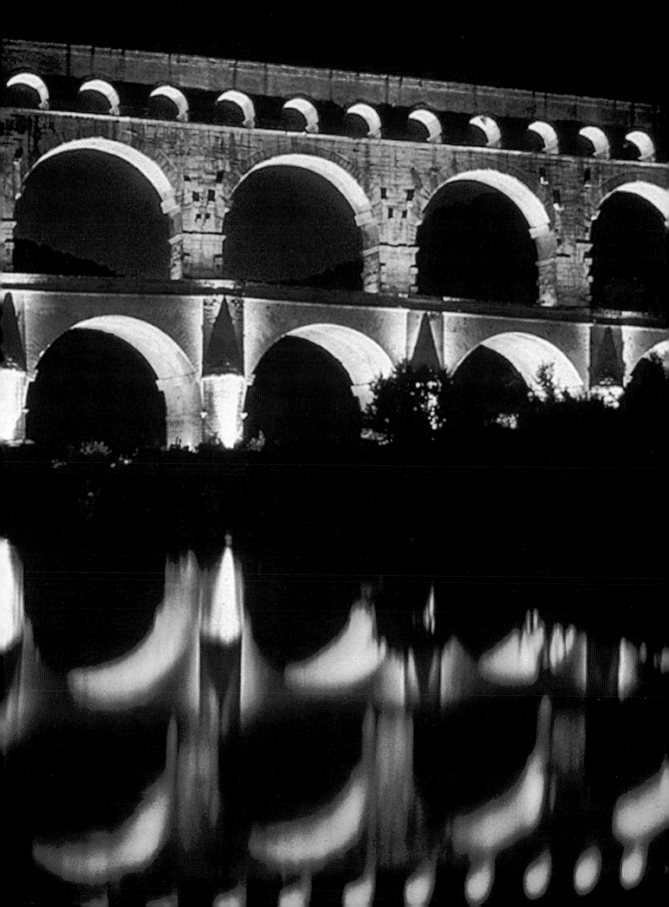

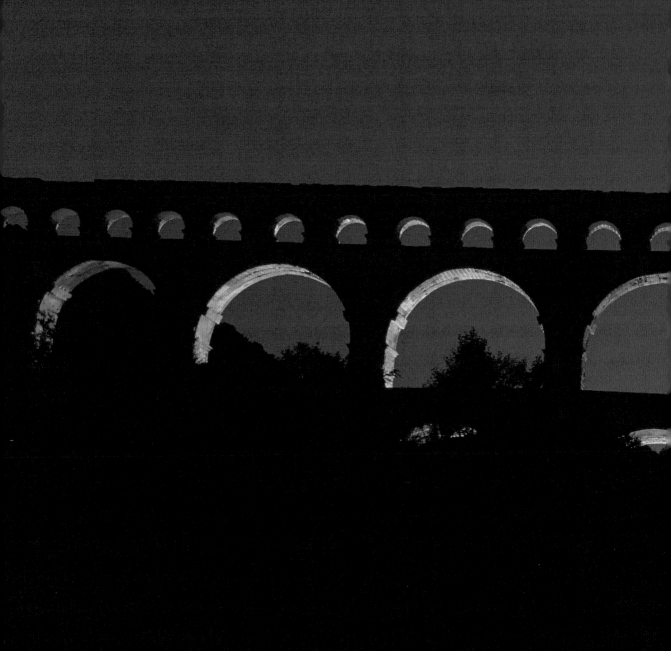

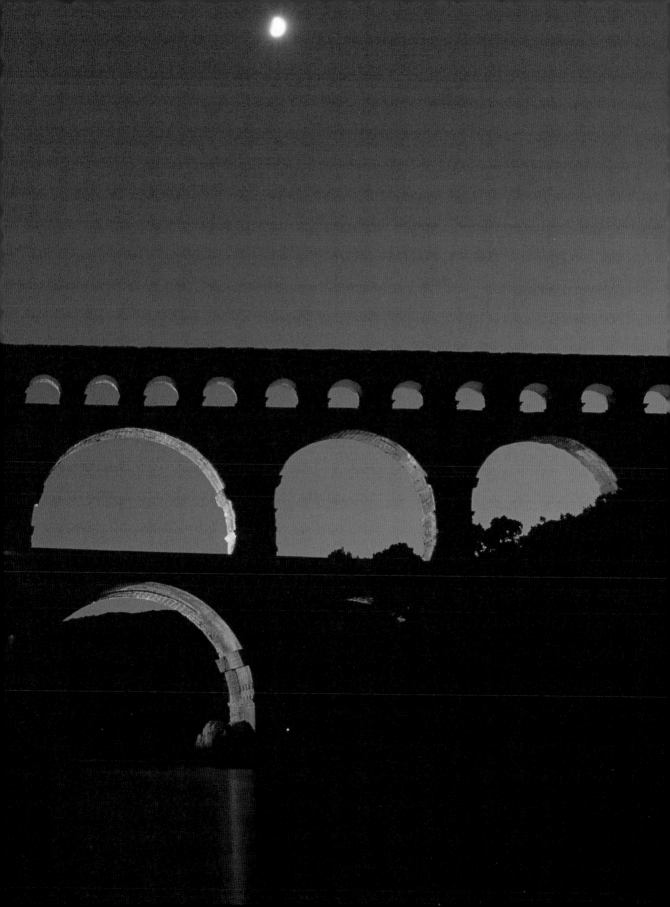

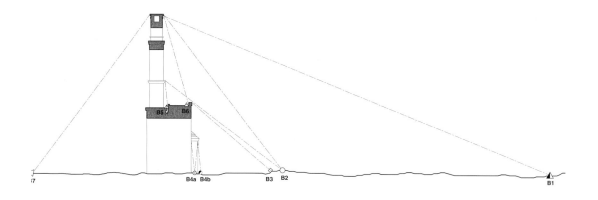

B1	2000W PAR APPAREIL, 3 COULEURS + BLANC, 4 ALIMENTATIONS SEPAREES
B2	1000W PAR APPAREIL, 3 COULEURS, 3 ALIMENTATIONS SEPAREES
B3	500W PAR APPAREIL, 3 COULEURS, 3 ALIMENTATIONS SEPAREES
B4a	200W PAR APPAREIL, 3 COULEURS, 3 ALIMENTATIONS SEPAREES
B4b	25W PAR APPAREIL
B5	144,5W PAR METRE LINEAIRE, 3 COULEURS, 3 ALIMENTATIONS SEPAREES
B6	500W PAR APPAREIL, 3 COULEURS, 3 ALIMENTATIONS SEPAREES
B7	1500W PAR APPAREIL, 1 COULEUR + BLANC, 2 ALIMENTATIONS SEPAREES

LE PONT - PRINCIPE B COUPE
PONT DU GARD LIGHTING PROJECT JAMES TURRELL

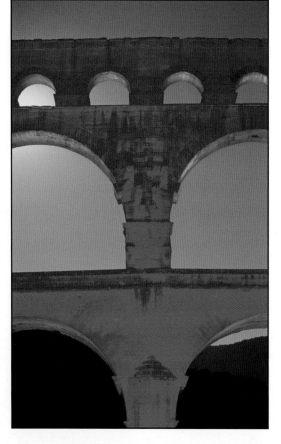

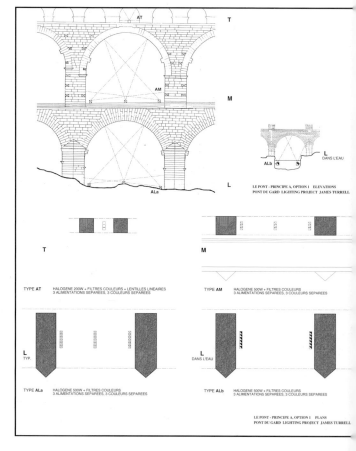

LE PONT - PRINCIPE A, OPTION 1 ELEVATIONS
PONT DU GARD LIGHTING PROJECT JAMES TURRELL

TYPE **AT** HALOGENE 200W + FILTRES COULEURS + LENTILLES LINEAIRES
3 ALIMENTATIONS SEPAREES, 3 COULEURS SEPAREES

TYPE **AM** HALOGENE 500W + FILTRES COULEURS
3 ALIMENTATIONS SEPAREES, 3 COULEURS SEPAREES

TYPE **ALa** HALOGENE 500W + FILTRES COULEURS
3 ALIMENTATIONS SEPAREES, 3 COULEURS SEPAREES

TYPE **ALb** HALOGENE 500W + FILTRES COULEURS
3 ALIMENTATIONS SEPAREES, 3 COULEURS SEPAREES

LE PONT - PRINCIPE A, OPTION 1 PLANS
PONT DU GARD LIGHTING PROJECT JAMES TURRELL

Pont du Gard

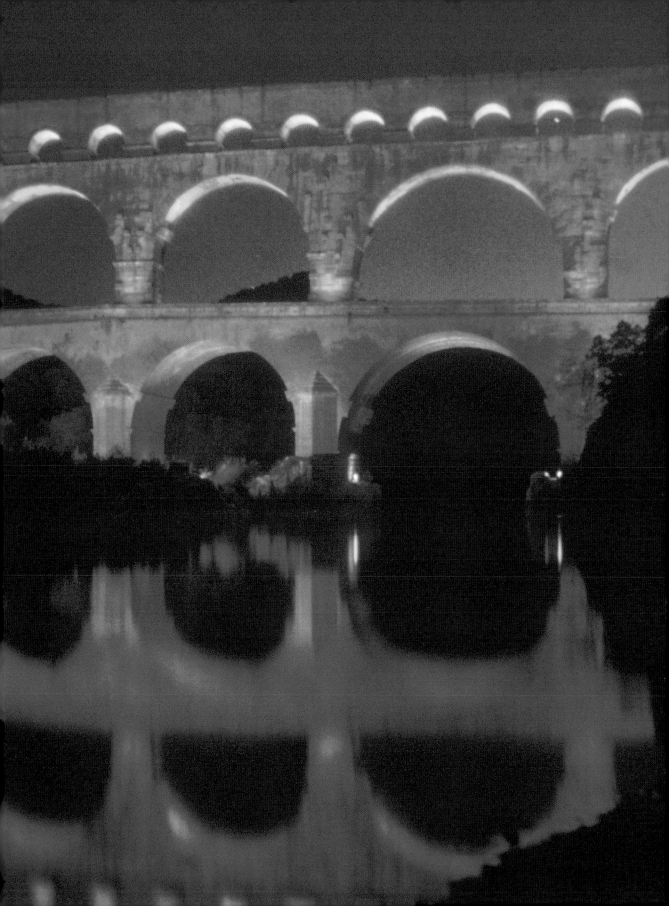

Caisse des Dépôts et Consignations

Location:	Paris, France
Architects:	Christian Hauvette, France
Artist:	James Turrell
Completed:	2004

The lighting design rounds off artist James Turrell's scheme to emphasize the volumetrics of the building with changing colored lights on the office building and facade of the interior street. For the project technical support was provided to realize his vision. Research was undertaken to avoid any reflection on extensive glass surfaces. The solution provided invisible light sources, installed as to not reflect on the interior facade.

Das Licht, das in immer wechselnden Farben das Bürogebäude und die von außen sichtbare Wand des Innengangs beleuchtet, vervollständigt das Beleuchtungskonzept des Künstlers James Turrell. Um seiner Vision Gestalt zu verleihen, erhielt das Projekt technische Unterstützung. Es wurden Untersuchungen angestellt, wie Reflektionen auf den großflächigen Glasfassaden vermieden werden können. Man fand die Lösung in der Installation verdeckter Lichtquellen, die so montiert wurden, dass sie keine Spiegelungen an der Innenfassade verursachen.

Le concept d'éclairage crée par l'artiste James Turrell met en valeur les volumes de l'immeuble, par des lumières colorées changeantes sur l'immeuble de bureaux et la façade de la rue interne. Pour le projet, une assistance technique a été apportée afin de réaliser sa vision. Des recherches ont été entreprises afin d'éviter toute réflexion sur les surfaces de verres très étendues. La solution a consisté à rendre les sources de lumière invisibles, installées de manière à éviter tout reflet sur la façade interne.

El diseño de la iluminación complementa el concepto de iluminación del artista James Turrell para destacar las medidas del edificio con luces de colores cambiantes en el edificio de oficinas y en la fachada de la calle interior. Para realizar la visión del proyecto se empleó apoyo técnico. Se emprendió un estudio para evitar cualquier reflejo en las grandes superficies de cristal. La solución aportó fuentes de luz invisibles, instaladas de tal forma que no se reflejaran en el interior de la fachada.

La struttura dell'illuminazione risponde allo schema d'illuminazione dell'artista James Turrell, volto ad enfatizzare le caratteristiche volumetriche dell'edificio con luci colorate alternanti sull'edificio adibito ad uffici e sulla facciata della strada interna. Per il progetto è stata fornita assistenza tecnica al fine di realizzare la sua visione. Sono state svolte ricerche volte ad evitare qualsiasi riflesso sulle ampie superfici di vetro, risolvendo il problema grazie a fonti luminose invisibili installate in modo tale da non causare riflessioni sulla facciata interna.

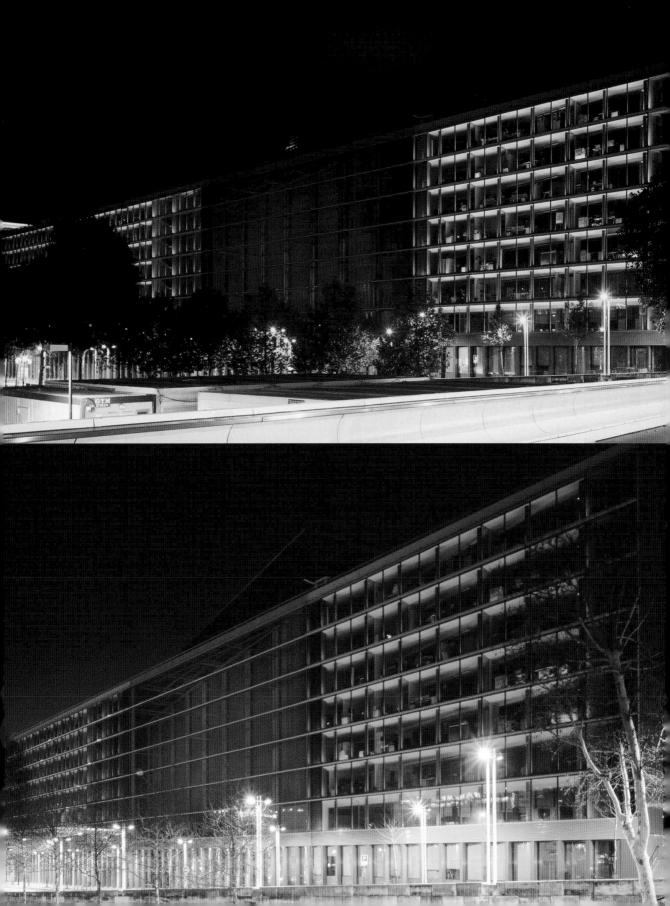

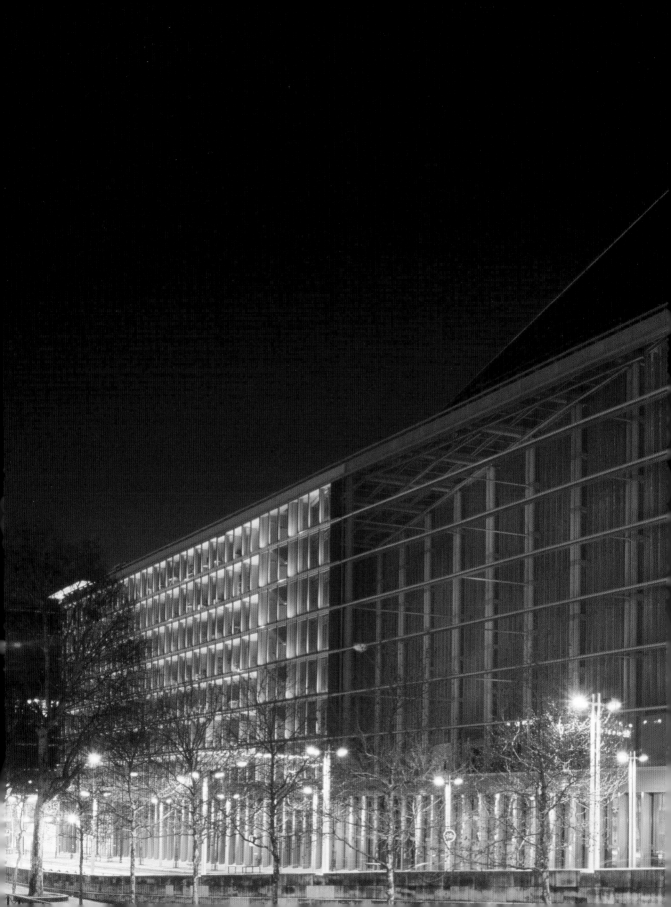

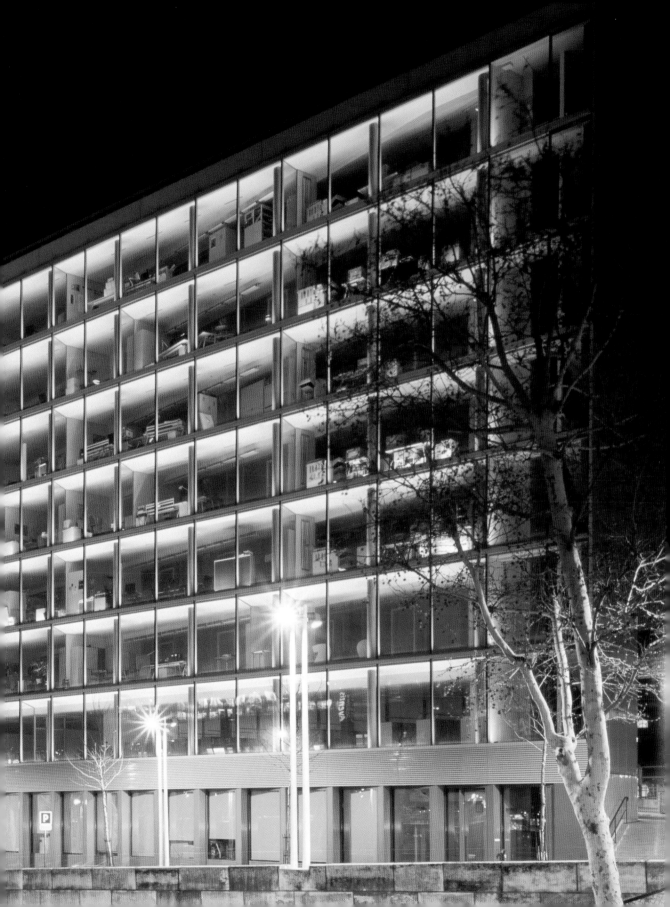

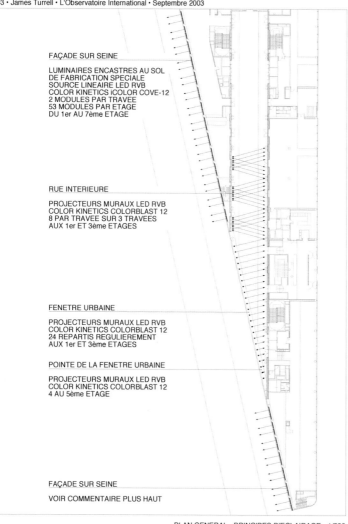

FAÇADE SUR SEINE

LUMINAIRES ENCASTRES AU SOL
DE FABRICATION SPECIALE
SOURCE LINEAIRE LED RVB
COLOR KINETICS iCOLOR COVE-12
2 MODULES PAR TRAVEE
53 MODULES PAR ETAGE
DU 1er AU 7ème ETAGE

RUE INTERIEURE

PROJECTEURS MURAUX LED RVB
COLOR KINETICS COLORBLAST 12
8 PAR TRAVEE SUR 3 TRAVEES
AUX 1er ET 3ème ETAGES

FENETRE URBAINE

PROJECTEURS MURAUX LED RVB
COLOR KINETICS COLORBLAST 12
24 REPARTIS REGULIEREMENT
AUX 1er ET 3ème ETAGES

POINTE DE LA FENETRE URBAINE

PROJECTEURS MURAUX LED RVB
COLOR KINETICS COLORBLAST 12
4 AU 5ème ETAGE

FAÇADE SUR SEINE

VOIR COMMENTAIRE PLUS HAUT

PLAN GENERAL • PRINCIPES D'ECLAIRAGE • 1/500

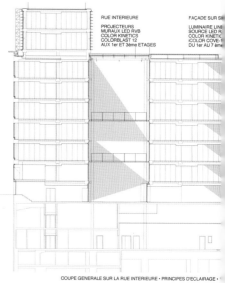

RUE INTERIEURE

PROJECTEURS
MURAUX LED RVB
COLOR KINETICS
COLORBLAST 12
AUX 1er ET 3ème ETAGES

FAÇADE SUR SE...

LUMINAIRE LINE...
SOURCE LED R...
COLOR KINETIC...
iCOLOR COVE-...
DU 1er AU 7ème...

COUPE GENERALE SUR LA RUE INTERIEURE • PRINCIPES D'ECLAIRAGE •

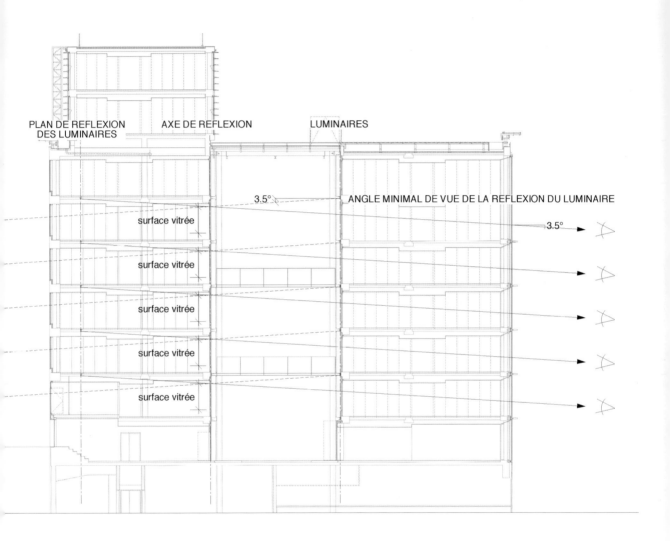

PLAN DE REFLEXION
DES LUMINAIRES — AXE DE REFLEXION — LUMINAIRES

3.5° — ANGLE MINIMAL DE VUE DE LA REFLEXION DU LUMINAIRE

surface vitrée — 3.5°

surface vitrée

surface vitrée

surface vitrée

surface vitrée

Studies of the angle of reflection of the lighting, done to avoid an unwanted reflection of the light source on the interior facade of the building

Le Secret des Churingas

Location: Musée National des Arts d'Afrique et d'Océanie,
 Paris, France
Artist: Marc Couturier
Completed: 2001

The churinga is a sacred ceremonial object used by Aboriginal men in secret rites. It is attached to a string and spun overhead, which causes it to emit a low-pitched sound believed to be the voice of the gods. Lighting played a major role in this close collaboration with artist Marc Couturier. Light is used to cast wing-like shadows off the objects, making them appear to be in flight as they would be when in use, thereby revealing a part of the ritual for which they are created.

Ein Churinga ist ein heiliges, zeremonielles Objekt, das von den Männern der Aborigines bei geheimen Riten verwendet wird. Es ist an einem Band befestigt und wird über dem Kopf herumgewirbelt, wodurch ein tiefer Klang entsteht, von dem man glaubt, es handele sich um die Stimme der Götter. In der Zusammenarbeit mit Künstler Marc Couturier spielte Beleuchtung eine wichtige Rolle. Licht wird so eingesetzt, dass die Kunstobjekte flügelartige Schatten werfen und so erscheinen, als kreisten sie in der Luft. Sie sehen aus, als würden sie benutzt und auf diese Weise wird ein Teil des Rituals sichtbar gemacht.

Le churinga est un objet cérémoniel sacré, utilisé par les hommes aborigènes dans des rites secrets. Il est attaché par une corde que l'on fait tourner au-dessus de la tête ce qui permet l'émission d'un son de tonalité basse qui est interprété comme étant la voix des dieux. L'éclairage joue un rôle majeur dans cette collaboration étroite avec l'artiste Marc Couturier. La lumière sert à projeter des ombres comme des ailes sur des objets, ce qui les fait apparaître comme étant en plein vol comme ils le seraient dans leur utilisation d'origine, tout en révélant ainsi une partie du rituel pour lequel ils ont été conçus.

El churinga es un objeto ceremonial sagrado utilizado por los aborígenes en los ritos secretos. Está ligado a una cuerda y a un hilo por la parte superior, lo que hace que emita un sonido de baja intensidad que se creía que era la voz de los dioses. La iluminación jugaba un papel esencial en esta estrecha colaboración con el artista Marc Couturier. La luz se usó para proyectar sombras con forma de alas fuera de los objetos, lo que hacía que pareciese que volaban como lo hubiesen hecho si hubieran sido usadas, de este modo revelaban una parte del ritual para el que se crearon.

Il Churinga è un oggetto cerimoniale sacro usato dagli uomini aborigeni in riti segreti. È attaccato ad una cordicella e risvoltato verso l'alto, motivo per cui emette una tonalità profonda che si presume sia la voce degli dei. L'illuminazione ha svolto un ruolo importante nell'ambito di questa stretta cooperazione con l'artista Marc Couturier. La luce viene impiegata per produrre ombre degli oggetti simili ad ali, facendoli sembrare essere in volo come se venissero utilizzati, rivelando in tal modo una parte del rituale per cui sono stati creati.

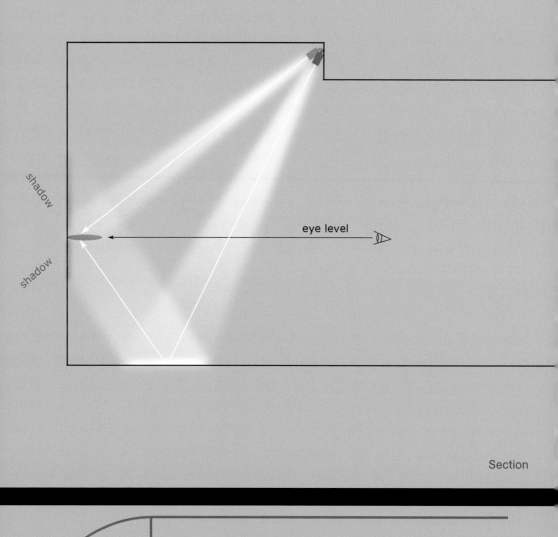

shadow

shadow

eye level

Section

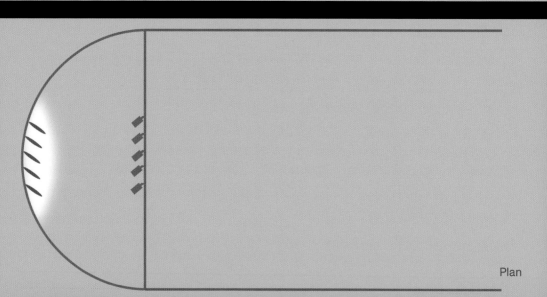

Plan

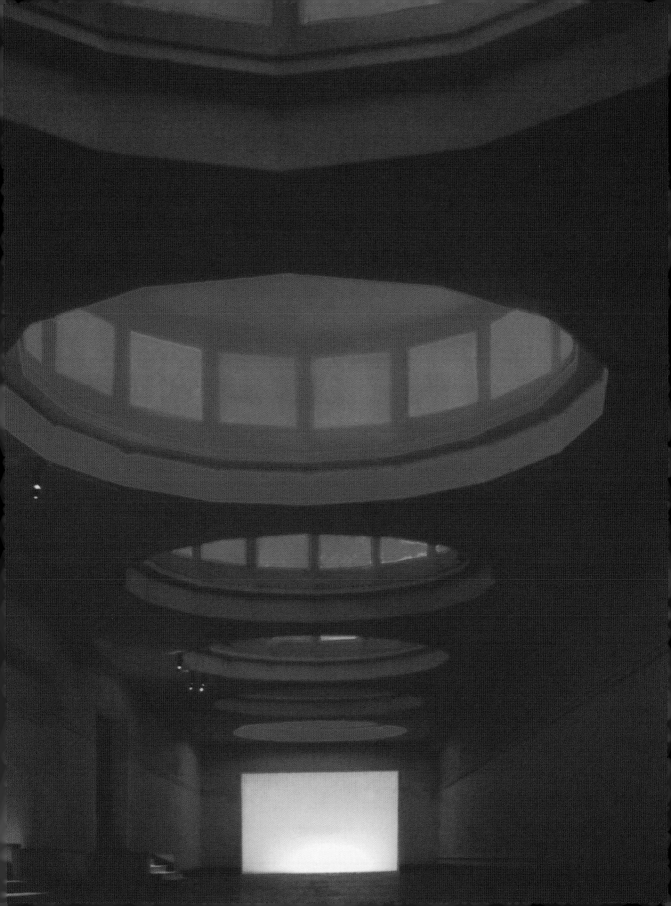

Le Carnaval des animaux

Location:	Montpellier, France
Director:	Jean Paul Scarpitta
Completed:	2001

Director Jean-Paul Scarpitta asked writer Marie Darrieussecq to provide a new libretto which was interjected into Saint-Saëns's original composition. Actor Gérard Depardieu narrates the lively fable including circus performers such as trapeze artists and contortionists. Lighting emphasizes the deep blue sea in which the performance is set.

Regisseur Jean-Paul Scarpitta bat die Librettistin Marie Darrieussecq ein neues Libretto zu verfassen, das in Saint-Saëns Originalgeschichte eingefügt wurde. Diese lebhafte Fabel wird von Schauspieler Gerard Depardieu erzählt, in der auch Zirkuskünstler wie Trapezartisten und Schlangenmenschen vorkommen. Die Beleuchtung betont das tiefblaue Meer, in der das Stück spielt.

Le directeur Jean-Paul Scarpitta a demandé à la librettiste Marie Darrieussecq d'écrire un nouveau livret qui a été introduit dans la composition originale de Saint-Saëns. L'acteur Gérard Depardieu raconte la fable vivante qui comprend également des artistes du cirque tels que des trapézistes et des contorsionnistes. L'éclairage met en valeur la mer d'un bleu profond où le spectacle se déroule.

El director Jean-Paul Scarpitta pidió a la escritora Marie Darrieussecq que le proporcionara un libreto nuevo que fue agregado a la versión original de Saint-Saëns. El actor Gérard Depardieu narra el cuento animado acompañado por actores circenses tales como trapecistas y contorsionistas. La iluminación enfatiza el profundo océano en el que se sitúa la acción.

Il dirigente Jean-Paul Scarpitta chiese alla scrittrice Marie Darrieussecq di fornire un nuovo libretto interposto nella composizione originale di Saint-Saëns. L'attore Gérard Depardieu narra la vivace fiaba includente artisti del circo come trapezisti e contorsionisti. L'illuminazione enfatizza il cielo con un profondo blu in cui è ambientata la performance.

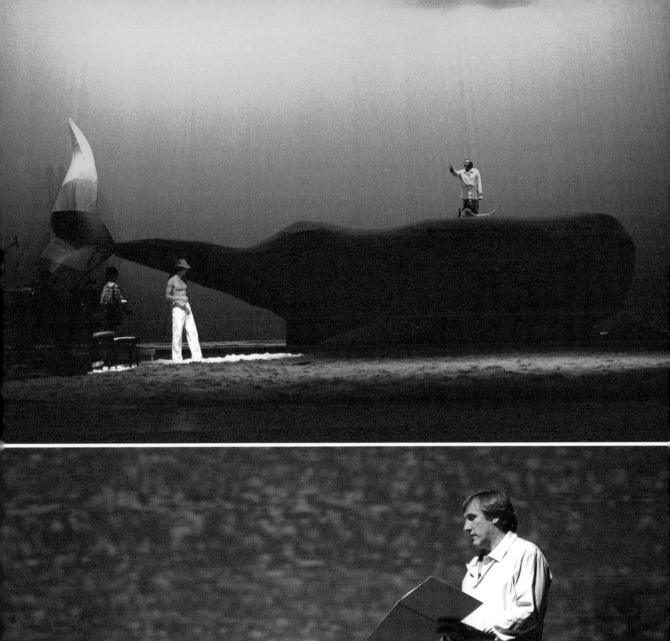

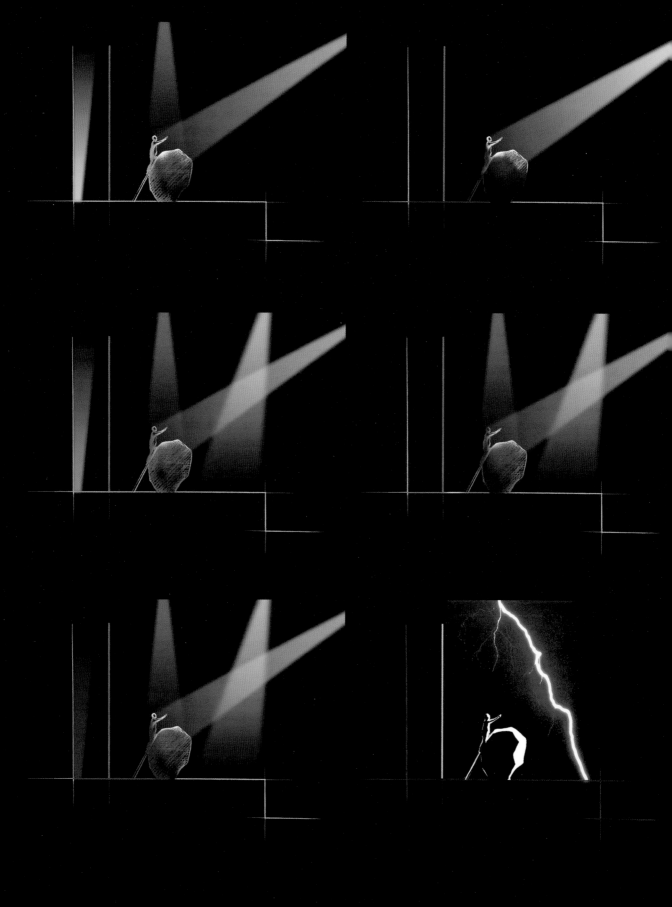

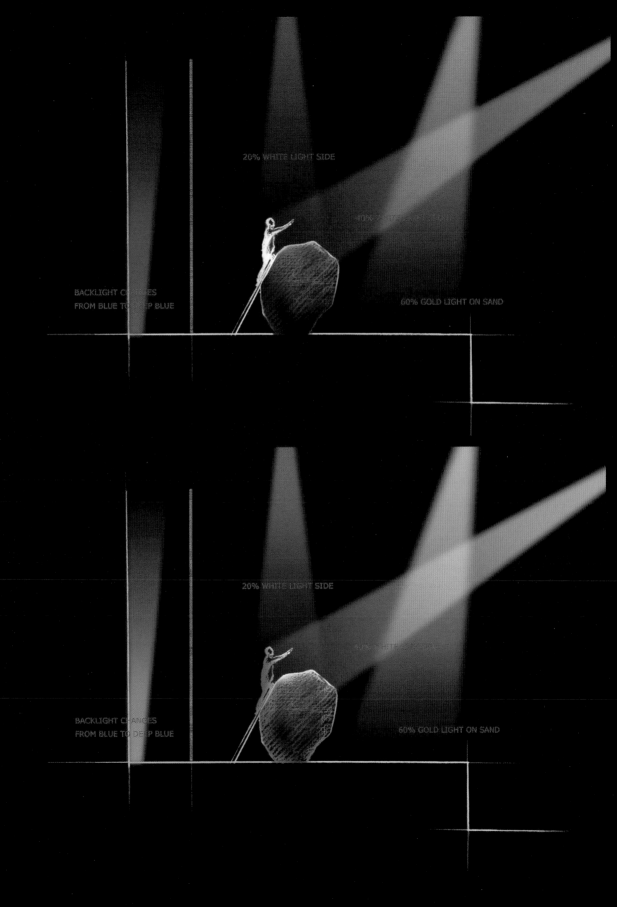

Serial Killer / Barbe Bleue

Location: Créteil, France
Designers: Agence Patrick Jouin, France
Completed: 2005

For this installation titled "Serial Killer," designer and director Patrick Jouin created boxes that emote through color and sound, to interpret Charles Perrault's celebrated tale of Blue Beard. The color and intensity of the light emitted both into and from of these boxes is subtly varied, thereby animating them and reflecting changes mood.

Für die Installation mit dem Titel „Serienmörder" entwarf der Designer und Regisseur Patrick Jouin Kästen, die mittels Farbe und Klang Emotionen versinnbildlichen und so Charles Perraults vielgerühmtes Märchen von Blaubart interpretieren. Farbe und Intensität des Lichts, das sowohl in die Kästen hinein, als auch aus ihnen heraus gestrahlt wird, werden raffiniert verändert, womit den Kästen Leben eingehaucht und die Wandlung der Atmosphäre wiedergegeben wird.

Pour cette installation intitulée « Serial Killer », le concepteur et directeur Patrick Jouin a créé des boites séparées qui émeuvent les visiteurs par la couleur et le son, dans l'interprétation du célèbre comte de Charles Perrault Barbe Bleue. La couleur et l'intensité des lumières émises vers et dans ces boites varient subtilement, tout en les animant et en reflétant les changements d'atmosphère.

Para esta instalación titulada "Serial Killer" (asesino en serie), el diseñador y director Patrick Jouin creó cajas que conmueven a través del color y el sonido, para interpretar el famoso cuento de Charles Perrault Barba Azul. El color y la intensidad de la luz que se emite tanto en el interior como desde el exterior de esas cajas varía sutilmente, animándolas y reflejando cambios de ambiente.

Per questa installazione intitolata "Serial Killer," il designer e dirigente Patrick Jouin ha creato dei box che destano emozioni con colori e suoni per interpretare la nota favola di Charles Perrault Blue Beard (Barba blu). Il colore e l'intensità della luce emessa sia verso questi box che dai medesimi vengono finemente variate, animando i box stessi e riflettendo cambiamenti di atmosfera.

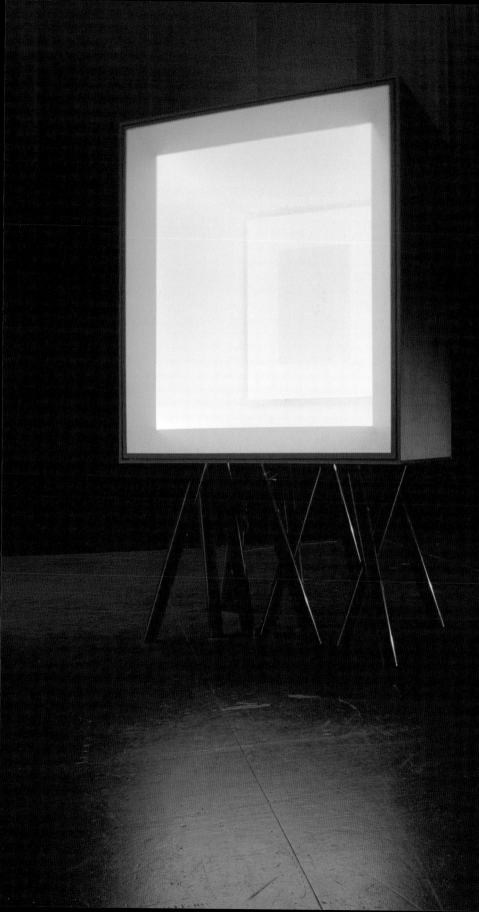

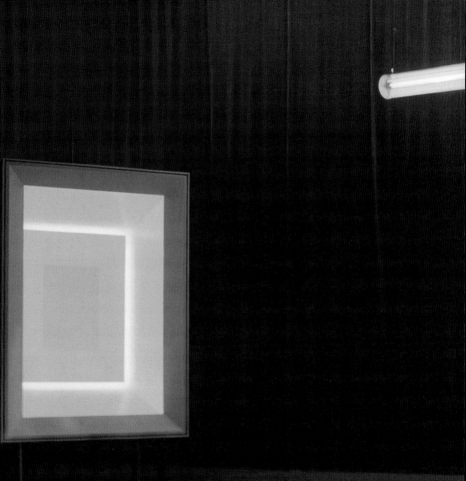

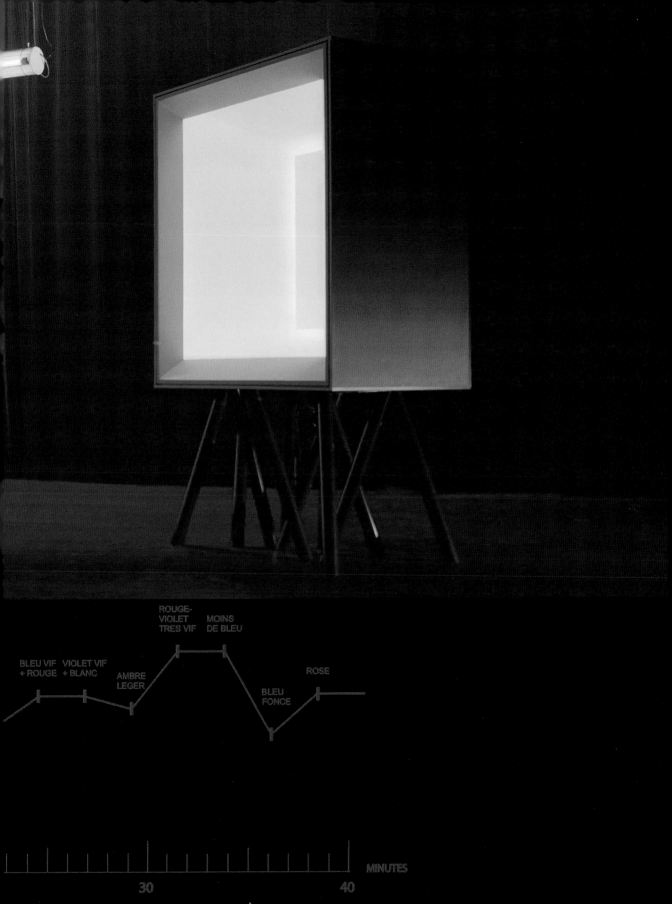

ROUGE-
VIOLET MOINS
TRES VIF DE BLEU

BLEU VIF VIOLET VIF
+ ROUGE + BLANC ROSE
 AMBRE
 LEGER BLEU
 FONCE

 MINUTES

 30 40

Boutique at the Musée des Arts Décoratifs

Location: Paris, France
Architects: Bruno Moinard, France
Completed: 2003

The general lighting for this space is realized with large diffusers of light mounted under the ceiling. Accent lighting highlights product displays, and touches of color provide a signature identity.

Die Hauptbeleuchtung in den Räumlichkeiten besteht aus großen an der Decke montierten Lichtdiffusoren. Akzentbeleuchtung hebt die ausgestellten Artikel hervor und ein Hauch von Farbe verleiht dem Ganzen eine charackteristische Atmosphäre.

L'éclairage général de cet espace est réalisé à l'aide de grands diffuseurs de lumière montés sous le plafond. Des éclairages ponctuels rehaussent les distributeurs de produits et des touches de couleur délivrent une signature identitaire.

La iluminación general para este espacio se lleva a cabo por medio de grandes difusores de luz montados bajo el techo. La iluminación de acento resalta los productos expuestos, y los toques de color proporcionan un sello de identidad.

L'illuminazione generale prevista per questo spazio è realizzata con grandi diffusori di luce montati sotto il soffitto. Luce d'accento esalta i prodotti esposti e tocchi di colore producono un'identità caratteristica.

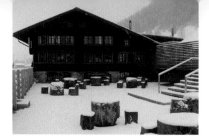

Spoon des Neiges à Chlösterli

Location: Gstaad, Switzerland
Designer: Agence Patrick Jouin, France
Completed: 2003

This dining and entertainment complex comprises four spaces including two restaurants, a bar and lounge, and a discoteque. As there are no physical partitions between most of these areas, each one provides a distinct mood while still complementing the other. Lighting takes the guise of fire and ice to both mimic and provide a refuge from Gstaad's changing climate. Not only do these effects shift with the change of seasons, but they are further manipulated in the span of an evening.

Dieser Restaurant- und Entertainmentkomplex besteht aus insgesamt vier Bereichen: zwei Restaurants, einer Bar und Lounge, sowie einer Discothek. Da die jeweiligen Bereiche nicht durch konkrete Trennwände voneinander abgegrenzt sind, wurde durch Licht und Design jedem eine eigene Atmosphäre verliehen. So sind die Bereiche visuell getrennt und ergänzen einander dennoch gegenseitig. Licht nimmt die Gestalt von Feuer und Eis an, um Gstaads wechselndes Klima widerzuspiegeln, aber auch um eine Zuflucht davor zu bieten. Diese Lichteffekte verändern sich nicht nur mit dem Wechsel der Jahreszeiten, sondern auch im Verlauf eines Abends.

Ce complexe de dîner et spectacle comprend quatre espaces réservés à deux restaurants, un bar et un salon ainsi qu'une discothéque. Comme il n'existe pas de cloisonnement physique entre la plupart de ces espaces, chacun d'entre eux rayonne une ambiance différente tout en complétant l'autre. L'éclairage prend l'aspect du feu et la glace afin de simuler et en même temps de fournir un refuge contre le climat changeant de Gstaad. Ces effets d'éclairage ne font pas que jouer avec les changements de saisons, mais ils font l'objet de manipulations tout au long de la soirée.

Este complejo hostelero y de ocio comprende cuatro espacios que incluyen dos restaurantes, un bar con salón, y una discoteca. Dado que no existen dos divisiones físicas entre muchas de estas zonas, cada una de ellas proporciona un ambiente diferente mientras que complementa a las demás. La iluminación toma la apariencia de fuego y hielo para imitar y proporcionar, al mismo tiempo, un refugio para el clima oscilante de Gstaad. Esos efectos no cambian sólo con el paso de una estación del año a otra, sino que también son manipulados en el espacio de una tarde.

Questo complesso di ristorante e locale di intrattenimento comprende quattro ambienti includenti due ristoranti, un bar e salone nonché una discoteca. Dato che tra la maggior parte di questi spazi non esistono divisioni fisiche, ciascuno di essi crea un'atmosfera diversa integrando tuttavia nel contempo gli altri. L'illuminazione assume le sembianze di fuoco e ghiaccio per imitare il clima variabile di Gstaad e per proteggere nel contempo dal medesimo. Non solo questi effetti cambiano con il variare delle stagioni, ma vengono manipolati ulteriormente nel corso di una serata.

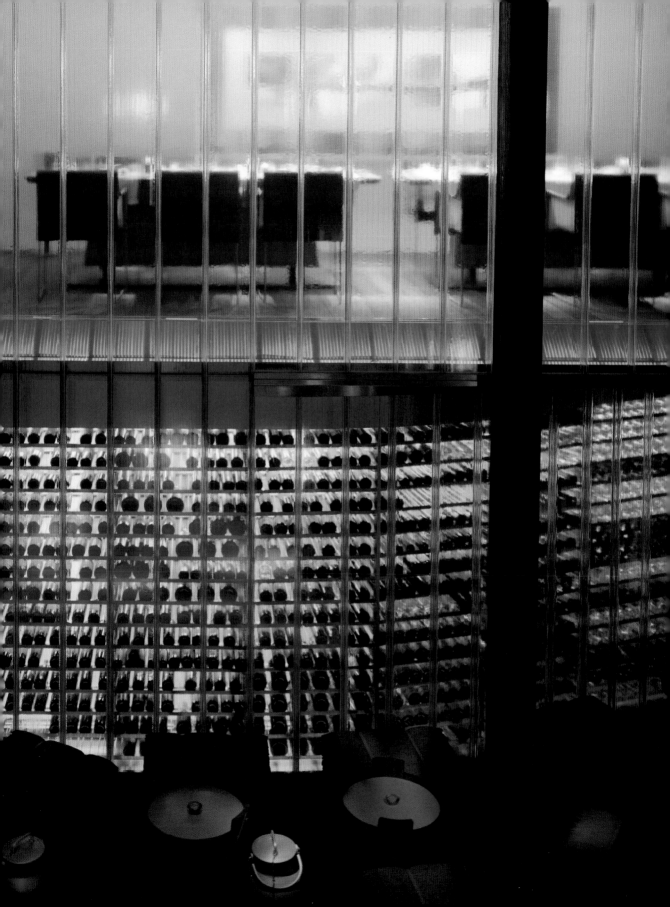

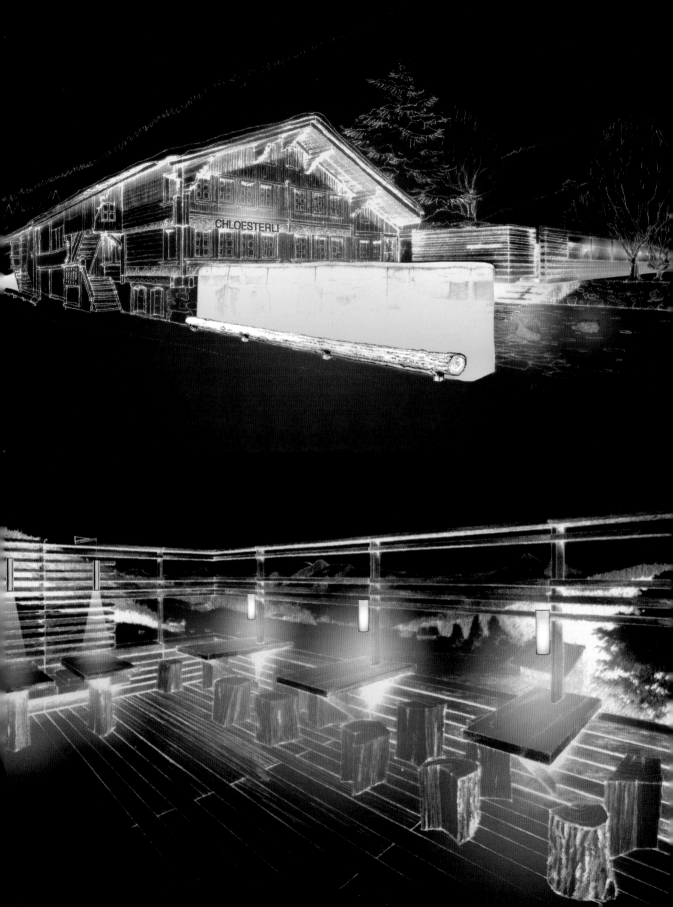

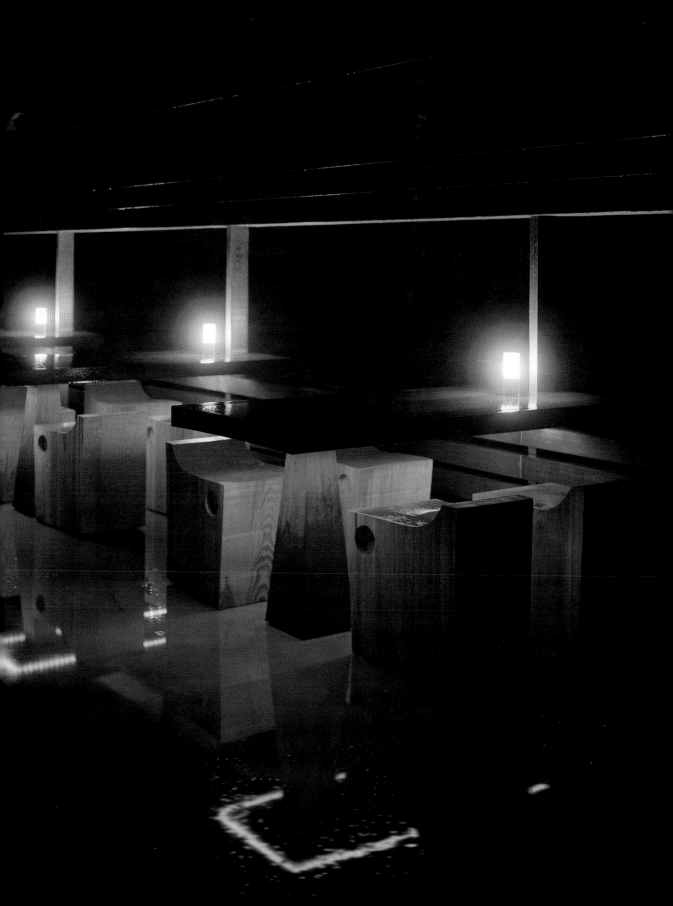

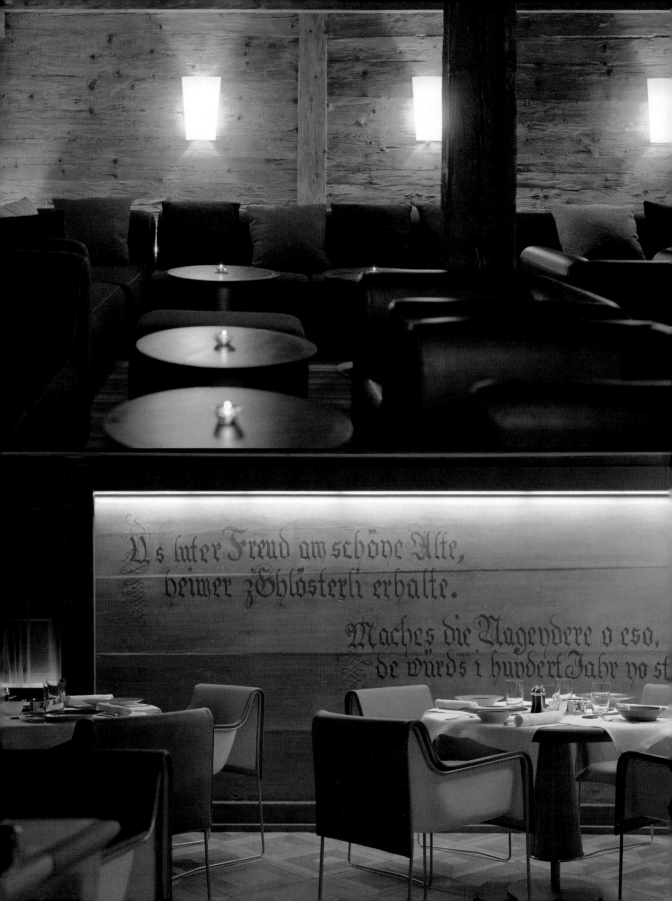

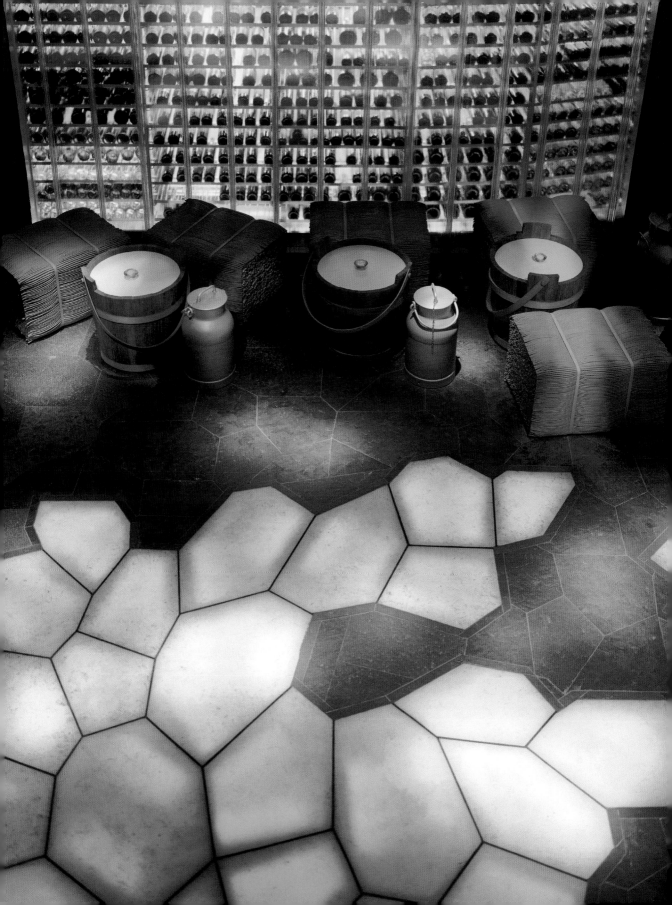

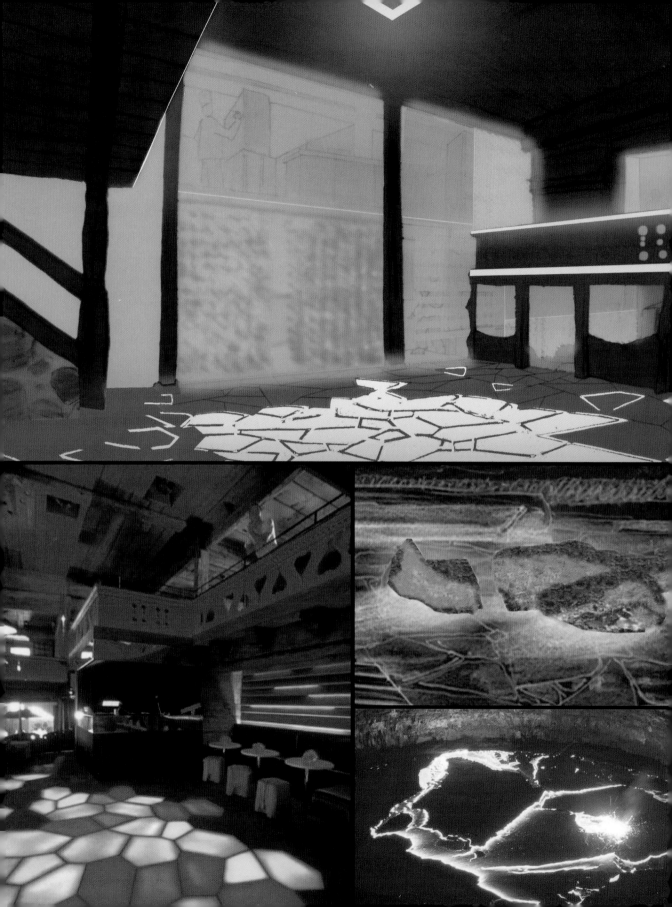

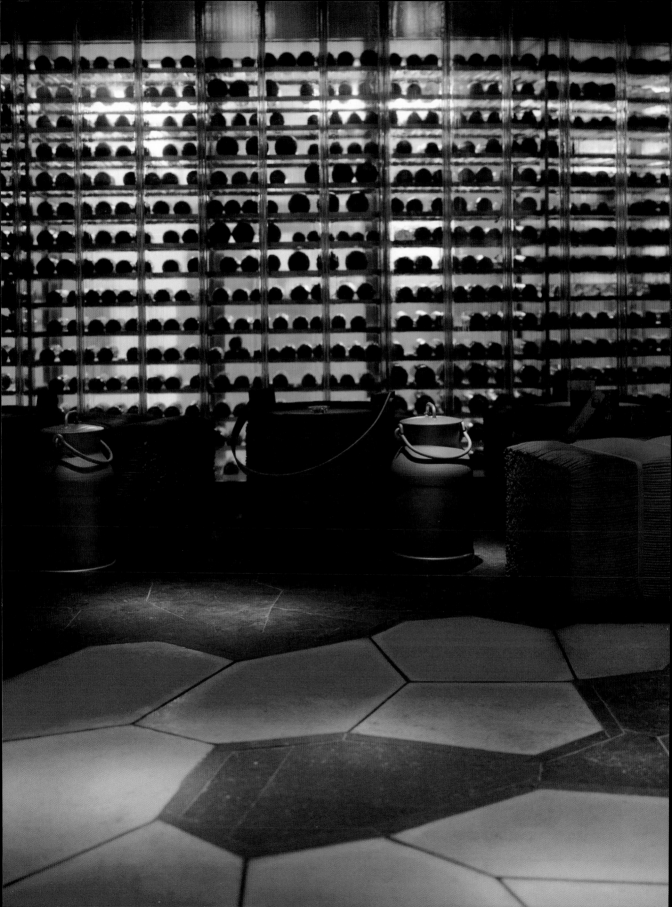

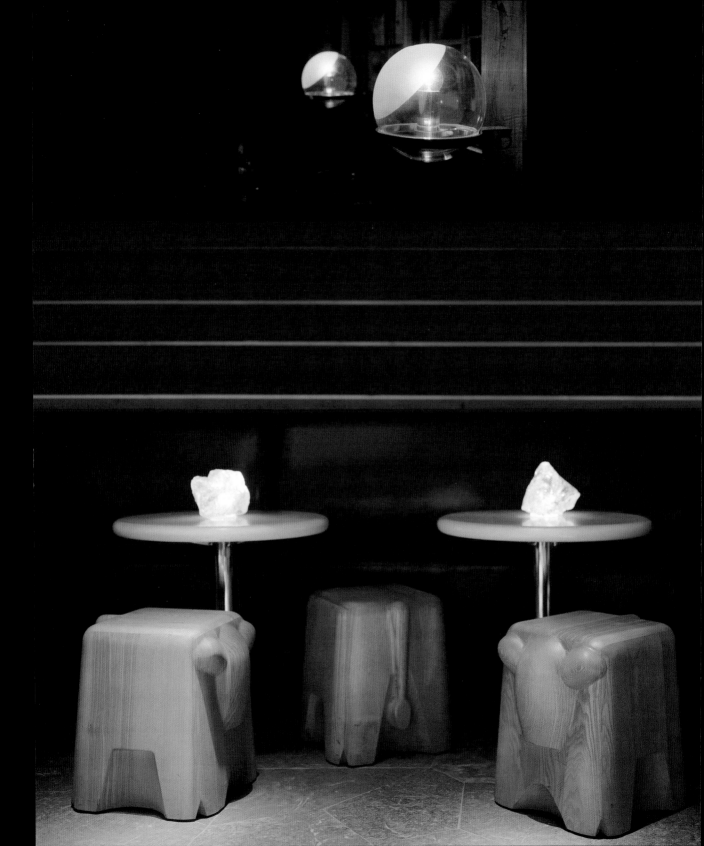

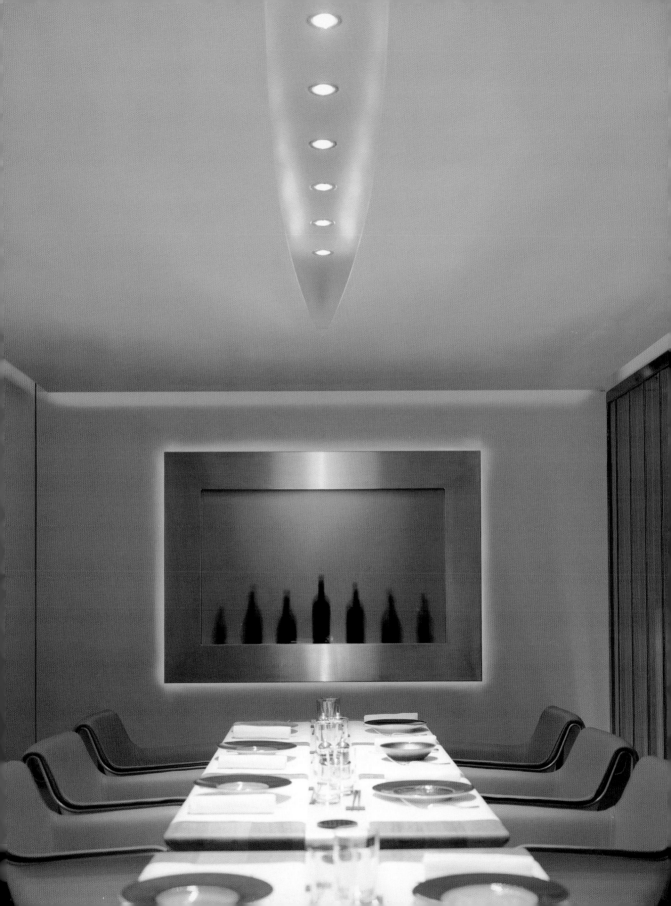

Bar at Hotel Plaza Athenée

Location: Paris, France
Designer: Agence Patrick Jouin, France
Completion Date: 2001

Lighting transforms the bar into fire and ice. The bar itself appears as a block of ice, emanating blue light from within. Conversely, the chandelier above radiates a range of colors created by varying intensity of red and blue lights. The room's color changes gradually throughout the night, starting with blue in the early evening and culminating in deep red at the end of the night.

Licht verwandelt die Bar in Feuer und Eis. Die Theke selbst leuchtet von innen heraus in einem bläulichen Licht, was sie wie einen Eisblock erscheinen lässt. Im Kontrast dazu strahlt der darüberhängende Kronleuchter in einem Farbspektrum, das aus dem Zusammenspiel roter und blauer Lampen mit unterschiedlicher Intensität entsteht. Die Farben im Raum verändern sich im Laufe des Abends stetig, von blau am frühen Abend bis zu tiefrot gegen Ende der Nacht.

L'éclairage transforme le bar en feu et en glace. Le bar proprement dit apparaît comme un bloc de glace par un éclairage bleu émanant de l'intérieur. Par contre le lustre situé au-dessus diffuse une palette de couleurs changeantes avec des lumières rouges et bleues dont l'intensité varie. La couleur d'ambiance de la salle se modifie graduellement au cours de la soirée, de bleu en tout début de soirée, elle prend une teinte de rouge profond pour terminer en fin de nuit.

La iluminación transforma el bar en fuego y hielo. El mismo bar parece un bloque de hielo, al emanar una luz azul desde su interior. Por el contrario, la lámpara de araña que tiene encima irradia una gama de colores creados por la variación de intensidad de luces rojas y azules. El color de la habitación cambia gradualmente a lo largo de la noche, comenzando con azul al atardecer y culminando con un rojo oscuro al final de la noche.

L'illuminazione trasforma il bar in fuoco e ghiaccio. Il bar stesso ha le sembianze di un blocco di ghiaccio, emanante luce blu dall'interno. Inversamente, il lampadario soprastante emana una serie di colori creati da varie intensità di luci rosse e blu. Il colore del vano cambia gradualmente per tutta la notte, iniziando dal blu all'inizio della serata per culminare poi in rosso profondo alla fine della notte.

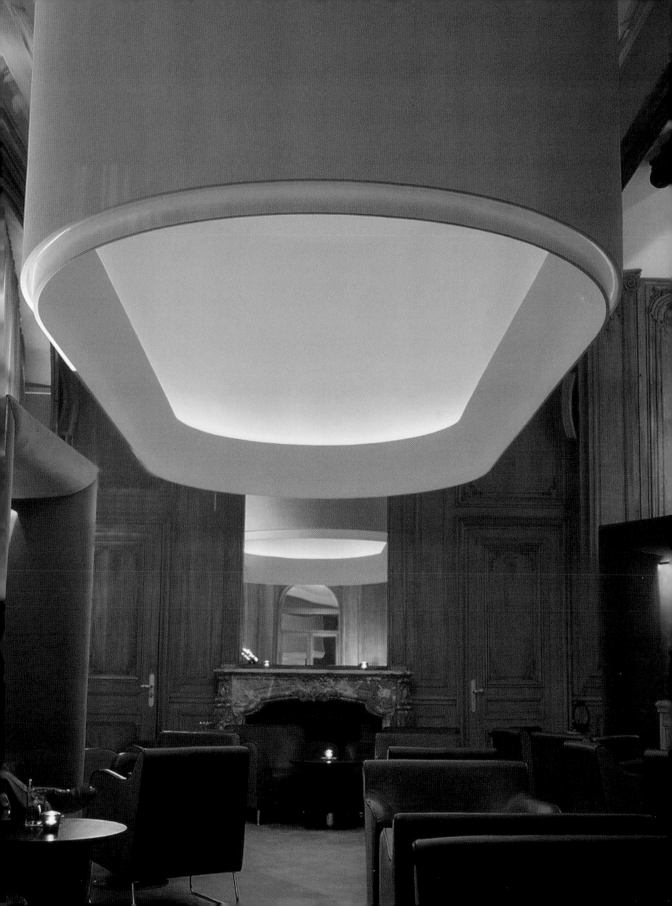

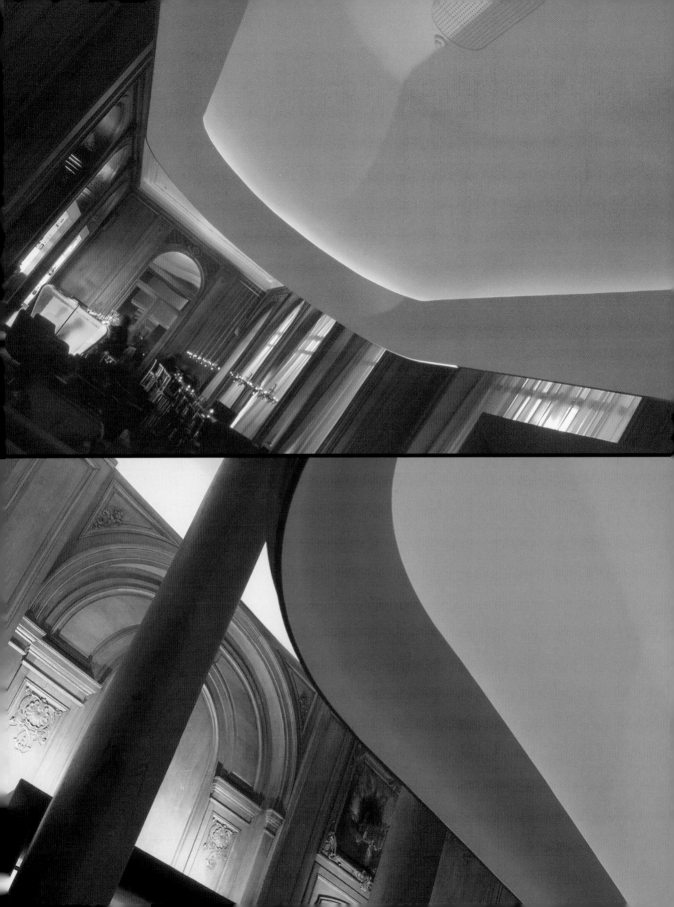

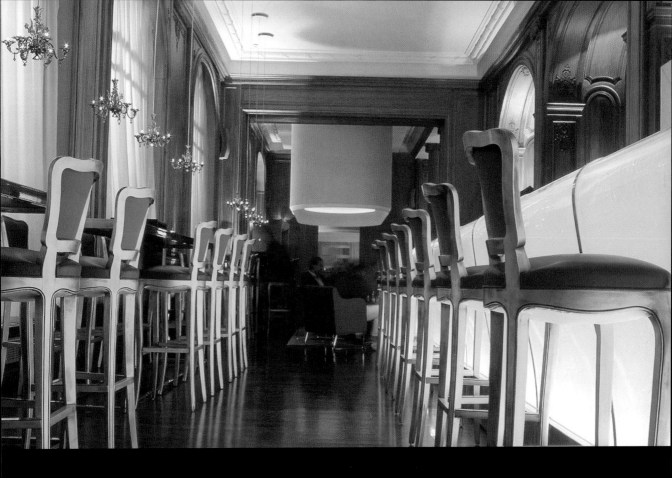

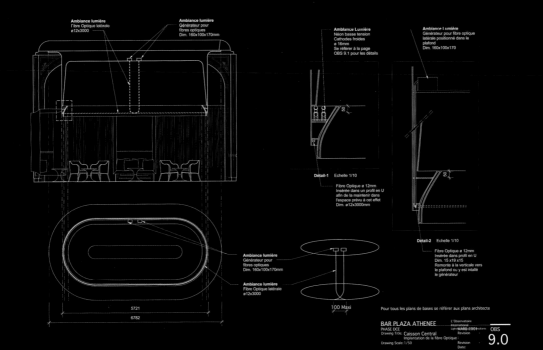

Ambiance lumière
Fibre Optique latérale
ø12x3000

Ambiance lumière
Générateur pour
fibres optiques
Dim. 160x100x170mm

Ambiance Lumière
Néon basse tension
Cathodes froides
ø 16mm
Se référer à la page
OBS 9.1 pour les détails

Ambiance Lumière
Générateur pour fibre optique
latérale positionné dans le
plafond
Dim. 160x100x170

Détail-1 Echelle 1/10

Fibre Optique ø 12mm
Insérée dans un profil en U
afin de la maintenir dans
l'espace prévu à cet effet
Dim. ø12x3000mm

Détail-2 Echelle 1/10

Fibre Optique ø 12mm
Insérée dans un profil en U
Dim. 15 x19 x15
Remonté à la verticale vers
le plafond ou y est intallé
le générateur

Ambiance lumière
Générateur pour
fibres optiques
Dim. 160x100x170mm

Ambiance lumière
Fibre Optique latérale
ø12x3000

5721
6782

100 Maxi

Pour tous les plans de bases se référer aux plans architecte

BAR PLAZA ATHENEE
PHASE DCE
Drawing Title: Caisson Central
Implantation de la fibre Optique :
Drawing Scale: 1/50

L'Observatoire
International
Lighting Consultants
MARS 2001
Revision
Revision
Date:

OBS
9.0

Alain Ducasse at Hotel Plaza Athenée

Location: Paris, France
Designer: Agence Patrick Jouin, France
Completed: 2004

The lighting design aims to link gastronomic experience with a magical one created by a myriad of crystals. As well as using chandeliers, the entire ceiling is covered in a layer of shimmering crystals lit with lights from behind.

Das Lichtdesign versucht kulinarische Erlebnisse mit der zauberhaften Erfahrung des Anblicks unzähliger Kristalle zu verbinden. Es wurden nicht nur Kronleuchter angebracht, sondern die ganze Decke wurde mit einer Schicht glitzernder Kristalle überzogen, die von hinten beleuchtet ist.

Le concept d'éclairage tend à relier une expérience gastronomique à une expérience magique créée à l'aide d'une myriade de cristaux. Il utilise aussi des lustres, le plafond tout entier est couvert d'un écran de cristaux scintillants éclairés par des lumières venant de l'arrière.

El diseño de la iluminación pretende ligar la experiencia gastronómica con una experiencia mágica creada por una miríada de cristales. De la misma forma que cuando se utilizan lámparas de araña, todo el techo está cubierto por una capa de relucientes cristales alumbrados con luces desde la parte trasera.

La struttura dell'illuminazione mira a connettere l'esperienza gastronomica con un'esperienza magica creata da una miriade di cristalli. Oltre all'uso di lampadari, l'intero soffitto è ricoperto di uno strato di cristalli brillanti illuminati tramite luci collocate posteriormente.

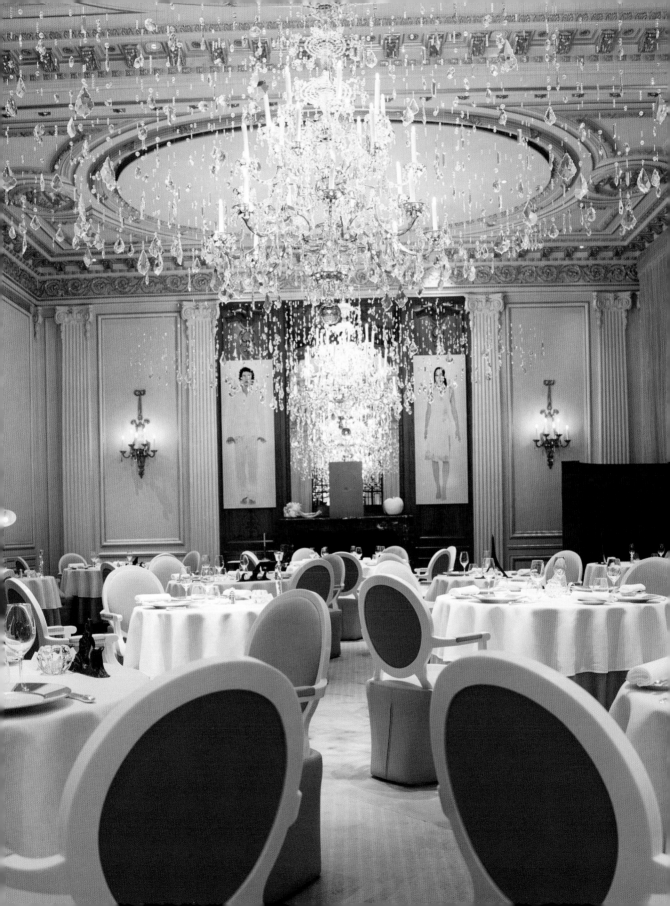

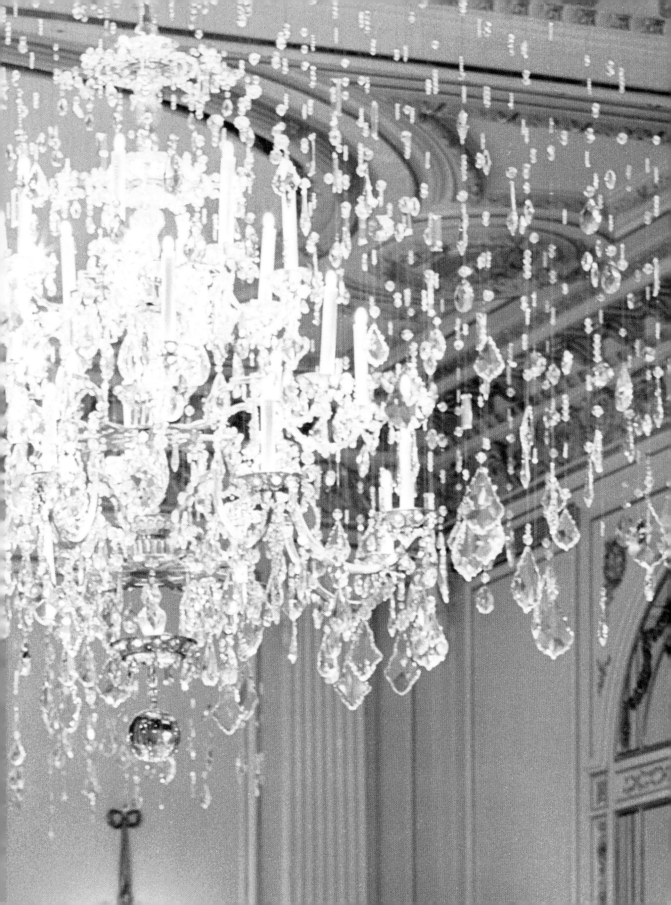

Asia

Leeum Samsung Museum of Art

Location: Seoul, Korea
Architects: Traditional Art: Mario Botta Architetto, Italy
 Modern & Contemporary Art: Ateliers Jean Nouvel, France
 Center for Child Education: Rem Koolhaas / OMA, The
 Netherlands
Completed: 2004

Lighting creates a common identity for three different buildings, each with its own distinctive architectural design and specific program. While the lighting concept unifies these buildings, it also engages the specific architectural vocabulary of each structure while unifying museographic and public spaces.

Drei unterschiedliche Gebäude, jedes mit seinen eigenen architektonischen Merkmalen und besonderem Verwendungszweck, werden durch Licht zu einer Einheit verbunden. Es wird aber auch den individuellen Besonderheiten der Architektur gerecht und verbindet gleichzeitig öffentliche und Museumsplätze.

L'éclairage réalise une identité commune pour trois différents immeubles, chacun possédant un concept architectural distinct et un programme spécifique. Tandis que le concept d'éclairage unifie ces immeubles, il emploi également le langage architectural spécifique de chaque structure tout en unifiant les espaces muséographiques et publics.

La iluminación crea una identidad común para tres edificios distintos, cada uno con su propio y peculiar diseño arquitectónico y su programa específico. Mientras que el concepto de iluminación unifica esos edificios, compromete también el vocabulario arquitectónico específico de cada estructura a la vez que unifica los espacios públicos y museográficos.

L'illuminazione crea un'identità comune di tre edifici diversi, ciascuno dei quali presenta la sua propria struttura architettonica ben distinta ed il suo specifico programma. Mentre il concetto dell'illuminazione unisce questi edifici, risponde anche alle specifiche caratteristiche architettoniche di ciascuna struttura unendo nel contempo gli spazi museografici e pubblici.

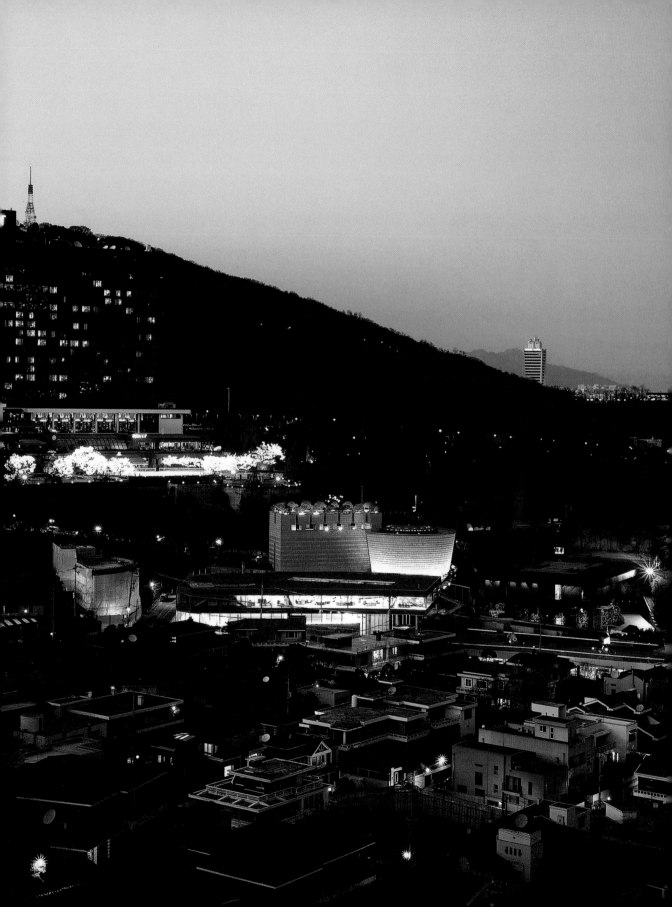

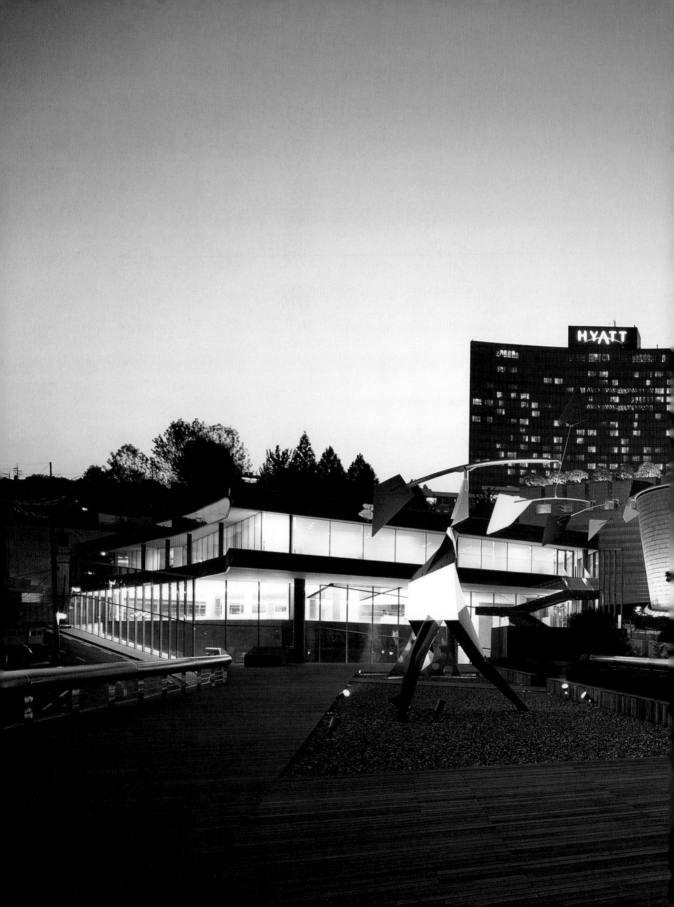

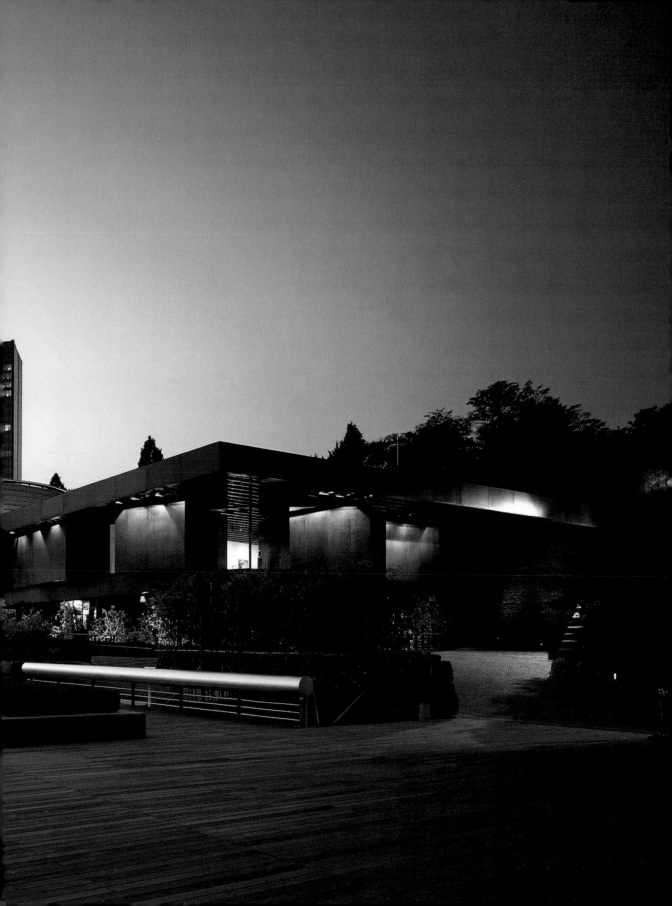

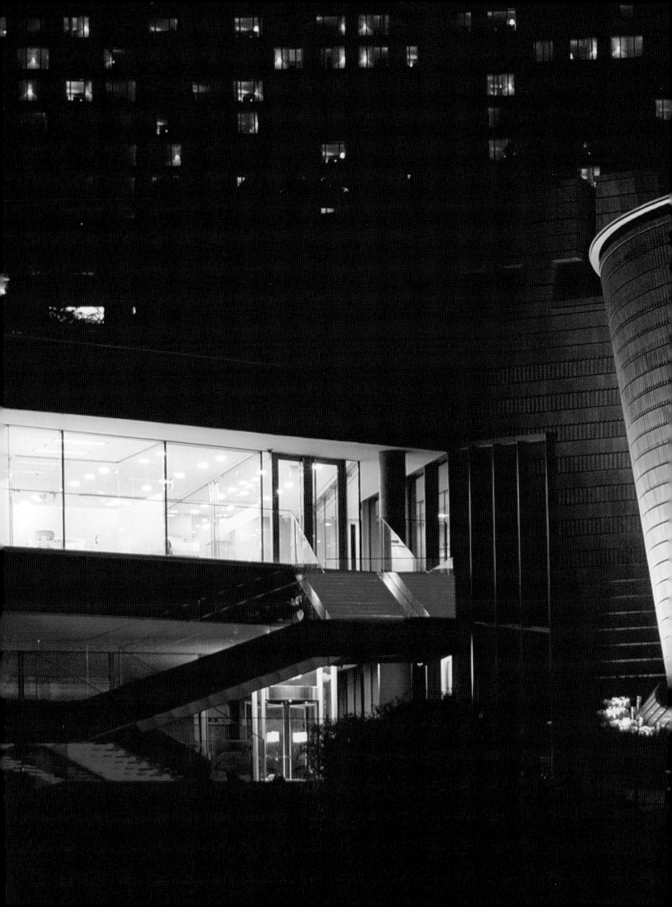

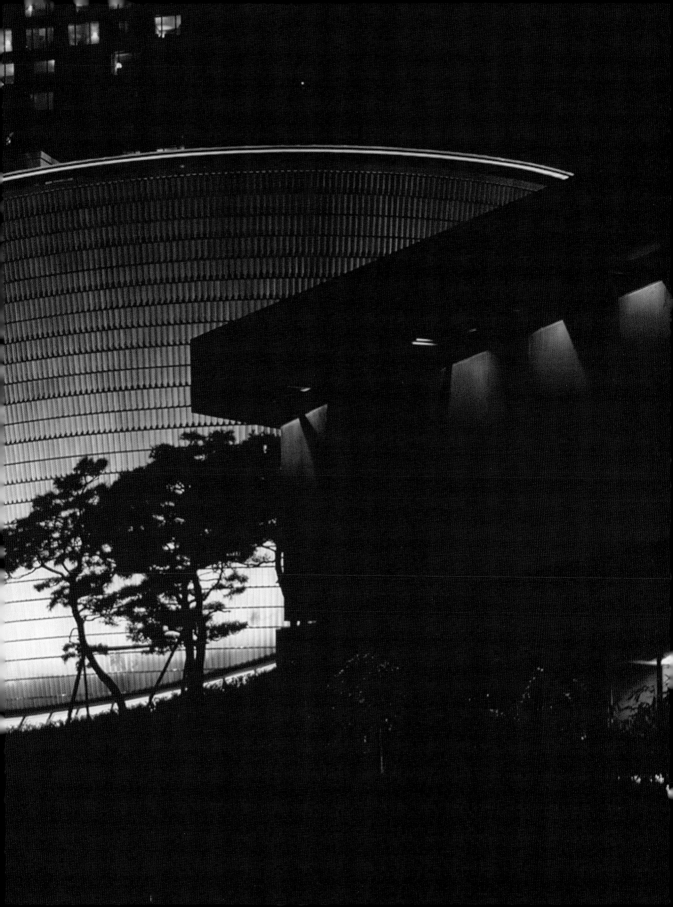

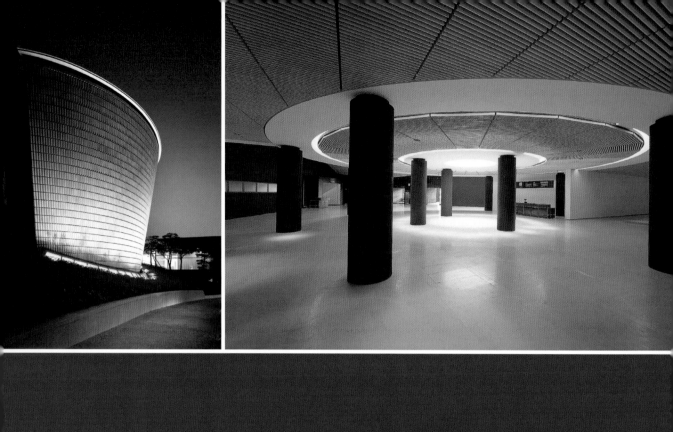
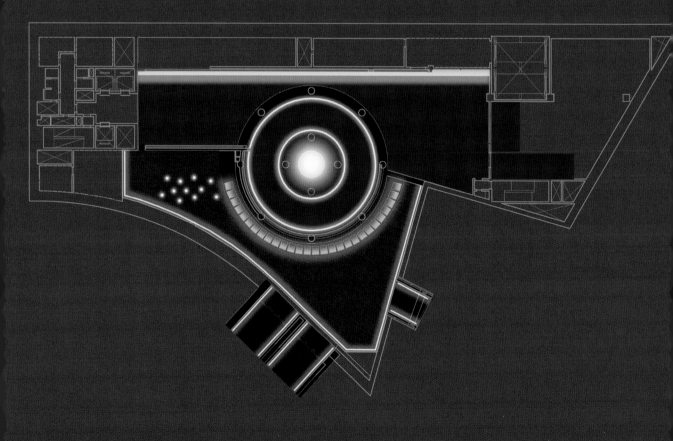

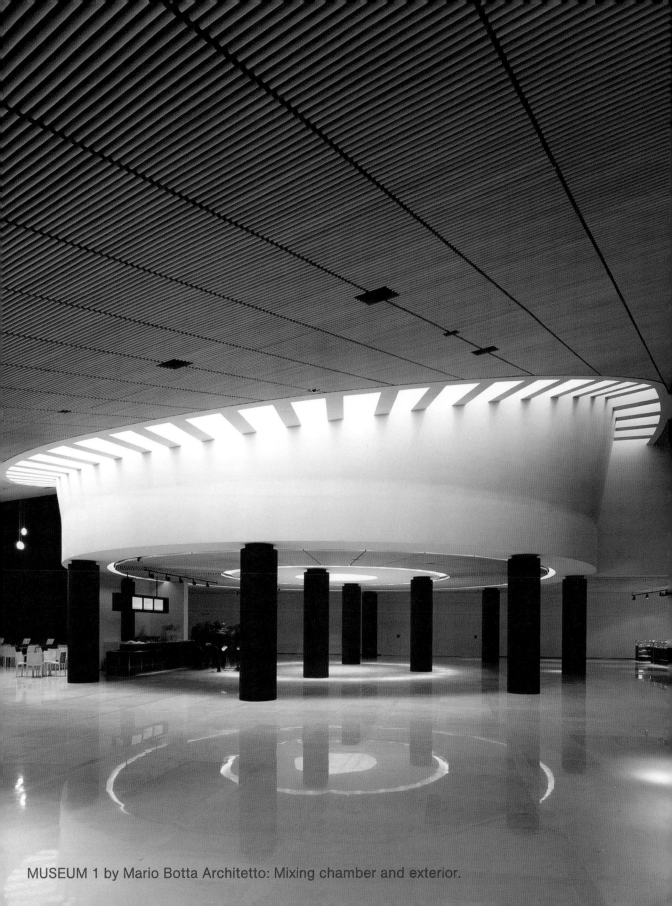

MUSEUM 1 by Mario Botta Architetto: Mixing chamber and exterior.

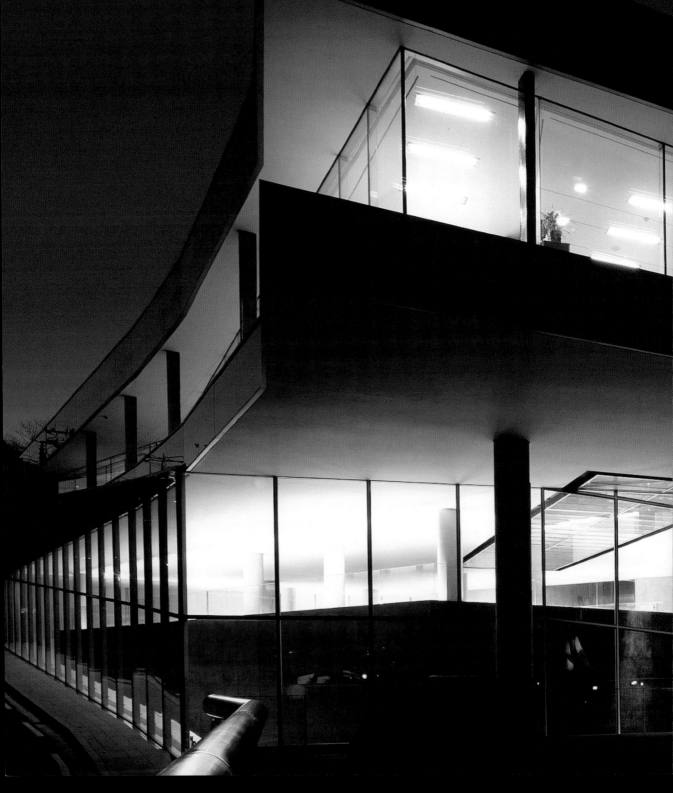

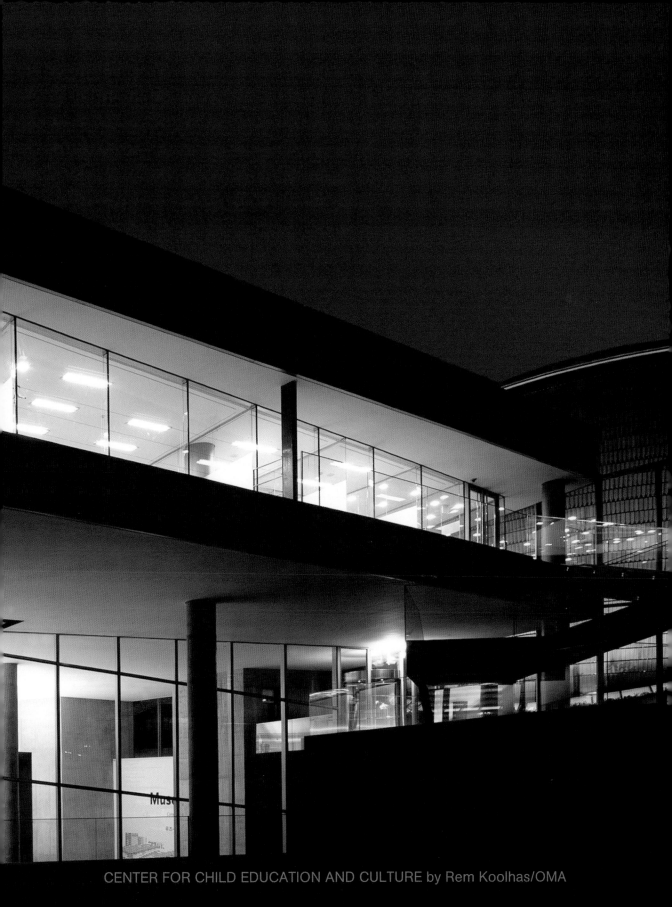

CENTER FOR CHILD EDUCATION AND CULTURE by Rem Koolhas/OMA

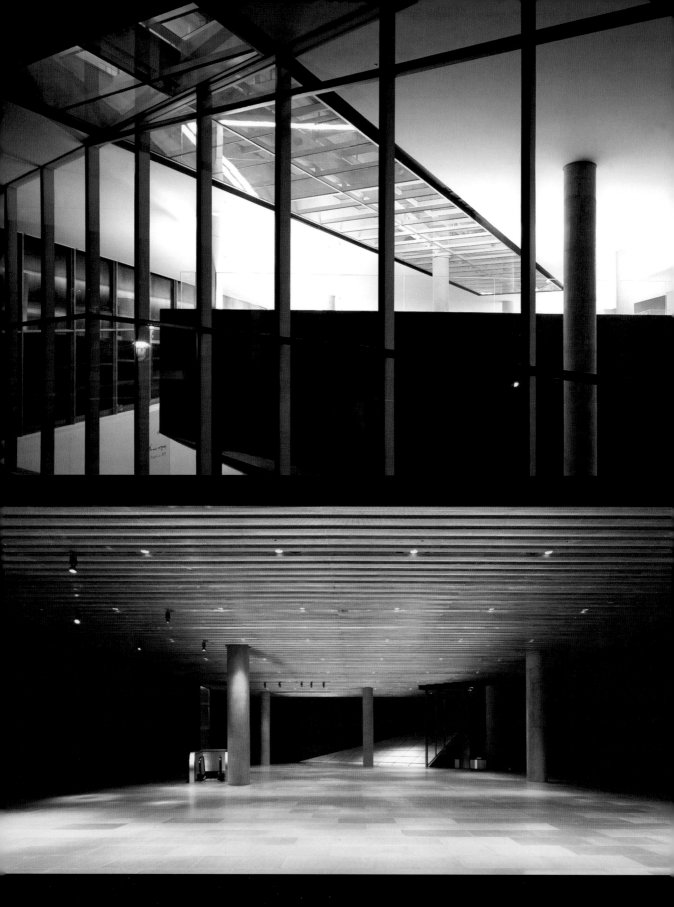

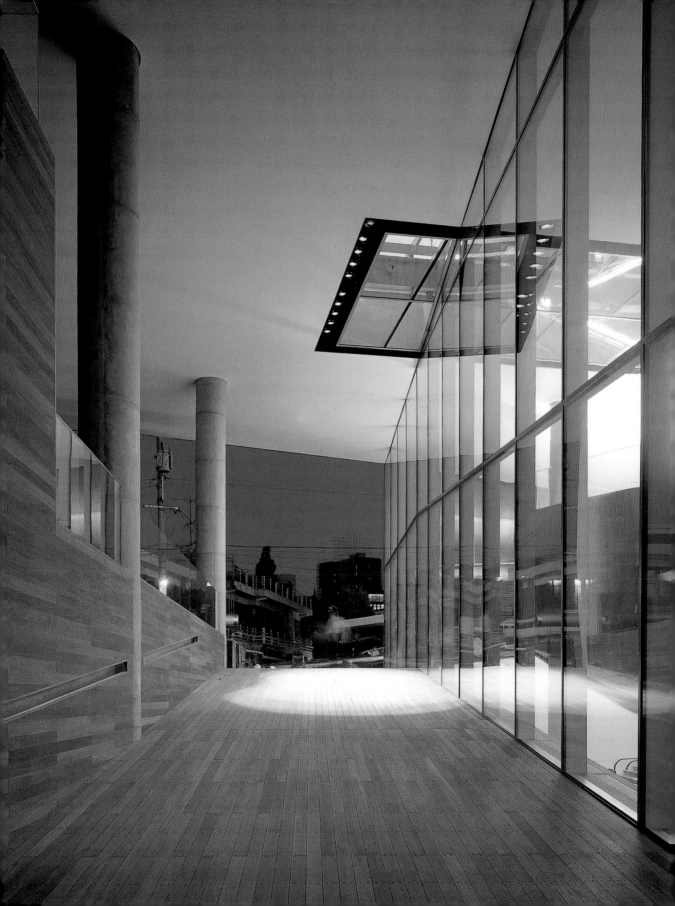

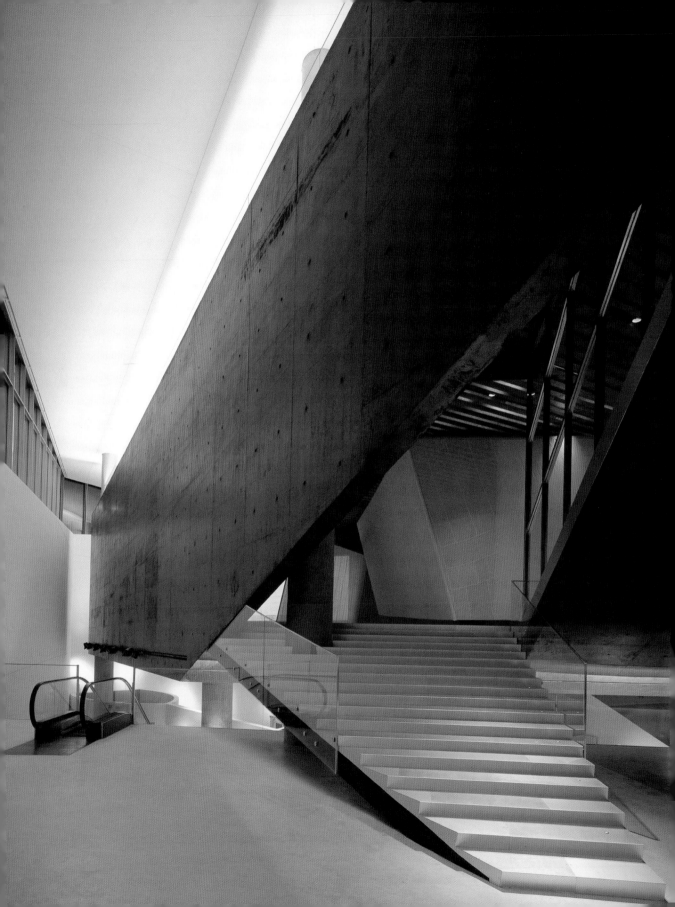

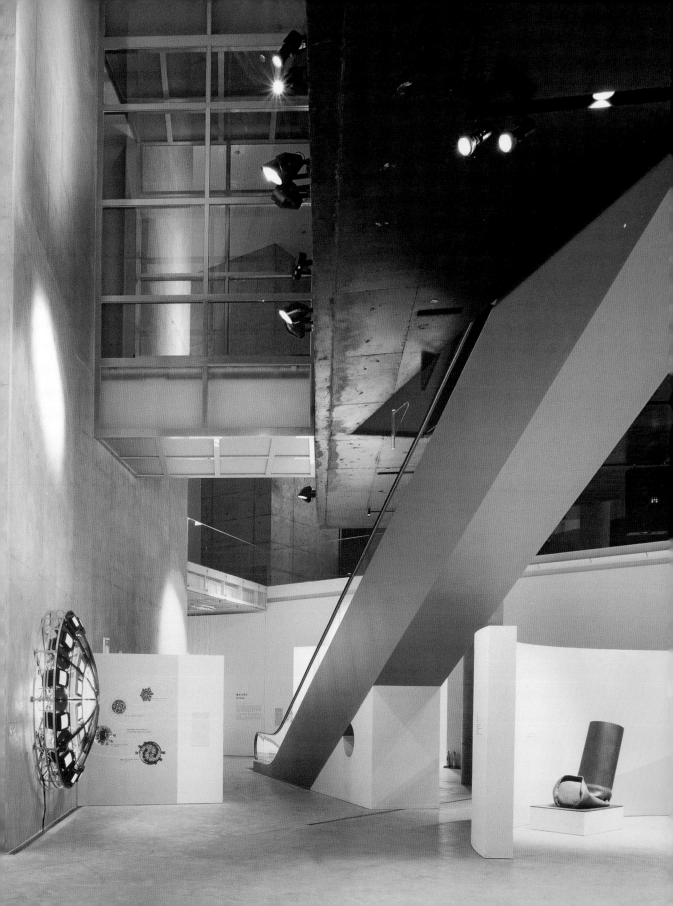

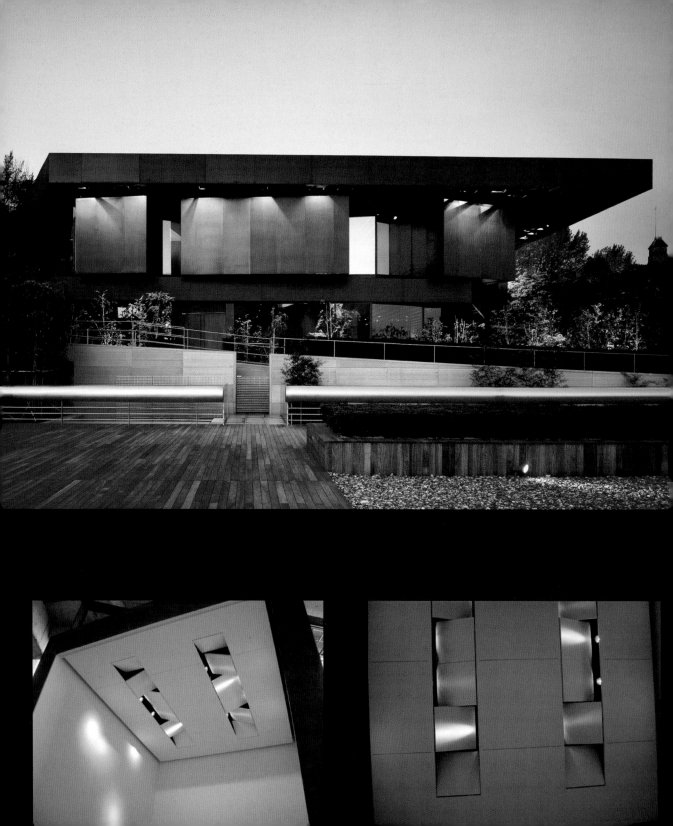

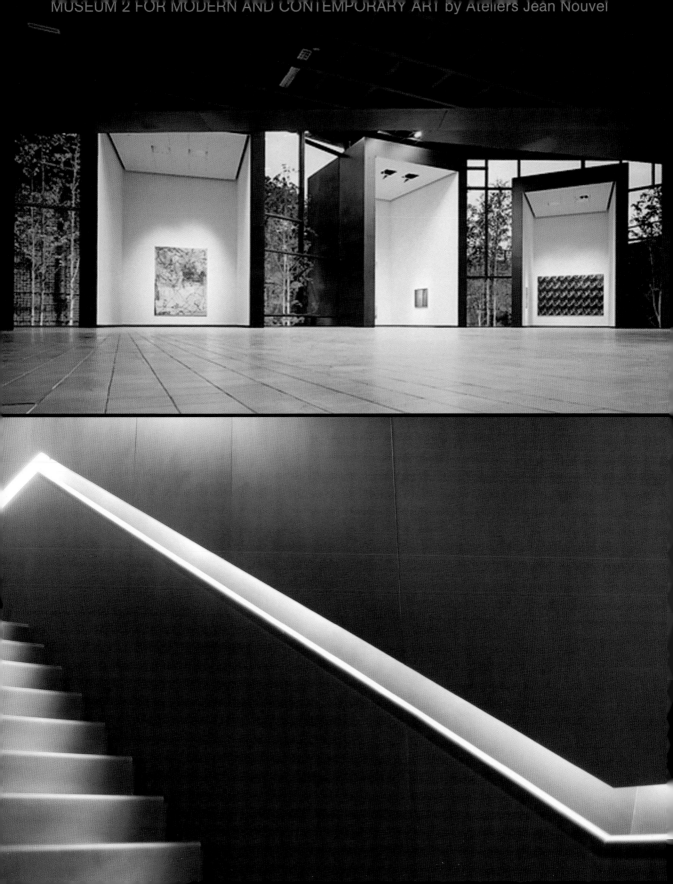

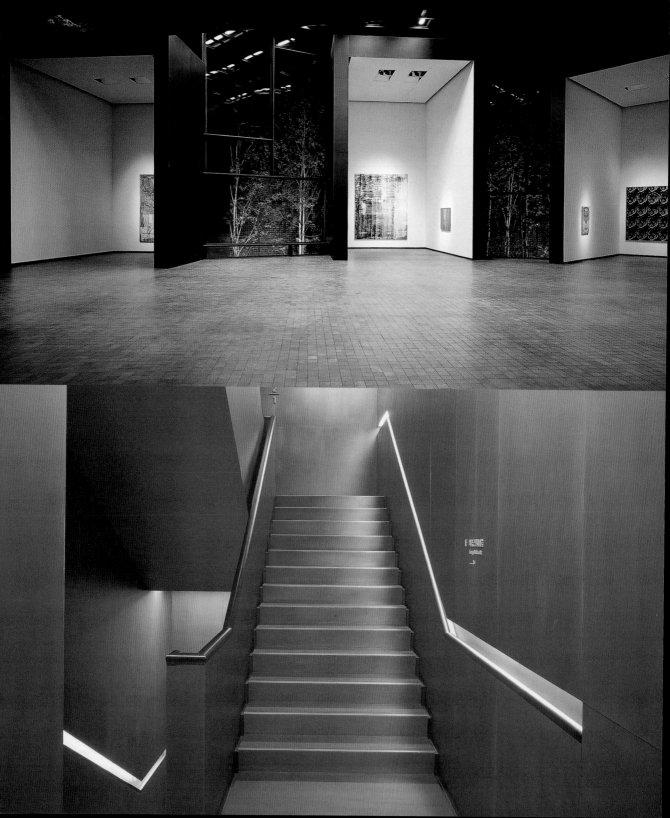

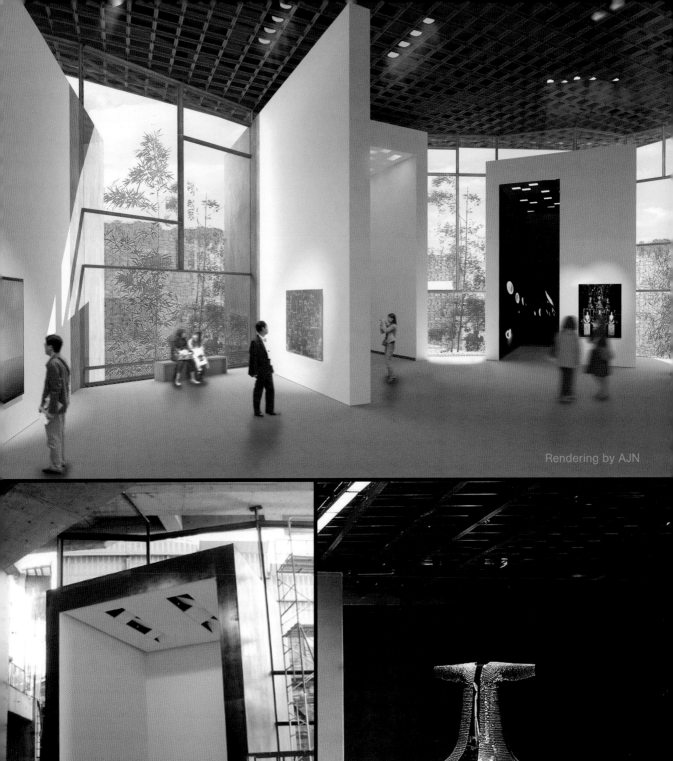

Rendering by AJN

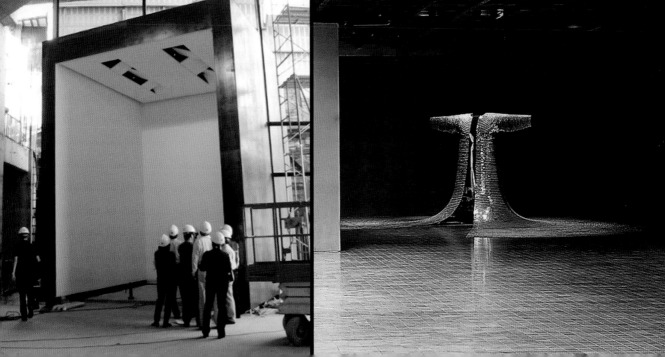

Linked Hybrid

Location:	Beijing, China
Architects:	Steven Holl Architects, USA
To be completed:	2007

Lighting unifies a number of buildings as well as public spaces. This is achieved with two rings of light, one located at eye level, and another situated higher in the air, correlating with the bridges above.

Mehrere Gebäude und öffentliche Anlagen werden durch Beleuchtung zu einer Einheit verbunden. Dies wird durch zwei Lichtringe erreicht, von denen sich einer auf Augenhöhe befindet, ein anderer weiter oben, auf Höhe der Übergänge.

L'éclairage unifie un certain nombre d'immeubles de même que des lieux publics. La réalisation comprend deux cercles de lumière, dont l'un est situé à hauteur des yeux et l'autre situé plus haut dans l'air, en corrélation avec les ponts situés plus bas.

La iluminación unifica una serie de edificios y de espacios públicos. Esto se logra con dos anillos de luz, uno situado a la altura del ojo, y otro más arriba, en el aire, en correlación con los puentes situados encima.

L'illuminazione unisce una serie di edifici e di spazi pubblici. Ciò è realizzato mediante due anelli luminosi, uno situato a livello dell'occhio ed un altro collocato più alto in aria, correlati ai ponti sovrastanti.

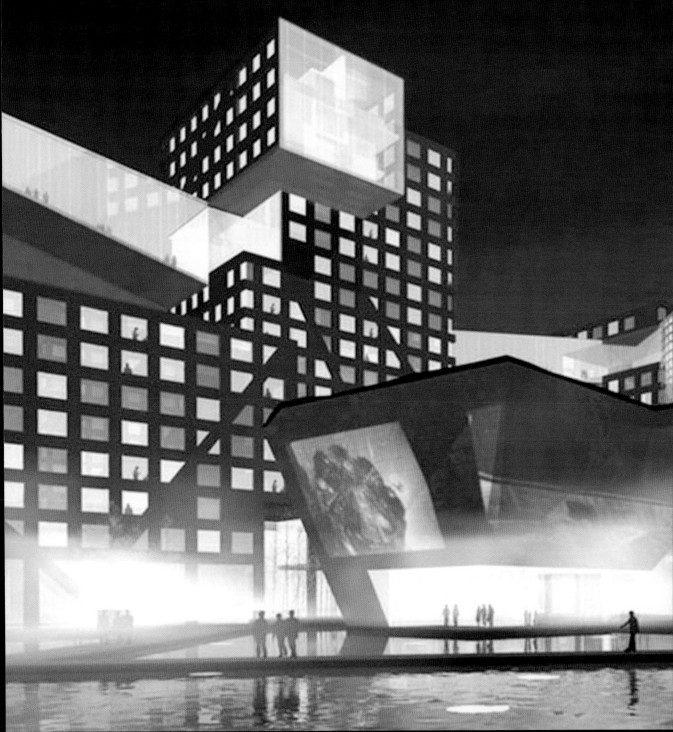

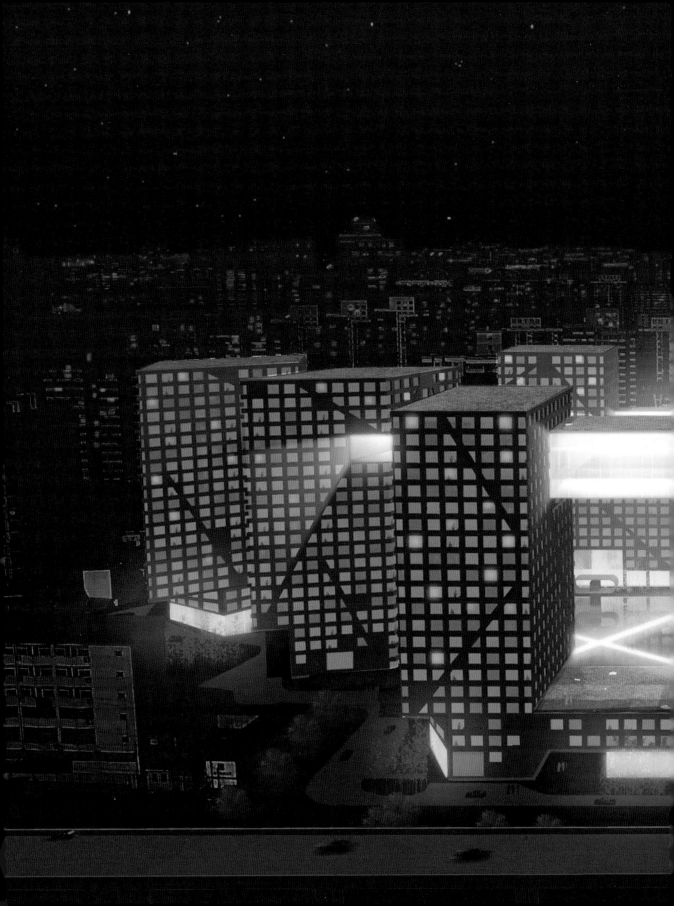

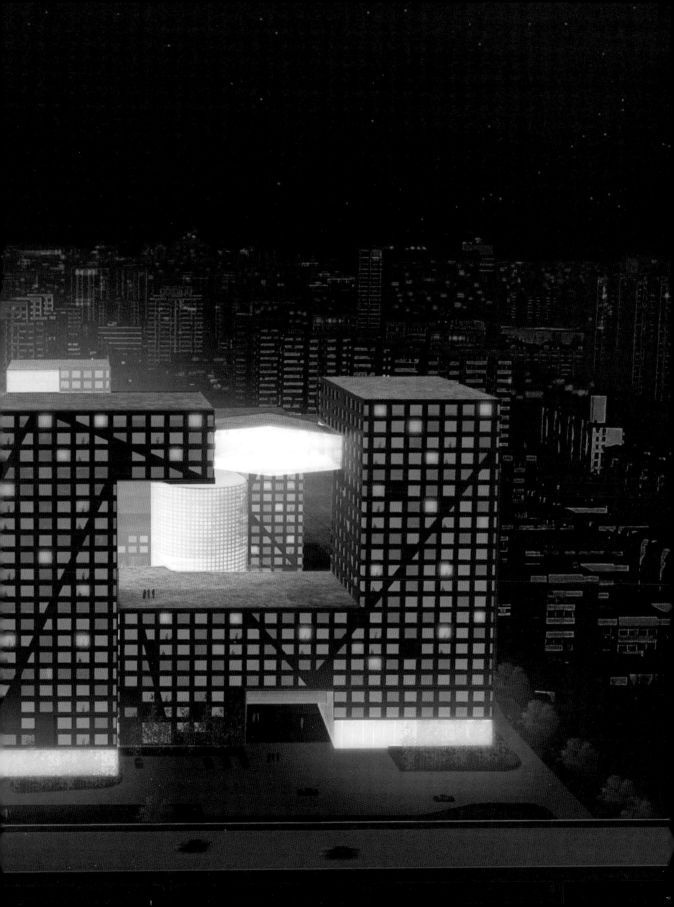

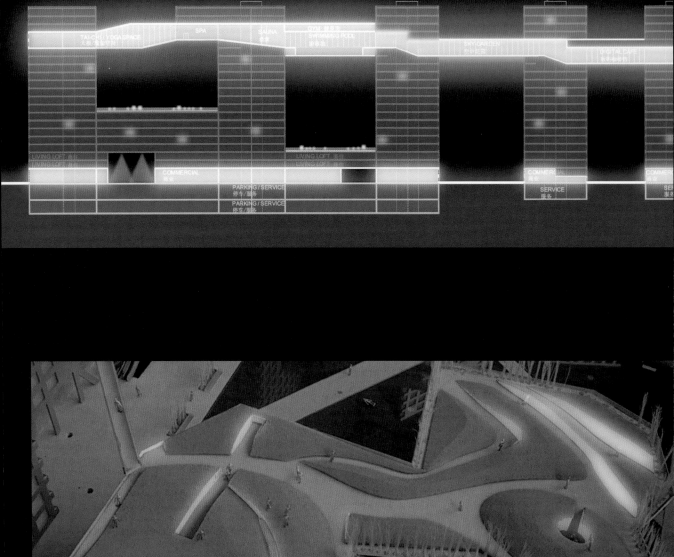

TAI-CHI / YOGA SPACE
太极 / 瑜伽空间

SPA

SAUNA
桑拿

GYM 健身
SWIMMING POOL
游泳池

ENV. GARDEN
生态花园

DIGITAL CAFE

LIVING LOFT 住住

LIVING LOFT 住住

LIVING LOFT 住住

LIVING LOFT 住住

COMMERCIAL
商业

COMMERCIAL
商业

SERVICE
服务

SERVICE
服务

PARKING / SERVICE
停车 / 服务

PARKING / SERVICE
停车 / 服务

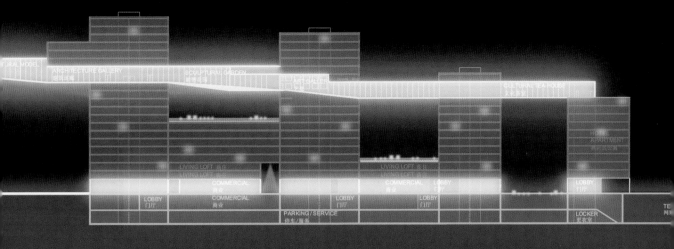

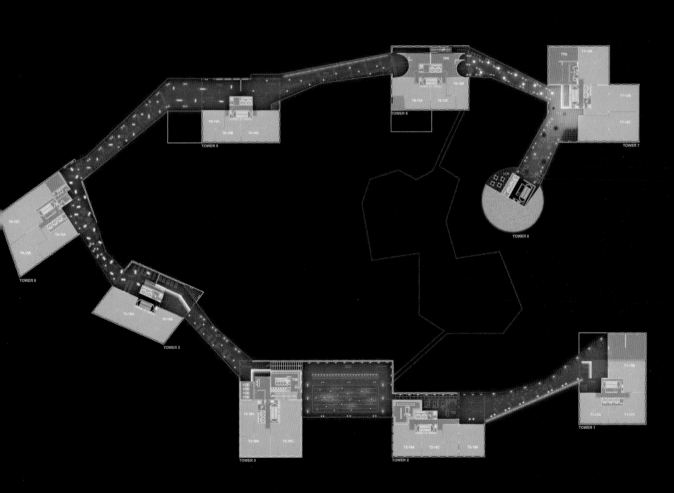

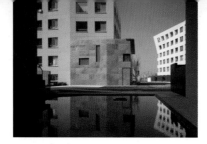

Makuhari Housing

Location: Chiba, Japan
Architects: Steven Holl Architects, USA
Completed: 1996

This is a residential complex in a recently developed area on the rim of Tokyo bay. For the project, light and shadow are emphasized and commingle in both interior and exterior spaces. This effect is created by deflecting light to project shadows onto different surfaces, and by hiding light sources in parts of the architectural body.

Makuhari ist ein Wohnkomplex in einem erst kürzlich sanierten Gebiet am Rande der Bucht von Tokio. Die besondere Betonung von Licht und Schatten, die sowohl im Innen- als auch im Außenbereich ein interessantes Zusammenspiel bilden, ist bei diesem Projekt von besonderer Bedeutung. Dieser Licht-Schatten-Effekt wird zum einen dadurch erzeugt, dass Licht umgeleitet wird und bestimmte Bereiche so im Schatten bleiben. Zum anderen sind Lichtquellen in Teile der Gebäudestruktur integriert und bleiben so verborgen.

Il s'agit d'un complexe résidentiel dans une zone récemment aménagée aux abords de la baie de Tokyo. Dans le projet les lumières et les ombres sont soulignées et mélangées, aussi bien pour les espaces intérieurs que les espaces extérieurs. Cet effet est réalisé par des lumières indirectes projetant des ombres sur différentes surfaces, et par la dissimulation de sources lumineuses dans des parties du corps architectural.

Es un complejo residencial en una zona recientemente explotada en la orilla de la bahía de Tokio. Para el proyecto se han enfatizado la luz y la sombra, que se mezclan tanto en el espacio interior como en el exterior. Este efecto se crea desviando la luz a las sombras proyectadas en distintas superficies, y escondiendo las fuentes de luz en partes del conjunto arquitectónico.

Si tratta di un complesso residenziale situato in un'area di recente sviluppo sulla sponda del Golfo di Tokyo. Per il progetto la luce e l'ombra vengono enfatizzati e mescolati in spazi sia interni che esterni. Questo effetto viene generato deviando la luce in modo tale da produrre ombre su diverse superfici e nascondendo le fonti luminose in parti del corpo architettonico.

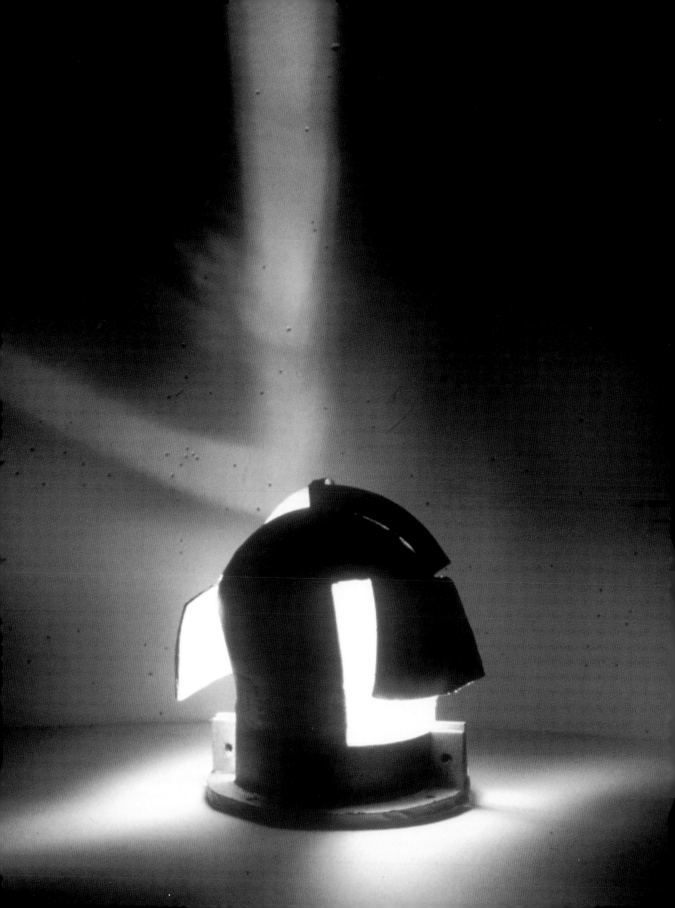

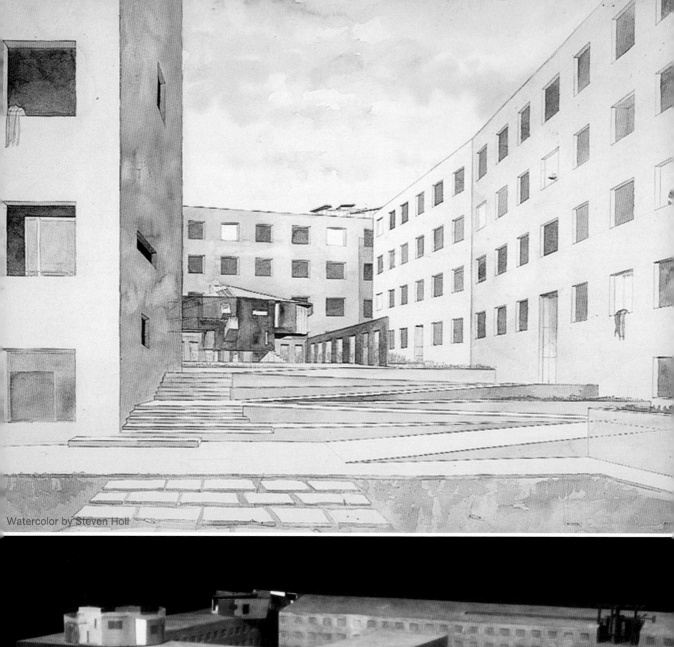

Watercolor by Steven Holl

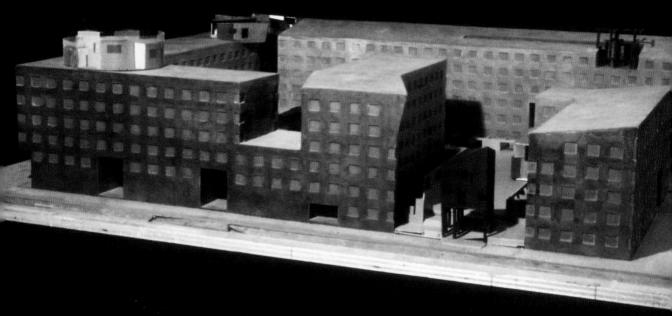

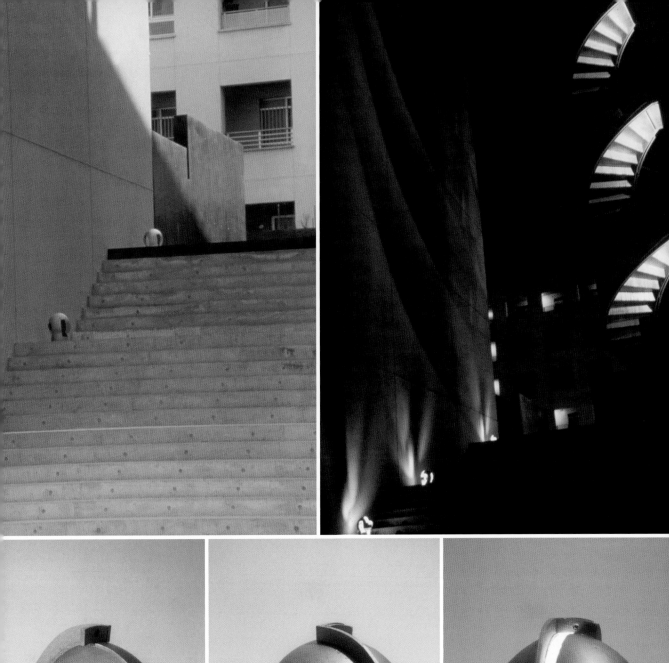
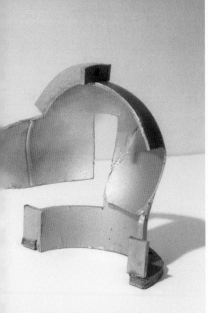

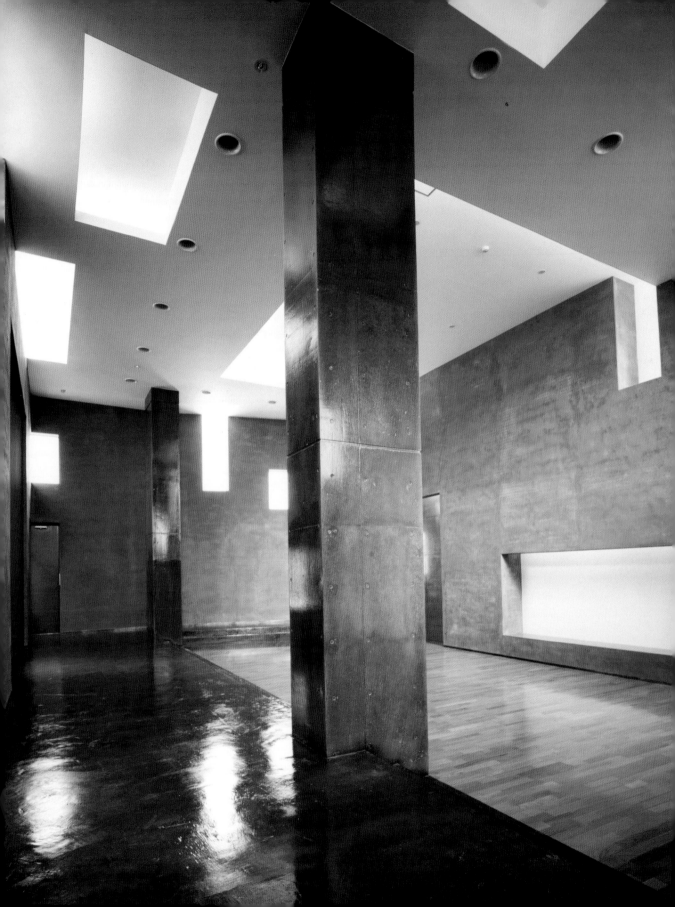

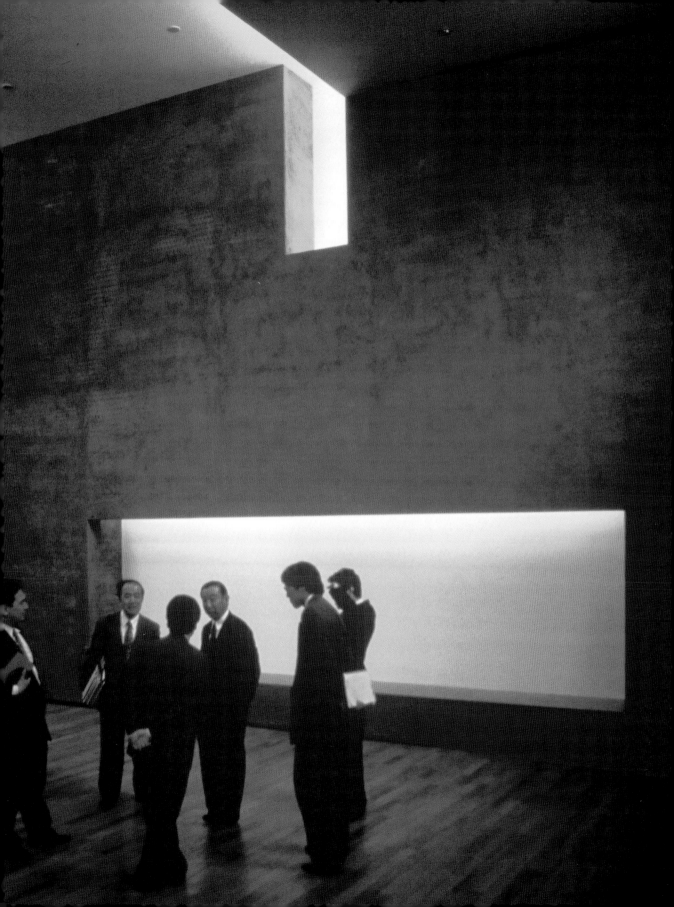

Beige / Alain Ducasse

Location: Tokyo, Japan
Architects: Peter Marino Architects, USA
Completed: 2004

The restaurant reflects the identities of the house of Chanel, in whose building the restaurant resides, and of Alain Ducasse, its star chef. The idea was to create an environment of warmth and intimacy amid the bustle of Tokyo. No lighting objects were used, instead all of the light sources are hidden, so as not to detract from the sleek aethetic of the space.

Das Restaurant spiegelt sowohl die Persönlichkeit des Hauses Chanel, in dessen Gebäude das Restaurant zu finden ist, sowie die von Chefkoch Alain Ducasse wider. Man wollte eine warme und persönliche Umgebung inmitten der hektischen Betriebsamkeit von Tokio schaffen. Lichtobjekte wurden nicht verwendet. Alle Lichtquellen sind verborgen, um nicht von der eleganten Ästhetik des Raums abzulenken.

Le restaurant reflète l'identité de la maison de couture Chanel, dans l'immeuble dans lequel se trouve le restaurant, et celle d'Alain Ducasse qui en est le chef vedette. L'idée était de créer un environnement chaleureux et intime au milieu de l'agitation de Tokyo. Aucun objet lumineux n'a été intégré, en remplacement toutes les sources de lumière sont cachées de manière à éviter de porter atteinte à l'esthétique de l'espace aux lignes épurées.

El restaurante refleja las identidades de la diseñadora de la casa Chanel, en cuyo edificio se encuentra el restaurante, y de Alain Ducasse, su chef estrella. La idea era crear un ambiente de calidez e intimidad en medio del bullicio de Tokio. No se utilizaron objetos luminosos, en su lugar las fuentes de luz están escondidas para no desvirtuar la estética de líneas elegantes del espacio.

Il ristorante riflette le identità del fabbricante di abbigliamenti Chanel, nel cui edificio si trova il ristorante, e di Alain Ducasse, star leader della medesima. L'idea era quella di creare un ambiente di calore e tranquillità nel bel mezzo del trambusto di Tokyo. Non sono stati utilizzati oggetti illuminanti, tutte le fonti luminose sono invece nascoste per non pregiudicare l'estetica liscia del luogo.

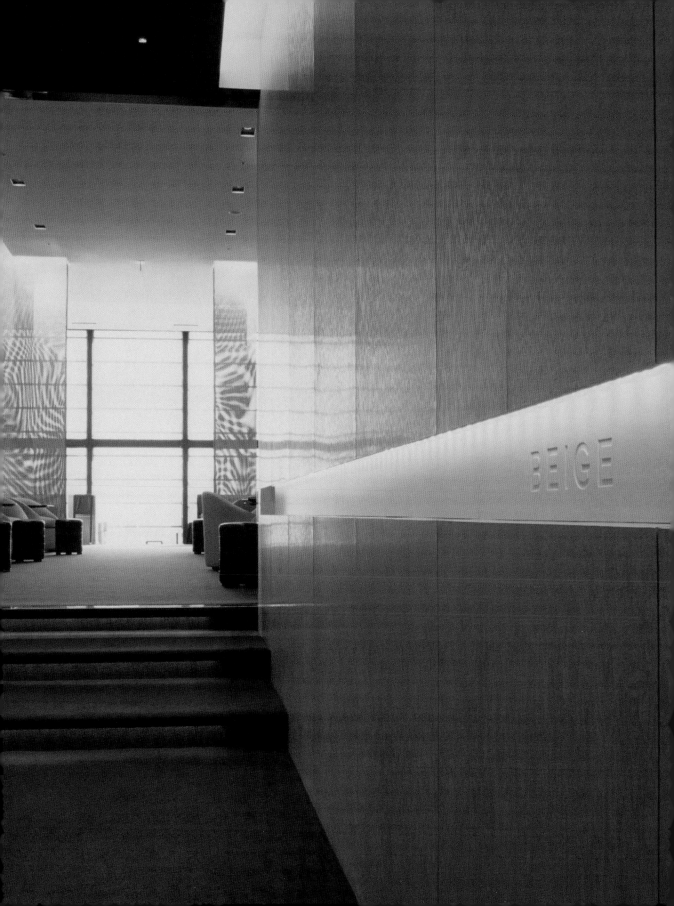

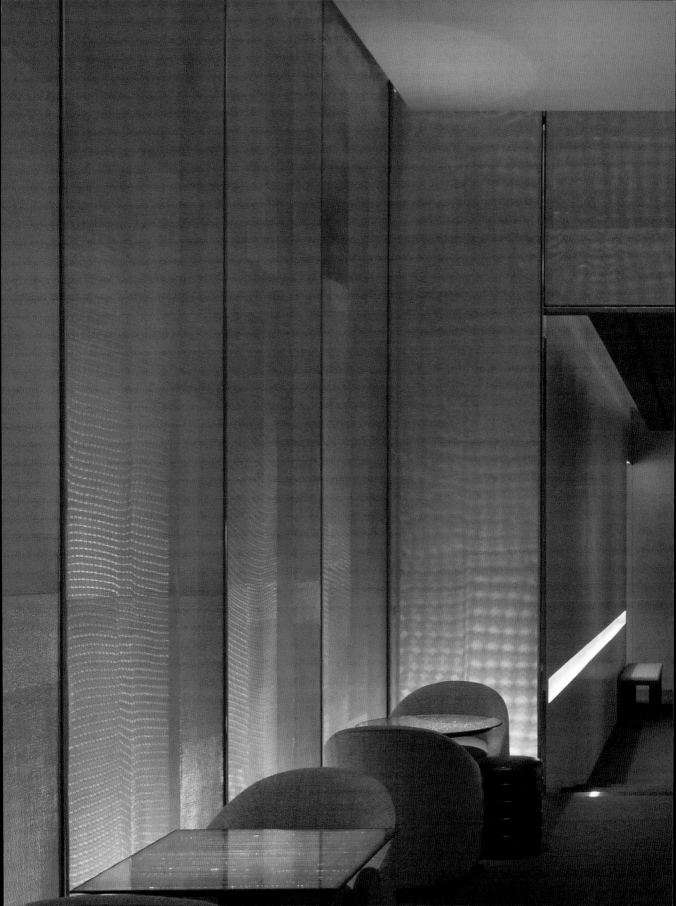

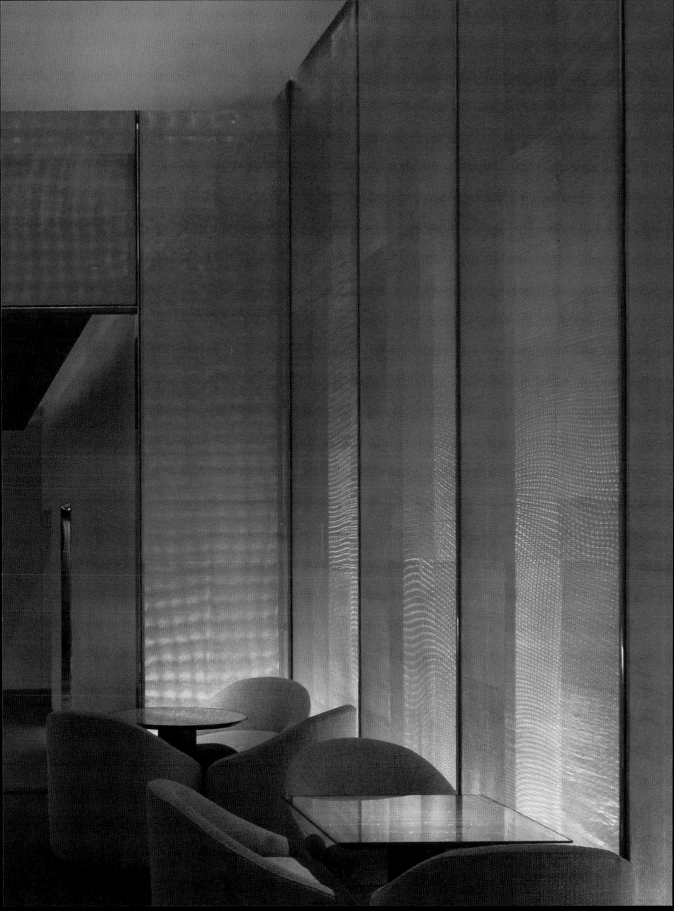

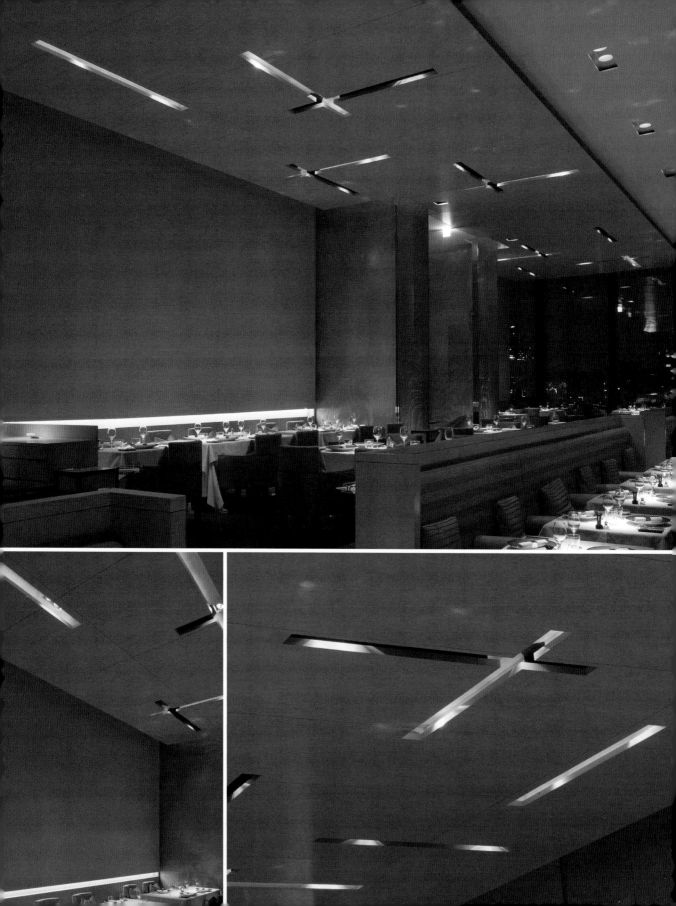

Jean-Georges Shanghai

Location: Shanghai, China
Architects: Michael Graves, USA
Completed: 2004

Jean-Georges Vongerichten's restaurant is divided into three spaces representing the earth, moon, and sky. Custom fixtures decorate each room, and are either in the shape of Chinese characters (representing earth and moon) or together form a character (symbolizing sky), and are suspended in the appropriate space. The fixtures are made of copper, a material used throughout the restaurant, and provide a warm pink glow.

Das Restaurant von Jean-Georges Vongerichten ist in drei Bereiche unterteilt, die Erde, Mond und Himmel symbolisieren. Eigens angefertigte Lampen zieren jeden Raum. Sie haben die Form der chinesischen Schriftzeichen für Erde oder Mond oder bilden in Kombination das Zeichen für Himmel. Sie sind als Hängelampen in den ihnen zugedachten Bereichen angebracht. Die Lampen sind aus Kupfer, einem Material, das im Restaurant immer wieder zu finden ist und ein warmes, rosarotes Licht ausstrahlt.

Le restaurant de Jean-Georges Vongerichten est divisé en trois espaces qui figurent la terre, la lune et le ciel. Des dispositifs faits sur mesure décorent chaque salle, et possèdent soit une forme de caractères chinois (qui représentent la terre et la lune) ou formant ensemble un caractère (symbolisant le ciel), ils sont suspendus dans la salle appropriée. Ces dispositifs sont fabriqués en cuivre, un matériau utilisé partout dans le restaurant et qui propage une tonalité rose chaleureuse.

El restaurante de Jean-Georges Vongerichten está dividido en tres espacios que representan la tierra, la luna y el cielo. Accesorios de iluminación tradicionales decoran cada estancia, y tienen la forma de letras chinas (que representan la tierra y la luna) o forman en conjunto una letra (que simboliza el cielo), y están suspendidas en el espacio apropiado. Los accesorios de iluminación están hechos de cobre, un material utilizado por todo el restaurante y que proporciona un brillo rosa cálido.

Il ristorante di Jean-Georges Vongerichten è diviso in tre spazi rappresentanti la terra, la luna e il cielo. Elementi personalizzati decorano ogni locale e sono realizzati o in forma di caratteri cinesi (rappresentanti la terra e la luna) o formando insieme un carattere (simbolizzante il cielo) e sono sospesi nello spazio appropriato. Gli elementi sono realizzati in rame, materiale usato in tutto il ristorante, e producono un caldo lume rosa.

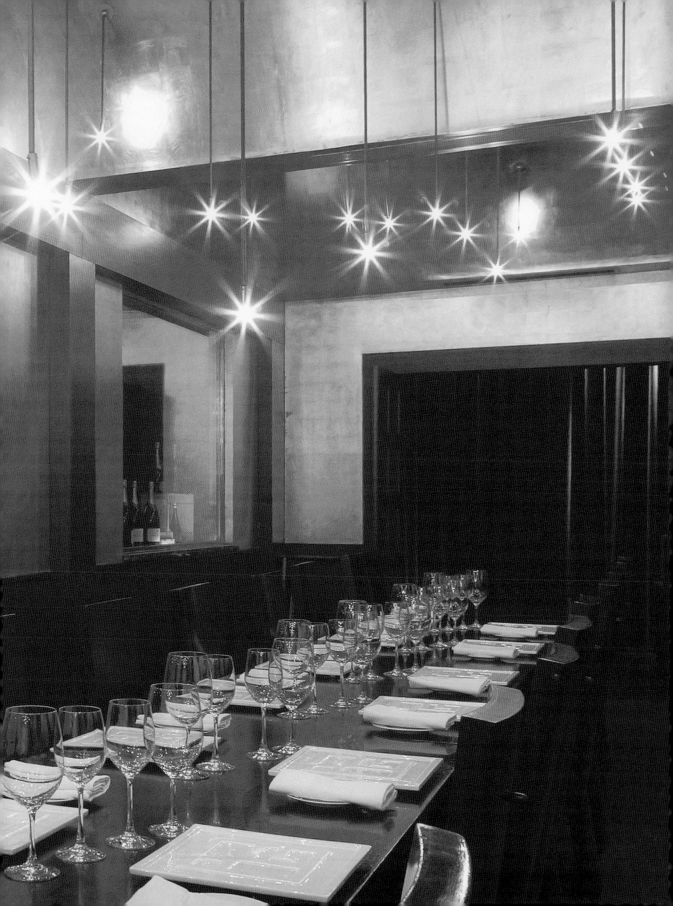

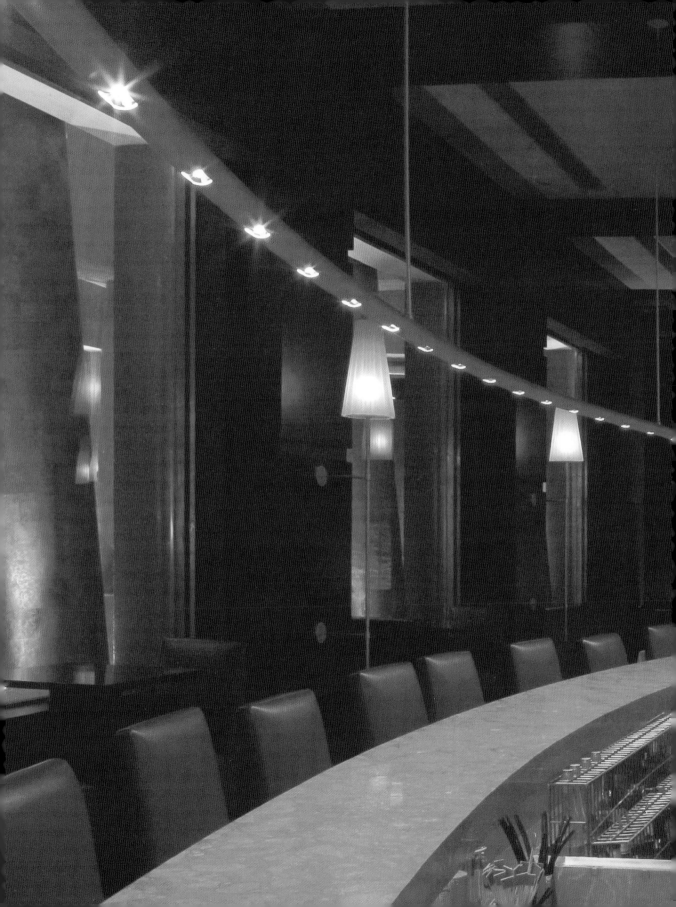

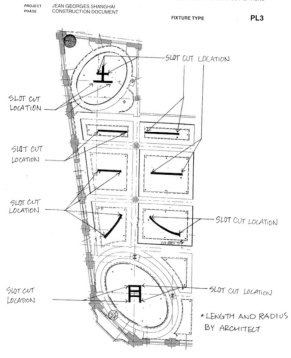

PROJECT JEAN GEORGES SHANGHAI
PHASE CONSTRUCTION DOCUMENT

FIXTURE TYPE PL3

SLOT CUT LOCATION

SLOT CUT LOCATION

SLOT CUT LOCATION

SLOT CUT LOCATION

SLOT CUT LOCATION

SLOT CUT LOCATION

SLOT CUT LOCATION

SLOT CUT LOCATION

* LENGTH AND RADIUS
 BY ARCHITECT

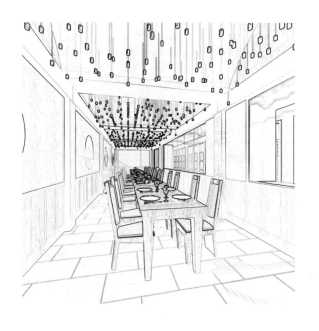

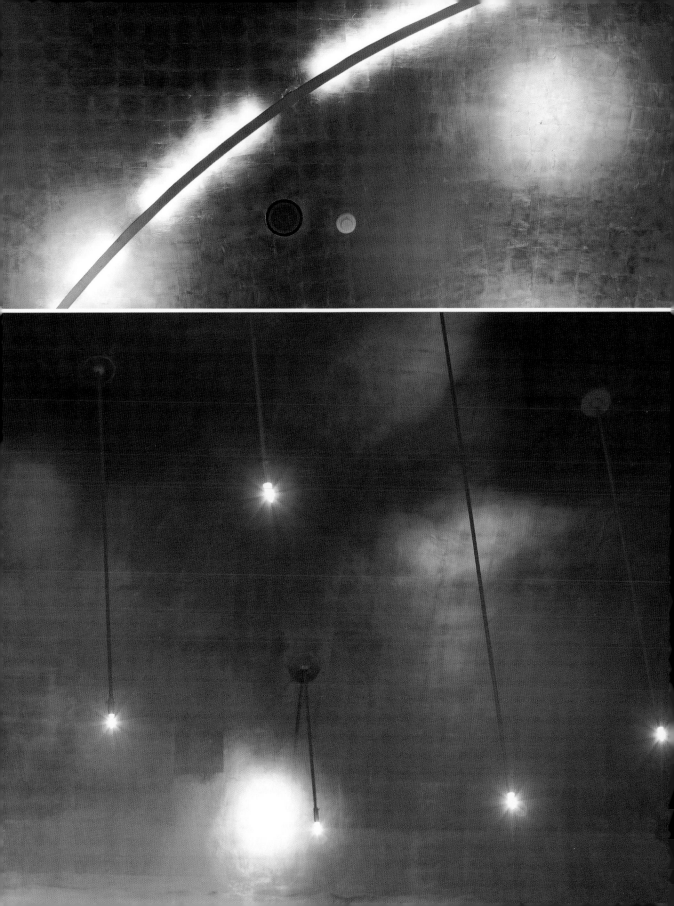

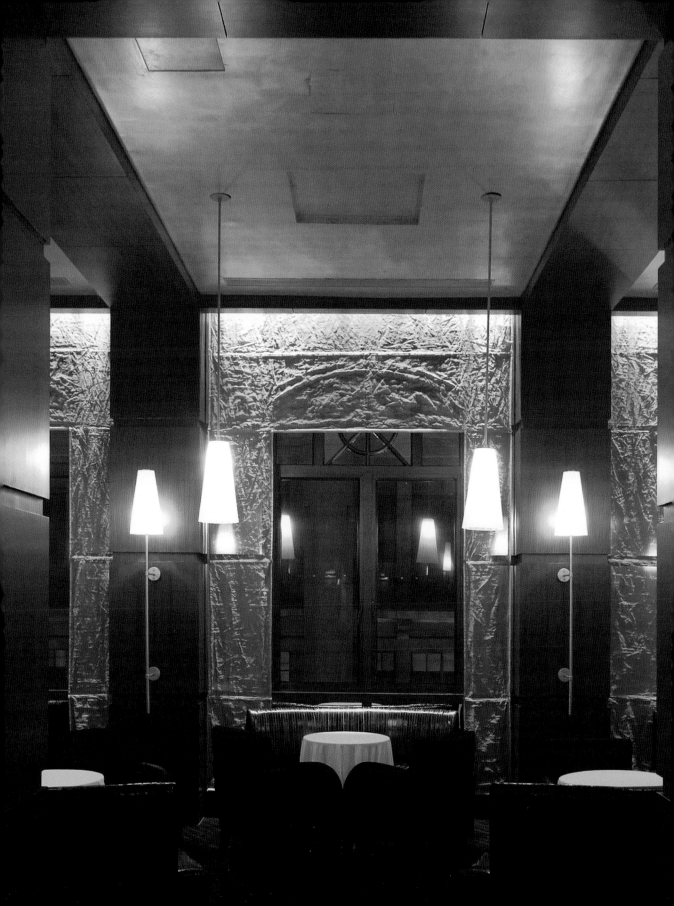

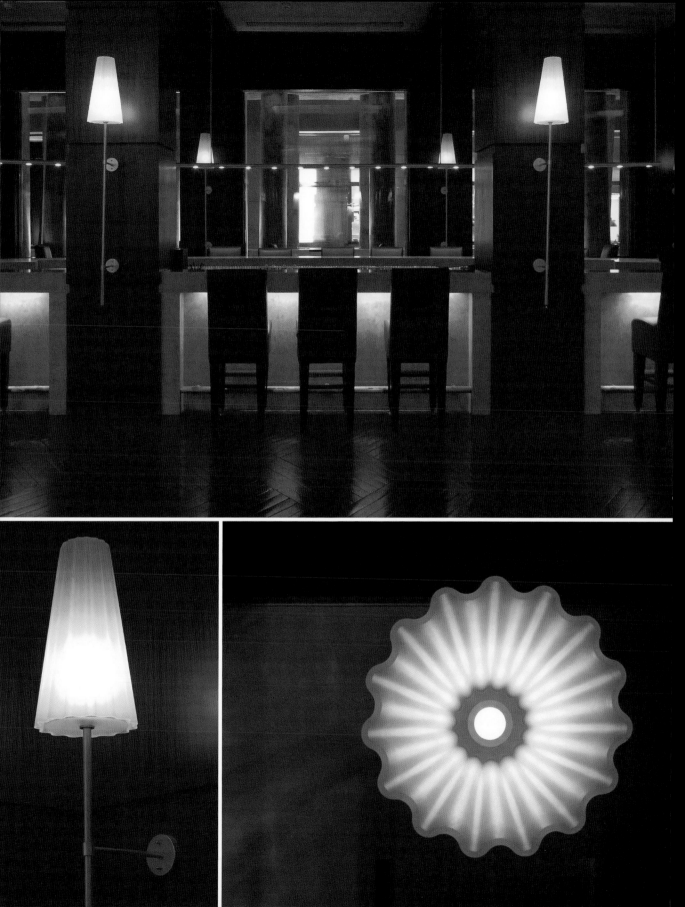

Hong Kong Harbour

Location: Hong Kong, China
Architects: Gehry International LLC, USA
Arquitectonica, USA
S.O.M., Hong Kong
Wong & Ouyang, Hong Kong
Design Year: 2004

There are three sites facing each other on the Hong Kong Bay linked together with beams of light whenever activity among the buildings coincides. When all three sides are connected, a pyramid of light floats above the bay, acting as an iconic gateway into Hong Kong. Light beacons are located along the shoreline, their color changing according to ongoing activity. A family of lighting objects, such as bamboo light sticks, floating balloon fixtures, and stone elements provide ambient lighting on various scales. Additionally, architectural elements are lit from within to create a glow.

Scheinwerfer verbinden drei gegenüberliegende Gebäude, sobald deren Aktivitäten miteinander in Verbindung stehen. Sind alle drei Gebäude durch die Lichtstrahlen verbunden, schwebt eine Lichtpyramide wie ein Eingangstor in die Bucht von Hongkong. Am Ufer sind Scheinwerfer installiert, deren Farbe sich je nach Vorgang verändert. Verschiedene Arten von Beleuchtungsobjekten, wie Bambus-Leuchtstäbe, schwimmende Ballonleuchten und Steinelemente kreieren verschiedenste Lichtsituationen. Zusätzlich erhellen von innen beleuchtete architektonische Elemente die Hafen-Skyline.

Dans la baie de Hong Kong se trouvent trois sites qui se font face, reliés entre eux par des rayons lumineux lorsque leur activité entre les immeubles coïncide. Lorsque les trois côtés sont connectés, une pyramide de lumière flotte au-dessus de la baie, jouant le rôle d'une porte d'entrée symbolique dans Hong Kong. Des balises lumineuses sont situées le long du littoral, leur couleur varie en fonction de l'activité actuelle. Une famille d'objets lumineux tels que des tiges de bambous lumineux, des ballons suspendus et des éléments en pierre réalisent une atmosphère lumineuse d'intensité variable. D'autre part des éléments d'architecture sont éclairés de l'intérieur afin de créer un éclairage diffus.

Existen tres zonas situadas unas enfrente de otras en la bahía de Hong Kong, y todas están unidas con haces de luz cada vez que coincide la actividad entre los edificios. Cuando las tres zonas están conectadas a la vez, una pirámide de luz flota sobre la bahía, actuando como una puerta icónica en Hong Kong. A lo largo de la orilla hay colocados unos faros de luz, cuyo color cambia según la actividad que se desarrolla. Una serie de objetos luminosos, como cañas de luz de bambú, accesorios luminosos de globos flotantes, y elementos de piedra proporcionan un ambiente luminoso de distintas intensidades. Además, los elementos arquitectónicos están iluminados desde dentro para crear un resplandor.

Alla baia di Hong Kong vi sono tre lati l'uno di fronte all'altro connessi con raggi di luce quando le attività tra gli edifici coincidono. Quando tutti e tre i lati sono connessi, una piramide di luce risplende sulla baia fungendo da accesso iconico ad Hong Kong. Lungo la costa sono posizionate mede luminose il cui colore varia in funzione dell'attività attualmente eseguita. Una famiglia di oggetti illuminanti, come ad esempio canne di bambù luminose, elementi galleggianti a pallone ed elementi di pietra producono un'illuminazione dell'ambiente in diverse graduazioni. Addizionalmente a ciò, gli elementi architettonici vengono illuminati dall'interno per creare incandescenza.

DYNAMIC LIGHTING TRIGGERED BY INDIVIDUAL SITE ACTIVITY

MOMENTS OF ENCOUNTER: BEAMS OF LIGHT BRIDGING THE HARBOUR

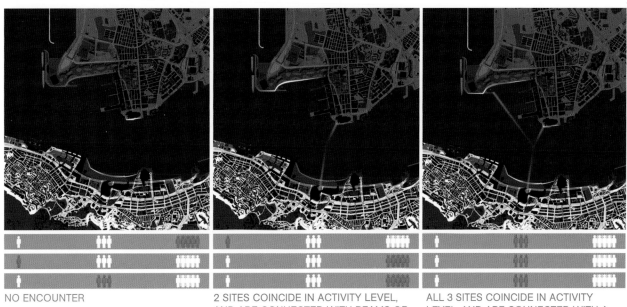

NO ENCOUNTER

2 SITES COINCIDE IN ACTIVITY LEVEL, AND ARE CONNECTED WITH BEAMS OF LIGHT

ALL 3 SITES COINCIDE IN ACTIVITY LEVEL, AND ARE CONNECTED WITH A PRISM OF LIGHT

Festival Walk

Location: Hong Kong, China
Architects: Arquitectonica, USA
Completed: 1999

The shopping mall boasts restaurants, a cinema, and Hong Kong's largest ice rink. Lighting brings a strong design sensibility to commercial areas executed on a large scale. The lighting concept for the shopping mall emphasizes the identity of its diverse program, as well as orientation throughout the building. Inside of the shopping mall, wave-like forms emanate light, composing a river which is identical on every floor. In addition, a canyon is devised from breaks in the ceiling which also shed light, yet their design changes on each level.

Dieses Einkaufszentrum kann mit mehreren Restaurants, einem Kino und Hongkongs größter Schlittschuhbahn aufwarten. Licht schafft in den weit angelegten Ladenbereichen eine starke Sensibilität für Design. Das Beleuchtungskonzept des Einkaufzentrums betont die verschiedenen Funktionsbereiche und bietet Anhaltspunkte zur Orientierung im ganzen Gebäude. Im Einkaufzentrum bilden wellenförmige Lichtelemente eine Art Fluss, der auf jedem Stockwerk identisch ist. Auch werden durch Brüche in der Decke Canyons geformt, die ebenfalls Licht werfen, ihr Design ist jedoch auf jedem Stockwerk unterschiedlich.

Ce centre commercial comprend des restaurants, un cinéma, et la plus grande patinoire de Hong Kong. L'éclairage apporte une grande sensibilité de design aux zones commerciales réalisées sur de grands espaces. Le concept d'éclairage pour le centre commercial rehausse l'identité des divers programmes, de même pour l'orientation à l'intérieur du bâtiment. A l'intérieur du centre commercial, de la lumière d'éléments d'éclairages en forme de vagues, imitant une rivière que l'on retrouve à chaque étage. De plus un canyon, conçu à l'aide de ruptures dans le plafond, diffuse aussi de la lumière, là encore la forme change à chaque étage.

El centro comercial alberga restaurantes, un cine y la pista de hielo más grande de Hong Kong. La iluminación dota de una gran sensibilidad el diseño de las áreas comerciales ejecutadas a gran escala. El concepto de iluminación para el centro comercial acentúa la identidad de su variado programa, así como la orientación por todo el edificio. En el interior del centro comercial, formas que imitan olas irradian electricidad, formando un río que es idéntico en cada piso. Además, se ha creado un cañón a partir de las aberturas del techo, que también aportan luz, aunque su diseño cambia en cada nivel.

Il centro commerciale vanta ristoranti, un cinema e la pista di pattinaggio su ghiaccio più grande di Hong Kong. L'illuminazione è realizzata con grande sensibilità in termini di design per le zone commerciali edificate su ampi spazi. Il concetto dell'illuminazione per il centro commerciale enfatizza l'identità del suo variegato programma nonché l'orientamento attraverso l'intero complesso. All'interno del centro commerciale forme ondulate emanano luce, componendo ad ogni piano un fiume identico. Addizionalmente a ciò vi è un canyon risultante da fessure nel soffitto anch'esse emananti luce, ma la cui struttura cambia da un livello all'altro.

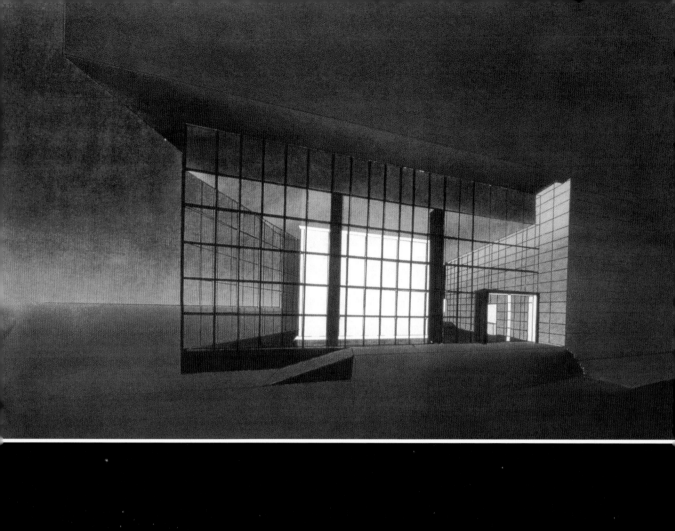
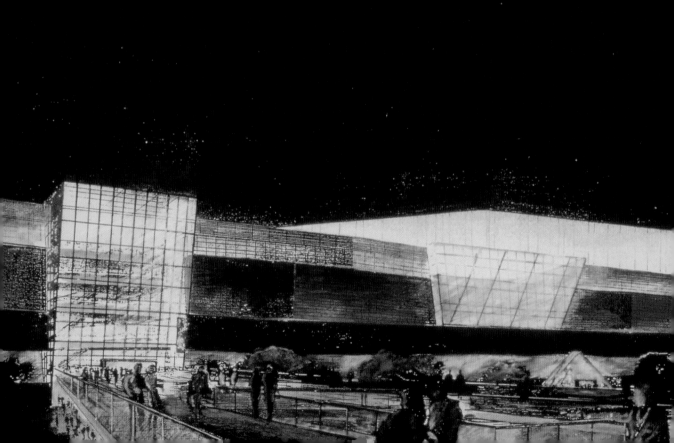

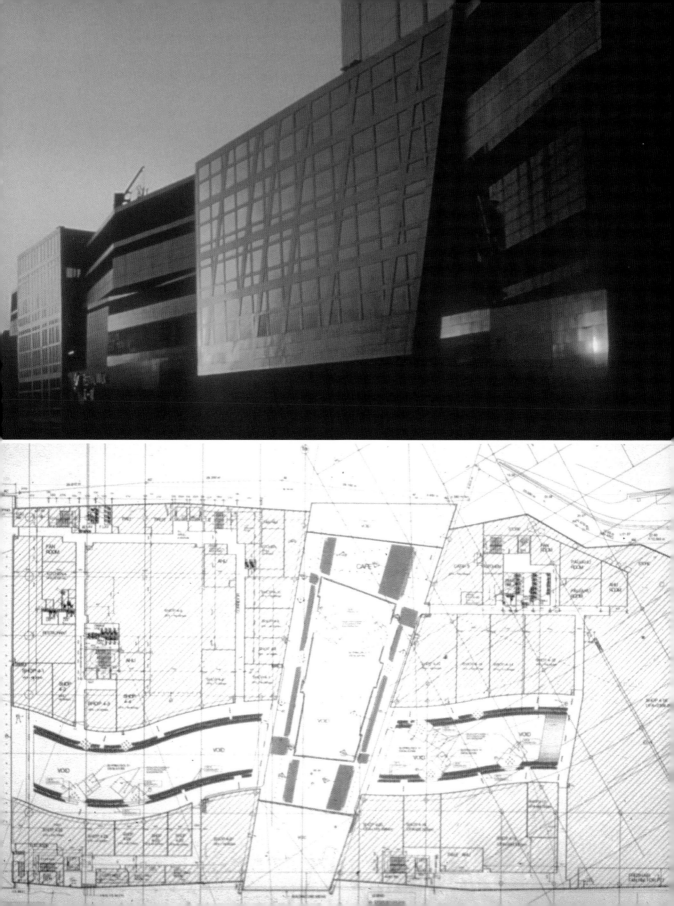

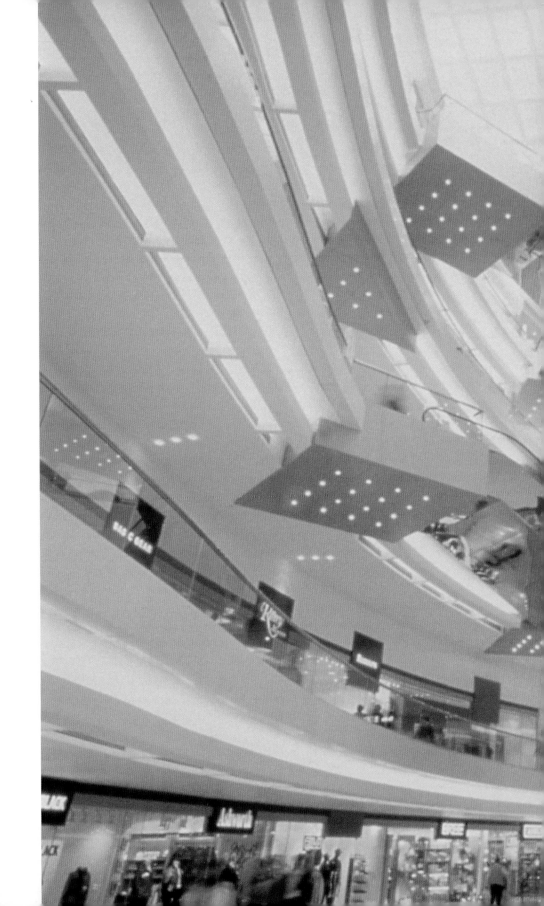

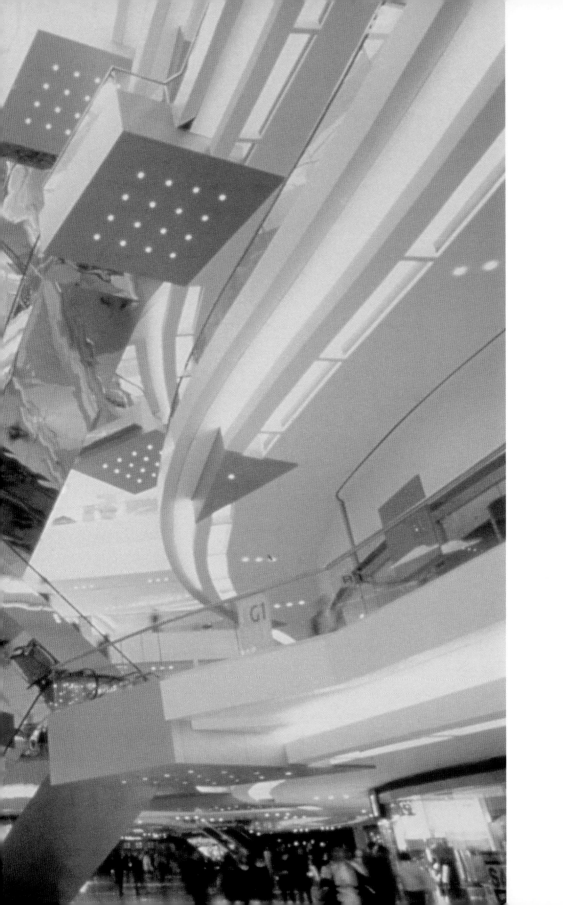

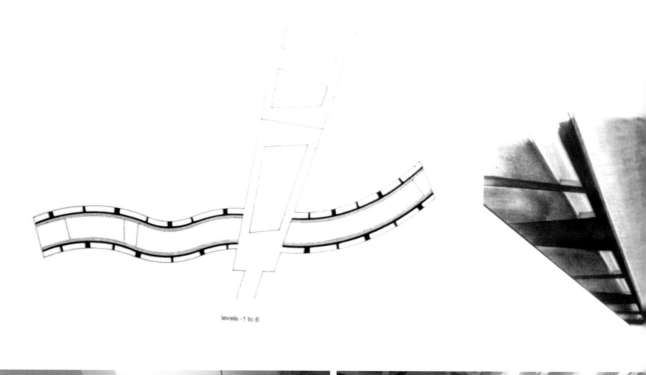

levels -1 to 6

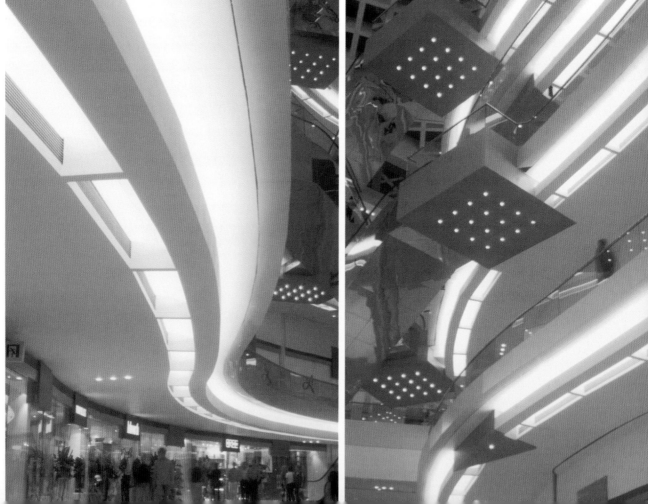

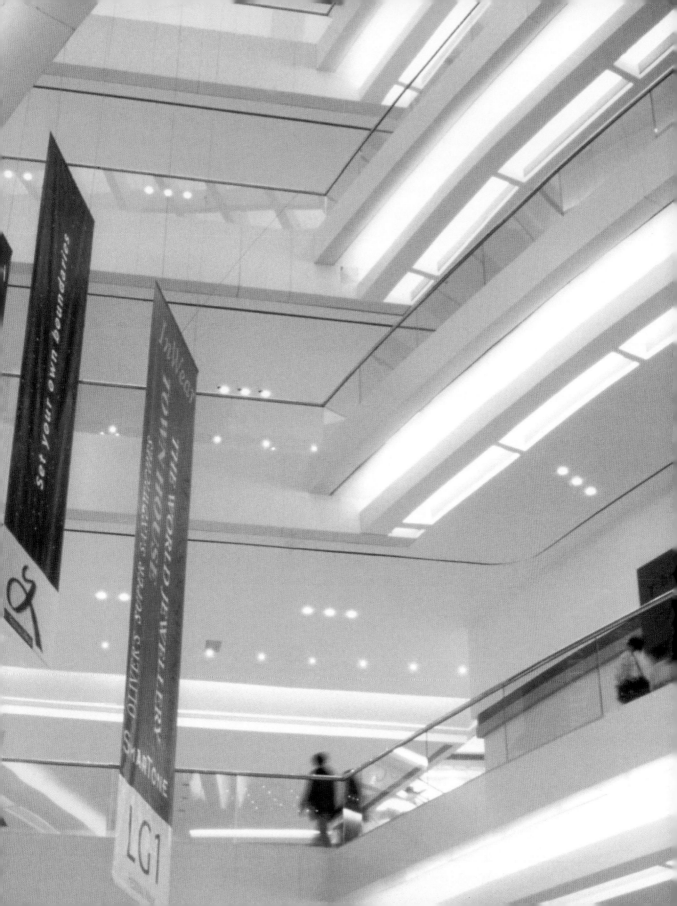

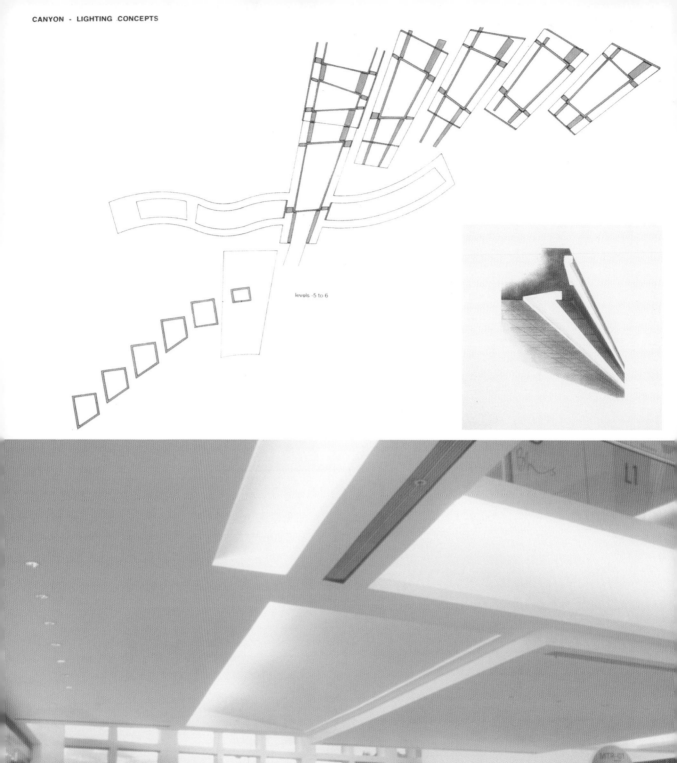

levels -5 to 6

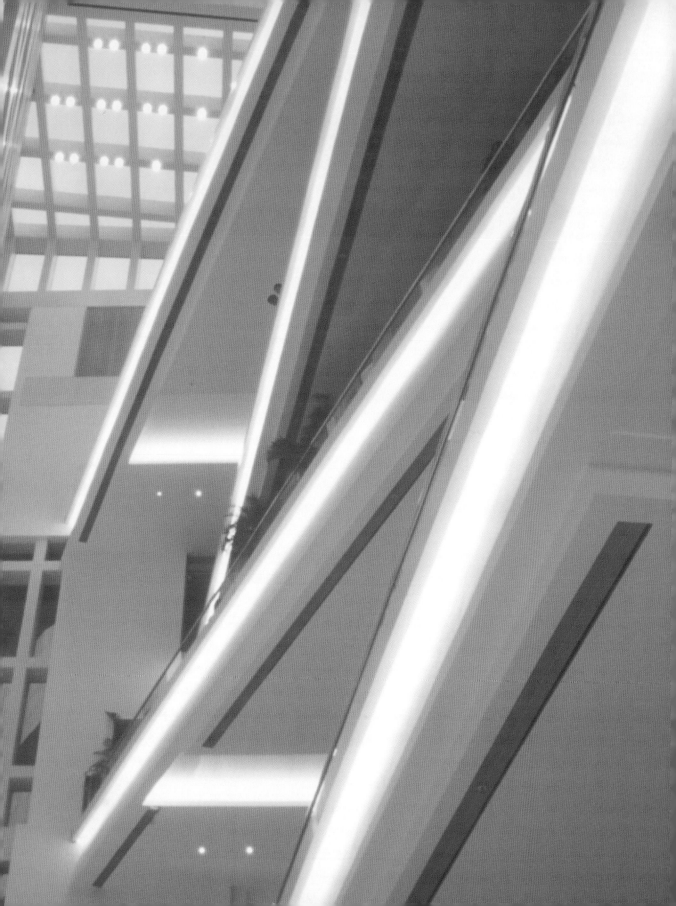

Cyberport

Location: Hong Kong, China
Architects: Arquitectonica, USA
Completed: 2003

This office complex caters to information technology. The lighting scheme reflects a spirit of community and fluidity engendered by a marked engagement with virtual networks. Moreover, light further emphasizes strong graphic schemes.

Dieser Bürokomplex ist ganz auf Informationstechnologie ausgerichtet. Der Beleuchtungsentwurf spiegelt den Geist von Gemeinschaft und ein Fließen wider, das durch eine ausgeprägte Beschäftigung mit virtuellen Netzen erzeugt wird. Darüberhinaus werden deutliche, grafische Schemata durch das Licht betont.

Ce complexe de bureaux est un centre pour la technologie et l'information. Le schéma d'éclairage reflète un esprit communautaire et fluide engendré par un engagement marqué pour les réseaux virtuels. D'autre part la lumière met encore plus en valeur des schémas graphiques forts.

Este complejo de oficinas está al servicio de la tecnología de la información. El esquema de iluminación refleja un espíritu de comunidad y fluidez creado por un marcado compromiso con las redes virtuales. Además, la luz resalta mucho los esquemas gráficos más fuertes.

Questo complesso d'uffici è adibito all'informazione tecnologica. Lo schema dell'illuminazione riflette uno spirito di comunità e di fluidità generati da un marcato impegno con reti virtuali. Inoltre, la luce enfatizza ulteriormente intensi schemi grafici.

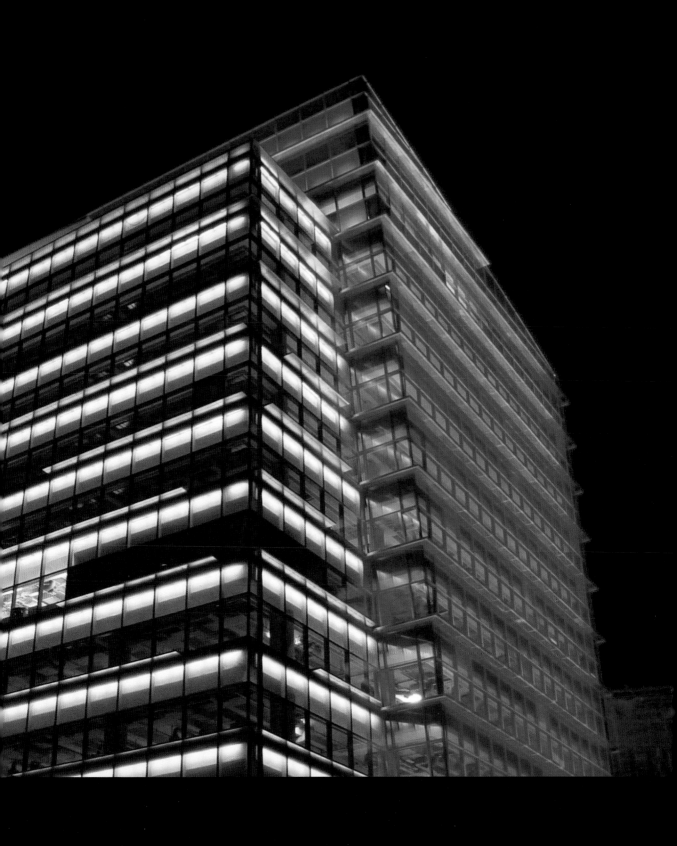

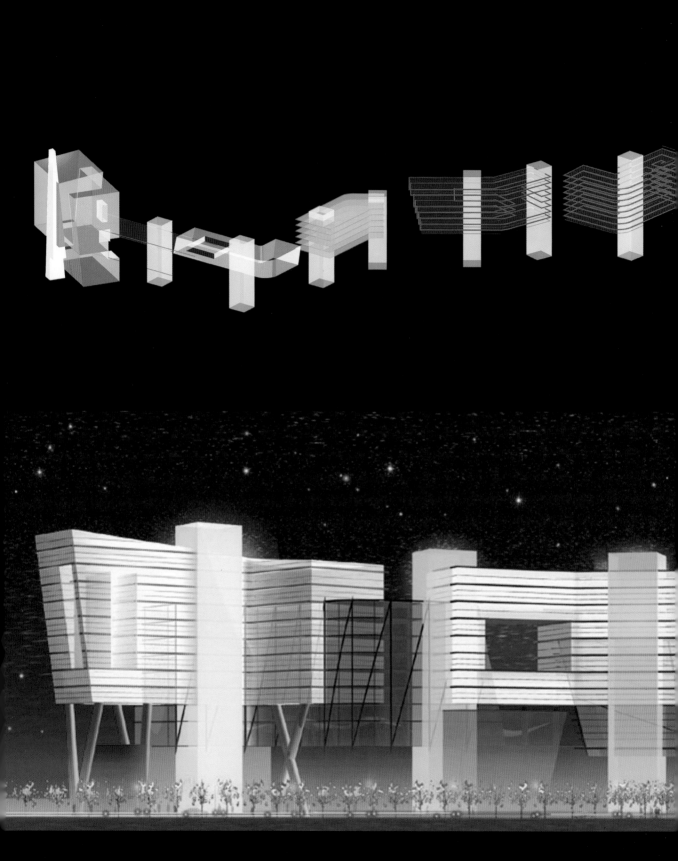

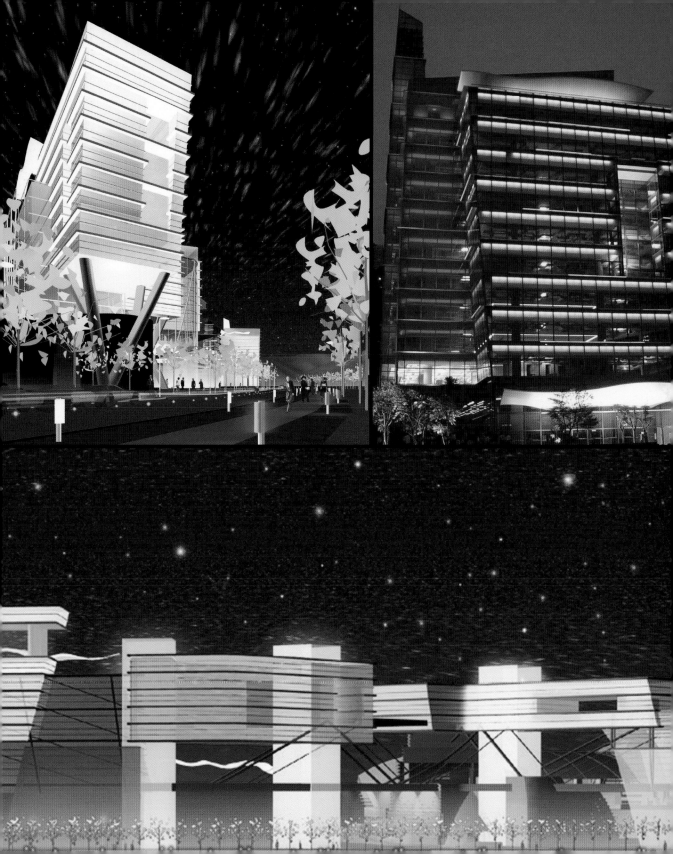

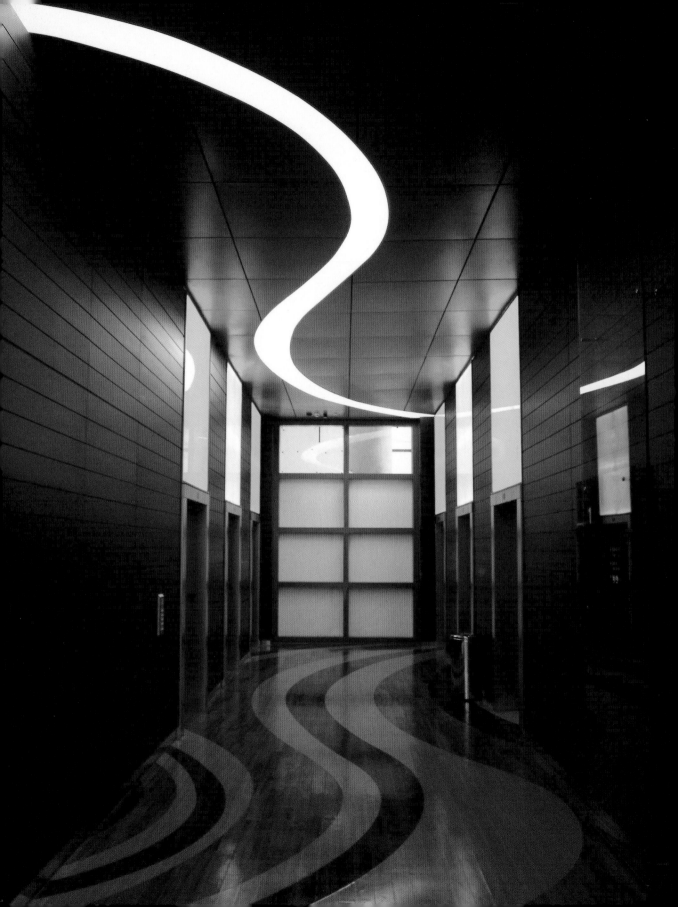

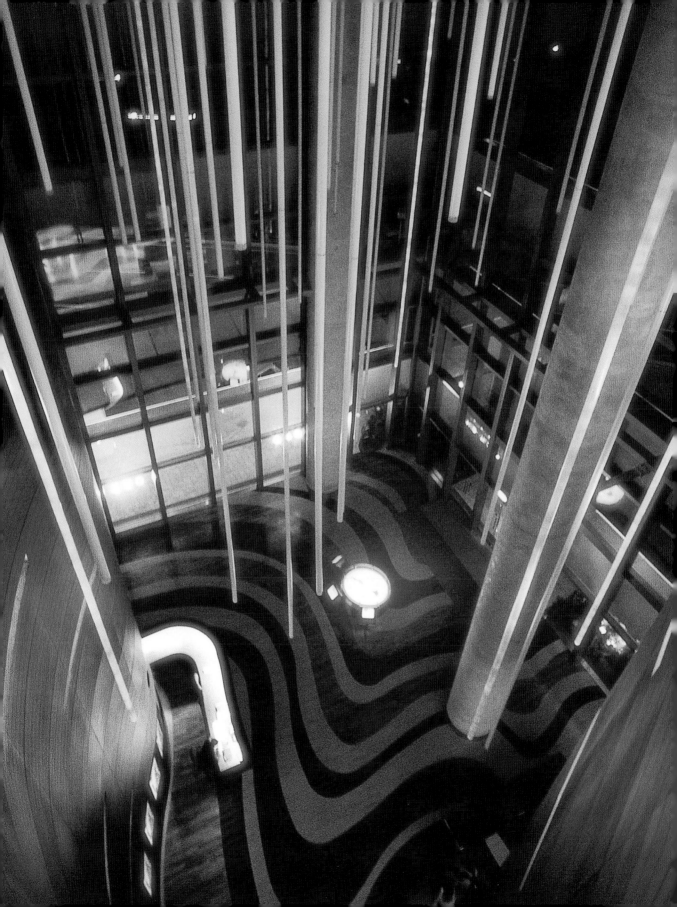

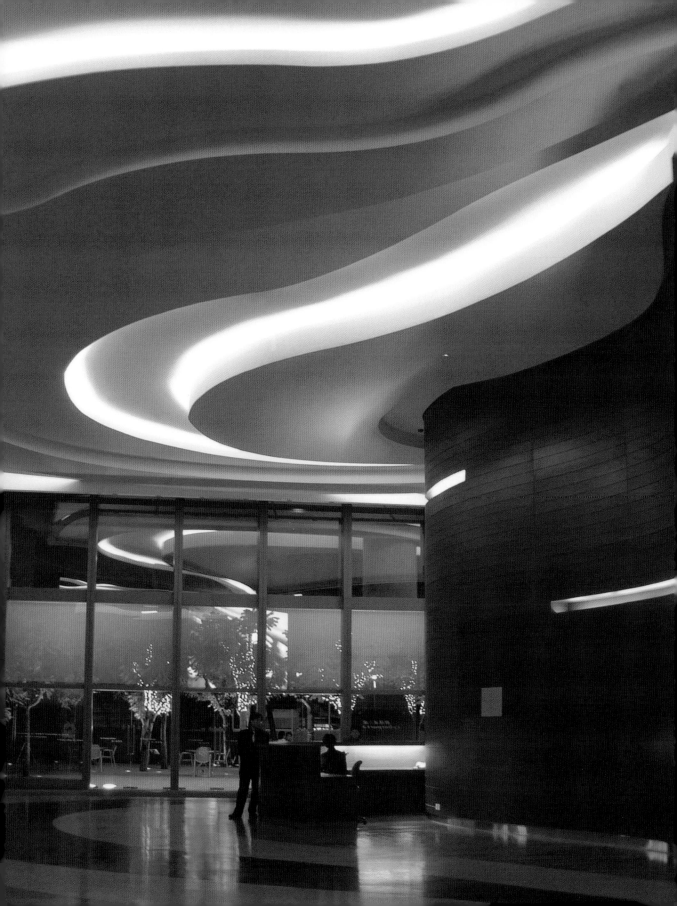

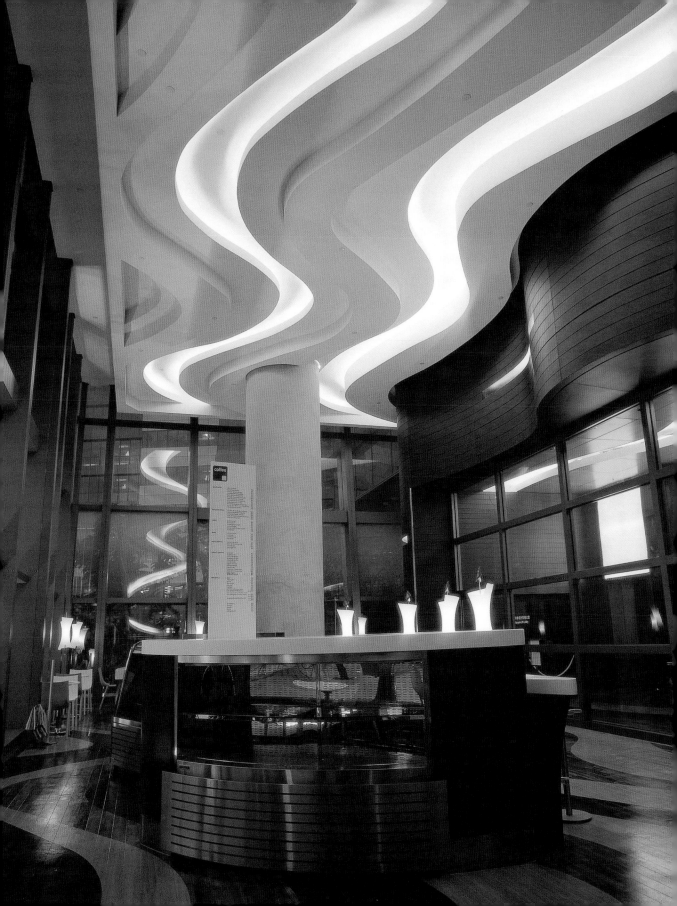

Winsland House II

Location: Singapore
Architects: Arquitectonica, USA
Completed: 1997

In this office and residential building complex, the ceilings of all nine stories of corridors are visible from the bottom of the inner courtyard. Using the image of falling leaves in a regional color scheme, a playful relationship is developed in the corridors between floors.

In diesem Wohn-und Bürokomplex sind die Korridordecken aller neun Stockwerke vom Innenhof aus zu sehen. Durch die Verwendung von Formen fallender Blätter in einer regionalen Farbskala entsteht in den Korridoren eine verspielte Verbindung zwischen den Stockwerken.

Dans ce complexe de construction pour bureaux et résidentiel, les plafonds des couloirs des neuf étages sont visibles depuis en bas de la cour intérieure. L'utilisation de l'image de la chute des feuilles mortes suivant la palette régionale des couleurs, développe une relation d'enjouement dans les couloirs entre les étages.

En este complejo residencial y de oficinas, todos los techos de los pasillos de los nueve pisos son visibles desde la parte baja del patio interior. Utilizando la imagen de las hojas otoñales en una gama de colores regional, se desarrolla una relación lúdica en los pasillos que existen entre los pisos.

In questo complesso adibito ad uffici e residenziale i soffitti di tutti i nove piani di corridoi sono visibili dal basso del cortile interno. Utilizzando l'immagine di foglie cadenti in uno schema di colori regionali, viene sviluppata una relazione svagata nei corridori tra i piani.

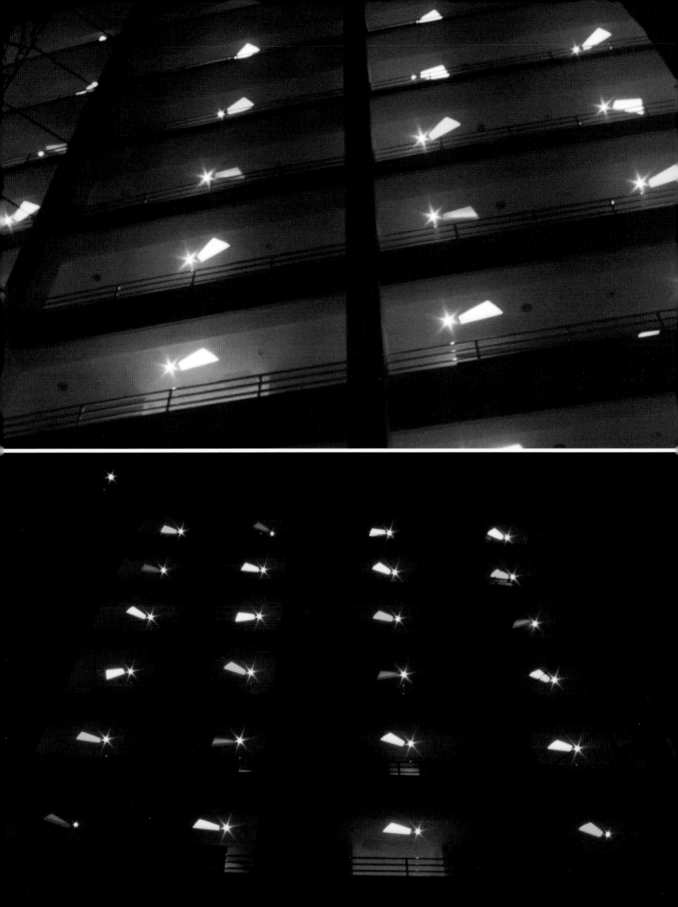

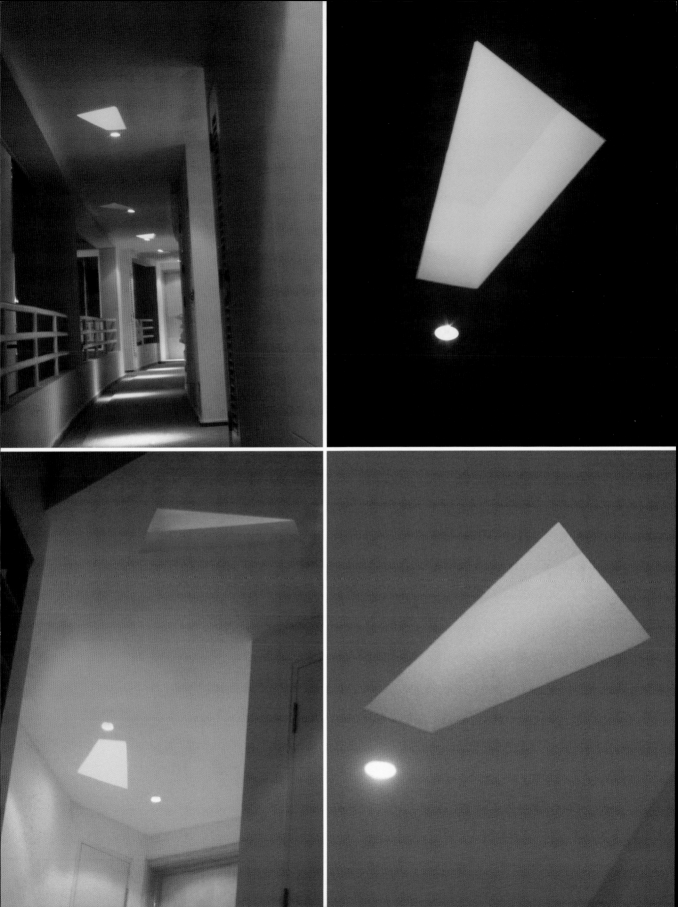

North One

Location:	Singapore
Architects:	Toyo Ito and Associates, Japan
Design Year:	2005

In this complex for technology information, light assists the building to function like a living organism. Lighting focuses its intensity within centers of activity in which light levels alter depending on the concentration of human movement and inter-action. Light radiates outward from each of these spaces like impulses in a neural network, becoming dimmer away from these nodes.

Dieser Gebäudekomplex für technologische Daten funktioniert wie ein lebender Organismus, was durch das Beleuchtungs-system unterstrichen wird. Aktive Zentren werden heller beleuchtet, da die Lichtintensität mit der Konzentration von mensch-licher Bewegung und Interaktion zu- oder abnimmt. Licht strahlt von diesen Zentren aus, wie Impulse in einem Nervensystem und wird gedämpfter je weiter es sich von diesen Knotenpunkten entfernt.

Dans ce complexe des technologies de l'information, la lumière contribue à faire fonctionner l'immeuble comme un organis-me vivant. L'éclairage focalise son intensité au sein des centres d'activité où les niveaux de lumière se modifient en fonction de la concentration des mouvements humains et des interactions. La lumière rayonne vers l'extérieur à partir de chacun de ces espaces comme des impulsions dans un réseau neuronal, et elle faiblit une fois éloignée de ces nœuds.

En este complejo para la información tecnológica, la luz ayuda a funcionar al edificio como si fuera un ser vivo. La iluminación centra su identidad en centros de actividad en los que los niveles de luz se modifican dependiendo de la concentración de movimiento e interacción humana. Desde cada uno esos espacios, la luz es irradiada hacia fuera asemejándose a los impul-sos de un sistema nervioso, y se debilita según se aleja de esos nódulos.

In questo complesso adibito all'informazione tecnologica la luce aiuta l'edificio a funzionare come un organismo vivente. L'illuminazione concentra la propria intensità in centri di attività in cui i livelli della luce variano in funzione della concentrazio-ne dei movimenti e delle interazioni umane. La luce irradia verso l'esterno da ciascuno di questi spazi come impulsi in una rete nervosa, divenendo più fioca allontanandosi da questi nodi.

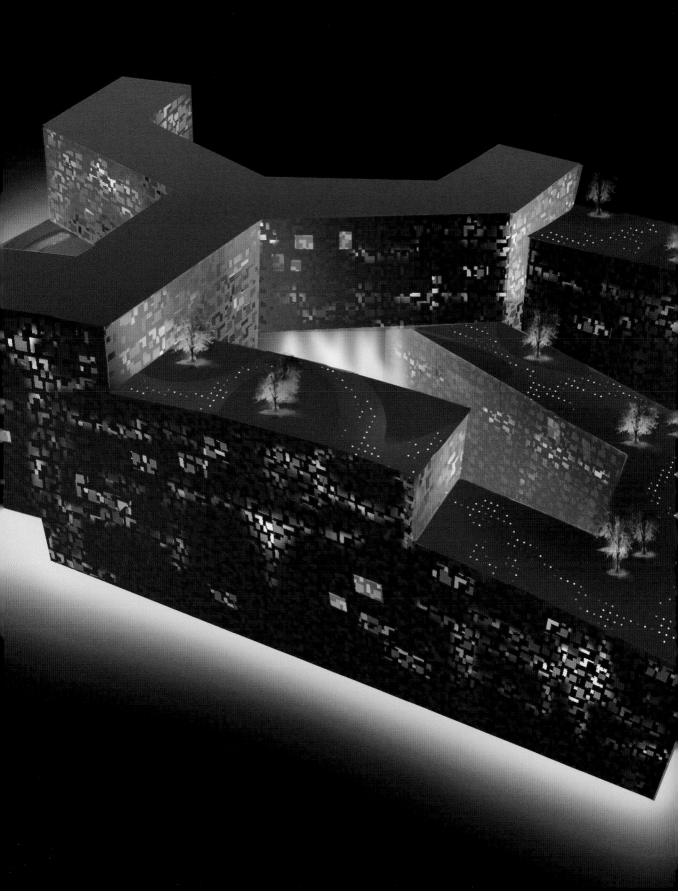

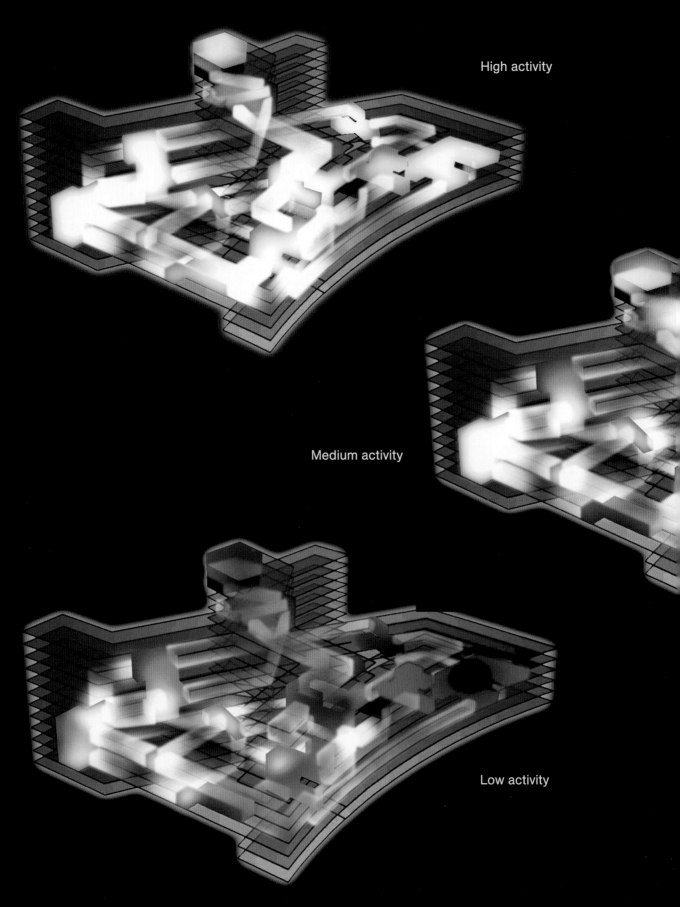

High activity

Medium activity

Low activity

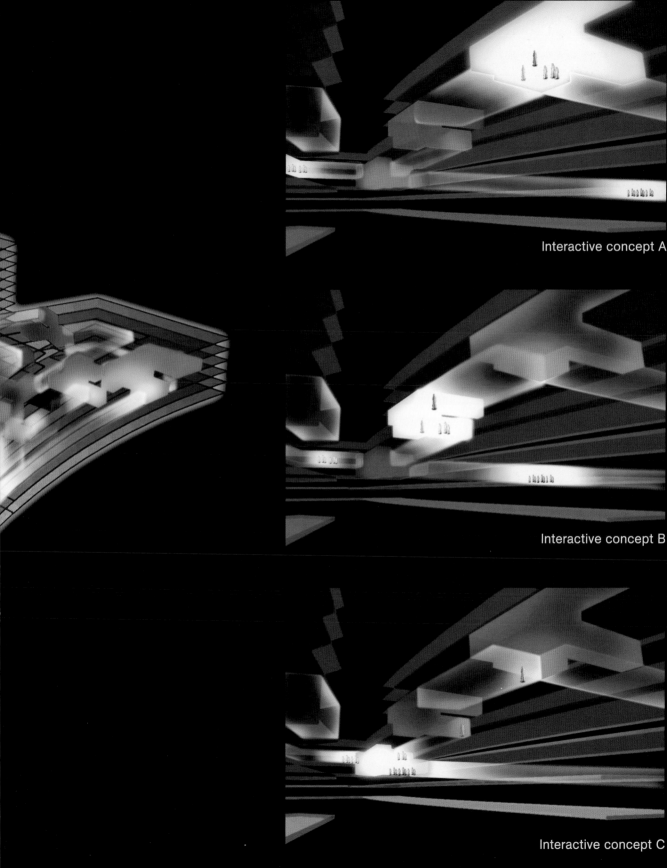

Interactive concept A

Interactive concept B

Interactive concept C

Custom Fixtures

An aspect of our work also includes the design of custom lighting fixtures. Not intended for mass production, these unique objects are created to meet the specific requirements of particular programs as well as distinct sites. Moreover, these fixtures are often executed in collaboration with various designers and architects in response to the design intent of individual projects.

Ein Aspekt unsrer Arbeit besteht auch darin, Beleuchtungsvorrichtungen speziell nach Wunsch des Kunden zu entwerfen. Diese einzigartigen Objekte sind nicht für Massenproduktion vorgesehen und so gestaltet, dass sie sowohl den Anforderungen des jeweiligen Konzepts, als auch den besonderen Voraussetzungen des Ortes gerecht werden. Darüber hinaus wird bei der Entwicklung dieser Vorrichtungen oft mit verschiedenen Designern und Architekten zusammengearbeitet, um auf die Zielvorstellungen der individuellen Projekte einzugehen.

Un des aspects de notre production concerne l'étude d'éclairages à la demande. Ces objets uniques, non prévus pour la production de masse, sont créés conformément à des exigences spécifiques de programmes particuliers aussi bien que d'emplacements différents. De plus ces équipements sont souvent réalisés en collaboration avec différents stylistes et architectes, afin de répondre aux objectifs de style de projets individuels.

Otro aspecto de nuestro trabajo es el diseño de elementos de iluminación personalizados. Estos objetos únicos, no destinados a su producción en masa, se diseñan para satisfacer las necesidades específicas de determinados programas y de diferentes lugares. Además, estos accesorios se crean a menudo en colaboración con diferentes diseñadores y arquitectos para responder a los propósitos de los proyectos individuales.

Un aspetto del nostro lavoro comprende anche la progettazione di strutture di illuminazione personalizzate. Non intesi per la produzione di massa, questi oggetti unici sono creati per soddisfare le esigenze specifiche di programmi particolari nonché come siti distinti. Inoltre, queste strutture vengono eseguite spesso in cooperazione con vari designer ed architetti in ottemperanza all'intenzione di progettazione nell'ambito di progetti individuali.

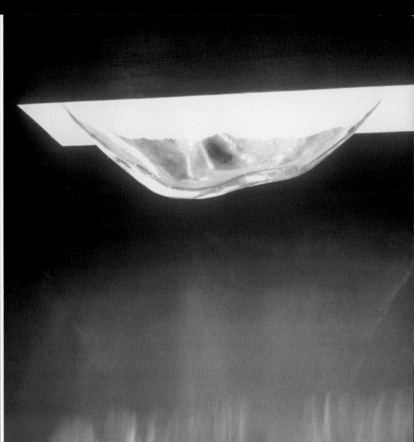

Effect:	Shadow projection
Type:	Semi ceiling recessed fixture
Material:	Handblown glass
Size:	45 cm x 17 cm
Year:	1998

OBS
53-103
31

transformer for
incadescent lamp

18w compact fluorescent

24w compact fluorescent

light pocket above

SLUMPED
GLASS

OBS
53-103
32

control gear for 2 lamps

24w compact fluorescent

suspended 75w incadescent
align bottom of bulb with bottom
edge of aluminum frame

18w compact fluorescent

slumped glass

hand sanded aluminum frame

24w compact fluorescent

suspended 75w incadescent
align bottom of bulb with bottom
edge of aluminum frame

24w compact fluorescent

slumped glass

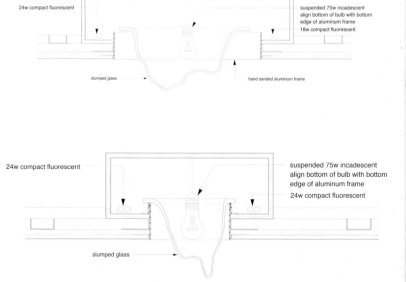

Kiasma Museum of Contemporary Art, Helsinki, cafe

Collaboration with Steven Holl

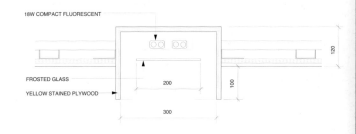

Effect: Diffuse light
Type: Semi ceiling recessed fixture
Material: Stained wood, frosted glass
Size: 30 cm x 30 cm
Year: 1998

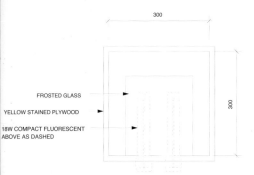

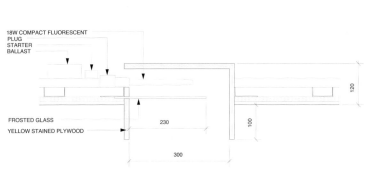

Kiasma Museum of Contemporary Art, Helsinki, coat room

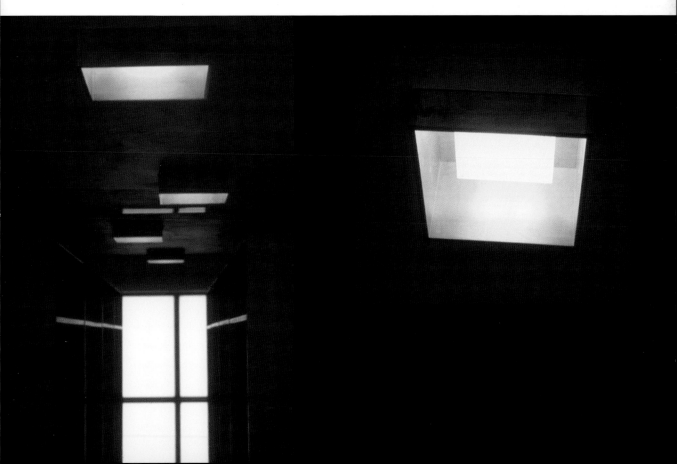

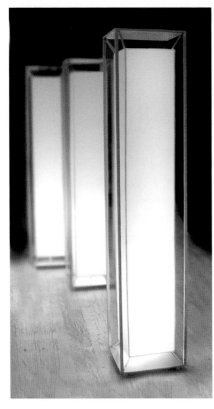

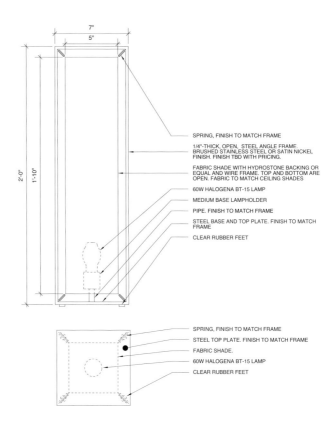

SPRING, FINISH TO MATCH FRAME

1/4"-THICK, OPEN, STEEL ANGLE FRAME. BRUSHED STAINLESS STEEL OR SATIN NICKEL FINISH. FINISH TBD WITH PRICING.

FABRIC SHADE WITH HYDROSTONE BACKING OR EQUAL AND WIRE FRAME, TOP AND BOTTOM ARE OPEN. FABRIC TO MATCH CEILING SHADES

60W HALOGENA BT-15 LAMP

MEDIUM BASE LAMPHOLDER

PIPE. FINISH TO MATCH FRAME

STEEL BASE AND TOP PLATE. FINISH TO MATCH FRAME

CLEAR RUBBER FEET

SPRING, FINISH TO MATCH FRAME

STEEL TOP PLATE. FINISH TO MATCH FRAME

FABRIC SHADE.

60W HALOGENA BT-15 LAMP

CLEAR RUBBER FEET

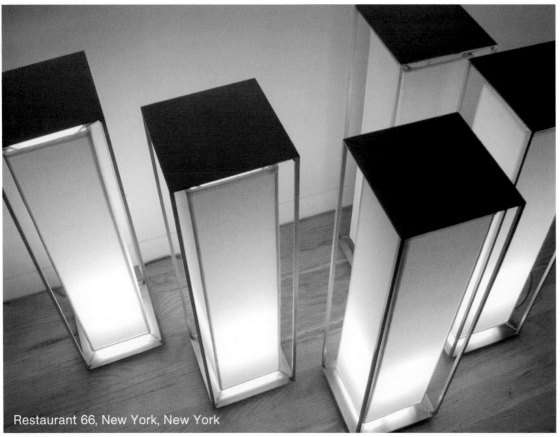

Restaurant 66, New York, New York

Effect: Diffuse light
Type: Semi ceiling recessed fixture
Material: Silk
Size: 180 cm x 180 cm
Year: 2002

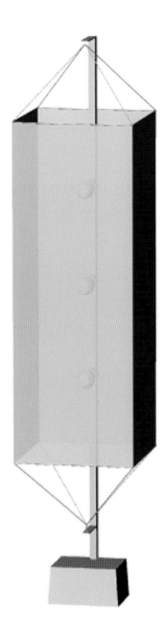

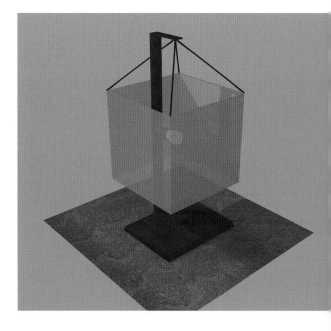

Effect:	Diffuse light
Type:	Floor lamp
Material:	Craft paper
Size:	2.0 m x 35 cm x 35 cm
Year:	2001

Ministère de l'Éducation Nationale, Paris

Effect:	Direct / indirect light
Type:	Chandelier
Material:	Metal pipe
Size:	4.5 m
Year:	2001

Effects: Projection of shadows on walls / surroundings
Type: Wall sconce
Material: Aluminium
Size: 30 cm diameter
Year: 2004

Camana Bay, Grand Cayman

Effect: Diffuse light
Type: Floor lamp
Material: Resin
Size: 35 cm x 35 cm
Year: 2001

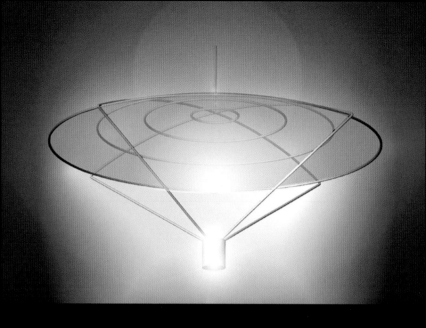

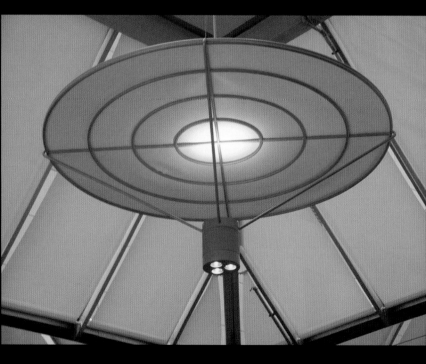

Effect:	Direct / indirect
Type:	Suspension
Material:	Aluminium and fabric
Size:	2.75 m in diameter
Year:	2002

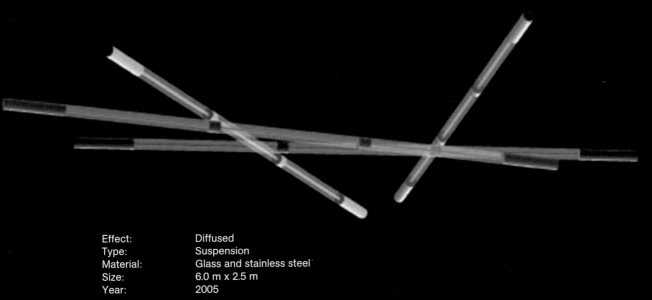

Effect:	Diffused
Type:	Suspension
Material:	Glass and stainless steel
Size:	6.0 m x 2.5 m
Year:	2005

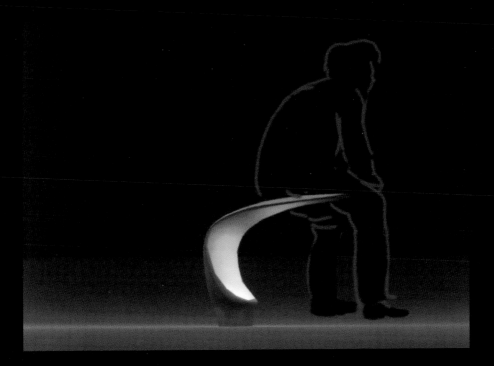

Effect:	Indirect
Type:	Surface mounted
Material:	Cast aluminium
Size:	0.60 m height
Year:	2003

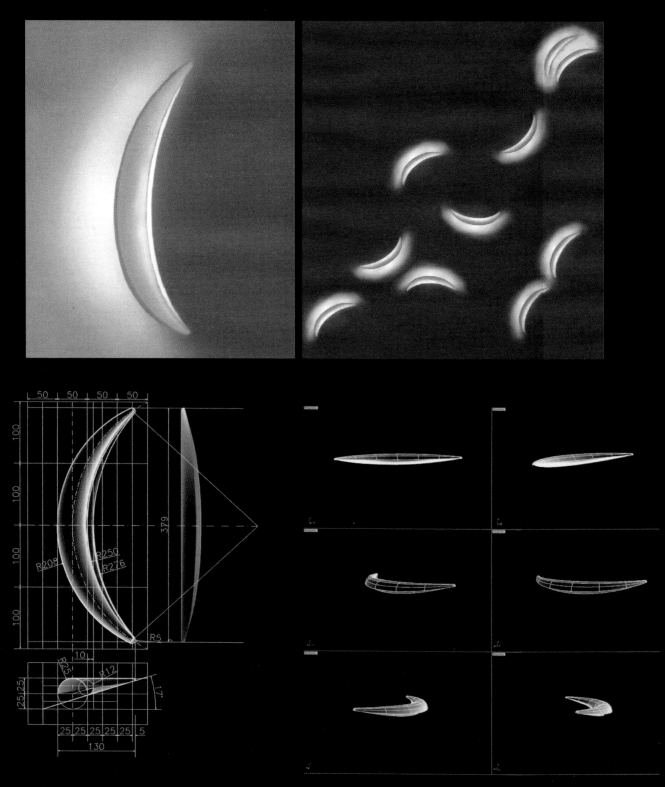

Camana Bay, Grand Cayman

Effect: Wall grazing
Type: Wall sconce
Material: Aluminium
Size: 50 cm tall
Year: 2005

Effect: Ground light
Type: Bollard
Material: Aluminium
Size: 80 cm tall
Year: 2005

Effect: Downlighting
Type: Street light
Material: Stainless steel
Size: 8.0 — 12.0 m
Year: 2004

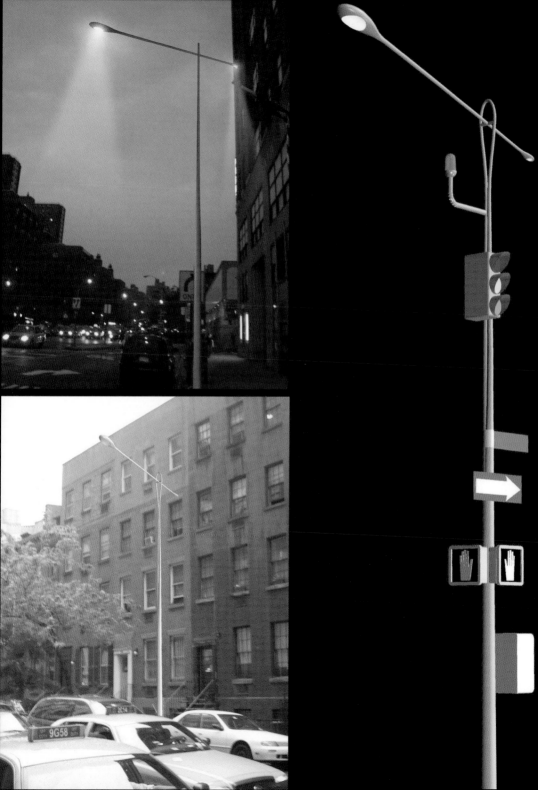

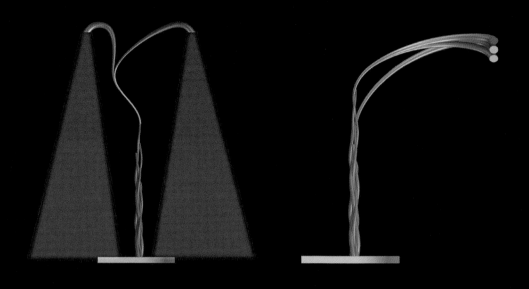

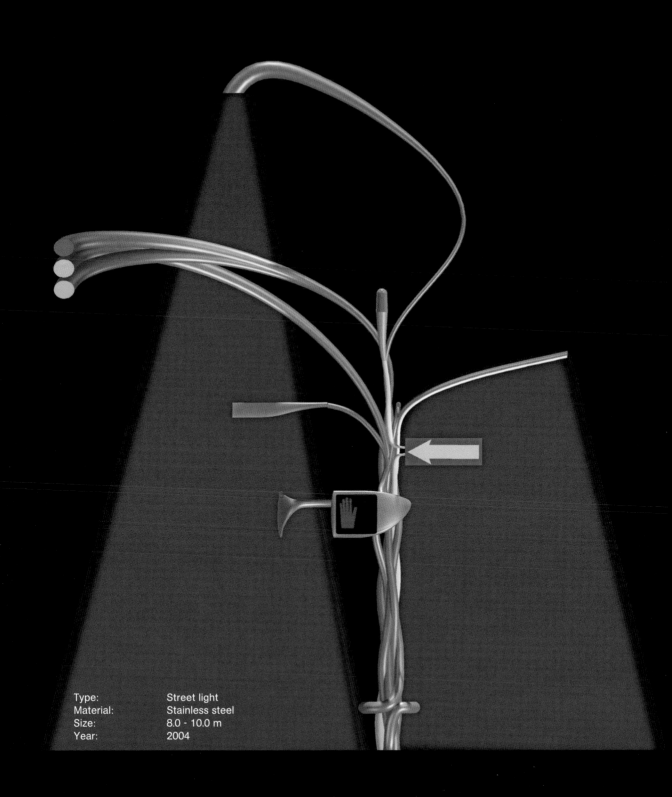

Type: Street light
Material: Stainless steel
Size: 8.0 - 10.0 m
Year: 2004

Appendix

Photo by Ana Bloom

Hervé Descottes Biography

Hervé Descottes is working on something that does not exist. How and who might even identify it? He is working, that is certain; with finesse, intensity, and staggering speed. Where does he find the knowledge that others attempt to seek elsewhere, but can only be found in himself?

First, he is French, but he does not live in France, rather in New York, thereby escaping the constraints of a definition that would be limiting. He is French, well, first and foremost a Burgundian. His roots reach deep into the soil in the exact same way vines do. They both draw from the earth the savors needed for a great vintage. He has retained these roots, an acute sensitivity to nature and taste for excellence.

Suddenly, I cannot help but think that at the beginning of François Blondel's architecture class in the 18th century, there was a dance lesson, as if architecture escaped architecture and that it owes its existence only to a codified form of social conduct. H.D. is sociable. Extensive office hours are only a prelude to many late evenings during which co-workers and colleagues share life and professional discussions.

H.D.'s art is neither bookish, cerebral, nor abstract. It is at the core of an increasingly unusual combination of three qualities, sensitivity, intelligence and authenticity. In his case, sensitivity might be to choose the most vibrantly and powerfully harmonious point for the highest degree of intensity, yet do so softly. Intelligence might be the ability to choose and define the best adapted means by which to obtain the effects he might desire. No, intelligence must first and foremost serve to initiate (one should think of ignition), to light the flame, to cast the first light. Authenticity might be dual: partly owing to the exceptional location, the unique nature of each project, and partly to its echoing of his roots. H.D. knows that the extreme aesthetic sensation that touches the sky often draws its grandeur from primitive sources.

Getting back to my earlier statement, H.D. is working on something that does not exist, which brings us right back to the many difficulties that define his art. First, there is an infinite variety among his interventions, in as much as his collaborations are very diverse, and also, the research material for his subject is intangible. What role does he play amidst architects and clients? One must have seen the projects to which he contributed in order to understand that architecture is nothing without light, and the best that one can hope for is a merging of light and architecture. Those who decided to put him in first place owe their best work to his influence.

We could settle for this almost classic definition of architecture even though the dialogue between architecture and light takes on a very different meaning. Before, architecture was born at sunrise everyday and disappeared into the realm of dreams when night fell. Candlelight invited an atmosphere of intrigue and mystery. H.D. remembers every detail faithfully, which he reveals with each new production. H.D. knows this basic magic trick and, even better the art of hiding the means by which he creates the magic. And since we live in an era of images, they assault us as they seduce us, all the while architecture itself stands at the center. And it is light, once again, colorful and sequential, that allows architecture to be a part of these transformations.

H.D., the evasive, might work on something that doesn't exist, has all the scientific knowledge required for architecture in his time. But in the end, science is not art. It is not enough to know how to create something that no one else can. In the place where his roots bind him to the earth below, there is also the voice of silence, which can be heard at the extreme height of emotion.

Sylvain Dubuisson, architect/designer
30 March 2005

Hervé Descottes arbeitet an etwas, was eigentlich nicht existiert. Wie sollte man und wer könnte es überhaupt identifizieren? Er arbeitet, so viel steht fest; mit Feinheit, Intensität und atemberaubender Geschwindigkeit. Doch wo findet er die Weisheit, die manch einer an anderen Orten sucht und die doch nur in ihm selbst zu finden ist?

Er ist Franzose, doch lebt er nicht in Frankreich, sondern in New York. So entkommt er den Zwängen einer Definition, die ihn einengen würde. Er ist Franzose, doch seine Heimat ist zuallererst Burgund. So wie die Weinreben ist er mit diesem Boden tief verwurzelt und beide entziehen diesem die Würze, die für einen guten Jahrgang nötig ist. Diese Wurzeln hat er sich erhalten, ein ausgeprägtes Feingefühl für die Natur und einen Geschmack für das Exzellente.

Mir will der Gedanke nicht aus dem Kopf, dass zu Beginn der Architekturvorlesungen von François Blondel im 18. Jahrhundert eine Tanzstunde stattgefunden hat, als ob die Architektur sich selbst entkommen wäre und ihre Existenz einzig und allein einer verschlüsselten Form von Gesellschaftsregeln zu verdanken hätte. H.D ist gesellig. Lange Arbeitszeiten sind nur der Auftakt für häufiges Zusammensitzen bis in die späten Abendstunden, bei dem Mitarbeiter und Kollegen sowohl Privates als auch Berufliches besprechen.

H.D.s Kunst ist weder überaus akademisch noch rational oder abstrakt. Sie steht im Zentrum einer zunehmend ungewöhnlicheren Kombination von drei Eigenschaften: Sensibilität, Intelligenz und Authentizität. In seinem Fall könnte es Sensibilität sein, das den dynamischsten und kraftvollsten Harmoniepunkt zur Entwicklung höchster Intensität wählt, dies aber mit Bedacht tut. Intelligenz könnte die Fähigkeit sein, die passenden Mittel zu wählen und zu definieren, mit welchen der von ihm angestrebte Effekt zu erreichen wäre. Nein, Intelligenz muss vor allem zündende Wirkung haben, eine Flamme entfachen, das erste Licht werfen. Authentizität könnte zwei Aspekte haben: Der eine wäre zurückzuführen auf die außergewöhnlichen Schauplätze, die einmaligen Gegebenheiten jedes Projekts, der andere auf den Wiederklang seiner Wurzeln. H.D. ist sich bewusst, dass die extreme, ästhetische Wahrnehmung ihre Größe oft aus einfacher Quelle schöpft.

Wenn wir noch einmal auf meine anfängliche Bemerkung zurückkommen, dass H.D. an etwas arbeitet, was eigentlich nicht existent ist, werden wir erneut auf die vielen Schwierigkeiten zurückgeworfen, die seine Kunst definieren. Da wäre zum einen die Vielfältigkeit seiner Arbeit, die sowohl aus dem Facettenreichtum seiner Projekte, als auch aus der Nichtgreifbarkeit der Materie seines Faches entsteht. Welche Rolle spielt er unter Architekten und ihren Kunden? Man muss die Projekte, an denen er mitgearbeitet hat, gesehen haben, um zu verstehen, dass Architektur ohne Licht nicht auskommt und dass das Beste ein Verschmelzen von Licht und Architektur ist. Diejenigen, die seiner Arbeit Priorität einräumten, verdanken ihre Meisterwerke seinem Einfluss.

Wir könnten uns mit dieser beinahe klassischen Definition von Architektur zufrieden geben, obwohl der Dialog zwischen Architektur und Licht eine völlig neue Bedeutung gewinnt. Früher wurden die Werke der Architektur bei Sonnenaufgang geboren und verschwanden bei Einbruch der Nacht. Kerzenlicht schuf eine faszinierende und geheimnisvolle Atmosphäre. H.D. bleibt dem kleinsten Detail treu, was er mit jedem Projekt neu offenbart. H.D. beherrscht diesen simplen Zaubertrick und besser noch die Kunst, die Mittel zu verbergen, durch die diese Magie erzeugt wird. Da wir in einem Zeitalter der Bilder leben – sie attackieren uns, so wie sie uns verführen – steht immer die Architektur selbst im Mittelpunkt. Und wieder ist es das Licht, farbenfroh und fließend, durch das die Architektur Teil dieser Verwandlungen wird.

In gewisser Weise arbeitet H.D. an etwas, was nicht existiert, hat alle wissenschaftlichen Kenntnisse, die ein moderner Architekt aufweisen muss. Doch letzten Endes ist Wissenschaft keine Kunst. Es reicht nicht aus zu wissen, wie man etwas erschafft, das niemand sonst erschaffen kann. Dort, wo seine Wurzeln die Erde berühren, ist auch eine Stimme der Stille, die in Momenten des absoluten Hochgefühls zu hören ist.

Sylvain Dubuisson, Architekt/Designer
30. März 2005

Hervé Descottes travaille sur un sujet qui n'existe pas. Comment et par qui serait-il même identifiable? Il travail certes, avec finesse, intensité et fulgurance. D'où lui viennent-ils ce savoir, cette science que l'on peut tenter de chercher ailleurs mais qui ne se trouvent qu'en lui?

Tout d'abord il est Français, mais pour échapper aux contraintes d'une définition qui lui fixerait des limites, il vit hors de France, à New York. Il est Français, non, il est avant tout Bourguignon. Ses racines descendent en terre comme celles de la vigne. Elles y puisent leur saveur afin de produire le meilleur cru. Il a gardé de ses origines, sa démarche terrienne, une sensibilité prononcée pour les natures et un goût pour l'excellence.

Soudain je ne peux m'empêcher de penser que le début du cours d'architecture de F. Blondel au 18ème siècle commence par une leçon de Danse, comme si l'architecture échappait à l'architecture et qu'elle ne doive son existence qu'à une forme codée de sociabilité. H.D. est sociable. Les heures de bureau déjà si efficientes ne sont que les préliminaires à d'autres heures extensibles et tardives où se poursuivent avec les commanditaires ou les partenaires de travail le partage de la vie et les discussions professionelles.

Car l'art d'H.D. n'est ni livresque, ni cérébral, ni abstrait, il est au cœur de ce qui se fait de jour en jour plus rare, il est issu de la conjonction de trois qualités, la sensibilité, l'intelligence et l'authenticité. La sensibilité serait chez lui, par exemple, l'art de fixer l'intensité au point exact où l'harmonie soit la plus vibrante, la plus puissante, dans la douceur même. L'intelligence serait la capacité de choisir et de définir le procédé le plus pertinent pour obtenir les effets qu'il aurait définis. Non, l'intelligence en premier lieu, c'est cela qui initie (on devrait parler d'ignition), allume la flamme, jette la première lueur. H.D. sait que la sensation esthétique extrême celle qui touche au ciel pulse souvent sa grandeur à des sources primitives. Il a le génie du simple qui confine à la sophistication la plus extrême.

Puis réitérant mon assertion: H.D. travaille sur un sujet qui n'existe pas, nous voilà aux prises avec les difficultés d'une définition de son art et ces difficultés sont de plusieurs ordres: elles tiennent au fait que ses interventions sont d'une variété infinie puisque ses collaborations sont de nature très diverses, elles tiennent enfin essentiellement au fait que la matière de son sujet est immatérielle. Quel rôle lui assignent les architectes ou les clients? Il faut avoir vu les projets auxquels il a collaboré pour comprendre cette évidence à savoir que l'architecture n'est rien sans la lumière et à la limite ou dans le meilleur des cas que l'architecture est lumière. Ceux qui lui ont octroyé la première place ont réalisé par lui leurs meilleurs œuvres.

Nous pourrions en rester là à une définition quasi classique de l'architecture cependant que le rapport de l'architecture et de la lumière prend aujourd'hui un sens très particulier. Auparavant l'architecture naissait avec la lumière du jour et disparaissait dans le monde des songes avec la nuit. La lumière des bougies s'accordait avec l'intrigue et le mystère. H.D. en a gardé la plus intègre mémoire et chacune de ses productions le révèle. H.D. connaît cet art basique du magicien ou plus encore l'art de dissimuler les moyens avec lesquels il réalise ses artifices. Et puisque nous vivons à l'ère des images, qu'elles nous assaillent en même temps qu'elles nous séduisent, l'architecture elle-même se tient au centre du dispositif et la lumière encore, colorée et séquentielle lui offre l'opportunité de prendre part aux mutations.

H.D. l'insaisissable, celui qui travaillerait sur un sujet qui n'existe pas, peut se prévaloir de connaître la science que requiert l'architecture de son temps. Malgré tout, la science n'est pas l'art, il ne suffit pas de savoir pour faire ce qu'aucun autre n'eut fait. Là où ses racines descendent, il y a la voix du silence celle que l'on entend au moment de l'émotion extrême.

Sylvain Dubuisson, architecte/designer
30 March 2005

Hervé Descottes está trabajando en algo que no existe. ¿Quién y cómo podría siquiera identificarlo? Está trabajando, eso seguro; con sutileza, intensidad y asombrosa rapidez. ¿Dónde encuentra el saber que otros intentan buscar en otra parte, pero que sólo se encuentra en él mismo?

En primer lugar, es francés, pero no vive en Francia, sino en Nueva York, de ese modo se escapa de las restricciones de una definición que podría ser limitadora. Es francés, bueno, ante todo burgundio. Sus raíces están tan ancladas al suelo de la misma forma que lo están las vides. Ambos sacan de la tierra los sabores necesarios para una buena vendimia. Él ha conservado esas raíces, una marcada sensibilidad por la naturaleza y un gusto por lo exquisito.

De repente, no puedo evitar pensar que en los comienzos de la clase de arquitectura de François Blondel en el siglo XVIII, existía una clase de danza, como si la arquitectura escapase a la arquitectura y ésta debiera su existencia sólo a una forma codificada de conducta social. H. D. es sociable. Muchas horas de oficina son sólo un preludio de muchas noches hasta las tantas durante las cuales los colaboradores y colegas comparten vida y debates profesionales.

El arte de H.D. no sigue los dictados de un libro, ni es cerebral, ni abstracto. Es el núcleo de una cada vez menos habitual combinación de cualidades, sensibilidad, inteligencia y autenticidad. En este caso, la sensibilidad podría consistir en elegir el punto más vibrante y poderosamente armonioso para obtener el mayor grado de intensidad, incluso en hacerlo poco a poco. La inteligencia puede ser la capacidad para elegir y definir los medios mejor adaptados por los que obtener los efectos que podría desear. No, la inteligencia debe, ante todo, servir para comenzar (uno debería pensar en el arranque), a encender la llama, a lanzar la primera luz. La autenticidad debería ser dual: en parte debido a una localización excepcional, a la naturaleza única de cada proyecto, y en parte debido al eco de sus raíces. H.D. sabe que la sensación ascética extrema que toca el cielo a menudo saca su grandeza de fuentes primitivas.

Retomando mi primera frase, H.D. está trabajando en algo que no existe, que nos devuelve exactamente a las numerosas dificultades que definen su arte. En primer lugar, existe una variedad infinita entre sus intervenciones, tantas como diversas son sus colaboraciones, y también, el material de estudio para su materia es intangible. ¿Qué papel desempeña entre arquitectos y clientes? Uno debería haber visto los proyectos a los que contribuyó con el fin de entender que la arquitectura no es nada sin la luz, y lo mejor que uno puede esperar es una unión de luz y arquitectura. Aquellos que decidieron ponerle en primer lugar deben su mejor trabajo a su influencia.

Podríamos establecer esta casi clásica definición de arquitectura aunque el diálogo entre arquitectura y luz acepte un significado muy distinto. Antaño, la arquitectura nacía con la salida del sol cada día y desaparecía en la esfera de los sueños cuando caía la noche. La luz de una vela invitaba a un ambiente de intriga y misterio. H.D. recuerda fielmente cada detalle, que revela con cada nueva producción. H.D. conoce este básico y mágico truco e, incluso, conoce mejor el arte de esconder los medios con los que crea la magia. Y ya que vivimos en una era de imágenes, nos asaltan mientras nos seducen, mientras que la propia arquitectura permanece siempre en el centro. Y es la luz, una vez más, llena de color y secuencial, la que permite que la arquitectura sea una parte de esas transformaciones.

De manera evasiva, H. D. puede trabajar en algo que no existe, posee todo el conocimiento científico que hoy en día se requiere para la arquitectura. Pero al final, la ciencia no es un arte. No es suficiente saber cómo crear algo que nadie más puede crear. En el lugar donde sus raíces le atan a la tierra que tiene debajo, también se encuentra la voz del silencio, que se puede oír en la cumbre más extrema de la emoción.

Sylvain Dubuisson, arquitecto/diseñador
30 de marzo de 2005

Hervé Descottes lavora su qualcosa che non esiste. Come e chi può solo identificarlo? Lavora, questo è certo, con raffinatezza, intensità e ad una velocità allucinante. Dove trova le cognizioni che altri sperano di trovare altrove, ma che possono essere trovate solamente in lui stesso?

Per cominciare, lui è francese, ma non vive in Francia, ma a New York, sottraendosi quindi alle restrizioni di una definizione che sarebbe limitativa. È francese, o meglio in primo luogo un borgognone. Le sue radici penetrano nella profondità del suolo come lo fanno i vini. Entrambi traggono dalla terra i sapori necessari per una grande vendemmia. Ha conservato queste radici, un'acuta sensibilità verso la natura e il gusto dell'eccellenza.

Di colpo non posso fare a meno di pensare che all'inizio della classe di architettura di François Blondel nel 18° secolo vi era una lezione di danza, come se l'architettura si sottraesse all'architettura stessa e dovesse la propria esistenza solamente ad una forma codificata di comportamento sociale. H.D. è socievole. Le estese ore d'ufficio rappresentano solo il preludio di numerose lunghe serate nel corso delle quali i collaboratori e colleghi discutono sulla vita e sul lavoro.

L'arte di H.D. non è né libresca, cerebrale né astratta. È al centro di una combinazione sempre meno consueta di tre qualità: la sensibilità, l'intelligenza e l'autenticità. Nel suo caso, la sensibilità potrebbe essere quella di scegliere il punto più vibrantemente e potentemente armonioso per il maggiore grado di intensità, ma facendolo con morbidezza. L'intelligenza potrebbe rappresentare l'abilità di scegliere e definire i migliori mezzi adatti per ottenere gli effetti che egli desidera. No, l'intelligenza deve per prima cosa e soprattutto servire a trovare un inizio (si dovrebbe pensare ad un'accensione), ad accendere la fiamma, a gettare la prima luce. L'autenticità potrebbe essere intesa in due sensi: da una parte nel senso che la natura unica di un progetto si riconduce ad una località eccezionale, dall'altra come eco delle sue radici. H.D. sa che l'estrema sensazione estetica che tocca il cielo trae spesso la propria grandezza da fonti primitive.

Per tornare sulla mia dichiarazione di prima, H.D. lavora su qualcosa che non esiste, il che ci riporta direttamente alle tante difficoltà che definiscono la sua arte. Per iniziare, esiste un'infinita varietà tra i suoi interventi, nella grande diversità delle sue collaborazioni, inoltre il materiale di ricerca per il suo soggetto è intangibile. Quale ruolo svolge tra gli architetti ed i clienti? Occorre aver visto i progetti a cui ha contribuito per essere in grado di comprendere che senza luce l'architettura non è nulla, e che il massimo in cui si possa sperare è una confluenza tra luce ed architettura. Coloro che hanno deciso di metterlo in prima posizione devono il loro migliore lavoro al suo influsso.

Potremmo accontentarci di questa definizione pressoché classica dell'architettura, anche se il dialogo tra l'architettura e la luce assume un significato molto diverso. In passato, l'architettura nasceva ogni giorno all'alba e spariva nel mondo dei sogni al calar della notte. La luce di candela invitava un'atmosfera affascinante e misteriosa. H.D. ricorda con precisione ogni dettaglio, che egli rivela con ogni nuova produzione. H.D. conosce questo magico trucco fondamentale, ed ancora meglio l'arte di celare il mezzo con cui egli crea la magia. E visto che viviamo in un'era di immagini, esse ci assalgono e ci seducono, mentre l'architettura stessa continua ad essere al centro. Ed è ancora una volta la luce, piena di colori e sequenziale, a consentire all'architettura di essere parte di tali trasformazioni.

Evasivamente, H.D. potrebbe lavorare su qualcosa che non esiste, dispone di tutte le cognizioni scientifiche necessarie per l'architettura dei suoi tempi. Ma in fin dei conti, la scienza non è arte. Non è sufficiente essere in grado di creare qualcosa che nessun altro riesce a fare. Nel posto in cui le sue radici lo legano alla terra sottostante, vi è anche la voce del silenzio, udibile all'estrema altezza dell'emozione.

Sylvain Dubuisson, architetto/designer
30 marzo 2005

Socorro Sperati in our
Phoenix, AZ office

Lea Xiao in Shanghai

L'Observatoire International Team

Back row left to right: Hervé Descottes, Beatrice Witzgall, Stephen Horner, Pelopidas Sevastides, Monica Composto, Étienne Gillabert, Eleni Savvidou, Jason Neches, Zac Moseley, Salvina Fragale.
Front row left to right: Miina Matsuoka, Nathalie Rozot, Vanessa Thaureau (missing: Kumiko Jitsukawa).

In 1993, Hervé Descottes established the lighting design and consulting firm L'Observatoire Intenational in New York City. L'Observatoire's team is comprised of an international cadre of lightin designers, culled from a variety of professional backgrounds, who collaborate on architectur urban, landscape, and fine art projects. We aim to investigate how lighting can be most advant geously engaged to reveal the program, space, and form of the built environment. We utilize th latest technology to achieve a functional, environmental, and creative product.

• In 2003, Hervé Descottes received the **Award for Collaborative Achievement in Design** from th American Institute of Architects (AIA).

• In 2003, the Art Commission of New York City granted him the **Award for Excellence in Design** f the exterior lighting of the P.S.1 Contemporary Art Center. Located in Long Island City, this affilia of the Museum of Modern Art in New York is one of the most experimental museums in the Unite States.

1993 gründete Hervé Descottes L'Observatoire International in New York. Die Firma entwir Konzepte und berät bei der Gestaltung der Beleuchtung von Gebäuden. Das Team besteht au Beleuchtungsdesignern verschiedener Nationalitäten und mit den unterschiedlichsten beruflich Werdegängen, die bei Projekten in den Bereichen Architektur, Stadtplanung, Landschaftsgest tung und Kunst zusammenarbeiten. Wir wollen herausfinden, wie Lichtgestaltung am besten g nutzt werden kann, um Aufbau, Raum und Form der gebauten Umwelt hervorzuheben. Wir ve wenden die neuesten technischen Mittel, um ein funktionelles, umweltfreundliches und kreative Endprodukt zu erhalten.

• 2003 wurde Hervé Descottes der **Award for Collaborative Achievement** in Design vom Amerik nischen Architektenverband (AIA) verliehen.

• 2003 überreichte ihm die Kunstkommission der Stadt New York den **Award for Excellence** **Design** für die Außenbeleuchtung des P.S.1 Contemporary Art Center. Diese Außenstelle des Ne Yorker Museum of Modern Art befindet sich auf Long Island und ist eines der experimentellst Museen der Vereinigten Staaten.

En 1993, Hervé Descottes fonde la société de conception et de conseil en éclairages : L'Observatoi International, à New York City. L'équipe de l'Observatoire comprend un équipe international c créateur en éclairages, qui couvrent une grande variété de domaines professionnelles, et qui cc laborent dans des projets d'architecture, d'urbanisation, paysagers, et artistiques. Notre objec consiste à rechercher comment mettre en œuvre l'éclairage de la manière la plus avantageuse af de mettre en valeur le programme, l'espace et la forme de l'environnement construit. Nous utiliso les technologies les plus actuelles, afin de concevoir un produit fonctionnel, écologique et créat

• En 2003, Hervé Descottes reçoit l'**Award for Collaborative Achievement in Design** remis p l'Institute des Architectes Americains (AIA).

• En 2003, la commission artistique de la ville de New York City lui remet **l'Award for Excellence in Design** pour le projet de la mise en lumiere de l'extérieur du Centre d'Art Contemporain P.S.1 (Contemporary Art Center) ; qui est situé dans la ville de Long Island, et qui est affilié au Musée des Arts Modernes de New York, et c'est le musée le plus expérimental aux Etats-Unis.

En 1993, Hervé Descottes fundó la empresa de diseño y asesoría de iluminación L' Observatoire International en la ciudad de Nueva York. El equipo de L'Observatoire está formado por un cuadro internacional de diseñadores de iluminación procedentes de distintos ámbitos profesionales, que colaboran en proyectos de arquitectura, urbanismo, paisajismo y arte. Pretendemos investigar cuál es la forma más ventajosa en que se puede combinar la iluminación para revelar el programa, el espacio y la forma del ambiente construido. Utilizamos la tecnología más puntera para lograr un producto funcional, medioambiental y creativo.

• En 2003, Hervé Descottes recibió el **Award for Collaborative Achievement in Design** del Instituto Americano de Arquitectos (AIA).

• En 2003, la Comisión de Arte de la ciudad de Nueva York le concedió el **Award for Excellence in Design** por la iluminación exterior del P.S.1 Contemporary Art Center. Situado en la ciudad de Long Island, esta filial del Museo de Arte Moderno de Nueva York es uno de los museos más experimentales de los Estados Unidos.

Nel 1993 Hervé Descottes fondò l'azienda di design dell'illuminazione e di consulenza L'Observatoire International a New York. Il team di L'Observatoire comprende un gruppo internazionale di designer dell'illuminazione, provenienti da diversi background professionali, cooperanti in progetti di architettura, urbani, paesaggistici e di belle arti. Miriamo a studiare il modo in cui l'illuminazione può essere impiegata al meglio per rivelare il programma, lo spazio e la forma dell'ambiente edificato. Adottiamo la più recente tecnologia per ottenere un prodotto funzionale, ambientalmente appropriato e creativo.

• Nel 2003 fu assegnato ad Hervé Descottes **l'Award for Collaborative Achievement in Design** dall'American Institute of Architects (AIA).

• Nel 2003 la Commissione Artistica (Art Commission) di New York gli assegnò **l'Award for Excellence in Design** per l'illuminazione esterna del centro di arte contemporanea "P.S.1 Contemporary Art Center". Situata a Long Island, questa affiliata del Museo delle arti moderne di New York rappresenta uno dei musei più sperimentali degli Stati Uniti.

Contact Information:

L'Observatoire International 414 West 14th Street, 5th Floor, New York, NY 10014
T: 001 212.255.4463 F: 001 212.255.8346 E: info@lobsintl.com

Acknowledgments

"This publication is the product of an intense collaboration. At the same time, it would not have been possible without those friends and colleagues who have provided unrelenting support and generosity over the years. I will remain forever grateful to Seda Bazikian-Boghossian who first put a roof over my head in America. John Brotzman introduced me to the California way of life. David Steinitz first spurred my interest in lighting design, and Ken Poulsen gave me my first job in the field. Guy Nordenson presented me to New York's architecture scene. Thanks to Stephen Rustow for always remaining close. I am indebted to Bernardo Fort-Brescia for believing in me. Thanks to Karena D'silva with whom I shared my second step in this country. Steven Holl is a friend and constant source of inspiration. I am thankful to Sylvain Dubuisson for having understood. I appreciate Keith Kerr for being my greatest critic. Thanks to Jay Cross for enhancing my sports skills. Edmund Cheng offered his friendship and taste for excellence. Anne Deleporte's advice has always been welcomed. Thanks to Ana Bloom for shooting me. Janet and Ando Cross have brought beautiful complications into my life. James Turrell has expanded the dimensions of my universe. L'Observatoire's team (past, present, and future) is at the heart of my work. I especially want to thank my family for their love. Lastly, I am grateful to Ken Ferris who has always been there and for introducing me to Désirée, and to Désirée for being." H. D.

Project Credits

66 New York, New York, USA

Client:	Jean-Georges Vongerichten, Phil Suarez
Architect:	Richard Meier Architects, USA
Project size:	160-seat restaurant

L'Observatoire International: Hervé Descottes (Principal), Zac Moseley (Project Manager), Marci Songcharoen (Team)

AmericanAirlines Arena Miami, Florida, USA

Client:	The Miami Heat
Architect:	Arquitectonica, USA
Associate Architects:	Heinlein & Schrock
Project size:	18,550-seat sporting arena

L'Observatoire International: Hervé Descottes (Principal), Stephanie Grosse-Brockoff (Project Manager)
Lighting Rendering: Solange Fabião, Dwayne Oyler

Art Gallery of Ontario Toronto, Ontario, Canada

Client:	Art Gallery of Ontario
Architect:	Gehry International LLC, USA
Project size:	80,000 sq. ft. of new construction, 120,000 sq. ft. of renovation, and 52,000 sq. ft. of rework renovation

L'Observatoire International: Hervé Descottes (Principal), Socorro Sperati (Project Manager), Jason Neches, Zac Moseley (Team)
Lighting Rendering: Zac Moseley

Bellevue Art Museum Bellevue, Washington, USA

Client:	Bellevue Art Museum
Architect:	Steven Holl Architects, USA
Project size:	70,000 sq. ft.

L'Observatoire International: Hervé Descottes (Principal), Peiheng Tsai (Project Manager)

Bioscleave House Long Island, New York, USA

Client:	Private residence
Artists:	Arakawa and Gins, USA
Project size:	2,700 sq. ft.

L'Observatoire International: Hervé Descottes (Principal)
Lighting Rendering: Anna Muslimova

Buffalo Bayou Houston, Texas, USA

Client:	Buffalo Bayou Partnership
Landscape Architect:	SWA Group, USA
Artist:	Stephen Korns, USA
Project size:	1.25 miles

L'Observatoire International: Hervé Descottes (Principal, Designer), Zac Moseley (Project Manager),
Nathalie Barends / Halie Light (Concept Design)
Lighting Rendering: Nathalie Rozot

Chapel of Saint Ignatius Seattle University, Seattle, Washington, USA

Client:	Chapel of Saint Ignatius
Architect:	Steven Holl Architects, USA
Associate Architect:	Olson Sundberg Architects
Structural Engineer of Record:	Monte Clark Engineering, Seattle
Project size:	8,000 sq. ft.

L'Observatoire International: Hervé Descottes (Principal), Tyler Brown (Project Manager),
Claire Peacock (Writer), Karena D'Silva (Team)

Chateau Marmont Los Angeles, California, USA

Client: Hotels AB
Project size: 80-room hotel

L'Observatoire International: Hervé Descottes (Principal), Caroline Voss (Project Manager)

**College of Architecture
 and Landscape Architecture** Minneapolis, Minnesota, USA

Client: University of Minnesota
Architect: Steven Holl Architects, USA
Associate Architects: Vince James Associates, Rozeboom Miller Architects
Engineer: Ellerbe Becket INC.
Project size: 150,000 sq. ft.

L'Observatoire International: Hervé Descottes (Principal), Étienne Gillabert (Project Manager), Sigrun Prahl (Team)
Lighting Rendering: Jessica Hawkins

Columbus Circle New York, New York, USA

Client: New York City Department of City Planning
Landscape Architect: Olin Partnership, USA
Project size: 40-foot monument, surrounding landscaping and water feature

L'Observatoire International: Hervé Descottes (Principal), James Long, Marci Songcharoen, Socorro Sperati, Peiheng Tsai (Team)
Lighting Rendering: Anna Muslimova

Cranbrook Institute of Science Bloomfield Hills, Michigan, USA

Client: Cranbrook Educational Community
Architect: Steven Holl Architects, USA
Engineers: Ove Arup & Partners
Landscape Consultants: Edmund Hollander
Project size: 56,000 sq. ft. renovation; 27,000 sq. ft. addition

L'Observatoire International: Hervé Descottes (Principal), Dusti Helms (Project Manager)
 Raphaelle Golaz, Caroline Voss, Ann C. (Team)

**Disneyland Theme Park Entry
 Esplanade** Anaheim, California, USA

Client: Walt Disney Company
Landscape Architect: Martha Schwarz, Inc., USA
Project size: 17 acres of streetscape and landscape

L'Observatoire International: Hervé Descottes (Principal), Dusti Helms (Project Manager), John Brotzman
Lighting Rendering: John Brotzman

**Edison School Distance Learning
 Centers** USA

Client: Edison School
Architect: Leslie Gill, USA
Project size: 50-student classroom

L'Observatoire International: Hervé Descottes (Principal), Judith Gieseler (Project Manager)

Fischer Center for the Performing Arts Bard College, Annandale-on-Hudson, New York, USA

Client: Bard Center for the Performing Arts
Architect: Frank O. Gehry and Associates, USA
Project size: 2 theatres

L'Observatoire International: Hervé Descottes (Principal), Maria Machado (Project Manager), Dusti Helms (Team)
Lighting Rendering: Antoine Robert-Grandpierre

French Consulate Garden New York, New York, USA

Client: French Embassy, Service Culturel
Landscape Architect: Field Operations, USA

L'Observatoire International: Hervé Descottes (Principal), Peiheng Tsai (Project Manager), Zac Moseley (Team)

Fresh Kills Landfill

	Staten Island, New York, USA
Client:	New York City Department of City Planning
Landscape Architect:	Field Operations, USA
Project size:	2,200 acres
L'Observatoire International:	Hervé Descottes (Principal), Nathalie Rozot (Project Director), Zac Moseley, Stephen Horner (Team)
Lighting Rendering:	Nathalie Rozot, Lea Xiao

"Rendez-vous" at the Guggenheim

	New York, New York, USA
Client:	Guggenheim Museum
Exhibition Designer:	Andrée Putman, France
L'Observatoire International:	Hervé Descottes (Principal), Sarah Pellegrini (Project Manager)

Guthrie Theater

	Minneapolis, Minnesota, USA
Client:	The Guthrie
Architect:	Ateliers Jean Nouvel, France
Project size:	2 theaters
L'Observatoire International:	Hervé Descottes (Principal), Peiheng Tsai (Project Manager), Zac Moseley, Nathalie Rozot (Team)
Lighting Rendering:	Nathalie Rozot, Ateliers Jean Nouvel

Highline

	New York, New York, USA
Client:	Friends of the Highline
Architect:	Diller, Scofidio + Renfro, USA
Landscape Architect:	Field Operations, USA
Project size:	1.25 miles
L'Observatoire International:	Hervé Descottes (Principal), Nathalie Rozot (Project Director), Stephen Horner (Team)
Lighting Rendering:	Lea Xiao

Issey Miyake Boutique

	New York, New York, USA
Client:	Issey Miyake
Architect:	Frank O. Gehry and Associates, USA
Architect of Record:	G-Tects, USA
Project size:	3,000 sq. ft.
L'Observatoire International:	Hervé Descottes (Principal), Peiheng Tsai (Project Manager)

JVC Omnilife Headquarters

	Guadalajara, Mexico
Client:	Grupo Omnilife
Architect:	Ateliers Jean Nouvel, France
L'Observatoire International:	Hervé Descottes (Principal), Solange Fabião
Lighting Rendering:	Solange Fabião

Langston Hughes Library

	Clinton, Tennessee, USA
Client:	Children's Defense Fund
Architect:	Maya Lin Studio, USA
Project size:	3,000 sq. ft.
L'Observatoire International:	Hervé Descottes (Principal, Designer), Dusti Holms (Project Manager)

Lever House Restaurant

	New York, New York, USA
Client:	Green Apple Group
Designer:	Marc Newson, Australia
Architect of Record:	CAN Resources
Project size:	130-seat restaurant
L'Observatoire International:	Hervé Descottes (Principal), Peiheng Tsai (Project Manager), Zac Moseley (Team)

Lincoln Center Redevelopment　　　　New York, New York, USA

Client:　　　　Lincoln Center
Architect:　　　　Diller, Scofidio + Renfro, USA
　　　　Fox and Fowle, USA

L'Observatoire International:　　　　Hervé Descottes (Principal), Nathalie Rozot (Project Director),
　　　　Stephen Horner, Jason Neches, Eleni Savvidou, Beatrice Witzgall (Team)
Lighting Rendering:　　　　Anna Muslimova, Beatrice Witzgall, Lea Xiao

Mercer Hotel and Mercer Kitchen　　　　New York, New York, USA

Client:　　　　Hotels AB
Interior Architect:　　　　Christian Liaigre, France
Project size:　　　　75-room hotel

L'Observatoire International:　　　　Hervé Descottes (Principal), Dusti Helms (Project Manager),
　　　　Solange Fabião, Caroline Voss (Team)

Mix Lounge　　　　Las Vegas, Nevada, USA

Client:　　　　Alain Ducasse, Mandalay Bay
Designer:　　　　Agence Patrick Jouin, France
Project size:　　　　200-seat restaurant

L'Observatoire International:　　　　Hervé Descottes (Principal), Zac Moseley (Project Manager),
　　　　James Long, Beatrice Witzgall (Team)

Mix Restaurant　　　　Las Vegas, Nevada, USA

Client:　　　　Alain Ducasse, Mandalay Bay
Designer:　　　　Agence Patrick Jouin, France
Project size:　　　　200-seat restaurant

L'Observatoire International:　　　　Hervé Descottes (Principal), Zac Moseley (Project Manager),
　　　　James Long, Beatrice Witzgall (Team)

Museum of the Moving Image　　　　Queens, New York, USA

Client:　　　　Museum of the Moving Image
Architect:　　　　Ali Hocek Architects, USA
Project size:　　　　30,000 sq. ft.

L'Observatoire International:　　　　Hervé Descottes (Principal), Stephanie Grosse-Brockoff, Karena D'Silva (Team)

**Newtown Creek Water Pollution
　Treatment Plant**　　　　Brooklyn, New York, USA

Client:　　　　NYC Department of Environmental Protection
Architect:　　　　Polshek Partnership, USA
Engineers:　　　　Quennell, Rothschild & Ptrs, Greeley & Hansen, Hazen & Sawyer, Malcolm Pirnie
Project size:　　　　2,000,000 sq. ft.

L'Observatoire International:　　　　Hervé Descottes (Principal), Nathalie Rozot (Project Director), Sophie Bruyère, Peiheng Tsai
　　　　(Project Managers), Dusti Helms, Stephen Horner Pelopidas Sevastides (Team)
Lighting Rendering:　　　　Hervé Descottes, Nathalie Rozot

New York Sports and Convention Center　New York, New York, USA

Client:　　　　NY Jets
Architect:　　　　Kohn Pederson Fox
Graphic Designer:　　　　Bruce Mau
Project size:　　　　80,000 seat stadium

L'Observatoire International:　　　　Hervé Descottes (Principal), Beatrice Witzgall (Project Manager),
　　　　Kumiko Jitsukawa, Peiheng Tsai (Team)
Lighting Rendering:　　　　Lea Xiao

Olympic Village Competition　　　　Queens, New York, USA

Client:　　　　NYC2012
Architect:　　　　Zaha Hadid Architects, UK

L'Observatoire International:　　　　Hervé Descottes (Principal), Beatrice Witzgall (Project Manager)
Lighting Rendering:　　　　Beatrice Witzgall

Parade Exhibition

Client:
Designers:

Project size:

L'Observatoire International:

São Paulo, Brazil

Brazil Connects
Agence Patrick Jouin, France
Stéphane Maupin, France
Julien Monfort, France
10,000 sq. ft. exhibit

Hervé Descottes (Principal), Maria Machado (Project Manager),
Cecilia Echenique, Magda Lolopetti (Team)

Phillips de Pury & Luxembourg

Client:
Architect:
Project size:

L'Observatoire International:

New York, New York, USA

Phillips de Pury & Luxembourg
Patrick Mauger, France
10,000 sq. ft.

Hervé Descottes (Principal), Étienne Gillabert (Project Manager)

P.S.1 Contemporary Art Center

Client:

L'Observatoire International:
Lighting Rendering:

Queens, New York, USA

P.S.1 Contemporary Art Center

Hervé Descottes (Principal), Zac Moseley (Project Manager)
Bernardo Zavattini

Hotel QT

Client:
Architect:
Project size:

L'Observatoire International:
Lighting Rendering:

New York, New York, USA

Hotels AB
ROY Co., USA
140-room hotel

Hervé Descottes (Principal), James Long (Project Manager)
James Long

The Standard Hollywood

Client:
Designer:
Architect of Record:
Project size:

L'Observatoire International:

Hollywood, California, USA

Hotels AB
Shawn Hausman, USA
Arquitectonica, USA
180-room hotel

Hervé Descottes (Principal), Dusti Helms (Project Manager)

The Standard L.A.

Client:
Interior Designer:
Architect of Record:
Project size:

L'Observatoire International:

Los Angeles, California, USA

Hotels AB
Shawn Hausman, USA
Koening / Eisenberg
145-room hotel

Hervé Descottes (Principal), Peiheng Tsai (Project Manager),
Zac Moseley, Marci Songcharoen (Team)

**Trading Floor Operations Center at
the New York Stock Exchange**

Client:
Architect:
Project size:

L'Observatoire International:

New York, New York, USA

New York Stock Exchange
Asymptote Architecture, USA
600 sq. ft.

Hervé Descottes (Principal), Peiheng Tsai (Project Manager)

Walt Disney Concert Hall

Client:
Architect:
Project size:

L'Observatoire International:

Los Angeles, California, USA

Music Center of Los Angeles
Frank O. Gehry and Associates, USA
2,265 seats, 293,000 sq. ft.

Hervé Descottes (Principal), Stephanie Grosse-Brockoff, Dusti Helms (Team)

Brancusi Ensemble Targu-Jiu, Romania

Client: Municipality, Targu-Jiu
Landscape Architect: Olin Partnership, USA
Project size: Lower park project area: 13,335 sq. m., Column park: 45,500 sq. m.

L'Observatoire International: Hervé Descottes (Principal), Nathalie Rozot (Project Director), Eleni Savvidou (Team)
Lighting Rendering: Nathalie Rozot

Caisse des Dépôts et Consignations Paris, France

Client: Caisse des Dépôts et Consignations
Architect: Christian Hauvette, France
Artist: James Turrell

L'Observatoire International: Hervé Descottes (Principal), Étienne Gillabert (Project Manager), Dominique Breemersch (Team)
Lighting Rendering: Christian Hauvette, France

Le Carnaval des animaux Montpellier, France

Client: Montpellier Festival
Director: Jean Paul Scarpitta
Project size: Lighting of the opera stage

L'Observatoire International: Hervé Descottes (Principal), Sophie Bruyère (Project Manager), Dominique Breemersch (Team)
Lighting Rendering: Anna Muslimova

Spoon des Neiges à Chlösterli Gstaad, Switzerland

Client: Alain Ducasse, Michel Pastor
Designer: Agence Patrick Jouin, France
Project size: 2 restaurants (200 seats) and nightclub

L'Observatoire International: Hervé Descottes (Principal), Étienne Gillabert (Project Manager)
Lighting Rendering: Étienne Gillabert

Kiasma Museum of Contemporary Art Helsinki, Finland

Client: Ministry of Public Buildings
Architect: Steven Holl Architects, USA
Local Architect: Juhani Pallasmaa, Finland
Project size: 140,000 sq. ft

L'Observatoire International: Hervé Descottes (Principal), Tyler Brown (Project Manager),
Georges Berne, Karena D'Silva, Raphaelle Golaz, Dusti Helms (Team)

Lille 2004 Lille, France

Client: European Cultural Capital, Lille 2004
Designer: Agence Patrick Jouin, France

L'Observatoire International: Hervé Descottes (Principal), Étienne Gillabert (Project Manager)
Lighting Rendering: Etienne Gillabert

Mont Saint-Eloi Saint-Eloi, France

Client: Conseil Général du Pas-de-Calais & Lille 2004
Project size: 60 meter high facade

L'Observatoire International: Hervé Descottes (Principal), Étienne Gillabert (Project Manager), Dominique Breemersch (Team)

Boutique at the Musée des Arts Décoratifs Paris, France

Client: Artcodif
Architect: Bruno Moinard, France
Project size: 6,000 sq. ft.

L'Observatoire International: Hervé Descottes (Principal), Raymond Belle (Project Manager)

Alain Ducasse at Hotel Plaza Athenée Paris, France

Client: Alain Ducasse, Hotel Plaza Athenée
Designer: Agence Patrick Jouin, France
Project size: 40-seat restaurant

L'Observatoire International: Hervé Descottes (Principal), Étienne Gillabert (Project Manager), Dominique Breemersch

Bar at Hotel Plaza Athenée Paris, France

Client: Alain Ducasse, Hotel Plaza Athenée
Designer: Agence Patrick Jouin, France
Project size: 3,000 sq. ft.

L'Observatoire International: Hervé Descottes (Principal), Sandrine Gréther (Project Manager), Raymond Belle (Team)

Pont du Gard Vers Pont du Gard, France

Client: Concession Pont du Gard, Chambre de Commerce et d'Industrie de Nîmes
Artist: James Turrell

L'Observatoire International: Hervé Descottes (Principal), Karena D'Silva, Lindsay Stefans (Team)

Sarphatistraat Offices Amsterdam, The Netherlands

Client: Woningbouwvereniging Het Oosten
Architect: Steven Holl Architects, USA
Associate Architect: Rappange & Partners Architecten bv
Electrical & Mech Engineer: Ingenieursgroep Van Rossum
Project size: 15,000 sq. ft. addition, 50,000 sq. ft. renovation

L'Observatoire International: Hervé Descottes (Principal), Maria Machado (Project Manager)

Le Secret des Churingas Paris, France

Client: Musée National des Arts d'Afrique et d'Oceanie
Artist: Marc Couturier

L'Observatoire International: Hervé Descottes (Principal), Raymond Belle (Team)

Serial Killer / Barbe Bleue Créteil, France

Client: Lille 2004
Director/Designer: Agence Patrick Jouin, France

L'Observatoire International: Hervé Descottes (Principal), Étienne Gillabert (Project Manager), Dominique Breemersch (Team)

Sony Center Berlin, Germany

Client: Sony with its partners Tishman Speyer Properties and Kajima
Architect: Murphy / Jahn Architects, USA
Project size: 1,322,000 sq. ft.

L'Observatoire International: Hervé Descottes (Principal), Dusti Helms (Project Manager), Nathalie Kirch (Team)

ASIA

Beige / Alain Ducasse

Client:
Architect:
Project size:

L'Observatoire International:

Cyberport

Client:
Architect:
Architect of Record:
Project size:

L'Observatoire International:
Lighting Rendering:

Festival Walk

Client:
Architect:
Architect of Record:
Project size:

L'Observatoire International:

Lighting Rendering:

Hong Kong Harbour

Client:
Developer:
Architects:

L'Observatoire International:

Lighting Rendering:

Jean-Georges Shanghai

Client:
Architect:
Project size:

L'Observatoire International:

Leeum Samsung Museum of Art

Client:
Architects:

Project size:
L'Observatoire International:

Linked Hybrid

Client:
Architect:
Project size:

L'Observatoire International:

Tokyo, Japan

Chanel Japan
Peter Marino Architects, USA
80-seat restaurant

Hervé Descottes (Principal), Étienne Gillabert (Project Manager)

Hong Kong, China

Pacific Century Cyberworks Ltd.
Arquitectonica, USA
Wong Tung & Partners Limited
1 million sq. ft. of office space and facilities, 6 buildings, landscape podium

Hervé Descottes (Principal), Raymond Belle (Project Manager), Peiheng Tsai (Team)
Innes Yates

Hong Kong, China

Swire Properties
Arquitectonica, USA
Dennis Lau & Ng Chung Man
1.35 million sq. ft.

Hervé Descottes (Principal), Georges Berne (Concept), Raymond Belle (Project Manager)
Tyler Brown, Nathalie Kirch (Team)
Nathalie Kirch, François Migeon

Hong Kong, China

The Government of Hong Kong Special Administrative Region
Swire Properties
Gehry International LLC, USA
Arquitectonica, USA
S.O.M., Hong Kong
Wong & Ouyang, Hong Kong

Hervé Descottes (Principal), Beatrice Witzgall (Project Manager),
Tip Wei Lam, Désirée von La Valette (Team)
Beatrice Witzgall

Shanghai, China

Jean-Georges Vongerichten
Michael Graves, USA
200-seat restaurant

Hervé Descottes (Principal), Zac Moseley (Project Manager), Kumiko Jitsukawa (Team)

Seoul, Korea

Samsung Foundation of Culture
Museum 1, Traditional Art: Mario Botta Architetto, Italy
Museum 2, Modern & Contemporary Art: Ateliers Jean Nouvel, France
Center for Child Education: Rem Koolhaas / OMA, The Netherlands
5,000 sq. m.
Hervé Descottes (Principal), Nathalie Rozot (Project Director), Zac Moseley, Socorro Sperati (Team)

Bejing, China

Beijing Modern Hongyun Real Estate Development Co. LTD
Steven Holl Architects, USA
7 residential towers

Hervé Descottes (Principal), Beatrice Witzgall (Project Manager),
James Long, Stephen Horner (Team)

Makuhari Housing

Chiba, Japan

Client:	Mitsui Fudosan Group
Architect:	Steven Holl Architects, USA
Block Design Coordinator:	Kouichi Stone (K. Stone + Enviromental Design Associates)
Block Architect:	Toshio Enomoto (Kajima Design)
Project size:	84,000 sq. ft. site

L'Observatoire International : Hervé Descottes (Principal), Tyler Brown (Project Manager)

North One

Singapore

Client:	Wing Tai Property Management Pte Ltd.
Architect:	Toyo Ito and Associates, Japan
Project size:	1,350,000 sq. ft.

L'Observatoire International: Hervé Descottes (Principal), Beatrice Witzgall (Project Manager)
Lighting Rendering: Anna Muslimova

Winsland House II

Singapore

Client:	Wing Tai Ltd.
Architect:	Arquitectonica, USA
Project size:	200,000 sq. ft.

L'Observatoire International: Hervé Descottes (Principal), Miriam Erbacher, Maria Machado (Team)
Lighting Rendering: Miriam Erbacher

Image Credits